we gotta get out of this place

we gotta get out of this place

popular
conservatism
and postmodern
culture

lawrence grossberg

routledge ■ new york & london

Published in 1992 by

Routledge
An imprint of Routledge, Chapman and Hall, Inc.
29 West 35 Street
New York, NY 10001

Published in Great Britain by

Routledge
11 New Fetter Lane
London EC4P 4EE

Library of Congress Cataloging-in-Publication Data

Grossberg, Lawrence.
 We gotta get out of this place : popular conservatism and postmodern culture / Lawrence Grossberg.
 p. cm.
 Includes bibliographical references.
 ISBN 0-415-90329-7; ISBN 0-415-90330-0 (pbk.)
 1. United States—Popular culture—History—20th century.
2. Conservatism—United States—History—20th century. 3. Rock music—United States—1981–1990—History and criticism. 4. Politics and culture—United States—History—20th century. I. Title.
E169.04.G757 1992
973.9—dc20 91-46191
 CIP

British Library Cataloguing in Publication Data also available

CONTENTS

Contents

ACKNOWLEDGMENTS

Walter Benjamin's dream of writing a book composed entirely of quotes is partly my reality, making this perhaps the hardest part of the book to write. This book is the product of many years of conversation, reading, learning and sharing with a large number of people, and I can no longer confidently identify what is "my own" and what someone else gave me. I apologize to those whose influence I have not acknowledged. It is not through lack of effort that I have failed, but rather because your work seemed so right that I have lost any sense of its origin.

I would like especially to thank:

—my wife, Barbara Claypole White, who has contributed much more than I can ever say, both emotionally and intellectually. Not only would this have been a weaker book without her, it probably never would have been written.

—and Stuart Hall, who has been my mentor and friend for a long time. It is to him that I turn when I feel desperate, when I doubt the importance of intellectual work, and when I need some intellectual guidance. I know of no better model of a humane and politically committed intellectual. He has had such a profound influence on my work that I can no longer separate my ideas from his.

Other invaluable friends have contributed significantly to this project. Meaghan Morris has generously shared her thoughts with me and often pushed me in new directions. Among other things, she helped me to understand Deleuze and Guattari and Lefebvre

and to bring them together. John Clarke gave me invaluable encouragement and criticism simultaneously. James Carey insightfully discussed many of the political and economic issues with me. Marty Allor, Andrew Goodwin and Harris Breslow have all offered useful criticisms of earlier versions. Ellen Wartella and Chuck Whitney have been very special friends and colleagues, who stood by me through the worst of times, and who constantly challenged me to question my own closed-mindedness.

I would also like to thank the following people: Fred Gottheil, Jennifer Slack, Simon Frith, Jan Radway, Andrew Ross, James Hay, Dick Hebdige, Tony Bennett, Marcus Breen, Angela McRobbie, Iain Chambers, Cary Nelson, Paula Treichler, Charley Stivale, Jon Crane, Jesse Delia, Henry Giroux, Howard Maclay, Catherine Hall (and Becky and Jesse), André Frankovits, and Daniel and Barbara O'Keefe. I also owe a debt of gratitude to the many wonderful graduate and undergraduate students I have been fortunate enough to work with. Some are still friends, others have disappeared into the landscape, but this book would not have been possible without them. I would also like to thank the University of Illinois Research Board and the Center for the Study of Cultural Values and Ethics for their generous support. And some more personal acknowledgments: my family (Miriam, Al, Edythe, Michael, Linda and Jeff Grossberg), Douglas and Anne Claypole White, Steve and Laurie Weidemier. And aging rockers Phil Strang, Charlie Edwards and Jon Ginoli.

I dedicate this book to my wife; to my mother and father, who gave me a reason to believe in myself; to my teachers (including Richard Taylor, Loren Baritz, Hayden White, Richard Hoggart, Stuart Hall, Jim Carey—I was fortunate indeed!); to all the people named here, and the many whose names have not been written here.

And to the memory of Saul Weiss, who, with Eva, taught me to love and respect intelligence, and to enjoy a good argument.

INTRODUCTION: THEORY, POLITICS AND PASSION

When I first began to write a book on rock and politics at the end of the 1970s, I already had a title: "Another Boring Day in Paradise." Ten years later, that title seemed too optimistic and naive. So I turned to the title of one of my favorite rock songs—"We Gotta Get out of This Place," a song by the Animals that even in the 1960s expressed an anxiety and desperation I felt but did not understand. Today, almost everyone, even George Bush, would agree with its sentiment, although they might have different ideas about where we are and where we should go. This book is about the change of titles: the transition from one form of dissatisfaction to another and its significance to our common history.

No doubt, this is a book with too many arguments and not enough evidence, but it may be forgiven in a world with too much evidence and not enough argument. It is a book which too easily embraces generalizations, but it may be forgiven in a political environment which increasingly denies their relevance. And it is a book which is too willing to gather fragments and speculate about their connections, but it may be forgiven in an academic culture which celebrates fragments and renounces speculation. Whether because we have become too fearful or too myopic, we increasingly censor the statements of our questions, thoughts and hypotheses.

The change of titles, however, signals something more than a different cultural atmosphere; it also signals a different intellectual project. I have always been interested in rock because it provided a

particularly powerful way into the relations of culture and power. My researches were part of a larger body of work which sought to explore the often sophisticated ways people use and respond to popular culture: to recognize the often pleasurable, sometimes empowering and occasionally resistant nature of their relation to popular culture.[1] This work has been criticized for substituting fandom for politics and for celebrating repressive cultural forms simply because they are popular.[2] To argue that people are often "empowered" by their relations to popular culture, that they may in fact seek such empowerment, and that such empowerment sometimes enables people to resist their subordination is not the same as arguing that all of our relations to popular culture constitute acts of resistance or that such relations are, by themselves, sufficient bases for an oppositional politics. On the contrary, it refuses to assume too quickly the political resonances of popular culture, of people's relations to it, and of its pleasures and empowering possibilities. Moreover, to argue that people are not cultural dopes is not the same as arguing that they are never duped; it merely says that the success of such efforts is never guaranteed. I do not want to give up the advances of this work: it took a long time to overcome the cultural and political elitism which condemned popular culture to be little more than the site of ideological manipulation and capitalist production.

But this is not a book about rock—that book still needs to be done—because I realized that the politics of rock in the 1980s were inseparable from a broader range of issues which seemed more pressing to me. This book, then, is about the political, economic and cultural forces which are producing a new atmosphere, a new kind of dissatisfaction, and a new conservatism in American[3] life. It is not an optimistic look at the possibilities of popular culture but a pessimistic speculation about the role that popular culture is playing in the contemporary reorganization of power in the United States. My studies of rock convinced me of the importance of passion (affect) in contemporary life.[4] This book questions the role of passion and its absence in contemporary political struggles and cultural studies. It is about the relations of theory, politics and passion: How is

culture, as both an object and source of passion, implicated in power, and how can we understand that relation?

ROCK UNDER SIEGE

Every exploration, no matter how speculative and abstract, has to find some event or landmark through which it can gain access to the labyrinths of culture and power. My attempt to map the present began with the recent explosion of attacks on rock.[5] The fact that similar attacks have appeared before does not allow us to assume that they emerge from the same political agenda, nor that they produce the same meanings and effects. The terrain of human life is too complex and contradictory to be conceived in terms of such simple relations. Something does not simply enter the field as if by magic, nor does it immediately and directly transform everything else in the same way. Events have effects but they are always complexly determined. Something happens (e.g., attacks on rock), but always in particular ways and for particular reasons; it has its effects, but they may be different (and differently experienced) at different social and cultural sites. The effects may move more quickly in certain directions, and be contradicted by other developments somewhere else.

Trying to make sense of the attacks raised a number of questions: Why now? Why in those particular forms? Why so successfully? None of them can be answered by simply uncovering the intentions of those producing the attacks, which, after all, might vary significantly. The import of these attacks can only be grasped if they are located within larger cultural fields, where they can help orient the effort to map the relations between culture, daily life and politics.[6] Such an effort involves organizing a range of cultural texts and logics around the attacks on rock, without claiming that the attacks are necessarily at the center, nor that they are the only signposts which can tell us something about the specific forms of contemporary cultural and political struggles. In fact, I quickly realized that they were but one example of the Right's (or more accurately, a new

conservative alliance's) intentionally complex and ambiguous relationship to popular culture. Another small example was provided by Colin Powell's and James Baker's visit with the troops during the Iraq war: I was at first amused and later perplexed when the two happily accepted, on national television, the gift of a large Bart Simpson doll. After all, Simpson is not only a symbol of everything the Right despises, his image is apparently something the new conservatives would like to see purged from our culture, or at least from our schools.

The ambiguity of the new conservative's relation to rock becomes visible when we identify the three different, even contradictory, forms that the attacks have taken. The first demands a complete and total rejection of rock music and culture; the second attempts to discriminate between the acceptable and the unacceptable, to police the boundary by locating rock within the relations of domestic power; the third attempts to appropriate rock and challenge "youth culture's" claim of "ownership."

Consider the following statement of the first strategy:

> Picture a thirteen-year-old boy sitting in the living room of his family home doing his math assignment while wearing his Walkman headphones or watching MTV. He enjoys the liberties hard won over centuries by the alliance of philosophic genius and political heroism, consecrated by the blood of martyrs; he is provided with comfort and leisure by the most productive economy ever known to mankind; science has penetrated the secrets of nature in order to provide him with the marvelous, lifelike electronic sound and image reproduction he is enjoying. And in what does all this progress culminate? A pubescent child whose body throbs with orgasmic rhythms; whose feelings are made articulate in hymns to the joys of onanism or the killing of parents; whose ambition is to win fame and wealth in imitating the drag-queen who makes the music. In short, life is made into a nonstop, commercially prepackaged masturbational fantasy.[7]

The passage is from Allan Bloom's *The Closing of the American Mind,* one of the few explicitly academic books (by a professor at the University of Chicago) to gain real public visibility in recent times. Bloom's attack is actually quite similar to those produced by

the Christian fundamentalist movement, and usually disseminated through their own media (including cable networks, satellites, syndicated television and radio programs, meetings, publications and mailing lists) Both Bloom and the fundamentalists see rock—the music and its culture—as responsible for a certain fall from grace, although they differ on where we have fallen from, as well as on the cure and the desired end. Bloom is part of an elitist fraction of the new conservative alliance (no populism in his book!) who would like to see a value-based education grounded in the "great books" of the Western (white, male) tradition.

Fundamentalist Christians are more populist, using the potential of televangelism to defeat the evils of secular humanism. Yet the fundamentalist vision is the source of many of the contemporary charges leveled against rock—from its obvious "sexuality" to its sublime "satanism," from subliminal messages to "backmasking" (messages recorded backwards incorporated into the music). According to the fundamentalist rhetoric, rock—"all of rock music, even the mellow sounding stuff"—is part of a "bizarre and fiendish plot designed by Satan's antichrist system" to "lull the youth of the world."[8] This has been firmly embodied in the notion that rock fans have to be monitored (according to the American Medical Association[9]) and even "deprogrammed," an idea which has been increasingly realized in the creation of centers and experts for such purposes, with the cooperation of law enforcement agencies and medical institutions.

The second strategy for attacking rock is best exemplified by the activities of the Parents' Music Resource Center. The PMRC has clear connections, not only with the PTA and the American Academy of Pediatricians, but also with such fundamentalist organizations as Focus on the Family and the American Family Association. Yet the PMRC's strategy is significantly different. It attempts to police the boundaries of rock and to place the power to define what is "proper" or "appropriate" music in the domestic authority of the parent (and, to some extent, the patriarchal government). The PMRC, founded in 1985 by four Washington wives, including those of Sen. Albert Gore and Secretary of State James Baker, has constructed a campaign designed to "educate" parents about certain

"alarming new trends" in rock music, trends which they claim add up to a sharp break, a "quantum leap," in the history of rock. The rhetoric of their attack is often predicated on a comparison of early and contemporary rock. The former, the music they grew up on, is viewed positively. By conveniently forgetting the attacks which were (and are) leveled against the music they defend, and by selectively ignoring more controversial examples of classic rock, they are able to celebrate their own youth culture while attacking its contemporary forms. The PMRC claims that "too many of today's rock artists— through radio, records, television videos, videocassettes—advocate aggressive and hostile rebellion, the abuse of drugs and alcohol, irresponsible sexuality, sexual perversions, violence and involvement in the occult."[10]

The PMRC denies that it is seeking to censor rock music and, to a certain extent, the claim must be taken seriously. For example, Tipper Gore "has praised Luther Campbell [the leader of 2 Live Crew] for his sense of responsibility in labeling his records and providing expurgated versions for sale to children."[11] The PMRC's major proposal advocated warning labels on rock albums. They negotiated an agreement in 1990 with the National Association of Record Manufacturers in which various state legislative efforts to mandate labeling were withdrawn in favor of voluntary labeling.[12] The call for labels is, the PMRC claims, merely a demand for "truth in packaging" which would inform both children and parents of what is being purchased and consumed.

The PMRC's argument is based on the fact that the average child listens to 10,462 hours of rock between the seventh and twelfth grades, more time than he or she spends in school. Although they admit that there is no statistical evidence against rock, they frequently adduce anecdotal evidence to "document" rock's evil effects. Most commonly, this involves cases of suicide or murder, often linked with occult or satanic overtones: e.g., a child listens to Blue Oyster Cult's "Don't Fear the Reaper" (or, in a recent court case, Judas Priest's "Stained Class") and then kills himself. The increasing suicide rate among adolescents (up 300% since the 1950s) is taken as proof of rock's detrimental effects, ignoring not only the impact of

other social factors but also the fact that the organizers of the PMRC themselves (like the vast majority of postwar youth) were also raised on rock.

The efforts of the PMRC have not been confined to such lobbying and proselytizing efforts; they have supported and encouraged the use of a wide range of legal weapons against rock, as documented in the valuable pamphlet *You've Got a Right to Rock*.[13] Obviously, the threat of such legal proceedings (e.g., recent cases involved the Dead Kennedys, 2 Live Crew and Judas Priest) has created an atmosphere of uncertainty for many bands, labels and distributors. The PMRC and other groups have supported the use of expanded economic and security requirements, boycotts, and political prohibitions, as well as the construction of various images of moral crisis, as part of the arsenal by which rock (especially, but not only, rap and heavy metal) can be controlled.

However, it is the third form of attack which is most insidious. For on the surface it appears to be anything but an attack on rock. Rather, it celebrates (at least certain forms of) rock, but only by significantly reconstructing its very meanings and significance. This is perhaps the ultimate affirmation of what Tom Carson described as the dilemma of having rock in the White House: "You can't associate pop with any sort of disenfranchisement when its headquarters is the White House."[14] When George Bush became president in 1989, Lee Alwater emerged as one of the most powerful political figures in the United States. As Bush's campaign manager and chairman of the Republican National Party, Atwater championed the use of popular media and marketing strategies.

Atwater claimed a special place for rock (more precisely, rhythm and blues)! He organized an inaugural party—"The Concert for Young Americans"—which was also billed as a Celebration of Rhythm and Blues. The vast majority of performers were in fact black, although a few white musicians, like Ron Wood and Delbert McClintock, were included. Imagine, if you will or can, Cheryl Ladd speaking on the history of rhythm and blues in black theaters, or Chuck Norris on the meaning of the blues. Envision the president entering and leaving to the sounds of "Soul Man," his brief appear-

ance highlighted by the gift of an electric guitar, which he obviously had no idea how to embrace. Lee Atwater was on stage, jamming with some of the greatest black musicians of our time! Following that, Atwater's rock career continued apace. He appeared on *Late Night with David Letterman*, not as a guest to be interviewed but as a guest member of Paul Schaeffer's band. He performed in various rock and blues venues, both solo and with a variety of other performers. His performances were regularly covered, or at least mentioned, by the media. And he released a "rhythm and blues" album in 1990 (which, fortunately, has flopped).

Three comments are worth making here. First, we must assume that Atwater's entrance into rock culture was planned, or at least that it was sanctioned by the image-makers and marketers of the Republican party. Second, Atwater was living out a new image of the rock fantasy: how to be rich and powerful and manipulative (and to have apparently all the wrong politics) and to be a rock star. And third, such appropriations are not confined to the Republicans: recently, Christian groups have organized tours (e.g., "Freedom Jam") which use rock to deliver their fundamentalist and conservative messages. And Pat Boone has started a campaign to have himself installed into the Rock and Roll Hall of Fame, presumably on the grounds that having made rock and roll "nice" was a valuable contribution.

Surprisingly, given the comparative successes of these campaigns, there has been relatively little public opposition from either the industry or fans. Many journalists and fans still deny the existence of an antirock conspiracy. In the past, such attacks were often the occasion for an increased public celebration of and self-assertion within rock culture, for they proved in a way the power of rock. Since attacks on rock have existed for most of its history[15] (and attacks on music, especially dance music, have a much longer history in the West), the question is less why the current attacks exist but why they have become so publically acceptable, even commonsensical. After all, in the past, such attacks on rock were located either in the domestic sphere—as a conflict between parents and children—or assigned to a lunatic fringe. The only exception—the Payola hearings

of the late 1950s—provides a clear example of how such popular moral outrage against rock can be appropriated into another struggle: in this case, the economic struggle between various competing interests in the music and media business.

There is something even more paradoxical about the contemporary attacks on rock: after all, rock has become a part of the dominant mainstream culture. Whether or not it has been totally "colonized" by the economic interests of capitalism, and incorporated into the routinized daily life of capitalist, patriarchal and racist relations, it is omnipresent (providing the background music for advertising, television, films and even shopping). And it is not only the classics or oldies but contemporary songs and sounds that are used. Whether or not it has become "establishment culture," it does seem that rock is losing its power to encapsulate and articulate resistance and opposition. Despite the proliferation of explicitly political performers, events and activities, it is difficult to see where and how rock is, or could be, articulated to political commitments (as more and more rockers jump onto the Right's antidrug bandwagon). But if this is the case, then how do we understand the attacks on rock? These attacks are an impassioned and urgent call to arms; but what is it they are struggling over?

Obviously, these attacks are part of a sustained movement—orchestrated in part by various fractions of the new conservative alliance (including the "New Right")[16] and winning various degrees of public support—to constrain, police and even regulate (read censor!) the production, distribution and consumption of art and popular culture in the United States.[17] There are important similarities among the various attempts at censorship (e.g., policing libraries and schools, discussions about television, limiting government spending on the arts), including: the mobilization of government support without legislative action, or at least with only the threat of such action; the use of indirect tactics (e.g., debates over funding which avoid explicit infringements of free speech); the use of commercial pressure on advertisers, retailers and corporations (e.g., boycott and publicity); framing the concerns in terms of the representation of immorality (e.g., of violence, drugs, homosexuality,

antipatriotism). But rock also provides some unique problems. Since it is difficult to maintain that the lyrics of rock are its most salient element (and its lyrics are often innocuous, ambiguous or unintelligible), its representation of specific morally suspect or antisocial activities cannot be taken as conclusive evidence of its social effects. This may explain the attention given to the claims of subliminal messages and backmasking. Rock's penetration into and dispersion throughout the social fabric has made it difficult if not impossible to locate it within simple causal equations. Consequently, the evidence used to identify and condemn the effects of its representations has rarely come from traditionally respected sources of knowledge and authority (e.g., university researchers) but from the very institutions (church, police) leading the attack.

Such efforts at censorship are clearly related to a number of important political and ideological struggles: to redefine "freedom" and reconstitute the boundaries of civil liberties; to (re)regulate sexual and gender roles (leading to the construction of ever more violent antifeminist and homophobic positions); to monitor and even isolate particular segments of the population, especially various racial and ethnic minorities who, along with women and children, make up the vast majority of the poor; and to discipline the working class (e.g., through attacks on unions) in order to (de)regulate an international consumer economy dedicated to the increasing accumulation of profit (without the apparent necessity of converting wealth into investment).

The attacks on rock are also part of a larger attempt to regulate the possibilities of pleasure and identity as the basis of political opposition and to dismantle the cultural and political field constructed in the 1960s. There is no doubt that "the autonomy of blacks, women and young people—to mention three groups whose emergence gave the 60s their distinct identity—is under siege again."[18] (We might add other groups, including gays and lesbians and Chicanos.) The field of struggle constructed by the various countermovements of the 1960s depended upon the articulation of politics and pleasure, of popular culture and social identity. Pleasure became a source of power and a political demand, enabled by the

very marginality of those struggling. The new conservatives have to regulate pleasure in order to reestablish the discipline they believe necessary for the reproduction of the social order and the production of capital (e.g., the family). But collapsing the attacks on sex, drugs, consumerism and rock into a single project fails to take account of the new conservative's rather sophisticated and strategic understanding of the place of media and culture in society.

How do we understand the relations among the three strategies? How do we understand why they have appeared at just this moment, not only in the history of rock, but of the nation as well? If we start with the fact that, taken together, the three strategies define an ambiguous relation to rock, then we have to ask how this ambiguity, originating in different social groups, with different political agendas, is effectively assembled within and connected to a larger conservative agenda. By too quickly assimilating the attacks on rock to the broad category of censorship, or to the larger struggle to discipline the population, we may in fact miss the specific strategy behind the attacks and the political struggles to which they point. Locating the attacks in the field of popular culture and daily life raises questions about their deployment and articulation. I want to suggest that they involve more than questions about contemporary musical trends and the place and power of rock in daily life. They point to one of the key strategies by which a new conservatism is being constructed in America.

DEPOLITICIZATION AND THE NEW CONSERVATISM

How we imagine the future, how we conceptualize the possibilities open to us, depends upon how we interpret our present circumstances. Too many of the stories we are telling ourselves seem to lead nowhere or to some place we would rather not go. Only if we begin to reread our own moment can we begin to rearticulate our future. If you want to change the ending, you have to tell a different story.

It is easy to tell the story of the king (Reagan or Bush), his evil

advisers (the military industrial complex) and his selfish noblemen (capitalists). It is easy to blame the media and popular culture for the apparent shifts in popular sentiment, to accuse the media of "narcotizing" or "brainwashing" the population. In both of these stories, real people disappear: not some romanticized band of authentic rebels sacrificing their lives in the name of their own sacred identity or some abstract principle. And not the amorphous and anonymous multitudes who, imprisoned by their own ignorance and stupidity, are easily manipulated. Much of the political discourse of this century continues to tell these same stories, with the same cast of characters.

Another set of stories treat the present situation as a rupture or "crisis," as if history had some inevitable trajectory which has suddenly been upset. Sometimes, they treat the present situation as if it had appeared, fully formed, ex nihilo. Certainly we live in a time when it feels that "everything solid melts into air."[19] We live in an age which refuses to give itself an identity. But it is unlikely that we are the only ones to have experienced life in these terms. Any student of U.S. history will recognize many of the features of our situation. On the surface, they seem to re-present tendencies which appear almost inherent in the "American character": a pious self-righteousness which leads people to control others' behavior and morality; and a lack of concern, not only with public affairs, but with the "facts" of public life. Acknowledging the historical precedents and continuities, however, does not mean that we can ignore what is unique and specific about the present situation. Perhaps we are living through another fin-de-siècle; perhaps it is a period of transition comparable to the end of the Middle Ages. But it is still different in some ways, and those differences have their effects.

All these stories have a common pessimistic ending which leaves no room for optimism, but their pessimism is unearned because it is not built upon an analysis of the concrete conditions and struggles. Rather than deferring judgment to the last instance, their judgments define both the beginning and the end of the story. A different story can provide some optimism only if it earns its pessimism; it has to describe the changing balance of forces, the field on which victory

and defeat are measured, and the strategies by which a new conservatism is penetrating into the lives of at least significant segments of the population of the U.S. In the last instance, theory can only be judged by what it enables, by what it opens up and closes off (and any theory always does both) in the contemporary context. Theory is of little use if it does not help us imagine and then realize better futures for ourselves and future generations. I propose, then, to offer a "speculative analysis," an interpretation of the contemporary political context of the U.S. which focuses on the way a new conservatism is being constructed at the intersection of popular culture and a specific structure of daily life. It is speculative both because it does not have the comfort and security of a completion and because it does not attempt to confidently and persuasively demonstrate its legitimacy before beginning to tell the story. Following Gramsci, I want to enter into the field of popular culture where some of the battles are being fought in order to identify the contradictions.[20] But the fact that contradictions exist does not guarantee that they can be "prised open," nor that they will actually become part of a more optimistic ending to the story.

The United States is a nation caught between passion and indifference, between dogma and apathy. Perhaps it has always been that way, the result of an isolationist society whose origins are built upon a rhetoric of salvation and the end of history. Perhaps it is the result of the enormous disparity between its economic and political promise (and the occasionally real possibilities) and the rather more grim reality of so many people's lives. A society of immigrants and migrants, criminals and fanatics, caught between the need to hold on to old identities (for they are all they have), and the desire to achieve that elusive dream—of freedom, but perhaps even more of comfort—which will relieve them of the burden of their past.

This book is about a population which increasingly finds itself caught within the contradiction between its own liberal ideology and its increasingly conservative commitments. It is a population cutting across generations, class, gender and, to a lesser extent, race; that no longer expects consistency in its life; that no longer seems to care about many of the things that have traditionally motivated people.

While some might claim that I am describing the baby-boom genera-
tion, I believe it is broader, encompassing a large part of the various
postwar generations: post–World War II, post-Korea, post-Cuba,
post–War on Poverty, post-Vietnam, post-Nicaragua, post-Iraq
(what next?). It encompasses all of those generations which have
been raised in and succumbed to the rhetoric which linked the
United States to war, to mobilization and ultimately to mobility. It
is most clearly visible in the new middle class that emerged after the
1950s, and yet it is a population defined largely by the disintegration
of that social space and of the comfortable boundaries around it. It
is a population committed to comfort but living an increasingly
uncomfortable life. But in the end, it may be impossible to define
it ahead of time; rather, my story is an attempt to create it and to
give it a common history.

There is something increasingly "conservative" about the nation,
and it is affecting every aspect of people's daily lives, although it is
not simply that the population has adopted a conservative ideology.
It is difficult to point to directly, but its symptoms are clear enough.
Not only has the center moved to the right, but the possible alterna-
tives and directions are increasingly constrained. Large segments
of the population are depoliticized, demoralized, pessimistic and
indifferent. In fact, the conservatism of the nation is being built
upon that pessimism and depoliticization. Somehow, regardless of
their beliefs (which are as likely to be "liberal" as conservative), the
same people find themselves pulled into a new conservatism. A
number of questions present themselves: What sort of depoliticiza-
tion is this? How is it being accomplished and to what ends? Is the
contemporary organization of pessimism being actively constructed
and strategically deployed as part of a larger political struggle over
the future of the nation?

For the fact of the matter is that, although people may be individu-
ally and collectively outraged, they remain largely inactive. After
all, even if you could organize enough people, it probably wouldn't
change anything. And if you were successful, success would only
corrupt you. Besides, even if you weren't corrupted, you would run
into other problems and groups which impinged upon your activity

and corrupted it. No where is this more visible than in the battle over abortion. Anti-abortionists have succeeded in making it more difficult for women to get an abortion,[21] not only by legal or political means, but through strategies of compulsion, harassment and terror ization aimed at doctors and patients in their daily life (often with the compliance of the state). Pro-abortionists, on the other hand, despite popular support, seem incapable of organizing any outrage against these tactics. The passion seems to belong to the Right which seems to be strategically directing and redirecting it, from economic policy to affirmative action, from the problems of a multicultural population to the crisis of political correctness.

I want to argue that the new conservatism is being put into place through cultural rather than political strategies. As Alan Wolfe has recently argued:

> Americans are increasingly oblivious to politics, but they are ex-
> ceptionally sensitive to culture. What constitutes for other coun-
> tries the meat and potatoes of political conflict—distribution of
> income among classes, regulation of industry, protectionism vs
> free trade, sectional antagonisms—captures in this country only
> the attention of the interests immediately affected. Politics in the
> classic sense of who gets what, when and how is carried out by a
> tiny elite watched over by a somewhat larger, but still infinitesi-
> mally small, audience of news followers. The attitude of the great
> majority of Americans to such traditional political subjects is an
> unstable combination of boredom, resentment, and sporadic at-
> tention. . . . Culture, on the other hand, grabs everyone's atten-
> tion all of the time. . . . Because they practice politics in cultural
> terms, Americans cannot be understood with the tool kits devel-
> oped by political scientists. . . . Unable to abolish war, they have
> abolished politics; the state has not withered away, but the amount
> of attention paid to its affairs has withered badly.[22]

But while Wolfe seems to assume that this depoliticization is a natural part of being American, I want to argue that it is being actively produced through relations of commitment rather than belief. That is why this is a book about passion, its absence (in the academy, the Left and large segments of the population) and its strategic use in the reorganization of the relations of culture and politics in the U.S.

COMING HOME TO CULTURAL STUDIES

This book is partly about what it means to do "cultural studies" at a particular moment in its history.[23] Admittedly, this question is of interest only to a small group of academic critics (and some readers may reasonably decide to skip over this discussion) but I have been trying to answer that question since I first returned to the United States after studying at the Centre for Contemporary Cultural Studies in England in the late 1960s. My identification with British cultural studies has always been both intentional and awkward, since I have never quite understood how one could do "British" cultural studies in America. For decades, cultural studies stood as a minoritarian critical practice, identified with a particular body of work, little known and often attacked. In the U.S., it found a grudging home primarily in departments of communication.[24] Only recently has it gained real visibility and even prominence throughout the international academic world.[25] But its success has created new problems. As it has become a global commodity, it has also become an intellectual fantasy. And like all fantasies, the more it is talked about it, the less clear it is what is being talked about.

I do not think that this situation results from cultural studies' increasing institutionalization since it has always been located within educational and even academic institutions. Nor is it the result of its increasing disciplinization since those practicing cultural studies have always had to accommodate themselves to and struggle against the demands of different disciplines and interdisciplinary committees. I think that the problem results from a misreading of the open-endedness of cultural studies which either allows anything to be cultural studies or identifies it with a "correct" paradigmatic version.

In attempting to delineate the extension of the term, it is useful, if not necessary, to come to terms with British cultural studies for two reasons. First, we have to ask why the signifier of "cultural studies" has been taken up now and I think it is empirically demonstrable that the answer has everything to do with the recent visibility, in the U.S. and elsewhere, of some of the leading figures of British cultural studies and their work. And the fact is that both personally

and intellectually they represented something not widely available. This is not to say that British cultural studies is the only way to do cultural studies; on the contrary, there are a variety of national and indigenous traditions of cultural studies which have remained invisible to many of us because of the largely unidirectional circulation of cultural discourses. But, and this is the second reason, I do believe that there are important lessons to be learned from the project and practice of British cultural studies if they are taken as exemplary rather than metonymically. And further, British cultural studies does seem to be serving, if only temporarily, as a common reference point and language around which different traditions and projects are coming together.[26]

But this does not mean that British cultural studies is a singular and coherent body of thought, an orthodoxy which can be or needs to be overthrown in endless replays of the Freudian narrative of killing the father. This seems to radically misrepresent the practice and history of British cultural studies. There never was an orthodoxy of cultural studies, even within the Centre of Contemporary Cultural Studies (often identified as the mythical origin of British cultural studies); there never was a singular and homogeneous, pure and unsoiled center. Cultural studies has always encompassed different projects and practices, sometimes in contestation with each other, sometimes in different spaces, sometimes moving across each other with very serious consequences.[27] There can be no single linear history of theoretical and political progress, for cultural studies has always proceeded discontinuously and sometimes even erratically. The diversity is often only ritually acknowledged, but it is much more, for it is the very practice of cultural studies. At every moment, every practice of cultural studies is something of a hybrid, with multiple influences.[28] Every position in cultural studies is an ongoing trajectory across different theoretical and political projects. Moreover, there have always been multiple practices and sites of cultural studies in every context.[29]

If there are real stakes in the practice of representation, including the ways we represent our own intellectual practices, then we have to take seriously the struggle over the name of cultural studies. I

refuse to relinquish the gains and lessons of this specific intellectual formation, with its own history, contradictions, uneven developments, conflicts, differences and unities. But it is important to acknowledge that British cultural studies is not the only formation in which such gains can be located. I want to begin by offering a tentative description of the practice of cultural studies or, perhaps more accurately, of the affect of its practice. Then I will try to say something about the terrain on which it operates, its field of specificity. (And in Part I following this introduction, I will offer one possible way of filling in its theoretical position.)

The practice of cultural studies can be encapsulated in two assumptions. First, it does matter what cultural studies is at any place and time. Cultural studies is not a thousand points of light, and not every project and practice of "culture studies"[30] is cultural studies; this doesn't mean that cultural studies is the only valid or interesting or politically engaged or critical practice. Partly cultural studies matters because it is about "how to keep political work alive in an age of shrinking possibilities."[31] Its "will to knowledge" (according to Gramsci, the first function of the political intellectual is to know more than the other side; the second function is to share that knowledge[32]) is driven by its attempt to respond to history, to what matters in the world of political struggle. I do not mean to render history unproblematic here. But recognizing that history is always problematic, that it has its own conditions of possibility, its own discursive mediations and strategic deployments, does not mean that history is simply the product of our discourses or that it can be subordinated to them. In that sense, for cultural studies, historical context and theory are inseparable, not merely because the latter constructs the former but also because the former leads the latter. For cultural studies, there is always something at stake;[33] Actually, in any context, there may be numerous stakes, numerous practices, numerous ways of reconstructing and responding to the context. Cultural studies is always a strategic intellectual practice.

The second assumption is that it also matters that the field of cultural studies is open and unstable and contested. For cultural studies assumes that history—its shape, its seams, its outcomes—is

never guaranteed. As a result, doing cultural studies takes work, including the work of deciding what cultural studies is, of making cultural studies over again and again. Cultural studies constructs itself as it faces new questions and takes up new positions. In that sense, doing cultural studies is always risky and never totally comfortable (although it can be fun). It is fraught with inescapable tensions (as well as real pleasures). In the U.S., the rapid institutional success of cultural studies has made it all a bit too easy. Cultural studies has to be wary of anything that makes its work too easy, that erases the real battles, both theoretical and political, that have to be waged, that defines the answers before it even begins.[34]

Theory can let you off the hook, providing answers which are always known in advance or endlessly deferring any answer into the field of its endless reflections and reflexivity. Too much contemporary theoretical work renounces all intellectual authority. Recognizing that intellectual work is a form of cultural production does not mean that it is exactly the same as every other cultural practice. Intellectual work must make a claim to authority, but authority is not dogma. It need not be derived from a presumption of a privileged access to the "correct" answer. There are no correct answers in history, but it does not follow that there are not better, more useful, more progressive analyses. Authority is derived from possibilities: possibilities to respond, possibilities to change, possibilities to extend. Such an intellectual authority "relies on no objective standards or transcendental guarantees, and yet . . . does not for all that abandon all 'cognitive control.' "[35] Cultural studies recognizes that theory is always open-ended, but it chooses, in any instance, to stop the theoretical game and offer a theoretically grounded analysis of its context. That is, knowing that your position still needs further elaboration, development and even criticism, you still have to make a pragmatic commitment, for the moment, to this theoretical analysis. We may be making it up as we go along (which does not mean that we ever start from scratch) but that need not undermine its authority—specific, contextual and modest, but authority just the same.

Similarly, politics can let you off the hook if political exigencies

substitute for intellectual work. Cultural studies believes in the importance of critical theoretical work to political intervention but it does not assume that intellectual work is or can substitute for such intervention; nor can it define ahead of time the appropriate form of such intervention.[36] Cultural studies refuses to let political pressures erase the necessity of theoretical work. Yet it is always frustrated by its apparent inability to actually effect change. Still, it has to resist the temptation to measure itself against other more direct forms of activism (which are available to us as people anyway). In its effort to realize the possible political role of the intellectual, cultural studies has to avoid the temptation to demand of its own discourse what it does not, and cannot, demand of other discourses: that it have a direct, immediate and visible impact.[37] Culture does not work that way, but it does work; it does make a difference. Of course, that is just what cultural studies is about, and yet it has not and will not ever successfully answer its own question. Understanding the articulation of culture and politics is a project that is always just beyond our reach. Hall refers to this as the "necessary displacement of culture": "there is something about culture which always escapes and evades the attempt to link it, directly and immediately, with other structures."[38]

Finally, cultural studies has always refused the easy path of taking up the already agreed upon, legitimated topics of studies. It is committed to revising and expanding the agenda of critical theory and progressive politics, to questioning the taken for granted objects and issues of critical work and to taking seriously those which critical work has excluded. For example, cultural studies never argued that all politics could be treated in terms of ideology, but it did argue that the Left had ignored the power of ideological practices. It never thought that popular culture defined its project but it thought it was important enough to be put on the agenda. From its beginnings, it argued that the Left had ignored questions of racism and imperialism, and some of its most important work in the past fifteen years has been devoted to these issues. Thus, doing cultural studies is not a matter of merely continuing the work that has already been done,

staying on the same terrain, but of asking what is left off the agenda in relation to specific contexts and projects. In this book, I want to put two things onto the agenda of cultural studies: passion and capitalism. It may seem odd to suggest that we need to put capitalism onto the agenda of a field that has been powerfully shaped by Marxism. But too often capitalism is taken for granted, as if it were fixed, as if everyone already knew what it was and how it related to culture.

I can summarize this description of the practice of British cultural studies as contextualist and interventionist. Not only its object but its practice, its problematic and its specificity can only be understood in response to particular historical contexts. But context is neither background nor the "local." It cannot be accomplished as an after-thought or a footnote; it is the end rather than the beginning of our critical efforts because it is defined by our particular project. This is the sense of cultural studies' "conjuncturalism." Thus cultural studies is not a theory of the specificity of culture; it does not assume that anything, especially culture, can be explained in purely cultural terms. It does not attempt to explain everything from a cultural point of view. Instead, it locates cultural practices in complex relations with other practices which determine, enable and constrain the possibilities and effects of culture, even as they are determined, enabled and constrained by culture. Hence, cultural studies argues that much of what one requires to study culture is not cultural.

This contextualism is what drives the interdisciplinarity of cultural studies as a demand that one take the projects and questions of other disciplines seriously enough to do the work necessary to map out the connections within which culture is located, to see how they have been made and where they can be prised apart.[39] But contextualism is not relativism for cultural studies measures its theoretical adequacy in political terms. While it has no pretensions to totality or universality, it does seek to give a better understanding of where "we" are so that "we" can get somewhere better. Nor does it attempt to smooth over the complexities and tensions; it chooses instead to live with them, to see any historical struggle (and its own intervention) as

neither pure resistance nor pure domination but rather, as caught between containment and possibility. It is this tension which is embodied in cultural studies' notion of "the popular."

There are two theoretical correlates of this critical practice (which will be discussed in chapter 1). First, against visions of culture as either a reflection of or reducible to other (e.g., political or economic) realities, cultural studies sees culture as material and constitutive. Second, against positions which would reduce all of human reality and experience to culture (or textuality), cultural studies argues that different forms of material practices are also constitutive. Cultural studies is in some sense about winning people and practices to particular relations and positions, about how the links are forged in and through cultural practices.

But I find this description of cultural studies' practice unsatisfying, partly because it is so obviously too romanticized. I want to start again to define cultural studies by suggesting that it is constituted by, and sometimes must reconstitute itself by, a double articulation. Its problematic is constructed at the intersection of what I shall call, for lack of better terms, a disciplinary and a historical terrain. Of course, they cannot be so easily separated and independently defined since each leans on the other. Moreover, they are constantly rearticulated by the contingent places, the historical conjunctures, to which a specific practice of cultural studies responds.

One of the oddest things about cultural studies is that it never defines its disciplinary terrain, that which it is obviously about: "culture." Other disciplines are constantly attempting to define their object of study, even if they can never achieve consensus for more than a fleeting moment. I think there is a good reason for this: every practice of cultural studies is articulated on top of the historically and socially constructed polysemy of culture. Cultural studies always holds onto the tension between at least two different meanings or concepts of culture. This tension is in fact the source of its productivity. For example, Raymond Williams's position is constituted in the space between the community of process and the structure of feeling, or, later, between cultural practices and a whole way of life (knowable community).[40] Similarly, James Carey works with the tension be-

tween Dewey's vision of community and either Geertz's theory of symbolic forms or Innis's theory of the technological organization of spatial and temporal power.[41] Another example is provided by recent work in anthropology, which crosses into the field of cultural studies only when anthropological notions of culture, while not abandoned, are placed alongside feminist and postcolonialist critiques.[42]

The historical terrain of cultural studies can be clarified if we recognize that the various concepts of culture deployed in cultural studies are closely connected to the emergence of "the modern" in the North Atlantic region, where "the modern" is understood as a particular articulation of historical processes, structures of experience and cultural practices. Williams argued that "culture" was a peculiarly modern concept which he defined in the following terms: "The idea of culture is a general reaction to a general and major change in the condition of our common life [modernization]. Its basic element is its effort at total qualitative assessment."[43] In this "modern" vision, culture involved a double movement into and out of a historical context; it was both descriptive and normative, producing the place from which and the space into which the critic had to speak. It is not coincidental that cultural studies emerged in England at the intersection of the New Left's critique of Western societies and the continuing debates about modernization in the form of mass culture.[44] Cultural studies was a modernist response to the continuing processes of a modernization: i.e., its practice reproduced the gap between the center and the margin (e.g., the avant-garde); it continued to focus on questions of identity and consciousness, history and temporality, textuality and mediation.

We are now perhaps in a better position to understand the current situation of cultural studies, a situation in which its success seems to have arrived only with its dispersion. But perhaps dispersion is too gentle an image, for the very configuration and boundaries of cultural studies are being fought over. I prefer the image of a diaspora, for cultural studies is being relocated, not only spatially and institutionally but also in relation to a number of other discourses. And it is not always a voluntary or friendly confrontation which results.

I think this diaspora is partly the result of various postcolonialist[45] challenges to the Eurocentrism of cultural studies which have opened a critique of the *limited* polysemy of culture as it is deployed in British cultural studies. This field of meanings is encapsulated in Williams' rereading of the tradition of English moralists.[46] Williams looks for the meanings of culture in the context of an imaginary English language and history. He treats the national culture as if it were constructed entirely within the nation, the result of internal productions and conflicts alone. Consequently, cultural studies has failed to acknowledge that the "national popular" is always produced in the field of international relations (colonialism, imperialism, etc.) in the effort to appropriate, respond to, resist and control diverse "other" practices and populations (e.g., the role of the colonial empire and the various "others" it constructed in producing "English" culture).[47] Contemporary notions of culture have to begin by assenting to the fact that we are all "coerced into globality" in the contemporary world.[48] Cultural studies failed to see that culture is deployed differently, that it takes on different meanings, in other histories and in other places. (These alternate traditions have in some instances given rise to ingidenous traditions of cultural studies.)[49]

But the diaspora of cultural studies is also the product of another failure, one perhaps even more paradoxical. For while British cultural studies always recognized that the very category of culture it took up, with all of its intentional ambiguities, was a "modern" concept, that it was a modern articulation of culture, it failed to challenge that articulation. Only now is cultural studies beginning to explore the link which implicated the very category of culture in the practices of power which the "modern" put into place (including forms of colonialism, racism and sexism, disciplinization and normalization, etc.). Only recently has cultural studies reflected on how culture itself was and is articulated by and to these practices of power.[50] In that sense, cultural studies' interest in postmodernism is not a matter of accepting that the history of the modern has come to an end; it is rather that postmodernism poses a new project for cultural studies' own rearticulation: that it must critically examine and hopefully delink itself from some of its complicities with the

modern. For example, cultural studies does not reject reason but acknowledges its limits and its deployment as a structure of power. It recognizes not only the existence of different rationalities but the importance of the irrational and the arational in human life. Thus as cultural studies moves into different sites which have been irretrievably reconstructed by the violence of the various forms of colonial power, diaspora and the modern, cultural studies will also have to be irretrievably reconstructed in some very fundamental ways.

My own effort to develop a specific practice of cultural studies is not an attempt to break with some imagined history or orthodoxy but to rearticulate the gains of cultural studies and to bring them to bear upon one aspect of the contemporary political transformations taking place in the United States: the appearance of a certain structure of depoliticization which is moving the nation into a new conservatism. While my project in this book is not to offer a general model for American cultural studies, I do want to offer some reflections on the theoretical work that needs to be done to construct a place for cultural studies in America, and for America in cultural studies. I want to briefly identify two sites for such work which will be addressed more extensively in Part I: the logic of identity and difference; and the politics of space and time.[51]

Much of the history of cultural studies is dominated by the particular logic of European modernism, a metaphysical logic of identity and difference, a Hegelian logic of negativity which appropriates or incorporates the other. As Robert Young describes it, knowledge is "unable to let the other remain outside itself, outside its representation of the panorama which it surveys, in a state of singularity or separation."[52] This logic, which rejects the reality or positivity of the other by reducing it to a phenomenon within the field of experience of the knowing subject, continues into the poststructuralist vision of the other as excluded from but necessarily constitutive of the self. While we may not want to accede to Young's assertion that this logic "mimics at a conceptual level the geographic and economic absorption of the non-European world by the west,"[53] it is reasonable to assume that this logic is implicated in and closely articulated to various histories and structures of power. Challenging that link will

lead us to explore ways of acknowledging the reality or positivity of the other and to criticize a politics which privileges identity.

There is a second aspect of this logic: the process by which "the other is neutralized as a means of encompassing it" involves the construction of a temporal Totality in which "the present is sacrificed to a future which will bring forth an ultimate, objective meaning."[54] As in the logic of progress, the present is sacrificed to its as yet unrealized future. This is Hegel's model of a History in which the subject (of the West, the nation-state) comes to realize itself at history's end. Barthes finds the plenitude of signs in Japan.[55] Baudrillard finds the desert of signs in America.[56] Both reconstitute Europe as History, as the site of totalization. Young concludes:

> History . . . constitutes another form by which the other is appropriated into the same. For the other to remain other, it must not derive its meaning from History but must instead have a separate time which differs from historical time . . . it is in its temporality, in anteriority, that we find an otherness beyond being.[57]

Rather than identifying alternative temporalities, I want to suggest that cultural studies might deconstruct this temporal theory of power. In fact, discussions of culture and power are usually dominated by models and metaphors of time and history. There is an interesting paradox in modernism's privileging of time over space, for it is imposed upon a much longer history of the primacy of the visual as a metaphor of reality. But vision is always understood phenomenologically and thus returned to the sphere of the temporal. The result is, nevertheless, that space is erased as an enabling condition and grid of political, economic and cultural power. Overcoming this bias of modernity suggests that cultural studies develop geographies of power mapping social structures of mobility and stability. Rather than locating culture in the dialectic of the singular and the totality, it would see culture as an active agent in the production of places and spaces. This does not mean that we embrace "the end of history," but instead that we recognize that history—or rather, different histories—are always placed somewhere. I do not want to deny other temporalities but to spatialize them, to look at how histories are

deployed in space: it is not so much a question of when the other speaks, but where.

A spatial model of culture and power seems somehow tied, both to diaspora populations and to nations founded as settler colonies. The latter (e.g., America, Canada and Australia) all have origins involving genocidal campaigns. To different degrees and in various ways, each of them actively represses this history (which doesn't mean it is not there but that its effects are articulated in different ways). Each of them constructs its identity in spatial rather than temporal terms, erecting billboards rather than monuments. In each, a national identity is forged from both the spatial enormity of the nation and the particular geographies of the space. In both Australia and Canada, this is tempered by a continued investment in and identification with their European origins. In the United States, however, this spatialization of national identity is almost total.[58] Debates about American identity often focus on the place where its original character is to be located: the New England town hall, the Southern plantation, the frontier trail, the midwest community. It is here, in America, that I propose to look at culture as a spatialized "field of social management."[59]

WITH THE BEST OF INTENTIONS: THE LIMITS OF THE ANALYSIS

I am aware of the many weaknesses of the present effort. Some of them I choose to defend, others I can only acknowledge and accept. Its questions, perspective and passions are undoubtedly determined in part by my own autobiography, which placed me in a liberal, white, Jewish, New York, ascending middle class family at the beginning of the baby boom. Although I was shaped by the 1960s counterculture, I do not believe that any one speaks as a singular representative of that generation: not only was it so much more fragmented than we often acknowledge, but we have each been remade by our experiences and the paths of our own mobilities. My intellectual, political and even emotional commitments were changed forever as a result of the time I spent in Britain and Europe.

And the move from the East Coast urban culture of New York to the Midwest produced more than culture shock; it produced as well a different sense of the potential tyranny of urban elitism, suburban boredom and agrarian populism. It is here that I realized that the new conservatism had to be taken seriously.

I live in the heart of the farmbelt, the "heartland of America." I live in one of those peculiar "university towns," too small (in both its population and its attitudes) to be a city and too large to be a town, dominated by a land-grant state university, a mega-university which graduates close to ten thousand students a year. As a research institution, it is as elitist as any university. As a pedagogical institution, it too often takes the democratization of higher education (which is, after all, the rhetoric of its origins, only realized after World War II) as an excuse for its unimportance. It is not an exciting or attractive town (unless you like the prairie), but it is, in contemporary terms, very "livable" and has a reasonably rich cultural life. The student body is almost entirely white and middle-class and, to a large extent, majors in "pre-wealth" through a variety of different curricula. Their social life is dominated by fraternities and sororities (the university has the largest Greek system in the country) and university athletics. The majority are certainly politically unenthused and inactive (although there has always been a reasonably large group of political activists, on both sides of the spectrum and across a broad range of issues). It is in this context—teaching classes in rock and roll, popular culture and cultural studies—that I began to see emerge, over the past decade, a rather paradoxical conservatism in the ways my students interpreted their lives and their commitments. But it was a conservatism which many of my faculty colleagues and friends reflected back at them, although often they acted as if it were their right, while the students had some obligation to be radical. It was through the lens of this mundane conservatism that I began to try to think about the changing political climate of the United States and its relationship to popular culture.

For someone attempting to make some sense of contemporary popular culture, the task is extremely daunting. After all, how can you describe a world in which everything is potentially evidence for

something, but you often don't know what it is evidence of, until it is too late? (How many times have people said to me that I should have seen or heard something because it was the perfect example of what I was arguing?) The simple fact of the matter is that no one can collect all of the material that is necessary or appropriate. And as the size and density of the field continuously expand, the contradictions multiply more rapidly than our writing. What I write today may easily be contradicted by what appears tomorrow. Almost every example I have used may have lost some resonances or taken on new ones by the time the book is published, for ephemerality is part of contemporary popular culture. Hence, I try not to judge texts and tastes, at least until I begin to see how the story might end. Examples are offered, not as conclusive evidence, but as billboards marking where we are, where we are going and where we might go. They are signposts of the changing relations of popular culture and daily life, and the changing configurations of our passions and commitments. They are also invocations (of a wider discourse) and invitations for the reader to supply his or her own examples, his or her own coordinates to the maps I am offering.

But the demands of politics and history still provide at least two standards for judging my argument. First, can it be continued, expanded, refined? After all, it admittedly collapses too much and ignores even more. Perhaps most importantly, while focusing on affect, I have too often ignored its link to particular ideological and libidinal codes. Nevertheless, I will be satisfied if I have told at least part of the story and managed to put some interesting questions on the agenda. Second, are there people who can recognize something of their own lives in my descriptions, who are able to locate and orient themselves within my maps? Every story told about the present invites the reader to locate themselves in relation to some "we." My own invitation to identification can move between progressive intellectuals and a broader fraction of the population because it points to a dimension of contemporary experience. Different people may feel different degrees of inclusion and investment in this dimension. I am not claiming that this "we" speaks for anyone, for it is not offered as an identity with its own sociological referent. The reader

will accede to, refuse or struggle against my attempt to locate them within this contemporary field of struggle.

Finally, I must acknowledge the difficulty of much of the language of this book. It is often too academic and occasionally hermetic, but I hope that the analysis will have something to say to a broader audience. I would have liked to arrive at a more accessible vocabulary, but I do not want to fall into a common pseudo-populism which rejects such work as elitist and exacerbates the tension between activists and organizers on the Left, and intellectuals. This tension contrasts sharply with the very real commitment of the Right to nurture its intellectuals. It is not that the Right is any less anti-intellectual but that it recognizes the importance of analysis and the possibilities of exploiting such intellectual labor (often through the use of professional writers who "translate" academic work) by disseminating it to those responsible for the production of popular culture and public opinion.

Intellectuals are laborers paid to produce something called knowledge. And like any laborer, they seek to develop skills and vocabularies which give them a privileged claim to compensation ("I understand poststructuralism, pay me!"), status and power (however little that may be). They are also motivated by the pleasure of the activity, by the material rewards and comforts of the social position and perhaps by a real desire to isolate themselves from the rather more difficult existence of other forms of employment. For whatever reasons, intellectuals seek more adequate understandings of particular aspects of the world. In such efforts, language is never an innocent cape placed on top of reality in order to hide it from the light of popular scrutiny. (This is not to deny that it may have such effects or that it may be motivated by an elitist desire for power.) Like Batman's cape, language remakes that which it is covering. Intellectuals are often criticized for introducing neologisms and dropping names, but these are often useful and efficient ways of bringing an entire argument or position quickly into the conversation. Such conversations with others seeking answers to the same or similar questions are absolutely vital to intellectual work.

Why are physicists or chemists describing the physical world

expected to use languages not available to most people, while those exploring social reality have to speak so that everyone can understand? Is human reality any less complex, less multilayered, less contradictory, less surprising than the relations of subatomic particles? If the social world is complex, then sometimes the obvious accounts don't work; sometimes we need complex and nonobvious explanations of what is going on. Why does the burden of responsibility belong to the researchers who use such languages instead of the social norms which define what "educated" people are expected to know, what languages they are expected to speak? (Our students are expected to speak the languages of genetics and computers, but not of Marxism or deconstruction.) Perhaps it is not researchers' desire to insulate themselves but the social pressures which maintain the languages of common sense, languages which protect the existing social relationships (and hence the existing structures of power) that need to be questioned.

The real elitism is the assumption that "ordinary" people are unable to read such material. Whether they are willing to do the work necessary to read it is a different matter; it may have less to do with academic language than with their perception that intellectuals do not address the questions to which they are seeking answers. For example, while intellectuals of the Left argue over whether "Right" and "Left" have any meaning, whether they can be used to describe the political terrain, the Right confidently continues its efforts to restructure the nation's commitments, and people still make judgments about which side they are on. This does not mean that the lines are not fuzzy; perhaps they have always been, perhaps they are fuzzier today than in previous moments. But we can describe those uncertainties, and the differences they make, and we can argue about ways of reinvigorating the possibility of a progressive Left politics.

But intellectuals are more than researchers; they are positioned in a number of institutions and discourses. They are almost always teachers—we forget at our peril that a professor is someone who "professes" a position—with pedagogical, social and political responsibilities. Many intellectuals, especially on the Left, are only willing to speak where their credentials legitimate it or when their self-

reflexivity can turn them back onto themselves. The result is that intellectuals speak too often in isolation. I would propose that while intellectuals must always approach questions from a particular region and with a particular perspective, they must continually attempt to draw the lines connecting their expertise to other, broader social structures and relations. Public intellectuals must take a risk to speak beyond the parameters of their own confidence in order to begin again a public debate which has largely disappeared.

IF YOU CHOOSE TO CONTINUE . . .

The rest of the book is organized into four parts, each of which can be seen as a relatively independent essay. This is not merely a gesture to fragmentation but a way of acknowledging the gaps and absences in the analysis. The first part is unapologetically theoretical and academic. It offers a model of cultural studies—a "nonstructuralist, empirical formalism"[60]—based on a synthesis of the Gramscian perspective of Stuart Hall and the "postmodern" theories of Michel Foucault, Gilles Deleuze and Felix Guattari. For those not inclined to begin at the beginning, I have provided a glossary of the key terms introduced in this section. The second part indirectly offers a definition of rock or at least an interpretation of its power and importance in American society. It describes how rock was shaped by the context of its emergence in the 1950s and the significance of the differences in the contemporary context. The third part argues that the new conservatism of America involves the rearticulation of selected aspects of rock's popular logic in order to restructure and discipline daily life itself. The final part considers why this new conservatism is being constructed and why there has been so little effective opposition. In the end, understanding this contemporary political struggle leads me to rethink the status of capitalism and the possibility of an oppositional Left.

I have tried to develop a political and theoretical practice concerned with its own possible shape and with the possibilities of a world which always at least partly escapes the critic's desire to restructure it. Whether it is appropriate, whether I have succeeded, can only

be answered contextually and strategically. Unfortunately, like any political struggle, you often only know if you made a bad choice when it is too late. I have attempted to initiate a project that I will never be able to complete by myself. Despite the occasional rhetoric of certainty to which my passion sometimes leads me, my conclusions are offered as both tentative and partial. In part the success of this book depends on its ability to move different readers between the different systems of identification and investment ("we's") constructed in each part. Even if my analysis is mistaken, I hope I have at least raised questions that can and will be fruitfully addressed in whatever discussion may follow.

CULTURAL STUDIES
THEORY, POWER
AND THE
POPULAR

1

ARTICULATION AND CULTURE

The questions I want to pose involve the relationship between popular culture—the popular culture people are offered, the popular culture they care about and the popular culture they reject—and politics. How does each inform and shape the other? How can critics make sense of current political changes (e.g., the increasing disinvestment from political activity conjoined with a growing conservatism) in the light of cultural habits, and vice versa? These questions go to the very heart of the significance of culture and of that part of people's lives which seems most personal: tastes, pleasures, commitments. But such domains are not outside of the social and political arenas. Nor are their meanings and relationships transparently available to critics. How then are critics to make sense of cultural practices, trends or events? How can they describe their political and social significance? How can they gain some insight into what possibilities they offer, and what possibilities are taken up?

CULTURAL STUDIES, POPULAR CULTURE AND COMMUNICATION

The quantitative explosion of popular culture in the twentieth century was no doubt enabled by the appropriation of the mass media as a system for the distribution of popular culture. This has often led critics to assume that popular culture and mass communication are

identical. But there was nothing inherent in the mass media that guaranteed that their most important function would be the transmission of popular culture (rather than, for example, education, information or propaganda). They were used in this way largely for two economic purposes: to maximize the profits of the emergent cultural industries (many of the companies were already involved in the production of both the technology and the programming); and to help create an economy based on mass consumption and ever-expanding demand.

This "massification" of popular culture, however, was not responsible for the commodification or industrialization of cultural production and distribution; these processes had begun much earlier. But it did reorganize the processes of cultural consumption by bringing the majority of the population into the cultural arena on a national (and eventually international) level. This expanded market provided important motivation for the increasing capitalization and regulation of culture. Moreover, the new media of distribution had important consequences for the ways in which popular culture was placed into the daily routines, spaces and times of social life. They also made it difficult for someone to avoid exposure to the new forms of popular culture which were being created for the media and designed for the new mass audience. But however dense and complex the relations between the mass media and popular culture, the two were not and are not the same.

The identification of popular culture as an instance of a more general process of communication needs to be challenged, for it has had important consequences. In particular, two assumptions have, I believe, hindered cultural studies' attempts to analyze popular culture. The first is structural: the model of communication assumes a relationship between two discrete and independently existing entities: whether between individuals, or between audiences and texts, or between signifieds and signifiers. The result is that any cultural relation takes on the form of an unspecified and unspecifiable exchange—a mediation—between encoding and decoding.[1] It makes little difference which term in the model is given priority as long as the distance or gap between them remains. Whether the text or

the audience (since different people can interpret the same text in disconcertingly different ways) has the power to determine the meaning of a specific communicative event, communication is the process by which that gap is overcome, the unknown becomes known, the strange becomes familiar. The model remains the same even if one hypothesizes a process of negotiation in which each is granted some power. The distance between them remains sacrosanct.

Even contemporary poststructuralist theories of "difference"[2] fail to challenge the structural gap which is the essence of communication in this model; rather, they fetishize it. Such theories do challenge the assumption that the terms within the model (text, meaning, experience, audience, subject) describe singular, consistent and self-identical entities that exist prior to their entrance into the relationship (the gap or difference) of communication. With that assumption— that every instance (e.g., of text) has a unified identity which corresponds or relates in necessary ways to another equally unified term (e.g., of meaning or audience)—the whole game (especially the outcome) is guaranteed in advance. Here is a text, unique and complete unto itself. Here is the meaning that corresponds to that text, that is necessarily produced by it. Here is an audience which also has its own proper identity guaranteed to it in advance. And here is the experience of that audience, necessarily resulting from its particular social position or its unique cultural history.

The concept of difference entails a sustained critique of any assumption of such guaranteed and necessary relationships. Just as structuralism argued that the identity and meaning of any sign depends upon its place within a system of differences, poststructuralist theories of difference argue that no element within the cultural field has an identity of its own which is intrinsic to it and thus guaranteed in advance. A text can never be said to have a singular meaning, or even a circumscribed set of meanings. Perhaps texts cannot be treated singularly and in isolation: the meaning of a text may depend upon its formal and historical relations to other texts (its "intertextuality"). An audience can never be said to have a singular identity, or even a finite set of identities. Each is replete with multiple and unrelated differences, each is potentially infinitely

fragmentable. Theories of difference emphasize the multiplicity and disconnectedness within and between texts and audiences. By erasing the identity of the terms of the relationship, the relationship itself becomes impossible or at least necessarily absent. Communication itself is an illusion which it is the critic's job to deconstruct.

While structuralism assumes that the fields of difference (e.g., of signs, meanings, subjects) are pregiven and stable, poststructuralism argues that the terms of the communicative relationship—the very existence of texts, meanings and audiences—are themselves the result of the continuous production of the difference, the gap, between them. Culture is the process by which the difference is produced and it is only within that process that texts and audiences can be said to exist, and even then only for a fleeting moment. For the process of producing the difference continues, making it impossible to ever capture a stable and coherent moment of the process. Poststructuralism does not reject the assumption that communication involves the relations between texts and audiences, mediated through the production of meaning. But it argues that meaning exists only within the process of the production of difference; furthermore, it argues that the terms of the relationship—text and audience—are themselves the product of the constant production of difference, of the constant deferral, gap or absence inherent within meaning itself. Culture merely involves a constant sliding from one difference into another.

Such theories of difference have not abandoned the structure of the communication model. The critic can only join into the endless and seemingly random movement of fragments, deconstructing any and every claim for stability, unity and necessity, but he or she can never succeed. In the end, "difference" not only negates the possibility of any guarantee, it reestablishes its own guarantees: first, that all such relations and identities are illusions; second, that the name of the game and the form of its outcome, however illusory they may be, are known in advance (in the ever to be deconstructed model of communication); and third, that the game never stops.

Changing historical conditions, including the changing spatial and temporal complexity of the field of popular culture, have dis-

solved the traditional confidence with which critics and consumers divide the terrain of culture into texts, genre and media, and the terrain of cultural subjects into audiences and communities. No one can escape the constant exposure to an enormous range of presentations of and references to various popular culture practices. They have infiltrated every aspect and institution of our existence. Everyone is constantly exposed to a variety of media and forms, and participates in a range of events and activities. How does one describe the constantly changing kaleidoscope of cultural practices and daily life? How does one construct the appropriate intertextual links? The cultural critic confronts a world in which intertextuality has gone mad, a world in which he or she no longer has the luxury of studying identifiable, stable practices and relations. Even if one could construct the intertextuality of popular culture, considering the relations among the various forms and media, (music, film, books, fashion, magazines, comics, etc.), one would also have to consider the complex relations between exposure and choices. How does the analyst stabilize the mobile and shifting alliances of audiences and subjectivities, of relations to and investments in various sites, events and activities of popular culture? How does he or she know the appeal of specific events—ranging from those presumably targeted to particular audiences to those apparently addressing the broad mythic American viewer?

In the modern world, the potential audience for popular culture (and the real audience for many if not most of its texts) is often so large and diverse that it is difficult to talk about it in any coherent way. Critics have had to seek ways to identify specific audience fractions. Such fractions can be defined and located in one of two ways: either by shared taste or by a shared identity which, in some way, determines people's relations to particular texts. In both cases, the audience exists outside of a particular interaction with the media, and they come to that interaction with their own resources, competencies and needs. In the former, however, its unity as an audience is only defined by its relation to the text; in the latter, it is defined entirely independently of the text. Neither view recognizes the way texts construct their own appropriate audiences.[3]

In what way does shared taste allow any access to popular culture? Taste reveals nothing about how people connect into the texts, and the fact that a group of people share a taste for some texts does not in fact guarantee that their common taste describes a common relationship. Taste merely describes people's different abilities to find pleasure in a particular body of texts rather than others. But it does not take us any further. A student recently told me that he could not understand how people could stand to be so blatantly emotionally manipulated by the likes of *The Sound of Music*, but he seemed untroubled by his own pleasure in being manipulated by horror films. Taste does not offer any explanation which justifies the construction of the imaginary unity of an audience fraction.

On the other hand, if an audience fraction is defined externally, by a common set of interests and experiences related in some way to its social position, how can such simple identifications deal with the complexity of an individual's social identity? Since any individual occupies a number of different social positions (white, middle-class, educated, Jewish, leftist, male, etc.), how can one possibly know which social position is most relevant in constructing a specific audience and in understanding their relation to a specific text? Or need the critic take all of the identities into account? One can never know in advance which social identities are pertinent to the construction of a particular cultural audience, any more than one can know what is pertinent in any specific text. How far does one carry such analyses, for certainly they can be carried all the way back to the unique biographical history of any individual?

In fact, it appears increasingly unreasonable to isolate the communicative relation between texts and audiences from the broader field of social existence. The critic cannot separate the consumption of popular culture from the range of leisure activities which fill in the spaces of our daily lives: jogging, shopping, mall-walking, games, exercise, dancing, etc. The critic cannot separate it from the contrary and often boring demands of work (both paid and unpaid, both domestic and nondomestic), education, politics, taxes, home life, illness, etc. One cannot ignore the relations between the changing cultural terrain and the changing forms, practices, discourses and

sites of labor. Not only are the places and meanings of both leisure and labor constructed in terms of gender, race, age and class relations, they are also inflected by the growing importance of service and leisure employment in the current economy (and its limited success), by the acceptance and exploitation of more flexible arrangements of productive time and space, and by the increasing reality of an enforced leisure time (through unemployment, cutbacks in school hours and daycare facilities, etc.). Further, for some people, consumption is actually a form of labor, and for others it is simply unavailable.

The second assumption implicit in the identification of culture with communication (and which has hampered cultural studies) is substantive: it involves the reduction of culture to texts and of human reality to the plane of meaning. The analysis of culture then involves the interpretation of cognitive, semantic or narrative content which lies hidden within the text. This reduction of both culture and lived reality starts with the important insight that human beings live in a meaningful world, a world in which they respond to, and are shaped by, the meanings which have been linked to their social and material realities. But it goes overboard, moving from a theory of the determining power of the plane of meaning in human life, to a theory in which social and material realities disappear into the plane of meaning. Meaning becomes the totality of human existence because it mediates an otherwise inaccessible and unknowable reality.

The view of culture as mediation places cultural studies within the modernist or, more accurately, the Kantian tradition,[4] which replaces ontology with epistemology. Kant argued that human beings are condemned to always confront, not a real world, but the phenomenal world of their own creation. This phenomenal reality was the product of transcendental categories (e.g., space and time) which served as the conditions of possibility of any perceptual relation to the world, and hence of any knowledge. Through a series of permutations, this mediating realm was transformed into the cultural forms through which meanings are produced, and the categories became structures or maps of meaning. These semantic or cognitive mediations, laid over the world as it were, enable us to interpret

events by locating them within specific maps. Here, between the objectivities of cultural texts and social realities, human existence is transformed into a world of experiences.

This model of mediation flattens the possibilities of cultural relations and effects. At the very least, the notion of meaning as semantic content has to be made more complex and contradictory. Meaning itself is not a simple category and there are different forms of meaning (narrative, connotative, evaluative, reflective, etc.). But this does not go far enough, for the same text not only can be interpreted differently, it can have different uses for different people in different contexts. The same text can be a source of narrative romance, emotional support, sexual fantasy, aesthetic pleasure, language acquisition, noise (to drown out other demands), identity formation or rebellion against various powers.

The active engagement with texts is rarely determined exclusively by the interpretive content of meaning production. People's choice of texts, and of the ways they use, appropriate and even interpret them, often depend upon a variety of other sorts of relations—for example, the pleasures they are able to derive. But pleasure, like meaning, is itself a complex notion. Sometimes pleasure may be the result of specific interpretations and meanings which reinforce one's sense of identity, or which provide guidelines for action. At other times, pleasure may result from the activity itself, from the exertion or lack of exertion, from escaping other demands or concerns. Pleasure may be the result of fantasies which either answer real needs and desires or express possibilities that might otherwise never be manifested (and would certainly never be actually lived). The fact that people often find pleasure, in a variety of ways, through texts, is often the determinant of their relations to culture.

Besides introducing the plane of desire (and that of pleasure),[5] cultural studies increasingly distinguishes between meaning and ideology.[6] The latter describes those maps of meaning which are, in some way, actually attached to the world; they not only provide a possible interpretation of the world, they provide a representation of reality. Under certain conditions, people take up or invest in the

map of meaning that a text offers in such a way that it is stitched onto the field of social and historical practices. This meaning then becomes *the* meaning, the truth, of the field of real practices. Take *Rambo*, for example. It is certainly possible for some people to interpret Rambo as the isolated and betrayed hero; such a reading is certainly imaginable within our common cultural context and resources. Whether it is taken up, by whom, and under what conditions determines how people are located in specific relationships to the maps of meaning, and the realities they represent. But cultural critics have failed to recognize that maps of meaning and ideological positions are never passively occupied. They are taken up, lived, in different ways, to different degrees, with differing investments and intensities. Understanding any instance of effective ideology demands a "psychology" which accounts for the ways individuals selectively relate to ideological practices.[7]

If not every meaning is a representation, and not every text has representational effects, it may also be true that texts may have effects other than meaning-effects, and meanings, interpretations, uses and pleasures may themselves have additional effects. Particular cultural texts may also have other sorts of effects (whether one calls them meaning-effects is not as important as recognizing that they cannot be reduced to the level of cognitive and narrative systems). Cultural texts are always at least potentially multifunctional.

CULTURAL STUDIES, THE REAL AND ARTICULATION

I want to propose a theory for cultural studies which does not identify culture with communication, and which can describe the complexity of effects and relations circulating through and around culture. Such a theory will be, on the surface, paradoxical, for it will not offer readings of either texts or audiences' responses (even though texts are what audiences "care" about). Rather, it will be concerned with particular configurations of practices, how they produce effects and how such effects are organized and deployed. I will

describe two commitments—alternatives to the assumptions of a model of communication—of a revised cultural studies: a return to the real via a materialist theory of effectivity; and a principle of contextuality understood as and through the practice of articulation. In fact, these two commitments are mutually constitutive, as Foucault recognizes:

> Is it inevitable that we should know of no other function for speech than that of commentary? *Commentary* questions discourse as to what it says and intended to say; it tries to uncover the deeper meaning of speech . . . in other words, in stating what has been said, one has to re-state what has never been said. In this activity known as commentary which tries to transmit an old, unyielding discourse seemingly silent to itself, into another, more prolix discourse that is both more archaic and more contemporary—is concealed a strange attitude towards language: to comment is to admit by definition an excess of the signified over the signifier; a necessary, unformulated remainder of thought that language has left in the shade—a remainder that is the very essence of that thought, driven outside its secret—but to comment also presupposes that this unspoken element slumbers within speech, and that, by a superabundance proper to the signifier, one may, in questioning it, give voice to a content that was not explicitly signified. By opening up the possibility of commentary, this double plethora dooms us to an endless task that nothing can limit: there is always a certain amount of signified remaining that must be allowed to speak, while the signifier is always offered to us in an abundance that questions us, in spite of ourselves, as to what it "means." Signifier and signified thus assume a substantial autonomy that accords the treasure of a virtual signification to each of them separately; one may even exist without the other, and begin to speak of itself: commentary resides in that supposed space.[8]

Foucault is arguing here that it is the structural assumption of the gap between the signifier and the signified (reproduced in the structural gap between text and audience) that opens up the space of meaning and interpretation. Nevertheless, I shall treat each of these assumptions somewhat independently, beginning with the question of the reduction of culture and even human existence to the realm of meaning.

Materialism and Effectivity: The Real

Placing cultural studies within the sphere of the poststructuralist (neo-Kantian) claim that all of reality is textuality[9] misreads the materialist foundations of cultural studies. As Stuart Hall writes,

> My own view is that events, relations, structures do have conditions of existence and real effects, outside the sphere of the discursive; but that it is only within the discursive, and subject to its specific conditions, limits and modalities, [that] they have [been] or can [. . .] be constructed within meaning. Thus, while not wanting to expand the territorial claim of the discursive infinitely, how things are represented and the "machineries" and regimes of representation in a culture do play a *constitutive*, and not merely a reflexive, after-the-event, role.[10]

But Hall's view does seem to bracket questions about the effects of the materialities which exist "outside the sphere of the discursive." In some instances, this silence is simply a matter of cultural studies' field of interest: to place questions of meaning and representation onto the agenda of Left analyses of contemporary society. This is an important project whenever questions of ideology are either ignored or oversimplified. However, today ideological analysis dominates much of the writing about contemporary society. While such researches into the field of ideology and ideological struggles in contemporary society need to be carried forward, they are no longer sufficient.

Often, the erasure of "the real" is not merely a strategic choice, but an epistemological assumption built upon the Kantian prohibition of metaphysics: since we can only describe the phenomenal world—the world of human experience constituted through the mediation of cultural forms—reality must remain forever beyond our analyses. It is ironic that so much of contemporary critical work accepts a premise which Georg Lukacs, over fifty years ago, identified as a fundamental "antinomy" of "bourgeois" or modern thought: "Modern philosophy . . . refuses to accept the world as something that has arisen . . . independently of the knowing subject."[11]

I believe it is necessary to bring "the real" back onto the agenda of cultural studies, recognizing that we have no simple or innocent access to it outside of the systems of signification and representation. But the fact that it is a difficult—and even impossible in the terms of modern philosophy's definitions of objectivity and the empirical— does not mean that we cannot talk about a "new empiricism"—a "wild realism"—which aims to describe the determining effects of the real. As Guattari puts it:

> Everything that's written in refusing the connection with the refer-ent, with reality, implies a politics of individuation, of the subject and of the object, of a turning of writing on itself, and by that puts itself into the service of all hierarchies, of all centralized systems of power, of what Gilles Deleuze and I call all "arborescences," the regime of unifiable multiplicities. The second axis (according to which everything that is written is linked to a political position), in opposition to arborescence, is that of the "rhizome," the regime of pure multiplicities . . . the pattern of breaks in reality, in the social field, and in the field of economic, cosmic and other flows. . . . An arrangement in its multiplicity forcibly works both on semiotic flows, material flows and social flows. There is no longer a tripartition between a field of reality, the world, a field of repre-sentation, the book, and a field of subjectivity, the author. But an arrangement places in connection certain multiplicities taken from each of these orders. . . . The book is an arrangement with the outside, opposed to the book image of the world: a book-rhizome.[12]

What is crucial here is the rejection of the model of culture defined by the need to construct a correspondence between two parallel, nonintersecting planes—language and reality. Such a correspon-dence opens the project of interpretation: language interprets or represents reality, and criticism comments on that interpretation. It is also a rejection of a model of reality as a transcendental whole existing outside of history and practices. Reality here is a structure of effects, marked by a multiplicity of planes of effects and the ways they intersect, transverse and disrupt each other. This is strikingly similar to Foucault's attempt to move beyond an understanding of language as commentary:

> I do not question the discourses for their silent meanings but on the fact and the conditions of their manifest appearance: not on

the contents which they may conceal, but on the transformations which they have effectuated; not on the meaning which is maintained in them like a perpetual origin, but on the field where they coexist, remain and disappear. It is a question of an analysis of the discourses in their exterior dimensions.[13]

Similarly, Foucault distinguishes his project from that of structural analysis:

The question posed by language analysis of some discursive fact or other is always: according to what rules has a particular statement been made, and consequently according to what rules could other similar statements be made? The description of the events of discourse poses a quite different question: how is it that one particular statement appeared rather than another?"[14]

Foucault's project, marked by his use of "discourse" in contradistinction to a language of signs and structures, is "a pure description of discursive events" in their "dispersion as events."[15] But to speak of discursive *events* is not to reduce everything to a new singular plane, comparable to that of meaning or representation:

It is not a question of putting everything on a certain plane, that of the event, but of seeing clearly that there exists a whole series of levels of different types of events, which do not have the same range, nor the same chronological breadth, nor the same capacity to produce effects. The problem is to both distinguish the events, differentiate the networks and levels to which they belong, and to reconstitute the threads which connect them and make them give rise to one another.[16]

These events have to be taken literally, in the facticity of their singular existence, rather than as texts to be interpreted. They have to be treated in their positivity, rather than in relation to the laws of signification. Thus, Deleuze and Guattari refuse to think of desire in terms of its relations to what they refer to as the "three errors" of lack, law and signifier:

It is one and the same error, an idealism that forms a pious conception of the unconscious. . . . From the moment lack is reintroduced into desire, all of desiring production is crushed, reduced to being no more than the production of fantasy; but the sign does not produce fantasies, it is a production of the real and

a position of desire within reality. From the moment desire is wedded again to the law . . . the eternal operation of eternal repression recommences, the operation that closes around the unconscious the circle of prohibition and transgression, white mass and black mass; but the sign of desire is never a sign of the law, it is a sign of strength. And who would dare use the term "law" for the fact that desire situates and develops its strength, and that wherever it is, it causes flows to move and substances to be intersected. . . .? From the moment desire is made to depend on the signifier, it is put back under the yoke of a despotism whose effect is castration, there where one recognizes the stroke of the signifier itself; but the sign of desire is never signifying, it exists in the thousands of productive break-flows that never allow themselves to be signified within the unary stroke of castration. It is always a point-sign of many dimensions.[17]

There is no lack behind desire, no signifier structuring it, no law controlling it. Desire is a plenitude of production, producing a multiplicity of connections between particular point-signs or "assemblages" that are as likely to be subindividual or social aggregates. Desire transverses the social and the individual, the fragment and the whole.

We can take this treatment of desire as exemplary insofar as it demands that desire be treated in its positivity or productivity. For both Foucault, and Deleuze and Guattari, the strategy of analysis involves drawing lines or connections which are the productive links between points, events or practices (Foucault seems to use these interchangeably) within a multidimensional and multidirectional field. These lines map out reality in terms of the productive relations between events. Productivity is here synonymous with effects or, more accurately, effectivities. This notion describes an event's place in a complex network of effects—its effects elsewhere on other events, as well as their effects on it; it describes the possibilities of the practice for effectuating changes or differences in the world. Such a description then asks how something comes to exist in its singularity (what Foucault calls its "rarity"[18]) and how it functions. But the description cannot be confined to a particular plane or domain of effects, such as the signifying or the representational. Effectivity points to the multidimensionality of effects, to the connections that

exist between disparate points as they traverse different planes or realms of effects:

> Although the points determine paths, they are strictly subordi-nated to the paths they determine . . . every point is a relay and exists only as a relay. A path is always between two points, but the in-between has taken on all the consistency and enjoys both an autonomy and a direction of its own.[19]

Cultural studies, then, begins by describing events within human reality in their singularity and their positivity; events are both them-selves practices and the results of practices. A practice is a mode by which effects are produced and reality transformed. Its origin, whether biographical (in the intentions of the actor) or social (in the economic relations of its existence) is, to a large extent, irrelevant. Thus, what is important in history is what practices are available, how they are deployed or taken up and how they transform the world. It is not merely a question of what, in any instance, people do in fact do, but of the possibilities available to them: of the means available for transforming reality, as well as those actually taken up.[20] Such practices, including discursive practices, have real effects which are neither guaranteed by, nor limited to, the effects of their textual representations or to their own signifying and representational effects. Rather than making reality linguistic, I propose to make language real (while not all of reality). Or in other words, the fact that culture cannot be reduced to ideology, that there is a gap between them, opens up a space for the multiplicity of cultural effects and, as we shall see, of political articulations.[21]

The connection between a particular cultural practice and its actual effects may be quite complex. Effects are always intereffective, on the way from and to other effects. A cultural practice (or text) may, in many contexts, have meaning effects, but it may also have others (e.g., television is rearranging the physical space and temporal organization of many of the activities and places of daily life, includ-ing the household; laws against drugs give shape to the commodity structure of that market; lower speed limits contradict the design practices of many of the highways built in the 1950s and '60s).

Cultural practices may have economic effects (on the accumulation of capital and money), just as economic practices can have other than economic effects. They can have libidinal effects (on the structure of our desires), political effects (as in presidential debates), material effects (on our physical environment), aesthetic effects (defining the "look" of things) and emotional effects. Nor are such "secondary effects" necessarily always secondary. They may often be accomplished through the mediation of the production of meaning (so that the meaning produces the other effects and exists only "on the way" to something else). But it is also possible that cultural practices may, in some circumstances, not operate through the production of meaning. For example, music often bypasses meaning altogether to act directly on the body of the listener. Sometimes the production of meaning may be little more than a distraction.

Articulation

The second question that faces cultural studies involves the structure of the relationships within which cultural practices and effects have to be located. If one rejects the communication model which guarantees that cultural events always involve relations between audiences and texts, between signifieds and signifiers, one must also question a more basic assumption: a principle of interiority or essentialism which locates any practice in a structure of necessity and guarantees its effects even before it has been enacted. In such a structure, any event—e.g., a particular political activity, an economic relation, a social identity or even a cultural text—is assumed to already contain its own identity, and its place in a history of transformation can only involve spinning out the associations, relations and correspondences already inherent within that identity. This statement has—intrinsic to it—that meaning. This political activity has—intrinsic to it—that political position. That economic relation has—intrinsic to it—that set of experiences. This story corresponds to this meaning; that is what it is, its essential identity. The commodity corresponds to alienation; that is what it is, its essential identity. The working class corresponds to a set of experiences and political

interests; that is what it is, its essential identity. Everything seems to be sewn up, stitched into place, guaranteed in advance. If you tell this story, if you engage in this political activity, if you produce commodities, if you occupy a particular social experience, you are already locked into its necessary consequences, consequences defined by virtue of it being what it already is. History itself appears to be guaranteed in advance—the inevitable march of events spinning out their inevitable consequences.

An alternative structure would have to be anti-essentialist.[22] It would have to start with the principle that nothing is guaranteed, that no correspondences are necessary, that no identity is intrinsic. If there is nothing essential about any practice, then it is only defined by its effects; it is in the production of its effects that the identity of a practice is given. To say that a practice is defined by its effects is to locate the practice in its connections to its exterior, to that which is other to it. If theories of meaning—including poststructuralism— exclude the other from the dialectic of identity and difference, for Foucault, Deleuze and Guattari, there is only others, the real. In this usage, the other is not the different, for it is defined by its own positivity and exteriority rather than always being located within a purely negative economy of the same and the different. A particular site is defined by "the exteriority of its [neighborhoods]."[23] A practice is a "point without a surface, but a point that can be located in planes of division and in specific forms of groupings.[24] Paradoxically, a practice is not where it is (enacted, for example) but at all of those sites where its existence makes a difference in the world, at the sites of its effects. The ability of a practice to produce specific effects, to produce this effect rather than that, is precisely what has to be constantly made and remade. Although the connections or identities are never intrinsic or guaranteed, they are always—at least temporarily—real and effective. There are no necessary correspondences in history, but history is always the production of such connections or correspondences.

It is here that the philosophies of Foucault, Deleuze and Guattari intersect with developments in the field of cultural studies, particularly the elaboration of Gramsci's concept of articulation in the work

of Stuart Hall and Ernesto Laclau.[25] Perhaps "intersect" is too neutral a term; rather, let me say that the latter is a necessary supplement to the former. Neither Deleuze and Guattari nor Foucault has an adequate description of either the complex multidimensionality of structure, or of the active process by which such structures are constantly constructed, deconstructed and reconstructed in history. On the other hand, their theories (e.g., of micropolitics and rhizomatics) do not preclude such questions (e.g., of macropolitical structures such as the state or political movements and historical struggles). The concept of articulation provides a useful starting point for describing the process of forging connections between practices and effects, as well as of enabling practices to have different, often unpredicted effects. Articulation is the production of identity on top of difference, of unities out of fragments, of structures across practices. Articulation links this practice to that effect, this text to that meaning, this meaning to that reality, this experience to those politics. And these links are themselves articulated into larger structures, etc.

Articulation is the construction of one set of relations out of another; it often involves delinking or disarticulating connections in order to link or rearticulate others. Articulation is a continuous struggle to reposition practices within a shifting field of forces, to redefine the possibilities of life by redefining the field of relations—the context—within which a practice is located. For the effects of any practice are always the product of its position within a context. The significance or effects of an event or practice cannot be gleaned from its origin nor guaranteed by the structure of its surfaces. Articulation is both the practice of history and its critical reconstruction, displacement and renewal.

Analyzing an event then involves (re)constructing or, in Foucault's terms, fabricating[26] the network of relationships into which and within which it is articulated, as well as the possibilities for different articulations. In other words, the practice of articulation reworks the context into which practices are inserted. It involves real historical individuals and groups, sometimes consciously, sometimes unconsciously or unintentionally, sometimes by their activity, some-

times by their inactivity, sometimes victoriously, sometimes with disastrous consequences, and sometimes with no visible results.

The notion of articulation prevents us from postulating either too simple a beginning or too neat an end to our story. The beginning point of one story, which we might take as self-evident, is the end of another story which has yet to be told. What we take for granted, what we use as the resources of our storytelling, is often what is most in need of having its own story told. There is no single structure or dimension of human life which stitches everything into place so that its patterns are indelibly sewn into the fabric of history. We cannot assume that, somehow, economic relations have already defined the outcome, nor that they will somehow resolve all the contradictions in the end. Nor can we assume that it is our maps of meaning or the ways we interpret the world that constitute the essence of our "reality." Such reductions make the story easy to tell, for they tell us where to lay the blame and reassure us of the truth of our story and the sincerity of our politics.

Articulation offers a theory of contexts. It dictates that one can only deal with, and from within, specific contexts, for it is only there that practices have specific effects, that identities and relations exist. Understanding a practice involves theoretically and historically (re)-constructing its context. This cannot be a matter of merely acknowledging the context, e.g., of interpreting a text and taking its context "into account." Too much of contemporary theory treats contexts as the beginning of analysis, as a background which exists independently of the practice being studied and which can therefore be taken for granted. But the practice of articulation does not separate the focus from the background; instead, it is the background that actually articulates the focus. At the same time, such a view refuses to fetishize the context as "the local," as if it were an atomized fragment which could be isolated from its own taken-for-granted background. The context is never a stable object of study. It is only available at the end of the analysis; it is precisely the goal and product of analytic and political work. It is the most difficult "thing" to get hold of, and the task is made even more difficult when the analyst is located in the context which he or she is fabricating. Articulation becomes a

constant practice of replacing oneself, in specific ways, into the contexts that are available for rearticulation.

Moreover, any context entails a complex set of relations. One has not adequately constructed a context merely by bringing the pieces together and noting that they are connected. The specific form of every linkage is at stake as well. Pointing out that two practices are articulated together, that the pieces "fit" together, is not the same as defining the mode of that articulation, the nature of that fit. (For example, what is the connection which brought together American punks and skateboard culture? Or heavy metal fans and certain sorts of comic books?) Nor is arguing that a particular articulation is taken up the same as describing the way it is taken up. Without this dimension, the analyst's stories can only be stories of our historical losses. They can only tell how a context has already been articulated. They cannot identify the form of that articulation or, in more social terms, the investment that has been made in it. Without understanding the form or power of a particular line or connection, how can one imagine the possibility of its being broken? In that sense, articulation can be understood as a more active version of the concept of determination; unlike notions of interaction or symbiosis, determination describes specific cause-and-effect relations. But, unlike notions of causality and simple notions of determination, articulation is always complex: not only does the cause have effects, but the effects themselves affect the cause, and both are themselves determined by a host of other relations. Articulations are never simple and singular; they cannot be extracted out of the interlocking context in which they are possible.

While it is common to read both Foucault and Deleuze and Guattari as denying that structure has any role in their analyses (other than perhaps as the always negatively weighted form of power), the notion of articulation emphasizes the importance of structure in their critical practices. In fact, the practice of articulation involves the constructing, dismantling and reconstructing of structures which have real effects. There are a number of different ways in which structures operate in this theory of contexts: as relations among effects; as planes of effects; as "rhizomes" or "assemblages"; and as

levels of abstraction. First, the different effects of a practice are themselves articulated into particular relations, rendering some more powerful than others, constructing both sympathetic reinforcements and antagonistic contradictions. The structure of effects (across different planes) which articulates a practice is never guaranteed; it too is always determined by the articulations of the practice into and within its context. But if different practices may, in specific conditions, have effects on more than one plane, there are no necessary relations between domains of practices and planes of effects. While we cannot reduce the reality of a context to a single plane of effects, contexts do offer us various ways in which these planes can themselves be structured together. The most common involve traditional notions of domains of social life (politics, culture, economics, psyche, etc.) which assume a necessary correspondence between specific practices and planes of effects (as if one could identify ahead of time the consequence of a practice).

Second, the different planes of effects are always structured, not intrinsically, but as a result of historical articulations. They are not random and shapeless fields or forces (e.g., as in the common images of libidinal forces exploding through and deconstructing the structured maps of meaning and ideology). The different planes of effects manifest their own structures, producing their own maps of reality. In the end, lived reality can only be understood as the concrete contexts within which these different maps of reality are articulated and which they articulate. Third, practices are themselves organized into a variety of active structures, creating different kinds of organization which cut across domains and planes. Such organizations define interacting systems or condensations of practices and social relations, each operating on different material, producing specific sorts of transformations and values. At any moment, such organizations are complex, contradictory and structured; within them, certain forms of practice are dominant, others are tolerated, still others are excluded if not rendered radically unimaginable.

Deleuze and Guattari offer a general theory of such organizations, which they refer to as assemblages or rhizomes.[27] Rhizomes are constructed in a struggle between two sorts of lines of effectivity:

lines of articulation—their use of the term differs only slightly from mine—produce hierarchies, locate centers, create master structures purporting to define and control the entire assemblage. They draw boundaries between particular planes of effects and exclude the external as they produce identity within difference. Lines of flight, on the other hand, disarticulate, open the assemblage to its exterior, cutting across and dismantling unity, identity, centers and hierarchies. They deterritorialize the territories that have been articulated, not by fragmenting the assemblage (a practice of difference which remains within the interior of the assemblage) but by subtracting the lines of articulation, the structures of unity and hierarchy. One note of caution: lines of articulation and flight cannot be too quickly identified with power and resistance respectively. Such effects must themselves be articulated.

Finally, structure operates as well in distinguishing the level at which particular structures, contexts and organizations function. It is in this sense that we have to distinguish between the particular and the concrete, and between the concrete and the abstract.[28] A particular event or practice, empirically given, has to be made concrete by constructing its context, by describing the complex systems of articulation which make it what it is. Our analysis becomes more concrete as we add more of the articulations, not only in terms of additional domains of practices and planes of effects, but also articulations into different levels of abstraction. What distinguishes an analysis built upon a principle of articulation is that its structures are "real" precisely because they are effective. But one has to specify the level at which they are effective. At any other level, they appear to be little more than an abstraction. What appears at one level as a fairly simple practice may, at another level, operate as a complex and contradictory structure. If the analysis ignores the appropriate level of abstraction for a particular structure, it is likely to become dysfunctional. In other words, every context is a piece of other contexts and vice versa; contexts exist within each other.

Structures have to be located within concrete contexts, both in terms of their own social and historical determination, and in terms of the ways their effects are articulated. They are real, but their

reality is defined by their articulations at specific levels of abstraction or concreteness. Although structures are real, before we can begin to understand the effectiveness of any specific structure, we must know at what level of abstraction it functions. If we stay at that level, its effects, however complex and contradictory, will seem simple and even direct. But as we move to another level, its effects are increasingly delayed, deferred, detoured, decreased, etc. Different structures, just like different practices, will have different capacities to produce effects, different reaches across time and space. We cannot assume that we already know where, when or how strongly particular historical tendencies are operating. Hence, however real a structure may be, we cannot assume its effectiveness or its effects without taking into account the articulations between specific structures operating at different levels of abstraction.

This is markedly different from essentialist analyses which take for granted the reality and even the necessity and universality of certain structures. And it is markedly different from analyses which assume that no structures are real. Consider Marx's description of the commodity as one of the determining structures of capitalism:[29] we live in a capitalist economy; ergo, the commodity is determining. But this argument ignores the level at which Marx's description was offered in *Das Kapital*. The level at which the commodity is a real and effective structure is the entire history of capitalism, stretching back into the sixteenth century and ahead to who knows where, encompassing many diverse societies and political systems. Surely, Marx was not saying that to understand any specific capitalist society, it is sufficient to point to the commodity structure. An appeal to the abstract concept of the commodity neither describes nor explains capitalism in the modern world. But the commodity—as an abstraction—cannot be ignored. Rather, the task is to see how the "commodity" is articulated into less and less abstract—more and more concrete—contexts, by adding the determinations, drawing the lines of articulation.

Similarly, Marx described the fundamental structures of capitalism: the contradiction between capital and labor; and the contradiction between the forces and the relations of production. This seems

true of any capitalist society. But Marx assumed that the two contradictions were, in the end, identical. It is perhaps truer to argue that, in a specific social formation (nineteenth-century Western Europe, with its peculiar history and conditions), the two contradictions were articulated together. They were, temporarily and concretely, identical. But it may be the case that this articulation is no longer particularly effective. The apparent unity needs to be prised apart, disarticulated, challenged by looking at how the articulation was itself accomplished. In the United States, with its different history and its very different conditions, both contradictions continue to have their effects, but they have been rearticulated and the two structures may even contradict each other. Any description of contemporary capitalism would have to acknowledge and describe its extraordinary ability to negotiate its own contradictions and to survive very real national and international crises. Capitalism has changed as it has been rearticulated from a national to an international scene: multinational corporations do not operate in national interests. They go wherever capital is made comfortable, wherever they are made to feel at home. A similar argument can be made about the determining power of certain basic psychoanalytic processes, or of patriarchal structures.[30]

A context, then, can be seen as a structured field, a configuration of practices; each practice is located in a specific place as a set of relations, close to some practices, more distant from others. Its effects will be determined by those relations and distances. They will appear at different places and in different ways across the field. One can conceive of such articulations as lines or vectors, projecting their effects across the field. Each vector has its own quality (effectivity), quantity and directionality. Because practices are differentially distributed across the field, the field itself is marked by different structures and densities. Moreover, any practice exists in multiple contexts across the space of a particular moment, articulated into different, sometimes competing and sometimes contradictory sets of relations. Articulations may have different vectors, different forces and different spatial reaches in different contexts. And they may also have different

temporal reaches, cutting across the boundaries of our attempts at historical periodization.

Analysis, then, involves producing maps of the interrelated vectors, each with its own trajectory and strength which define its ability to penetrate into and affect reality. The greater that purchase, the more abstract the description of the articulation must be if it is to traverse adequately the various contexts in which it is effective. And the more abstract the description, the less it tells about the concrete articulations and their effects, about any specific context. In this way, analysis can acknowledge that articulations can have effects— create structures—which transcend any local context, although they exist only in their local articulations. There are always different levels of structures that have to be taken into account, where levels are defined by the effective spatial, temporal and social reach of different articulations across contexts. The practice of cultural analysis then involves the attempt to construct the specificity of an articulated context, the appropriateness of which is only given by the intellectual and political project at hand.

The Practice of Cultural Studies

Wild realism and articulation have important implications, not only for cultural studies, but also for my own project of telling a different story of contemporary conservatism. If the status of any event, as well as its description, are never guaranteed, analysis cannot take for granted what is being taken up, how it is articulated, and what sort of effects it produces. The analyst cannot assume what he or she knows when he or she know something; that is, one cannot assume the place of some interpretation or fact in the story. It too can only be contextually articulated. One has to know where on the map it belongs, how it occupies that space and at what level of abstraction. Obviously, a critic can give a close and careful reading of a text; he or she can even try to connect it to the contexts of its production, and to broader contexts of its possible intertextual articulations. But he or she cannot know how this knowledge is to

be used, what role it is to play in the larger story. Similarly, an ethnographer can describe how active audiences appropriate, use and interpret texts. These are real articulations, real effects; but the status of these articulations is no less problematic than that of the "texts" themselves. Meanings, representations, interpretations, uses, pleasures—all of these are effects which have, in turn, their own effects. To put it another way, uses have effects and effects have uses. They provide more "facts" that we can use to piece together the story, but they define the beginning, the resources of our story, not the story's conclusion. They are as much in need of being located in their context as any other statement or practice. They only do work in the analysis when placed into a particular position, assigned a particular role. I am not saying that texts or people's experiences are irrelevant or in any sense mistaken. I am saying that this cannot be the whole story; not only may the text have other effects but those experiences themselves have their own effects and their own determinations. Similarly, one cannot assume ahead of time that the analytic task involves seeking the "proper" meaning of a text, whatever the measure of its propriety. If one starts by assuming the questions—how texts impose their meanings or how audiences interpret texts—one will miss the actual possibilities of living that are opened up and closed off by such practices. So analysis must construct the concrete totalities within which such experiences can be located, their determining structures and effects identified.

Thus, the project of reconstructing historical contexts or organizations of practices, despite superficial similarities, is not a search for the underlying codes governing and determining human behavior. Nor is it the same as, for example, Williams' project of describing a "structure of feeling."[31] It is not a description of experience, of what it felt like to live at a particular time and place. It is not a phenomenologically motivated attempt to capture a context of experience or, as Foucault puts it, to grasp "a 'whole society' in its 'living reality.' "[32] The position I have presented here is not concerned with how people experience daily reality but with how they live and act in ways over which they may have no control and about which they may be unaware, experientially as well as consciously.

In this project, experiences are not privileged; they are to be treated as facts among other facts.

This model of cultural analysis, with its picture of myriads of structures, practices and effects circulating around and determining each other, offers the possibility of different stories about culture (and power). It is not merely a matter of questioning the relationship between meaning, representation and fantasy, or of the ability to distinguish reality from fiction. Cultural practices are the sites of many different activities and effects. They can be enacted or practiced in many different ways, at different tempos, constructing different contexts. Hence, the analyst's story will have to be constructed from the range of maps, not only of meaning and representation, but also of affectivity, libido, economics, etc. Its critical practice will be inappropriate to the rhythms, forces and densities of lived reality if it assumes that all cultural events are taken up, lived, practiced, effective, in just the same way, and to just the same degree. The question facing cultural analysts is how cultural practices rearticulate or reshape the contexts of people's lives and of history. How do specific cultural practices work, through what modes of functioning, to produce what concrete effects?

This analytic project might be described as a cartography of daily life[33] which attempts to (re)construct at least a part of the complex texture of a certain terrain. That terrain may have many strata and pathways crossing each other; how it is mapped depends on the paths noticed, followed, the strata focused on. Some attempts will, at least for the moment, be dead ends. Others will open rich possibilities, but their possibilities will never be obvious from the start. Something is discovered here, but its resonances, its significance for the larger map, remain unclear. One continues to follow the path, still uncertain where it will lead, intrigued by other paths that cut across the way, by other landmarks that offer different possibilities. Somewhere else, another discovery offers new possibilities, resolutions and questions. Each new discovery not only changes the maps that have already been drawn, but forces one into new directions, to search for new sorts of evidence. The analyst always starts by taking evidence literally—at its face value—and then attempts to reconstruct the

threads that connect the pieces, the forces that hold them together and the structures that organize them. In this, the practice of reassembling and mapping historical contexts is somewhat analogous to constructing a jigsaw puzzle without knowing how many pieces are needed, if they are all present (and if the only ones present are necessary), or what the puzzle is a picture of. What one finds on the surface of any piece is all there is to go on, yet there is no guarantee that the lines inscribed on the surface correspond to the lines of the puzzle. The identity of any piece remains a mystery until the puzzle begins to give up its image.

Such an analysis describes how practices, effects and vectors are woven together, where the boundaries are located and where the fault lines lie. This structured assemblage is a force-field encompassing different forms of objects, facts, practices, events, whatever can be found along the way. On this model, cultural studies attempts to construct a contour map measuring the effects of underlying processes over time. The map describes a configuration of practices which is constantly working on itself, deconstructing and reconstructing, reproducing and changing, extending and drawing back. Its history will not be coherent and linear but will follow the discontinuous and often serendipitous histories and relations of a number of contiguous maps. The "truth" of the result is not hidden below the surface of the real, but rather obscured by its very visibility on the surface; cultural analysis seeks to discern a pattern dispersed on the surfaces that have to be traversed. The maps of cultural studies fabricate the real in an attempt, not to represent or mimic it, but to strategically open up its possibilities, to intervene into its present in order to remake its future.

Thus, the cultural analyst is directly implicated and involved in his or her story, for the storyteller cannot help but be as much a character in the story as any other socially defined subject. The stories told, the knowledge produced, are never innocent or neutral. Descriptions, stories and explanations are important parts of how people come to organize their daily lives and social relations. Cultural analysts do not have the luxury of assuming that their stories have no impact upon the world they attempt to describe. Neutrality

is not an objective stance but a privilege available to certain positions of power, and a value defined within the cultural habits of particular social groups. On the other hand, there are no guarantees what the effects of any story will be. It may have quite unintended and unexpected consequences. People can and do of course seek to have some control over them, but they are not always successful. Thus, it is not merely a matter of declaring one's political allegiance and assuming that the politics of one's story is now guaranteed. The demand that one declare one's allegiances is often politically important, but it is also rather simplistic—as if there were only two sides, good and bad, powerful and powerless.

The cultural analyst must recognize his or her own paradoxical situation, always implicated in the structures of power he or she is trying to dismantle or change. Declaring oneself to be on the side of the oppressed too often serves as a way of avoiding the more difficult task of locating the points at which one already identifies and is identified with those who hold power in society. The analyst is not the vanguard of an already imagined revolution, but a member of a particular fraction of the masses attempting to influence its own march through history. He or she is another social actor standing in a specific (and, admittedly, in some ways "privileged") social position. No story can claim to speak for the masses, as if it were the story they would tell. For there is no singular "they"; we would all tell different stories, depending upon the position from which we survey the scene and the resources that we have available to us. The "elitist" assumes that the masses are necessarily silent, passive, political and cultural dopes who are incapable of struggling against their own subordination. But it is simply that they (we?) do not always speak when intellectuals want them to, and when they do speak, they do not often say what intellectuals want them to say. The cultural analyst cannot assume that people are so totally colonized that they are incapable of actively engaging in the processes by which a contingent and changing history is constantly being made, unmade and remade. He or she must be able to identify those sites, those moments, when people do struggle to win a bit of space for themselves in the world. But at the same time, the analyst must

also be able to acknowledge those sites, those moments, when people do seem unable to participate in the historical struggles, when they are manipulated and duped into positions they might not otherwise have taken up.

Analysts are not always capable of seeing what the masses never can, nor are they necessarily any less susceptible to being manipulated. Thus, the analyst must consciously reposition him- or herself in the maps he or she is constructing. But this is not the same as constantly problematizing his or her relations to the map, as forcing her or himself into an endless self-reflexive denial of the authority of the map. The cultural analyst moves through the complexity of social positions and social identities, allowing him- or herself to travel through and be mobilely situated in the fluidly structured field of forces. He or she moves with and within the field of popular culture and daily life, mapping as best he or she can the configuration of practices, the lines of articulation and flight. While such wandering is never random or capricious, its paths can never be guaranteed in advance (for example, by the lines which divide the terrain within our own critical standards or popular tastes between proper or improper, good or bad, authentic or inauthentic), nor can such wandering ever complete its itinerary through the field. There are always paths to follow, other paths one could have taken, and the choices made reflect as much the strategic intentions of the analyst as they do the historical determinations of the critical act. If one is never in control of such wanderings, one is also never merely blown about by the winds of popular and intellectual judgment. In the final analysis, analysts as storytellers are reshaped by the story they are telling.

The story I want to tell seeks to follow one set of trajectories across the field of popular culture and contemporary power. By gaining a better sense of the state of play on the field of forces in popular culture and daily life, perhaps we can see more clearly where struggles are possible and, in some cases, even actual. Then we can try to find ways to oppose them, or to help articulate them, to nurture and support them and perhaps, to bring them into visible relations with other struggles. Opposition, like all of history, must be fought over

and articulated. As critics and cultural analysts, we have to look at how both domination and subordination are lived, organized and resisted; we have to understand the possibilities of subordination that are opened and allowed within the structures of domination, and perhaps point beyond them. We have to understand the ways in which resistance itself can become a strategy for rearticulating the structures of domination.

My project, then, begins with a particular situation; it begins to tell the story of the articulation of hegemony and postmodernity as the new context within which we might understand one not insignificant line of contemporary politics. In the light of this project, I propose to offer three intersecting maps of the cultural field: The first (Chapter 2 and Part II) describes the articulation of historically specific cultural discourses (rock and the formation of postwar popular culture); the second (Chapter 3 and Part III) describes how such formations are articulated into and transformed by the contexts of power (the articulation of the rock formation into an apparatus of the regulation of space and time in daily life); the third (Chapter 4 and Part IV) describes the strategic place of this apparatus by locating it in a structure of historical agency, as the site of real historical struggles in a particular field of forces. These three maps may be seen as intersecting descriptions of a region of the cultural field: in the terms of my own study, of the ways in which the rock formation is deployed into particular apparatuses and struggles of power. Taken together, the three maps attempt to describe only one part of the dynamic and multidimensional relationship between popular culture and power in the current conjuncture.

2

MAPPING POPULAR CULTURE

Few people would deny the pervasiveness and power of popular culture. It is increasingly visible, not only as an economic force, but as a powerful force of education and socialization, and as one of the primary ways in which people make sense of themselves, their lives and the world. As people are increasingly caught up in its seductive hooks, popular culture becomes something more than a mere representation of, or fantasy about, the "real" world. Popular culture is a significant and effective part of the material reality of history, effectively shaping the possibilities of our existence. It is this challenge—to understand what it means to "live in popular culture"—that confronts contemporary cultural analysis. This is not just that popular culture has become a dominant forum for ideological struggles, nor that it has become the predominant source for the iconography of people's lives. Popular culture plays a significant, active role in the material milieu in which they live. It is this role that needs to be interrogated.

CULTURAL FORMATIONS AND SENSIBILITIES

The first map attempts to describe how a set of cultural practices comes to congeal and, for a certain period of time, take on an identity of its own which is capable of existing in different social and cultural contexts. Unlike notions of genre, which assume that such identities

depend on the existence of necessary formal elements, a formation is a historical articulation, an accumulation or organization of practices. The question is how particular cultural practices, which may have no intrinsic or even apparent connection, are articulated together to construct an apparently new identity (e.g., the articulation of rhythm and blues, country and western music, and certain techniques of Tin Pan Alley into something called rock). As Foucault describes it:

> A discursive formation, then, does not play the role of a figure that arrests time and freezes it for decades or centuries; it determines a regularity proper to temporal processes; it presents the principle of articulation between a series of discursive events and other series of events, transformations, mutations, and processes. It is not an atemporal form but a schema of correspondence between several temporal series. [1]

To account for the emergence of the formation, one must look elsewhere, to the context, the dispersed but structured field of practices in which the specific articulation was accomplished and across which it is sustained over time and space. It is not a question of interpreting a body of texts or tracing out their intertextuality. Rather, the formation has to be read as the articulation of a number of discrete series of events, only some of which are discursive. The formation is not accountable in its own terms, but only in terms of its specific conditions of possibility and its own effectivities. Through such a mapping, one can understand not only the emergence of a particular cultural formation, but its possible transformations and deployments.

My analysis of rock in Part II attempts to understand its existence as a real cultural structure by placing it into the historical relations which *enabled* its appearance. In this way, I hope to identify at least a part of rock's specificity. By mapping the way in which certain textual practices were articulated to a variety of other cultural, social, economic, historical and political practices (e.g., a certain apocalyptic rhetoric, youth, bohemianism, juvenile delinquency), the formation of rock comes into existence, and into our view. Whether in fact this identity is real in musical terms is irrelevant, for the existence

of the rock formation has had its own effects; it has enabled other events and practices: it has become the condition of possibility for other social and cultural articulations.

A cultural formation describes the lines that distribute, place and connect cultural practices, effects and social groups. Such an articulation not only involves a selection and configuration from among the available practices, but also a distribution of the formation itself within the social space. That is, a formation—and the practices within it—is not equally available at every social site, nor to every fraction of the population. Different social groups have differential access to specific clusters of practices and these relations are themselves part of the determination or articulation of the formation. Moreover, at different sites, for different fractions, the distribution and configuration of the formation itself will determine different relations to and experiences of the formation itself.

A cultural formation is articulated into and functions within different contexts of daily life. Such articulations create a series of "alliances," each representing a particular selective appropriation of the formation itself; no alliance includes every element of the formation. From one perspective, this is merely a description of the fact that no one is likely to relate to every practice within the formation; no rock fan listens to every record, or likes every sound, or approves of every title. The same "text" can and often will be located in a number of different alliances, and in each it will be articulated differently; it will be, at some level, a different practice with different relations to and effects on daily life. An alliance is a secondary articulation of the formation; it too is a material collection of practices, structured both in relation to other alliances and to the more abstract cultural formation itself. An alliance is a local, yet potentially dispersed, concretization of the more abstract existence of the formation.

From another perspective, the formation itself makes a number of different positions available to different groups, all of which may have some relationship to the formation. "Audiences" do not exist outside the formation and specific alliances; they are incorporated into them, part of their configuration of practices and relations.

Cultural formations surround and invade the bodies of their various populations, incorporating them into their own spaces, making them a part of the formation itself. People can be inserted in very productive and complex ways, and many of the practices of cultural enthusiasts clearly function to guarantee and even exaggerate this effect (e.g., the active role of rock audiences and the importance of local music).

Every formation cuts across and operates on a number of different planes of effects. These different planes are themselves organized within and by the formation so that a particular configuration (which may or may not be identifiable with a single plane) is dominant. I will call such a dominant organization of effectivity a "sensibility," which is similar in many ways to Williams' "structure of feeling."[2] Every formation puts into place a particular sensibility, which describes its effects in people's daily lives and thus the way in which a particular formation is lived. It defines the relationships that can exist between specific practices and the individuals or groups located within the formation (or any alliance within the formation). It determines how specific practices can be taken up and lived (e.g., as texts to be interpreted), how they are able to affect people's places in the world, and what sorts of practices can be incorporated into the formation.

A sensibility can be understood in a number of different ways. For the individuals living within it, it defines a historically determined and socially distributed mode of engagement with (or consumption of) particular practices. It determines the "proper" and appropriate way of selecting cultural practices, of relating to them, and of inserting them into daily life. In other words, the notion of a sensibility replaces and refines the concept of taste, for the sensibility of a particular formation determines the very meaning of "taste" within it. Taste means entirely different things in different formations. Unless one understands the sensibility active within a particular formation, the appeal to taste fails to identify the domain within which the differentiations of taste are being made. The formation determines the ways in which those living within it can relate to its elements; it defines the possible and appropriate relations that exist

within the context it constructs. It identifies the ways the formation empowers the groups existing within its spaces, and simultaneously, the ways these groups empower the practices of the formation. Empowerment refers to how cultural formations in daily life make possible particular sorts of practices, commitments and relationships.

For the formation itself, a sensibility is a principle of articulation which defines the planes and intersections of effects on which the practices of the formation operate. It identifies the specific sorts of effects that are produced, the relationships between the practices and the structures of daily life that are enabled. A sensibility locates the particular planes and organizations of effects that dominate the formation it governs. It determines the coherence among the elements of a formation. One can only understand how the various pieces of a formation (or an alliance) "fit" together in terms of its sensibility. How the specific sounds, styles and behaviors of a specific alliance (e.g., surf music and surf culture, or thrash music and skateboards, or the particular configuration of "mod" culture) make sense together depends upon the sensibility at work.

Of course, identifying the sensibility of a formation is rarely a simple matter: a formation can, in different contexts, be articulated to different and even multiple sensibilities, although one is likely to be dominant. Thus, sensibilities do not belong to particular sorts of practices (e.g., as if literature always produced meaning). Nor do they belong to specific social groups (as if intellectuals had some proper authority over meaning). Sensibilities have to be articulated to different formations and populations, and this struggle often defines the politics of culture.

Pierre Bourdieu has described some of the most important sensibilities operating in contemporary culture.[3] Academics often locate every cultural practice within an "aesthetic" sensibility which foregrounds the formal structure of the text and a "disinterested" relation to the text. This sensibility subordinates function to form, life to "art." It treats everything—whether works of art, profane cultural objects, social events, or even natural objects—as things to be considered in isolation, as the embodiments of formal principles of construction. A more common sensibility involves a motivated reading

which treats everything as an ideological act, and asks what it says to, and about, the life of a social group. For example, religious fundamentalists seem to experience culture in terms of the moral prescriptions "embodied" within different practices, of the ways they function to regulate the routine behavior of daily life. Both of these sensibilities involve different organizations of the planes of signification and representation. And both judge cultural practices by standards that lie outside of the relationship to the practice itself. Is it formally complex—given a certain definition of complexity? Is it ideologically correct—given a certain definition of moral or political correctness?

However, the dominant sensibilities of contemporary popular culture often construct different organizations, involving other planes of effects, including desire (a libidinal sensibility), fantasy, economics and especially pleasure. Of course, pleasure is itself a complex phenomenon and the term covers a number of different relations: the satisfaction of doing what others would have you do; the enjoyment of doing what you want; the fun of breaking the rules; the fulfillment—however temporary and artificial—of desires (although here we should acknowledge the complex and close relationship between desire, as psychoanalytically understood, and ideology); the relief of catharsis; the comfort of escaping from negative situations; the reinforcement of identifying with a character; the thrill of sharing another's emotional life; the stature of expertise and collecting; the euphoria of "vegging out"; the compulsion of overconsumption.[4]

All of these are involved in the normal and common relationship to popular culture. People are engaged with forms of popular culture because, in some way and form, they are entertaining; they provide a certain measure of enjoyment and pleasure. Of course, such relationships might also produce ideological effects, either directly or indirectly (through the articulation of pleasures to ideological positions, or through the pleasures of ideological reinforcement), but these are almost never the source of the relationship, nor the plane of their primary effectivity.

POPULAR CULTURE

If, as I suggested earlier, the media are not identical to popular culture, then we must ask about the sensibility which articulates some media formations as popular. That is, what makes popular culture popular? The question seems innocent enough, but as soon as one begins to look for an answer, one finds a great deal of ambiguity and uncertainty. What is it, after all, that is in need of explanation? Popular culture has always been a rather paradoxical field; it is usually defined in explicit opposition to the "legitimate" culture of the intelligentsia (what Bourdieu describes as the dominated fraction of the dominant class). But it also stands ambiguously poised in relation to the actual culture of the dominant classes. Reading the literature on popular culture, one would never guess that the various fractions of the middle and upper classes have a popular culture of their own.

"Popular culture" exists within a complex series of terms (mass, elite, legitimate, dominant, folk, high, low, midcult) and oppositions (civilized versus vulgar, dominant versus subordinate, authentic versus inauthentic, self versus other, same versus different) which are, in various contexts, linked together in different ways.[5] Even within these series, the relations are never stable or comfortable: As Stallybrass and White[6] have demonstrated, even while those "in power" may be threatened and even "repulsed" by the vulgar tastes of "the masses," that vulgarity often continues to function as a repressed fantasy which structures the more "cultured" tastes. As intellectuals have tried to consider popular culture more sympathetically, their strategies evidence their continued discomfort: they divide it into the acceptable and the unacceptable; they grant value to certain elements, practices and commitments but first remove them from their daily context and often from their sensibility; or they celebrate those texts that are consistent with their own cultural tastes and political projects.

Popular culture has been defined formally (as formularized), aesthetically (as opposed to high culture), quantitatively (as mass cul-

ture), sociologically (as the culture of "the people") and politically (as resistant folk culture). Sometimes it is identified with mass culture and condemned for reducing culture (and the masses) to the "lowest common denominator." At other times, it is located outside of mass culture, as if it had some necessarily more authentic relation to the people and consequently had some intrinsically greater possibility of articulating resistance to the dominant culture. Often, discussions of popular culture conflate aesthetic, sociological and political questions. How can popular culture be different from mass culture when it seems so odd to say that the contemporary forms of mass culture are not popular? Is popular culture identified more directly with particular social groups—those who are oppressed or actively subordinated? Is it intrinsically more likely to articulate resistance? Is it qualitatively different from other forms of culture? But, then, how can something be popular at one historical moment and not at another? Or how can some popular culture practices become integrated into other cultural formations?

Can the difference between popular practices and other forms of cultural practices be defined by moral or aesthetic criteria? History has shown that texts move in and out of these categories (e.g., what was popular can become high art) and that a text can exist, simultaneously, in different categories. There are no necessary correspondences between the formal characteristics of any text and its status (or audience) at a particular moment. Is it, then, a matter of where the text comes from, of how and by whom it is produced? But again, there are too many exceptions to this assumed correlation. The mode by which a text is produced, or the motivations behind it, do not guarantee how it is placed into the larger cultural context nor how it is received by different audiences. So perhaps the answer is the most obvious one: what makes something popular is its popularity; it is, in other words, a matter of taste. But this formulation does not help very much, for the same questions remain, albeit in different forms: how much popularity? whose tastes? and what do these different tastes signify?

One cannot overcome the ambiguities inherent in such questions merely by pointing out that the relations between different cultural

domains are continually being redefined and challenged.[7] Certainly, the boundaries of the popular are fluid. Culture is never a fixed set of objects, and the meaning of "the popular"[8] as a qualifier is always shifting. The construction of the popular is always the site of an ongoing struggle; its content as well as its audience varies from one historical period to another. It is a domain in which different meanings and values, many of them with powerfully constituted political inflections (whether dominant, subordinate or oppositional) confront and mix with each other. This terrain of cultural diversity no doubt plays a significant ideological role, for it is here that popular experience and identity are constructed and framed.

Such diversity need not recreate the old dichotomy between folk and mass culture, between a pure and spontaneously oppositional culture and an externally produced and repressive culture. Every cultural practice is a hybrid, already located within this complex terrain, and thus it is partly determined by the various contradictory forces, tendencies and positions that are already operating. There are no pure cultural practices, as if records with acoustic guitars were somehow less contaminated by the technologies and economies of capitalist culture, as if reggae were not an impure and complex mélange of many cultural influences. Nor is there ever a simple relation between specific cultural practices and preconstituted social groups which exist independently of their cultural practices. It is in the struggles around popular culture that social identities and groups are constructed. If "there is no fixed content to the category of 'popular culture,' so there is no fixed subject to attach to it."[9]

Although there is no necessary content to, or boundaries around, popular culture within a social formation, there are always boundaries already defined and content already inserted. At the same time, popular culture does not simply and always function outside of the dominant culture—whether the dominant is understood as the domination of an elite or of the masses. Simply making popular culture into an abstract site of struggle, an empty signifier, does not specify what the struggles are about or how they are organized in any historical moment. To say that popular culture is the site of a struggle does not automatically tell us what people are struggling over and

what the weapons are. The cultural analyst has to enter onto the terrain of popular culture to understand the ways in which it works and struggles, to recognize that its place in daily life and the social formation is defined by more than its difference from something else (and even by more than its potential as resistance).

Popular culture appears to describe structures of taste or degrees of consumption that are not legitimated by the critical or commercial systems of discrimination. But can we approach it more directly, in its positivity: popular culture points to an assemblage of formations, to other sensibilities and to another plane of effects. I want to start with the fact that people spend time with popular culture and that it matters to them, that it is often an important site of people's passion. This is often treated as if it were trivial compared to the "meaning-fulness" of specific texts. But in fact, its "mattering" may have its own impact on history and daily life.

Critics often ignore popular culture's immediacy, its physicality and its fun: its very popularity. If it is a form of escapism (which seems woefully inadequate to describe the complexity of relations to popular culture), what is it escaping from? And what is its escape route? One has to explore the work popular culture is doing, which is very different from merely celebrating its fun: "Many left intellectuals are not only fed up; they are, in a sense, bored. It gets draggy to keep on repeating all that left-wing stuff when the nation is busy waving plastic flags at Fergie. . . . All these people on the left . . . are in fact *rediscovering* popular culture as really quite good fun. However the vast majority of people knew it was quite good fun all along."[10] More importantly, there are different forms of fun, and fun may have different effects in specific contexts. Fun is itself articulated into larger structures of daily life, and of social and political relations.

When the *New Left Review* began in the early 1960s, Stuart Hall wrote: "The task of socialism is to meet people where they *are*—where they are touched, bitten, moved, frustrated, nauseated—to develop discontent and at the same time, to give the socialist movement some *direct* sense of the times and the ways in which we live."[11] Interestingly, the images are all physical, emotional and passionate. Surely, Hall did not intend to suggest that how people think, how

they interpret the world, is not a significant part of where they are, but where and how they live, especially in the field of popular culture, are perhaps more powerfully determined by other sorts of relations. Popular culture is always more than ideological; it provides sites of relaxation, privacy, pleasure, enjoyment, feeling good, fun, passion and emotion.

Popular culture often inscribes its effects directly upon the body: tears, laughter, hair-tingling, screams, spine-chilling, eye-closing, erections, etc. These visceral responses, which often seem beyond our conscious control, are the first mark of the work of popular culture: it is sentimental, emotional, moody, exciting, prurient, carnivalesque, etc. Such effects are not intrinsic to popular practices. They are historically articulated and a large part of the struggle over popular culture concerns the ability of certain practices to have such effects. My students regularly oppose classes on rock because, in some sense, they know that too much intellectual legitimation will redefine the possibilities of its effectiveness; it will become increasingly a meaningful form to be interpreted rather than a popular form to be felt on one's body and to be lived passionately and emotionally. Popular culture is not defined by formal characteristics but by its articulation within particular formations and to specific sensibilities.

AFFECT AND THE POPULAR

Popular culture seems to work at the intersection of the body and emotions. Emotion is itself a notoriously difficult topic for cultural critics who often try to explain it as if it were merely the aura of ideological effects. Such accounts cannot explain why certain practices elicit strong emotive effects while others do not. The very fact that there is an unavoidable quantitative aspect to emotions suggests that there must be more to the production of emotional effects. I conclude that they are the product of the articulation of two planes: signification (rather than ideology, since people can be quite emotional about meanings that do not claim to represent reality) and *affect*.[12] And consequently, I will locate the sensibilities of popular formations primarily on the plane of affect.

The most obvious and perhaps the most frightening thing about contemporary popular culture is that it matters so much to so many different people. The source of its power, whatever it may seem to say, or whatever pleasures it may offer, can be identified with its place in people's affective lives, and its ability to place other practices affectively. For many people, certain forms of popular culture become taken-for-granted, even necessary, investments. As a result, specific cultural formations become "affective alliances." Their logic or coherence—which is often so difficult to define—depends upon their affective relationships, their articulated places within people's mattering maps. One cannot assume that such affective alliances satisfy needs created elsewhere, or that they create the needs which they in turn satisfy.

Affect is perhaps the most difficult plane of human life to define and describe, not merely because it is a-signifying (and contemporary theory is so heavily directed toward signifying practices), but also because there is no critical vocabulary to describe its different forms and structures. But this does not mean that affect is some ineffable experience or a purely subjective feeling. Affect is a plane of effects, a matter of "actualization, effectuation, practices . . . an ability to affect and to be affected. It is a prepersonal intensity corresponding to the passage from one experiential state of the body to another and implying an augmentation or diminution in that body's capacity to act."[13]

Affect is closely tied to what we often describe as the "feeling" of life. One can understand another person's life, share the same meanings and pleasures, but still not know how it feels. Such "feeling" is a socially constructed domain of cultural effects. Some things feel different from others, some matter more or in different ways than others. The same experience will change drastically as its affective investment or state changes. The same object, with the same meaning, giving the same pleasure, is very different in different affective contexts. Or perhaps it is more accurate to say that different affective contexts inflect meanings and pleasures in very different ways. Affect operates across all of our senses and experiences, across

all of the domains of effects which construct daily life. Affect is what gives 'color,' 'tone' or 'texture' to the lived.

There are different forms of affective investments. These are the result of the energy of affect articulated through different principles of structuration. First, one can distinguish between libidinal (sexual) and nonlibidinal investments.[14] Libidinal affect (or desire in psycho-analytic terms) is always focused on an object (whether real or imaginary), while nonlibidinal affect (affect for short) is always dispersed into the entire context of daily life. Desires can be satisfied, if only temporarily and mistakenly, while affect can only be realized. The concept of desire assumes that there are hidden truths behind or below our conscious life (the unconscious), while affect always exists on the surface. And there is an active mechanism of hiding (repression) which constitutes the unconscious, while affect seems to operate in something like the "preconscious." A second distinction can also be drawn, within nonlibidinal effect, between moods and will. Moods define the affective frames within which we find ourselves, frames which surround any activity and inflect any investment.[15] Will (or passion) defines investments which appear to be isolated instances in the particular context.[16]

Each of these forms of affect can be articulated through the mediating effects of ideological narratives to produce different forms of emotional response and involvement. Our emotional states are always elicited from within the affective states in which we already find ourselves. Unlike emotions, affective states are neither structured narratively nor organized in response to our interpretations of situations. Compare, for example, *The Sound of Music* and David Lynch's *Wild at Heart*: both are extraordinarily manipulative, but while the former works on and through emotional narrative, the latter works more immediately on affective investments. For the purposes of my analysis, I will use "affect" to refer to its nonlibidinal forms, ignoring the differences between mood and will.

Affect actually points to a complex set of effects which circulate around notions of investment and anchoring; it circumscribes the entire set of relations that are referred to with such terms as "volition,"

"will," "investment," "commitment" and "passion." Affective relations always involve a quantitatively variable level of energy (activation, enervation) that binds an articulation or that binds an individual to a particular practice. Affect identifies the strength of the investment which anchors people in particular experiences, practices, identities, meanings and pleasures, but it also determines how invigorated people feel at any moment of their lives, their level of energy or passion. In this quantitative dimension, affect privileges passion and volition over meaning, as if simply willing something to happen were sufficient to bring it about (e.g., as one ad campaign continuously declares, "Where there's a will, there's an A").

Affect is also defined qualitatively by the nature of the concern (caring, passion) in the investment, by the way in which the specific event is made to matter. Too often, critics assume that affect—as pure intensity—is without form or structure. But it too is articulated and disarticulated—there are affective lines of articulation and affective lines of flight—through social struggles over its structure. The affective plane is organized according to maps which direct people's investments in and into the world. These maps are deployed in relation to the formations in which they are articulated. They tell people where, how and with what intensities they can become absorbed—into the world and their lives. This "absorption" constructs the places and events which are, or can become, significant. They are the places at which people can anchor themselves into the world, the locations of the things that matter.

These "mattering maps"[17] are like investment portfolios: there are not only different and changing investments, but different intensities or degrees of investment. There are not only different places marked out (practices, pleasures, meanings, fantasies, desires, relations, etc.) but different purposes which these investments can play. Mattering maps define different forms, quantities and places of energy. They "tell" people how to use and how to generate energy, how to navigate their way into and through various moods and passions, and how to live within emotional and ideological histories. In fact, affect is the missing term in an adequate understanding of ideology, for it offers the possibility of a "psychology of belief" which would explain how

and why ideologies are sometimes, and only sometimes, effective, and always to varying degrees. It is the affective investment in particular ideological sites (which may be libidinal or nonlibidinal) that explains the power of the articulation which bonds particular representations and realities. It is the affective investment which enables ideological relations to be internalized and, consequently, naturalized. But this description may make such investments sound too conscious or at least subjective. If affect cannot be "found" in the text or read off its surfaces (any more than meaning can), it is also the case that affect is not simply something that individuals put into it. Affect is itself articulated in the relations between practices. It is, as Lyotard suggests, the unrepresentable excess—the sublime?—which defies images and words, which can only be indicated.[18] But there is no single way in which such affective investments are lived or manifested. As one college student in a television documentary put it, "I don't think the old ways of showing that we care are the ways that we show we care now."[19]

The dominance of the affective dimension does not mean that such popular formations do not also involve relations of ideology and pleasure, materiality and economics. Daily life always involves the inseparable articulation of these various domains; it can only be understood as the complex relations among these. But within the relations of and to popular culture, the determining moment is often the history of struggle within and over the affective plane. For it is in their affective lives that people constantly struggle to care about something, and to find the energy to survive, to find the passion necessary to imagine and enact their own projects and possibilities.

Popular culture, operating with an affective sensibility, is a crucial ground where people give others, whether cultural practices or social groups, the authority to shape their identity and locate them within various circuits of power. People actively constitute places and forms of authority (both for themselves and for others) through the deployment and organization of affective investments. By making certain things matter, people "authorize" them to speak for them, not only as a spokesperson but also as a surrogate voice (e.g., when we sing along to popular songs). People give authority to that which they

invest in; they let the objects of such investments speak for and in their stead. They let them organize their emotional and narrative life and identity. In this way, the structures and sites of people's investments operate as so many languages which construct their identity. Insofar as such investments are dispersed, their identity is similarly dispersed. But insofar as their investments are organized, both structurally (in affective alliances) and intensively, popular culture establishes different moments of relative authority, moments which are affectively connected to each other (e.g., the investment in rock may make an investment in certain ideological positions more likely, although it can never guarantee them). To put this another way, affect is the plane or mechanism of belonging and identification (of which identity, constructed through either ideological or psychoanalytic interpellations, is only one form). This opens up the possibility of investigating, not only the different sites of investment (anchoring) and identification, but also the different modes of such investments.

The image of mattering maps points to the constant attempt to organize moments of stable identity, sites at which people can, at least temporarily, find themselves "at home" with what they care about. Affect defines a structure and economy of belonging. The very notion of "the popular" assumes the articulation of identification and care; it assumes that what one identifies with (including moments of identity) matters and that what matters—what has authority—is the appropriate ground for identification. But mattering maps also involve the lines that connect the different sites of investment; they define the possibilities for moving from one investment to another, of linking the various fragments of identity together. They define not only what sites (practices, effects, structures) matter but how they matter. And they construct a lived coherence for those enclosed within their spaces.

This analysis of popular culture suggests that everyone is constantly located within a field of the popular, for one cannot exist in a world where nothing matters (including the fact that nothing matters). Contemporary popular culture may be, in fact, the conjunctural articulation of a relationship which has historically consti-

tuted the popular in very different forms and domains, including relationships to such diverse things as labor, religion, morality and politics. There is no necessary reason why the affective relationship is located primarily on the terrain of commercial popular culture. But it is certainly the case that, for the vast majority of people in advanced capitalist societies, this is the primary space where affective relationships are articulated. It is here that people seek to actively construct their own identities, partly because there seems to be no other space available, no other terrain on which they can construct and anchor their mattering maps. And the consumer industries (and the new conservatism) increasingly appeal, not only to ideological consensus, but to the contemporary structures of affective needs and investments (e.g., "sleeze TV," which always attempts to present the position of maximum passion or sentimentality). However, I do not mean to suggest that the category of the "popular" exists in the same way in every historical situation, that there is a singular stable affective sensibility. The popular can only be understood historically, as located in a set of cultural sensibilities.

The empowerment produced by one's place within an affective (popular) alliance is not the same as that produced through pleasure, for on the affective plane, pleasure can be disempowering and displeasure can be empowering. Empowerment here refers to the reciprocal nature of affective investment: that is, because something matters (i.e., one invests energy in it), other investments are made possible. Affective empowerment involves the generation of energy and passion, the construction of possibility. Unlike pleasure, an affective investment in certain practices always returns some interest through a variety of empowering relations: by producing further energy (e.g., rock dancing, while exhausting, continuously generates its own energy, if only to continue dancing); by placing people in a position from which they feel they have a certain control over their (affective) life; or by reaffirming the feeling that one is still alive and that this matters. In all of these cases, affective empowerment enables one to go on, to continue to struggle to make a difference. The investment in popular practices opens up strategies which enable one to invest in new forms of meaning, pleasure and identity, and

to cope with new forms of pain, pessimism, frustration, alienation, terror and boredom.

But the affective investment in certain sites demands a very specific ideological response, for affect can never define, by itself, why things should matter. That is, unlike ideology and pleasure, it can never provide its own justification, however illusory such justifications may in fact be. The result is that affect always demands that ideology legitimate the fact that these differences and not others matter, and that within such differences, a particular term becomes the site of our investment. Ideology does this by articulating the investment to a principle of excessiveness. Because something matters, it must have an excess which explains the investment in it, an excess which ex post facto not only legitimates but demands the investment. The site of investment is constructed as an excess, distinguishing it from other potential sites. The more powerful the affective investment, the more powerfully it must be ideologically legitimated, and the greater the excess which differentiates it from other sites. For example, the rock fan "knows" there is something *more* in rock music which distinguishes it from other forms of music. This excess, while ideologically constructed, is always beyond ideological challenge, because it is called into existence affectively. The investment guarantees the excess. But the relationship between the planes of ideology and affect is itself historically articulated. What happens as the relation becomes increasingly tenuous?

Affective empowerment is increasingly important in a world in which pessimism has become common sense, in which people increasingly feel incapable of making a difference, and in which differences increasingly seem not to matter, not to make any difference. Affective relations are, at least potentially, the condition of possibility for the optimism, invigoration and passion which are necessary for any struggle to change the world. At this level, popular culture offers the resources which may or may not be mobilized into forms of popular struggle, resistance and opposition. The organization of struggle depends upon its articulation to different affective organizations and empowering investments. While there is no guarantee that even the most highly charged moments will become either

passive sites of evasion or active sites of resistance, without the affective investments of popular culture, the very possibility of such struggles is likely to be drowned in a sea of historical pessimism. On the other hand, affective relations can also be disempowering (even through an initial moment of empowerment). They can render ideological and material realities invisible behind a screen of passion—not quite an aestheticization of politics. They can position people in ways which make them particularly vulnerable to certain kinds of appeals, and, most frightening, they can easily be articulated into repressive and even totalitarian forms of social demands and relations. Affective organizations, and hence popular culture, are a complex and contradictory terrain, but one that the Left ignores at its peril.

3

POWER AND DAILY LIFE

As the 1990s begin, it seems increasingly difficult, not only for cultural analysts but also for the vast majority of people, to gain some handle on the rapidly changing political alliances, positions and struggles of contemporary life. Their attempts to offer effective strategies for intervening into the political relations of domination and subordination seem oddly out of touch with the complexity and mobility of relations in the modern world.

Nowhere is this failure more obvious then when analysts consider the intersection of popular culture, capitalism and the structures of social power. For example, a few years ago, I attended a conference in Ottawa which focused on the new Canadian National Museum of Civilization: participants were given a tour of the facilities, hosted by the designer/curator and the architect. The papers were all predictably critical of the capitalist, imperialistic, Eurocentric, ethnocentric, racist, sexist biases, not only of particular displays, but of the design philosophy of the museum as well. They demanded that, in one way or another, the entire project be dismantled or turned over to "the people" on behalf of whom the various critics were all sure they could speak. Admittedly, the museum is perhaps most impressive as a suggestion of what would have happened if Marshall McLuhan and Walt Disney had ever gotten together: every technological gadget and marketing technique are deployed in its architectonic spaces. And undoubtedly, the critics were right; it is easy enough for those who are trained to find evidence of the structured

inequalities of our society—classism, nationalism, imperialism, racism, sexism, homophobia, Eurocentrism—coded into the practices of the museum. But then, wouldn't it be more surprising if the Canadian government had produced a museum that did not somehow incorporate inflections of these various relations?

An occasional critic rejected the elitist and self-righteous tone of the majority, opting instead to defend the pleasures that ordinary people could and would find in the museum as they appropriated its practices and displays into their daily lives. But they could rarely identify the concrete pleasures; instead they simply assumed that people always find pleasure wherever they look. And even more importantly, they seemed to assume that, in some unspecifiable way, such pleasures automatically define a set of counterstrategies, if not resistances, to the overcoded structures of power of the museum. In each case, the politics of the museum seem to be given well before any real analysis. Rather than looking for ways to use the unique context of the conference as an opportunity to think about strategic changes, and to negotiate for tactical (and therefore limited and imperfect) compromises which might have offered other political possibilities to the public as they moved through the museum, the museum curator left, confident that these intellectuals would never understand the beneficent possibilities offered by his pedagogical and cultural institution.

POWER AND CONSENSUS

Most of the contemporary analyses of the politics of popular culture operate within the limited field of choices defined by a model of culture as communication. The maintenance of power through communication is the alternative to the direct use of coercive force in so-called democratic societies. Society is divided into preconstituted social groups, each with its own realities, experiences and even cultures. Power is located in the hierarchical relations—domination and subordination—between these groups. It is maintained through the ongoing effort of dominant groups to forge a *consensus* which not only legitimates the status quo but also incorporates subordinated

groups which might otherwise resist it. Power operates vertically, as the dominant groups use culture to organize subordinate populations from above. To the extent that the struggle to achieve a consensus is successful, then the dominant groups succeed in making the subordinated populations over in their own mirror image.[1]

In order to accomplish this, people must come to see the existing order of relations as the way things have to or are supposed to be. The social order must appear natural and rational. These are questions, not of reality itself, but of the way reality is interpreted, given meaning and represented. People have to see the world in ways that reproduce their subordination (as well as the domination of those already in power). The majority of people, living in subordinate political positions, generally accept their oppression because they are living in someone else's ideological universe. When they are able, somehow, to see "the truth" of their relations, to construct an alternative system of meaning and struggle to establish a new and different consensus, their resistance places them outside of the dominant ideological systems. And the response to such resistance, the way in which it is defeated or disarmed, is to incorporate or absorb its "deviant" ideology back into the consensual mainstream, a mainstream which is always in the service of the interests of the existing relations of power.[2]

It is possible to identify three different critical strategies within this broad model of consensus, built on the twin assumptions of the model of culture as communication. The first sees people as either actively and intentionally manipulative of or passively manipulated by the attempt to establish or deconstruct consensual interpretations of reality. Cultural texts embody, communicate and hence reproduce—either through what they say or through what they don't say—the dominant ideologies which reflect and reproduce relations of power existing outside of the texts. Texts may occasionally offer new meanings, embodying new relations of power, but these too will reflect the interests of those in control of the production of the text. The only leakage in the system is the fact that the critic has the ability to see the truth behind the message, the ideological function of its meaning. Cultural politics is defined by ideological messages

which can be found in the text; and the messages guarantee how the audience is placed into the existing political relations, how it is delivered to political positions. Despite the often sophisticated textual readings which such critics offer, in the end, the popularity of Rambo evidences the xenophobic and militaristic anticommunism of the U.S. audience, just as the success of *The Bill Cosby Show* traces out the public's nostalgia for a conservative domestic economy as well as its continuing racism (by erasing any representations of a specifically black culture and the majority of non–middle-class Blacks). On the other hand, specific marginal (or subcultural) subjects can and do produce their own alternative and resistant messages. *Pee Wee's Playhouse* is read as a statement of the postmodern resistance to gendered stereotypes, just as Chantal Akerman's *Jean Dielman* is a clear example of women's resistance to their daily subordination. But such moments are always quickly reincorporated into the passively received and dominantly constructed mainstream.[3]

A more sophisticated version of this strategy eschews any attempt to read the content of the message, assuming instead that there is a correspondence or homology between the form of the message and the structure of political relations in the social formation (e.g., avant-garde films which violate the conventions of Hollywood realism must be resistant). Insofar as any text can be shown to be internally fragmented and contradictory, no text ever successfully constructs a singular, ideologically dominant meaning. Correspondingly, the subject of daily life is always fragmented and multiple, always located in the complexities and the seams of the unitary structures of social power. Even apparently dominant cultural texts can now be read for the ways in which they allow, or even call for, more fractured, partial and even oppositional interpretations.[4]

The result in any case is that the critic always finds domination where he or she expected to find it, and, moreover, it always takes the forms that he or she knew it would. Popular culture is nothing more than the attempt—its pleasures being little more than the requisite distraction—to re- or de-inscribe the transhistorical and abstract relations of domination and subordination: e.g., patriarchy (or feminism), or commodification and consumerism (or socialism).

The critic is, more often than not, merely the doomsayer, witness and chronicler of the impending if not continuous victory of the dominant forces or of their inevitable overthrow.

A second strategy locates politics in the audience's ability to appropriate the text, to interpret and use it, to create its own message.[5] It assumes that each audience fraction subverts the dominant meaning by inflecting it into their own needs, desires and experiences. The particular social position or identity (e.g., women, children, peoples of color) which defines an audience fraction is somehow directly correlated with how the individual audience members appropriate specific texts. Insofar as an audience is subordinated or oppressed, their interpretation of a text must be different from the dominant or consensual interpretation, unless they are duped into not recognizing the significance of their experience and the reality of their conditions. Every appropriation, insofar as it reinflects the dominant ideology, must therefore constitute an act of resistance or at least evasion. Since politics is rooted in the identity and experience of the audience fraction, every interpretation is an expression of their subordination and even a moment of resistance. The result is that subordination and resistance are both discovered exactly where one wishes—and already knew—them to exist.

The third strategy begins with the assumption of an essential difference between the organizations of power and consensus, on the one hand, and daily life[6] and pleasure, on the other. There are two ways of interpreting this essential difference. First, the difference can be seen as a purely formal one: it is a matter of competing logics.[7] Social power is embodied in the attempt to put structures—any structure—into place (e.g., to establish a singular order of meaning, to give any text its proper meaning, to construct a single coherent subject who will always be subject-ed to the order of power). Daily life, on the other hand, always celebrates difference, refusing and deconstructing structure; it constantly seeks multiple meanings and ambiguities; it celebrates the wide range of practices, meanings, pleasures and subjectivities available within culture. Social consensus and power are always an illusion contradicted by the anarchic utopia of daily life. Second, the essential difference between power

and daily life can be located in the distinction between meaning and pleasure (although sometimes pleasure is not enough, it must be orgasmic pleasure or *jouissance*).[8] Pleasure is seen as intrinsically disruptive or at least outside the sphere of social control. In either case, daily life is the scene of a constant struggle against the dominant, hierarchically organized modes of modern cultural power.

It is important to criticize such celebrations of daily life, not only because they are becoming the new common wisdom of cultural studies, but also because they have made it even more difficult to come to terms with the specific nature of contemporary daily life and its articulation to the politics of the social formation. They simply answer too many questions ahead of time, reducing the structured, rich complexity of the practices, relations, forces, structures and institutions of daily life to a simple, formal dichotomy between structure and difference, between meaning and pleasure. Daily life is not the promised land of political redemption.

By ignoring the articulations between social structure and daily life, this strategy often vacates the historically specific lived terrain of cultural and political struggle. By valorizing daily life as intrinsically disruptive and playful, it constantly discovers moments of resistance, whether or not they have any tangible effects. By equating structure and power, it creates the illusion that one can escape them. But such fantasies merely occlude the more pressing task of finding ways to distinguish between, evaluate and challenge specific structures and organizations of power. After all, structures not only constrain and oppress, they also enable and empower. And certainly not all structures are equally oppressive. By equating resistance with the deconstruction of any structure, it often unconsciously reproduces those positions of power which, at any moment, for whatever reasons, have escaped the deconstructive onslaught.

Consequently, such theories of daily life are unable to explore the relations between the forms of pleasure and survival with which people maintain some control over the construction of their own differences, their own lives, and their own possibilities, and the structures and tendential forces of the social formation. Instead of offering an analysis which is empowering—since empowerment it-

self has to be contextually articulated—they substitute one which always finds empowerment already there. They treat daily life as if it were absolutely autonomous, and its practices as if they were always forms of empowerment and resistance. They ignore the fact that there are moments and formations of ignorance, passivity and domination within everyone's daily life. The fact that people appropriate texts, or find pleasure in them, does not erase the reality of dominant, "preferred" meanings.[9] Furthermore, not all interpretations or uses of a text are oppositional, or even resistant. And the fact that specific cultural practices are pleasurable, even empowering, does not tell us anything about the political valences of such pleasures, or the possibilities of articulating such moments to explicit political positions. Empowerment is never total, never available to everyone, never manifested in exactly the same way; moreover, its success is never guaranteed. It is too easy for such celebrations of daily life to become little more than the fantasy of politically correct (guilty) pleasures. Cultural analysis has to acknowledge, not only that "pleasure," "resistance" and "struggle" refer to complex sets of concrete effects, but also that the relations among them are themselves complex and never guaranteed in advance.

Only in this rather messy terrain can cultural studies begin to sort out how people recognize and transform themselves and their world at the intersection of daily life, social structures and popular culture. Critics need to address the complex and contradictory ways in which practices produce pleasure and even empowerment, but also displeasure, anxiety, boredom, drudgery, fragility, insecurity and even disempowerment. They need to analyze how specific forms of cultural practices, which may produce a variety of pleasures, subject positions, etc., and which may empower their audiences in a variety of ways, are themselves struggled over and articulated to larger political projects. Practices which are empowering over here can be disempowering over there; and forms of empowerment which are effective as resistance over there, might be ineffective over here. Empowerment—having a certain control over one's place in daily life—is not the same as struggle, the attempt to change one's conditions. And struggle is not always resistance, which requires a specific

antagonism. And resistance is not always opposition, which involves an active and explicit challenge to some structure of power.

Theories which reduce cultural power to the production of consensus are imprisoned in the space between domination and resistance, or despair and unearned optimism. Either they take the obvious too much for granted—we are all dominated by cultural practices manipulated in the service of the existing structures of power—or they flee from the obvious, presumably because its consequences are too frightening, too unthinkable. The celebration of people's power to interpret, or of the disruptive pleasures of daily life, simply closes its eyes to the ways in which structures of oppression and domination are real and increasingly successful. The fact is that both popular culture and daily life are somehow implicated in the mounting victories of capitalism, patriarchy, racism, etc., even if they are also a part of their occasional defeats. By too quickly rejecting "conspiracy theories," critics ignore the reality of conspiracies—always multiple, always in competition, always only partially successful—in history. Cultural studies need a theory of how cultural empowerment and disempowerment are articulated to larger structures of social power, and of how, sometimes, people can be defeated and oppressed by articulations of the very practices that empower them. It needs to understand the struggles being waged by competing political agencies and institutions, at different sites, and the stakes of these struggles in relation to popular culture and daily life.

A POLITICS OF DAILY LIFE

A different conception of power would acknowledge that it operates at every level and in every domain of human life. It is neither an abstract universal logic nor a subjective experience. It is both limiting and productive: producing differences, shaping relations, structuring identities and hierarchies, delimiting complexity, drawing boundaries, reducing contradictions, but also enabling practices and identifications and empowering social individuals. At the "micro-level," power describes the complex and contradictory capacities of practices to produce effects: e.g., capital, money, meanings,

representations, subject identities, pleasures, desires, affects, etc. These effects can be seen as values or resources which enable other practices and effects. Power is also always organized into a variety of structures, operating at a variety of levels. Such structures reach into and through both daily life and the social formation. They are articulated to specific historical agencies, forces and interests.

It is here that one can begin to identify the concrete existence of power as something more than capacity, as a source of control, riches and suffering. The simplest structures of power regulate the availability ("rarity"), deployment and circulation of specific values. Such "economies of value" are historical systems of production, distribution and consumption. They organize, constrain and enable social possibilities and historical struggles. They operate, for the most part, on a single plane of effects, although their determination may lie in complex and transverse relations across a multitude of planes. Different planes (money, meaning, ideology and affect) may have different economies (with different principles of operation, allowing for different forms of intervention and transformation); there may even be competing economies within a single plane. Such "economies" are not the intrinsic property of the concept of value itself, or of the particular plane on which they operate. They are the result of historical struggles and articulations; they follow their own laws (which may change over time). They can be analyzed and described in ways comparable to analyses of capitalism. They construct the structured inequalities of social power even as they are the site of such inequalities. But there is no guarantee that the different economies of value trace out the same lines of inequality. Similarly, while the different economies may be articulated together in complex ways, there are no guarantees about what forms such articulations will take: some may be subordinated to others; others may be largely deprived of their productivity (i.e., their power to enable other practices).

The structural articulations of the economies of value describe how, in any social formation, certain kinds of practices and effects are enabled. But they do not yet describe how social groups and individuals are located within the various circuits of value and how

they are differentially empowered by their locations. It is here that the structures of inequality in society are most starkly manifested, particularly because the inequalities are never random. On the contrary, the various economies of value circulate around, and are articulated to, historically constructed systems of social identification and belonging, most commonly in the forms of systems of identity and social differences (e.g., race, gender, age, sexuality, ethnicity, class, etc.) It is through these articulations that the social formation is organized into relations of domination and subordination. The struggle over power involves the struggle to deconstruct and reconstruct correspondences between systems of the unequal distribution of values and systems of social identities and differences (e.g., emotion is often identified with or assigned to women). Thus power is never merely a question of the distribution of wealth, of the means of production, or of access to information and decision-making practices. Power is organized around every value and resource in human life. Power describes a constantly changing state of play in this shifting field of forces.

Concrete relations of power are always multiple and contradictory. Since people always live in a complex and changing network of social relations, they are implicated in contradictory ways in the hierarchical relations of power. Whether a particular group is dominant or subordinate, what the effects of a particular practice are— these are never simple matters. It depends upon where both the group and the practice are situated within the social field. Wherever people and practices are organized around economies of value, there is a differential distribution of power. Hence politics is never limited to state or economic relations, never merely a question of the distinctions between classes or between politically empowered fractions. Relations of gender, sexuality, race, class, differential abilities, age, nationality, ethnicity—all describe social differences that can be articulated into the organization of power in the contemporary world. Moreover, such differences rarely exist in isolation or in some clearcut, decontextualized forms. What it means to be "Black" or "female," or "working-class" is itself the product of contestations over the articulations of social differences and identity.[10] One cannot take

for granted the meanings of the identities and differences which organize and describe the relations of power in any particular context. For the unequal distribution of practices—or, in other words, the differential access which different social groups have to specific forms of practices and values—is always a part of the articulation of the identity of that group as well. The meaning or difference signaled by such notions as gender, race or class is not available apart from the struggles to articulate their meanings and effects.

The relations between these different systems of inequality are similarly complex.[11] People are never only Black or female or working-class; people's identities are defined precisely by the complex articulations between their different positions in a variety of systems of social difference. (Of course, in specific contexts, people can be cast with, or may choose to locate themselves with, a single identity.) People often occupy a position of domination in one set of social differences, and a position of subordination in another. A specific social group, by virtue of its place within one set of social differences, may have access to certain systems of value, but not to others. And the relative importance of different social differences, as well as of different social values, depends in part on the particular configuration of the social field, and the position of a social group within it. Thus, overthrowing capitalism does not guarantee a society that is not racist or sexist. Similarly, overthrowing the particular historical forms of patriarchy in our society would not guarantee the elimination of the specific historical forms of racial or economic oppression. If analysis is never able to totally and simultaneously explore all of these structures, it must at least recognize their relative autonomy, their complex relations to one another and to their specific historical context. While they are always hierarchically organized in particular contexts, one can never know in advance how this is articulated.

Hence, no single structure is always and everywhere fundamental, as if it were the real locus of power and oppression. History is never that neatly tied up into a single knot, waiting to be unraveled. There is no single structure which stitches every relationship, every practice and every identity into place; there is no pattern indelibly etched into the fabric of history. The fact that people cannot live without

minimal access to some material conditions ensures only that economics (in a narrow sense) must always be addressed in the first instance. Nor can power be reduced to one single system of social difference. No single economy of value (enablement) or system of difference (empowerment) is ever identifiable, once and for all, with domination. And no single plane of disenablement or disempowerment, of suffering or oppression, has a guaranteed privileged relation to history.[12]

Finally, any practice is also complexly articulated into relations of power; it may have multiple and contradictory effects within even a single circuit. One cannot know its effects in advance. People can win something and lose something simultaneously; they can be both empowered and disempowered. For example, buying commodities may be alienating and disempowering, but it also gives one access to new forms of social production and knowledge, to new languages of social and political circulation; participating in apparently sexist cultural forms may also empower women to discover new relations to their own bodies and identities; the exportation of U.S. cultural products certainly contributes to the continued redistribution of international wealth and to the exploitation of third world labor, and it may have real consequences on the production of traditional cultural forms, but it may also give its audiences a common language, or a new vision of social and political possibilities. One can gain power in the economic domain, while losing power over one's emotional life. One can be empowered through cultural consumption even while still disempowered productively. Sexual empowerment may have complex relations to economic, interpersonal and affective relations of power. Thus, not only can one not be sure whether any practice is empowering or disempowering, but the question makes no sense apart from concrete contexts and struggles in people's daily lives and the social formation.

THE PRODUCTION OF POWER

The relationship between economies of value and systems of social identification and belonging (e.g., of identity and difference) has to

be located in a broader theoretical context. In fact, the historical struggles over power can be seen as contesting the shape of, and relations between, these different organizations of power. The very production of such economies and systems is itself structured—through a variety of "apparatuses"[13] or "machines."[14] Power itself operates in and is constructed through different forms or mechanisms (e.g., of regulation, differentiation, repression, consensus, disciplinization, territorialization, etc.). Foucault's notion of apparatuses describes a particular sort of structured context, one which actively produces and organizes the larger context in which it is deployed. An apparatus is an ensemble of heterogeneous practices: "discourses, institutions, architectural forms, regulatory decisions, laws, administrative measures, scientific statements, philosophical, moral and philanthropic propositions—in short, the said as much as the unsaid."[15] An apparatus can bring together various "regimes" of practices—particular technologies or "programmings" of behavior. Foucault identifies two forms of such regimes, each of which includes both discursive and nondiscursive practices.[16] Regimes of jurisdiction prescribe what can be done: procedures and strategies.

Regimes of veridication provide reasons and principles justifying these ways of doing things by producing "true discourses." "True discourses" are statements which exist "within the true," that is, within a space in which they can—but need not—produce "truth effects."[17] The particular effectivity of such events—both their effects and their conditions of possibility—cannot be accounted for within purely discursive terms. Truth effects are not a measure of epistemological validity; rather, they describe the inclusion and exclusion of discursive statements from those sites at which they might have particular effects. But it is not only discourse that can have truth effects: the "regime of sexuality" as an organization of the body, material and discursive practices, for example, has its truth effects.[18] Thus, while the notion of a regime of jurisdiction resembles that of ideology (which naturalizes particular representations), it is both narrower and broader: narrower because it involves apparatuses of power, and broader because it is not merely a question of meaning and representation. It raises the question, which cannot be answered

through "commentary," of the effectivity of "true" discourse. Foucault himself was primarily concerned with apparatuses in which these two forms of regimes supplemented each other. His project was to explore the political history of the production of truth.[19]

This does not, however, exhaust the possibilities of his theory of power and apparatuses. There is no reason to assume that every apparatus works by positioning itself "in the true." An apparatus brings together disparate discursive and nondiscursive events, regimes of practices which condition and modify each other's functions and effects. It is an active assemblage of techniques of power. Particular techniques and apparatuses always emerge in response to a particular historical need: they are strategic. But their existence is not completely conditioned by this "origin," for they continue to exist through "functional overdetermination" and "strategic elaboration."[20] Because a technique enters into a context of complex relations in which it conditions and is conditioned by other techniques, its effects demand that the apparatus readjust itself. And further, the technique may have effects that demand the elaboration of the technique itself, beyond the original strategy but nevertheless completing its effectiveness. In other words, the effectivity of techniques extends well beyond their intended or even imagined possibilities because they enter into larger apparatuses.

Particular techniques and apparatuses, then, are neither natural nor arbitrary, but rather connected with a multiplicity of historical forces.[21] Given the singular event, one must "rediscover the connections, encounters, supports, blockages, plays of force, strategies, and so on"[22] which, at a given moment, articulate an apparatus and, by deploying it at particular sites, articulate its effects as well. An apparatus is an active formation which operates as a machine of power, organizing behavior by structuring economies of value, systems of social identification and belonging, and their relations. Not every formation is an apparatus in these terms; specific formations have to be rearticulated and deployed in specific ways around particular struggles if they are to operate, strategically, as an apparatus. If power is produced and structured as the effect of such machines, then it becomes crucial to look at the form of the machine itself, to

see how the apparatus is operating, according to what principles and on what planes. Rather than focusing on the outcome of power's operations, we need to begin exploring its mechanisms, the structures of its machineries. Consider Deleuze and Guattari's discussion of the machineries of social identification:

> Binary oppositions (men/women, those on top/those on the bottom, etc.) are very strong in primitive societies, but seem to be the result of machines and assemblages that are not in themselves binary. The social binarity between men and women in a group applies rules according to which both sexes must take their respective spouses from different groups (which is why there are at least three groups). Thus Lévi-Strauss can demonstrate that dualist organization never stands on its own in this kind of society. On the contrary, it is a particularity of modern societies . . . to bring into their own duality machines that function as such, and proceed simultaneously by biunivocal relationships and successively by binarized choices. Classes and sexes come in twos, and phenomena of tripartition result from a transposition of the dual, not the reverse . . . It seems that modern societies elevated dual segmentarity to the level of a self-sufficient organization. *The question, therefore, is not whether the status of women, or those on the bottom, is better or worse, but the type of organization from which that status results* [emphasis added].[23]

There are at least two ways in which systems of identification and belonging are themselves produced, structured and deployed in the social formation. Differentiating machines are primarily regimes of veridication; they are responsible for the production of the systems of social difference and identities. They are, for the most part, binary machines in which the "other" is constructed as the necessary correlate of the self. Territorializing machines are regimes of jurisdiction which locate the places and spaces, the stabilities and mobilities, of daily life.

Most of the work of contemporary critical and cultural studies has been devoted to analyzing the mechanisms of differentiating machines and the particular structures of identity and difference they produce. Differentiating machines attempt to produce naturalized correspondences between economies of value and systems of social difference. They articulate equivalences between and across the two

structures of power. Differentiating machines are normalizing: they produce systems of mutually constitutive differences (internal to the field itself) such as self/other, within which the normal is both distinguished from and privileged above the abnormal. In the end, the abnormal is always expunged from the field of the normal, even while its trace remains as a constitutive feature.

Territorializing machines do not construct identities, nor do they erase the real (in favor of the ideological), nor do they operate by creating normalizing systems. If differentiating machines construct boundaries (differentiating the "inside" from the "outside"), territorializing machines are concerned with the "spacing of time" and the "timing of space." Territorializing machines operate distributively to spatialize time and temporalize space. They produce systems of circulation. When Deleuze and Guattari castigate those who would deny reality (as in the quote in chapter 2), they are rejecting the reduction of power to differentiating machines. For example, the fact that both types of machines are active should lead the analysts to refuse to reduce the politics of capitalism to a politics of class identity. In fact, cultural studies has to refuse to limit the effectivity of any practice to its place within a normative system of difference.

The difference between the two apparatuses cannot be defined by assuming that they operate on different planes of effects, as if differentiating machines worked through ideology and desire (although this is how critics have theorized it) while territorializing machines worked through affect. Most commonly, differentiating and territorializing machines are linked through an articulation on the plane of affect. They operate together, each articulating and disturbing the other's effects. But this need not always be the case. Later, I will argue that the contemporary form of depoliticization is accomplished by disarticulating a differentiating machine from a territorializing one. The new apparatus—a disciplined mobilization—no longer constitutes the other as different but erases the other altogether.

Affect plays a crucial role in both of these types of apparatuses, although its role in differentiating machines has often been ignored. The power of affect derives, not from its content, but from the fact

that it is always the vector of people's investment in reality, that it is the plane through which (but not necessarily on which) articulations are accomplished. Hence, affect has a real power over difference, a power to invest difference and to make certain differences matter in different ways. If ideology (and even pleasure) constitute structures of difference, these structures are unrealized without their inflection through an affective economy. For it is affect which enables some differences (e.g., race, gender, etc.) to matter as markers of identity rather than others (e.g., foot length, angle of ears, eye color) in certain contexts. While one might notice foot length on certain occasions, it is difficult to imagine a world in which it mattered in the construction of relations of power. Those differences which do matter can become the site of ideological struggle, and to the extent that they become commonsense social investments, they are landmarks in the political history of our affective economies.

Through such investments in specific differences, affect divides the cultural world into us and them, self and other, but the authority of any single identity may vary within and across contexts. For example, while being a rock fan sometimes entails a visible and self-conscious identity (such as punks, or hippies, mods or headbangers), more often it does not appear on the surface of the fan's life, or even as a primary way in which most fans would define themselves. But it may still function as one of the ways in which the fan marks his or her difference from others (and hence, it gives a certain authority to that difference). In fact, as individuals and as members of various social groups, there are many axes along which we register our difference from others: some are physical categories, some are sociological, some are ideological and some are affective. I am white, medium-built, dark (greying) haired, middle-aged, middle-class, youthful, Jewish, educated, moody, and so on. Any particular difference, including that marked out by being a rock fan, is always augmented and reshaped by other differences. At different moments and places in people's lives, they reorder the hierarchical relations among these differences; they redefine their identity out of these relations. They reorder their importance, investing themselves more in some than in others. For some, being a particular sort of rock fan

can take on an enormous importance—and this can be determined by either the quantity or quality of the investment—and thus come to constitute a dominant part of the fan's identity (e.g., subcultures). For others, it remains a powerful but submerged difference that colors but does not define their dominant social identities. And for still others, their enjoyment of rock does not enter at all into their identity.

TERRITORIALIZING DAILY LIFE

Cultural studies needs a critical practice capable of describing, not only the ways in which popular culture and daily life can become the battlegrounds for real struggles over power, but also how they are articulated to broader struggles in the social formation. Such a practice must be appropriate to the terrain of daily life itself, to its rhythms and forces, its shapes and dimensions. It must be sensitive to the fact that the effects of a practice can move along different planes, in different directions and with different velocities. Neither a map of enablement (economies of value) nor of empowerment (value articulated to systems of social difference) is adequate to the task of describing the *lived* reality of daily life. They are too passive, as if it were merely a matter of locating the positions which are available for possible articulation; they too easily treat articulation as if it merely involved the insertion of a practice into a passive grid. And they are too static, as if there were a stable relationship between people and practices which determines the effectiveness of specific practices. But the relationship is never static; both people and practices are constantly in motion, always moving from one place to another, *circulating* through the terrain, but always constrained.

Daily life is structured, not only by differentiating machines and regimes of veridication but also by territorializing machines as regimes of jurisdiction. These produce daily life as the way in which people live the always limited freedom to stop in and move through the various realities within which their identifications, identities and investments are mutually constructed. Their effects can be "diagramed"[24] as a mobile configuration or circulation of "places,"

points in social space where practices are articulated with specific densities into formations and alliances. At such places, people's investments empower them to temporarily stop—the durations may vary greatly—and "install" themselves, creating temporary addresses, as it were. These places serve as temporary points of belonging and orientation, dwellings around which maps of meaning, desire, pleasure, etc. can be articulated. Affective investments are crucial to this circulation, for they are always implicated in the practices by which such places are constructed. Affective investments are the mechanism by which the circulation is stopped, fixed and articulated. Of course, such affective investments are themselves constrained by the already existing structures of circulation which have been historically and politically articulated. And the ways in which people can move between such temporary and partial addresses—the spaces—are also constrained: they cannot get there from here, or they can do so only very slowly and arduously, and others cannot get there at all.

A map of territorialization charts this dynamic quality of daily life. It does not ignore the lines that distribute, place and connect cultural practices and social individuals, nor the structures of differential access which social groups have to specific clusters of practices. But it also looks at how the material deployment of cultural practices and economies of value construct the space within which people live their lives, at how daily life is articulated by and to the specific formations and apparatuses of cultural practices. It is a map of the circulation of practices and sensibilities through space and time, and of the effects of and constraints on this circulation. It locates them in a dispersed field in order to ask how they occupy different places in relation to the ongoing structuring of the field itself. Hence, it measures not only places and spaces but also distances and accesses, intensities and densities. It sees the distribution of practices and sensibilities as having certain effects in its own right: in particular, as producing a certain "structured mobility" which defines the spaces and places, the stabilities and mobilities within which people live. Such a structured mobility is produced through a strategic interplay between lines of articulation (territorializing) and lines of flight

(deterritorializing). While the difference between these lines does not correspond to the difference between places and spaces, the dynamic nature of both the places and spaces of daily life is the result of this interplay.

The lines of this "structured mobility" offer both an organization of space and a model of mobility. They constantly enact and enable specific forms of movement (change) and stability (identity), and empower specific forms of action and agency. They determine what sorts of places people can occupy, and how they can occupy them; and they determine how much room people have to move, and where and how they can move. At certain historical moments, such structured mobilities themselves become the site for a struggle between competing forces in the social formation. They become implicated in a project of regulation directed primarily at how affect is organized, mobilized and deployed within or against already existing structures of mobilization. Through this struggle to rearticulate the structures of mobility of different populations, practices and values, a certain structure of power may be secured.

A structured mobility describes the ways fractions of the population travel across the surfaces of culture and the ways they anchor themselves into their imaginary depths. It is a historical organization, both spatial and temporal, which enables and constrains the ways space and place, mobility and stability, are lived. Consequently, it is neither a rigid system of places nor a predefined itinerary of imagined mobility. It is precisely the condition which makes both stability and mobility possible. It defines the very possibilities of where and how people move and stop, of where and how they place and displace themselves, of where and how they are invested into cultural formations and deployed into apparatuses. It can never guarantee how a practice will be enacted at any particular instance, since it does not totally determine what one does at a particular site, nor can it guarantee how one moves on from that site. But it does construct the "highways" which structure and constrain the possibilities at any moment, the intersections which define the ambiguous possibilities of changing directions and speeds, and the addresses at which people can take temporary lodging and engage in various

activities. It fabricates daily life as a constant transformation of places into spaces, and spaces into places. It describes the sites people can occupy, the ways they can take up practices constituting those sites, and the paths along which they can connect and transform them so as to construct a consistent livable space for themselves.

Within such structured mobilities, cultural practices function more like "billboards" than like signs or texts. They do not present a *problem* of interpretation: they are always taken "literally." Billboards are neither authentic nor inauthentic, true nor false. Their function cannot be predefined, nor are they distributed according to some logic of the "proper" organization of space or the "proper" use of place. Instead, they constantly invent places and define new directions through space. They perform, provoke and enable a variety of different activities: they open a space for many different discourses and practices, both serious and playful, both institutional and guerilla. People stop or turn near them, adjust their speed, mood and desires; they get on and off roads by them, "live near them, photograph them, picnic near them, read books besides them, deface them, or even . . . shoot at them."[25] They manifest complex appeals which draw people down certain roads, opening and closing alternate routes, and which locate them in a variety of different ways at different sites and intersections: there one can rest, or engage in other activities, or move on.

Billboards then construct "homes" (not necessarily as sites of domesticity which is, after all, only one way of stopping, only one of many addresses, nor even as sites of comfort), neighborhoods and even regions as sites of belonging. Because the effects of billboards are always articulated, the availability, mobility and "comfort" of different "homes" are themselves differentially distributed and articulated. People may carry some of their addresses with them, using them to reconstruct other sites and to orient their travels. Certain addresses become crucial magnetizing poles, as in Fishman's description of suburbia: "The true center of this new city is not in some downtown business district but in each residential unit. From that central starting point, the members of households create their own city from the multitude of destinations that are within suitable driving

distance."[26] Not all roads are equally available to, nor equally comfortable for, everyone traveling within the broader social spaces. Not all roads intersect, and some roads have very limited access from specific social points. Access may even be granted only in one direction (e.g., the complex relations between forms of Afro-American culture and the predominantly white mainstream). Not all roads are equally easy to travel and the differences (comparable metaphorically to the difference between highways, toll roads, county roads and side streets) are themselves marked by billboards. Thus, it is not sufficient to describe the unequal distribution of cultural and economic capital; one must also describe the differential availability of different life trajectories by which one might acquire such resources. Billboards are the signposts, not only of various vectors that define the travels and work of daily life, but also of the effectivity of power within it. Like any practice, they are enabling and empowering for some, disenabling and disempowering for others, and, like any practice, they are themselves unequally distributed.

The attempt to map a structured mobility cannot begin by either reifying a certain knowledge of place or by dictating a particular organization of movements through space. That is, the analyst cannot assume that she or he already knows the proper locations at which people should invest themselves and construct their belongingness. Nor can he or she assume that the connections between such sites are always given in advance, so that people's travels through daily life are predictable. Within a map of territorialization, people are always caught in the relations of daily life and social power, always directed by their own projects but operating within the socially constructed maps of the various territorializing and differentiating machines. The very act of drawing such a map is an active intervention into the possibilities of "constantly transform[ing] places into spaces and spaces into places."[27]

Such a critical practice offers a record of roads taken and a few not taken, of successes and failures, of sites stopped at, as well as some seen from a distance, some passed by too quickly and some missed entirely but heard about along the way, and sometimes, even of other peoples' travels, whether real, possible or only imagined.

The cultural analyst constructs a record, always partial and partly imaginary, that re-marks the densities and distances within which people's travels—including his or her own—are constituted. Thus, this critical practice recognizes that the analyst is already within the spaces of daily life and the social struggles of power, implicated in his or her own maps. They are, in part, the analyst's own maps, since they are at least partly purposive and partly reconstructive. The analyst is always and already living inside the spaces of contemporary popular culture. Analysis cannot start by dividing up the terrain according to the analysts' own maps of tastes and distastes (although their travelogues are always contaminated by them), or their own sense of some imaginary boundary which divides a mythic (and always dominant) mainstream from a magical (and always resistant) marginality, or of an assumed impassable gulf between their intellectual self and their daily self, with only the latter invested in the alliances of popular culture.

4

ARTICULATION AND AGENCY

I have proposed two different ways of mapping the contemporary cultural/political landscape: formations and apparatuses. In fact, I will argue that a particular formation of postwar popular culture is being rearticulated and deployed as a territorializing apparatus. But the analysis will remain incomplete until the stakes of this struggle have been identified. But the stakes only become obvious by considering who the players are, what forces are at play, and what possible outcomes are being imagined. Identifying the politics of any struggle ultimately requires a map, not only of the actors and agents, but of what I shall call the agencies of this struggle. This points to one of the most difficult theoretical issues: the relationship of subjects, actors and agency. This relationship holds the key to understanding how history is made, how articulations are put into place. This process is not necessarily intended or conscious. More importantly, the author of an action, the speaker of a discourse, may not be the actual agency which is, through such actions and discourses, struggling to bend history in specific ways, to specific interests and goals. While an action or discourse is constructed here, it may have its effects elsewhere, for another purpose altogether.

Articulations are always accomplished through the practices of a real (corporate, social or biographically unique) individual. This is what it means to say that "people make history," for there is no one else capable of enacting a practice. Looking at real people in history, one can only be amazed by what they can do with whatever is made

available to them. One might easily—and correctly—conclude that people are never entirely passive or manipulated, that they are always attempting to make the best of what they are given, to bend their environment to their own desires and needs, to their own projects and interests, to win a bit more control over their lives, to extend their purchase on their own realities. They take what they are given and use it in ways never imagined; they take what they are told and interpret it in ways never predicted. They are constantly struggling to win a bit of space for themselves in the world. Of course, they do not always struggle, and when they do, it is not always where, when or how some people might want them to. It may not even be in ways that others can recognize. And of course, the fact that some struggle does not guarantee that they will win, or if they do, that it will have the intended consequences, or if it does, that those consequences will be in anyway progressive. Sometimes winning a bit more space for yourself can be selfish and exploitative; sometimes struggles can be regressive, even intentionally. Consequently, history cannot be understood as a process in which people simply live out the already inscribed results of their lives; it is rather a constant struggle to construct the concrete realities of their lives by making the links, by establishing the correspondences, by articulating the identities that are active in their lives. It is accomplished, whether consciously, unconsciously, or even conspiratorially (remembering that there are always many competing conspiracies operating in any context), whether by activity or inactivity, whether through victories or defeat.

The field of historical relations is never entirely open to any rearticulation.[1] History is not merely a matter of human whim and creativity. People are never simply free to produce any articulation imaginable, and there are always possibilities which cannot even be imagined. For if human beings make history, it is always under conditions that they do not control. These conditions include the historical material they are given to work with (e.g., particular forms of practices or statements become historically available or unavailable to different groups; sometimes this can be traced back to forms of corporate or state control over the distribution of particular practices).

But people are also constrained, powerful pressures are exerted

on them, by the effective force of historical articulations. Practices do carry their histories with them. These "traces" of articulations (e.g., of the meanings and political positions that seem to be so tightly bound together as to appear natural, like wealth and conservat ivism or youth and radicalism) often create an inconsistent heritage since they often derive from different histories. People may be convinced by the historical force of an articulation that it had to be that way, that the form and effects of some event were already dictated by its intrinsic identity. And although their logic is mistaken—the outcome was not guaranteed—they may be correct that the struggle against a particular articulation is likely doomed to failure. These traces do not carry the logics of their articulation with them. They are "traces without an inventory,"[2] which define the field of articulations into which people enter. It is never possible to completely separate a practice—as if it had an essential, ahistorical core, as if it could appear by itself—from its history. Practices are more like chemical radicals: while they may be forced to float freely for a brief moment by some disruptive intervention, their identity and power depend upon their bringing their history into new relations.

Finally, the possibilities of articulation are constrained because history is never merely waiting for its own rearticulation at every moment. It is constituted by very real "tendential forces" (e.g., the "long-term" organic struggles of capitalism, nationalism, patriarchy, heterosexualism, etc.) which often make it difficult, if not impossible, for people to win or even to know that there is a battle that could be fought.

Consequently, people are always located in overdetermined historical realities in which things are done to them. The identity and effects of any event are produced, not merely by the appropriations and interventions of people, but by active historical practices and structures, tendential forces and struggles, relations of domination and subordination. If people make history in conditions not of their own making, the process of making history is, to varying degrees in various circumstances, partly anonymous. While people's practices are the motor force of articulation, people do not control their effects as they reverberate and spread throughout the context any more than

they controlled the conditions which engendered it. No one can guarantee the multiple and unforeseeable consequences of actions; events can always be reinflected, detoured, rerouted and even hijacked by other forces and practices. Often this involves attempts to strategically control the means by which what already exists (having been determined elsewhere) can be rearticulated (e.g., the New Right's rearticulation of discourses of youth and the family). Whatever the intentions and interests that propel various groups into these struggles, history is partly constructed through unequal and antagonistic resources and contingent effects.

This view of history suggests that cultural studies holds a particular model of agency, of how history is made, which opposes two more commonly held views. The first substitutes structural descriptions for causal explanations, reducing diachronic events to synchronic homologies. It is content with identifying formal similarities between discrete levels of the social formations. Structural correspondences between culture and economics are taken as a sufficient account of the politics of specific formations, as if, for example, the very fact of cultural fragmentation entailed commodification and the victory of capitalism. This creates the illusion of a causal argument by making the economy into an external superordinate structure reflected in culture.[3] Contrary to this view, seeing history as articulated implies the existence of continuous and active causal relationships among determining conditions of possibility across diverse levels and planes.

The second view sees history as the product of forces (agency) transcending the structure of history itself; it presupposes an ontological difference between structure (history) and agency.[4] Historical subjects (whether individuals or groups) are not only the authors of actions but the agents of history. History is made according to the intentions and will of human beings whose subjectivity is never entirely determined by history. The very nature of human subjectivity entails an essential creativity, a principle of uncaused causality, of an undetermined power of determination. This "humanistic subject" is "the psychic unity that transcends the totality of the actual experiences it assembles and that makes possible the permanence of the consciousness."[5] This subject is the reflexive and reflective sub-

ject of Descartes, transparent to itself, capable of taking a critical distance from its experience, of examining and even changing its existence. It is the "knowing subject" who stands objectively poised outside of reality, the site of rationality, language-use, creativity and responsibility.

Contrary to this view, cultural studies suggests that what individuals are, as human beings, is not guaranteed or intrinsic to them. "Humanity" is the product of social practices which define what it means to be human. There is no essential and universal human nature which makes all people the same. Different people in different societies struggle to define the boundaries of human nature, if only to be able to exclude some people or practices: "savages," "infidels," "the insane," "the criminal," "the sexually deviant," "women," "Blacks," etc., have all been excluded, both semantically and functionally, at different times and places. It is difficult to imagine a definition of humanity which would not be exclusive and normalizing since it is the product of a differentiating machine. This does not mean that there is no human nature. On the contrary, there is always a human nature, but it is different in different social formations, in different historical periods. It is not less effective, less powerful or less valid because it is historically articulated. It is real but neither universal nor transcendent.

This poses a real paradox: individuals as subjects must serve, simultaneously, as both the cause and the effect of social structures and, ultimately, of history itself. Under the sign of "interpellation,"[6] critics have increasingly recognized that the subject is culturally and linguistically determined. Subjectivity and experience are always determined by the specific position from which the world is experienced and known. The subject is the individual occupying a specific position in a phenomenological field. From that position, individuals may have access only to certain experiences, to certain understandings of themselves and of reality. Everyone experiences the world, even if the way in which they experience it, the place from which their experience is determined, is socially constructed. Subjectivity is the product of ideology's power to interpellate—to place—individuals at particular sites within the field of meanings which it

constitutes. From this place, the individual becomes the apparent author of the specific maps of meanings, and hence responsible for them. The individual becomes the source and guarantee of the incontestability—the obvious and necessary truth—of the experience. After all, it is the subject who now appears to "have" the experience.

The subject is merely the passive occupant of a particular position within a linguistic universe: as the speaker ("I"), the direct object ("it") or the indirect object ("you"). For example, the film viewer is required to exist within the subject position of the camera which defines the only available perspective on, and hence the only experience of, the cinematic world. While every individual is positioned within the domain of subjectivity, not all positions are equal. Not all positions are empowered to speak the experience and knowledge available within the ideological field. Not all positions are empowered to speak the languages which have interpellated them. Subordinate subject-positions are denied specific possibilities of having a voice within an ideological formation. They may be denied the resources of language and discourse, or their own discursive resources (and their experiences) may be excluded from the realm of legitimate knowledge. There are some who are entitled to speak in every language and every situation (in clichéd terms, the white middle-class, middle-age, Euro-American male). One can at least imagine the individual who is totally denied the right to speak, whose experience is entirely delegitimate and never able to be articulated in publicly legitimate ways. Such individuals would be objects rather than subjects, although they would still have their own subjectivity: they would still experience the world, even if that experience was totally determined by languages they were never allowed to speak. And they could never articulate their experience to and for themselves with a language in which they were the creative speakers. Such individuals would be slaves in the fullest sense, but it is doubtful that such individuals have ever existed, for even the most subordinated position still has its own subjectivity. Even the most sustained attempt to deny any and all entitlements to speech to a particular subject-position cannot totally police and control the subject's ability to construct its own linguistic practices, its own speech which articu-

lates, for itself and its community, a collective definition of experience.

Thus, de Certeau's[7] attempt to define the subordinate only by their difference, by their lack of a place which would entitle them to certain forms of practices, is misguided. According to de Certeau, practices performed from a position of subordination (tactics) are intrinsically different from those which reinscribe existing relations of power (strategies). The latter operate spatially (to construct places), while the former operate temporally (moving across space without a place of their own). But even the most subordinate positions have their own places from which they can act upon themselves and their world. The relations between the entitled and the disentitled, between dominant and subordinate subjects, are complex and contradictory. De Certeau negates the positivity of the other in favor of its difference; he erases the working of the territorializing machine, reducing spatio-temporal distributions to ideological differentiations. It can never be a matter of merely listening to the other's speech, for both the dominant and the subordinate have constructed languages which are based on the others' exclusion, whether by choice, inheritance or necessity. Nor can it simply be a matter of giving subordinate subjects a voice in those places where they have been excluded, for the exclusion is an active one and any attempt to deconstruct the difference must take into account the mechanisms which have excluded and silenced them, as well as the mechanisms which have given dominant subjects access to the voice of the subordinate.[8] Hence, subjects exist only after the inscription of historical power. It is in this sense that Lefebvre can say that the subject "can never be caught red-handed, because it is 'made up' after the event."[9]

Theories of interpellation historicize and politicize subjectivity, denying it the privileged status as the "essence" of human existence. Yet in what sense can this subject be described as the agent of history or the creative force in language? The theory of interpellation seems to place too much power in language and discourse, leaving little or no room for individuals to act in ways which challenge and change the history which has already positioned them. Individuals are always placed by ideology into specific subject-positions and left with no

active role in determining their own location as experiencing subjects within maps of meaning. The individual appears to be empty and weightless, thrown about by the weighty fullness of ideological discourses. Ideology (and history) always hold the winning hand, determining in its own spaces and structures the subject-ion of individuals, hailing them into the places it has already identified for them within its maps of meaning. Such theories of the subject appear to guarantee that history will constantly reproduce the same experiences over and over, constantly replaying the same psychic and social history that is already in place. They seem to deny the possibility of agency or rather, to locate agency in the processes by which history constantly reproduces its structures.

A number of different strategies have been used to respond to this dilemma. Perhaps the most common solution attempts to mitigate the oppressive operation of ideological interpellation by arguing that interpellation is never entirely successful. But merely recognizing that no one is ever perfectly positioned leaves open the question that must necessarily follow: what is the excess that remains outside of the interpellation.[10] A more compelling version of this strategy emphasizes the complexity of and contradictions between subject-positions.[11] Individuals exist in multiple languages over time and space. Hence, the individual subject is always overdetermined by the contradictory interpellations which construct her or his subjectivity. Although the subject only exists as the product of ideological systems, the subject always transcends any single system; it is dispersed into its multiple positions. The result is a fragmented subject which can act against any single instance of its own subjection. Its unity is only constructed by and as a hierarchical organization of the different positions into some unified but never coherent totality. (Thus one might argue that contemporary capitalism has not so much fractured the subject as undermined the possibility for constructing subject-organizations, thus leaving each fragment as an apparently autonomous entity.) But merely fracturing subjectivity does not seem to explain how individuals can make history, how they can be the source or locus of historical agency.

A second solution to the problematic relation of subject and agent

places the latter in another ontological—and usually repressed—realm. Kristeva's "semiotic chora," Irigiray's "body" and Foucault's "pleb"[12] all locate the possibility of transcending interpellation in a realm which is both independent and transcendent. Such theories fail to adequately account for the social construction of these various sites of agency. In fact, they ignore the fact that these supposed sources of agency are not only sites of struggle (i.e., their repression is an attempt to control where and when they appear) but also planes of struggle (over how they are structured). Too often, these sites remain abstract and dehistoricized (hence, the occasional charge of essentialism raised against these theories). Moreover, they only describe the agency of resistance. There is no theory of the agency of domination (although all of these positions acknowledge the reality of such agency). A slightly different version of such an ontological theory of agency can be found in Deleuze and Guattari's image of desiring machines and their valorization of the "schizo."[13] They too quickly identify the difference between territorializing lines of articulation and deterritorializing lines of flight with power and its deconstruction. The result is that agency is too individualized and dispersed; there seems to be little possibility of organizing and articulating agency into social and historical structures of resistance.

A third strategy argues that the theory of interpellation is an incomplete account of subjectivity and identity, that identity is produced only when subject-positions are themselves articulated to ideologically produced systems of meaning.[14] The subject is always located within, articulated to, ideologically constituted systems of social differences (Black/white, female/male, gay/hetero, working class/bourgeoisie). Such identities cannot be reduced to subjectivities, for although they are constituted ideologically, they are determined by a number of social forces, and operate differentially within different social domains—social, economic, legal, political, psychic. Individuals inhabit, their identities are constituted by, particular socially and discursively defined positions within the complex systems of social relationships. Ideology then constructs a set of "cultural identities" which determine the meaning and experience of the various subject positions. Political and historical agency depends on

the articulation of the various moments of identity since there is no guarantee that, for example, a subordinated economic subject will automatically take up a politically resistant position.

Cultural studies has to carry this strategy one step further by realizing that the paradox of subjectivity results from a mistaken identification of individuals with both the subjects and the agents of history. History is always partly and often largely made "behind our backs," not in the sense that someone else is manipulating events or is able to predict their consequences, but because the "our" remains constantly ambiguous, postulating a singular relationship between individuals, practices and history. This ambiguity of the individual has to be unpacked to open the possibility that the implication of people in history is a complex process by which different individualities and relations are produced, including subjectivity (the site of experience and of the attribution of responsibility), agency (the active forces struggling within and over history), and agent-hood (actors operating, whether knowingly or unknowingly, on behalf of particular agencies).

Once again, the problem can be laid at the door of a certain Kantianism, in which an epistemological/phenomenological issue (who knows/experiences?) displaces and is identified with a series of other issues: an aesthetic question of creativity (how are the limits of social and cultural possibility transcended?); a social question of identity (who am I?); a pragmatic question of action-theory (what is the difference between my raising my arm and my arm rising?); and a political question of agency (who makes history?). Too many critics have too quickly identified the various planes on which individuals operate in history; they must now be prised apart, dis-articulated, so that they can be productively rearticulated. For the task is to win various identities, subjects, knowledges and actors to specific commitments of agency. Without this detour, the identification of these relations results in an almost inevitable reduction of the possibilities of politics: all politics is a politics of identity and subjectification.

Action involves what people do, not what they know or even what they are. Individual actions may well be determined, although they are also intentional. One acts from ideologically interpellated and

articulated positions, but this may, in the end, be irrelevant. For example, workers may join unions because they want more money. But how this act is articulated historically and politically is a question of agent-hood and agency. Agency is never merely a matter of the individual's power to act. The individual (whether as a biographical or corporate individual, or as a social group) as an actor on the historical scene also exists in relation to nonepistemological and nonideological relations of power, and it is here that we might begin to locate questions of historical (whether economic, political or cultural) agency. It is not a matter of how the individual is located within systems of language and social difference, but of actual historical effectivity. Moreover, the locus of such effectivity is not a matter of social identity but of the specific forces at work in the context of struggle. Hence there can be no universal theory of agency; agency can only be described in its contextual enactments. Agency is never transcendent; it always exists in the differential and competing relations among the historical forces at play.

Agency is not a matter of individuals or groups but of what Gramsci called "tendential forces."[15] Such forces, which often seem to have a life of their own but only exist conjuncturally, represent a movement and a direction which appears to be independent of the desires or intentions of any and even possibly all social groups. Capitalism, industrialism, technology, democracy, nationalism, religion—all are examples of such forces. They do not exist independently of or in some opposition to individuals, actors, identities or subjects. In determining the configurations of people and practices, they also create the spaces within which people can experience and act. But in specific circumstances, these forces or structures function as agencies partly determining the forms of historical structures and struggles. This does not mean that they are the subjects of history, but rather that they map out the long-term directions and investments which have already been so deeply inscribed upon the shape of history that they seem to play themselves out in a constantly indeterminate future. Nor does it mean that they are not imbricated with the interests and activities of social groups.

Such forces can only act through the intercession of "agents."

Agents are, in fact, the real actors of history—the site of the practices and struggles to control the direction and destiny of a society. An agent may be an individual or a "nominal group," a group whose identity is defined primarily by its members' common effort to act in particular historical ways. They need not have a sociological reality, a shared social identity or even a single ideological or political position. It is a group which comes together at a particular moment in order to accomplish specific activities, to bring about specific historical changes, to effect economic and political struggles. Political parties, various social movements (e.g., CND, various fractions of the feminist movement), political and civil alliances (such as the New Right), and even temporary mass movements (such as the recent upheavals in Eastern Europe) are all examples of agents.

Two things are important here. First, the relations between agents and agencies are neither simple nor direct. Agents often have their own agenda which may not, even upon close examination, appear to be "in the service" of a particular historical force, but its actions may in fact be articulated to the vector of that force anyway. The most obvious example of this is the relations between the apparent pro-democracy movements in Eastern Europe and capitalism. (Only in retrospect is it becoming clear that these movements were not as "spontaneous" as they appeared.) Second, if agents are the "players" in historical struggles, their ability to play the game depends upon their access to the apparatuses and institutions of agency. The existence of a nominal group (e.g., the PMRC) is always determined by its relation to specific institutional sites and practices, to machines of power, which provide the possibility for an effect beyond their immediate actions. Such sites might be apparatuses of governance or regulation, or institutions of voting; they may depend upon media of public opinion-making and information distribution, or they may simply be defined by a geography of publicly visible debate and protest (e.g., civil society). Within such sites, agents need not function as subjects; that is, it is not necessarily a matter of agents' creative voices being constructed and heard or even of their identities. It can be a matter of controlling others' voices, or of redistributing re-

sources, or of violence, or of controlling key appointments and positions, etc.

One additional question needs to be raised here: What does it mean to talk about a position of subordination in relations of agent hood and agency? The situation is decidedly different than that of the subject. On the one hand, many individuals and nominal groups (whether actual or possible) are simply denied any access to either specific sites or to all sites of agency. For example, many oppositional groups complain that they are denied, even actively excluded from, any significant access to the media, the various government, deliberative and decision-making bodies, and judicial institutions (the last often on financial grounds). Groups may also be subordinated to the specific structures of tendential forces, although such subordination need not take the form of subject-ion (i.e., the construction of positions in relation to knowledge, language and experience). Instead, such subordination constructs relations to historically effective forces, positions of activity, as it were. Certainly, the classic example of such subordination is the relation of labor to capital and the construction of "the worker." In fact, there are at least two possible relations here:[16] the worker can be "enslaved" to the specific agency, serving as little more than a necessary component of its activities, or he or she can be placed "outside" of its mechanisms as a "user." The latter need not result in any greater real freedom from the demands of the tendential force of capitalism, but it does define a different form of subordination to the specific principles of capitalist agency.

There is, finally, one other articulation of individuality that needs to be considered: What are the links that connect ideological subjects to agents? The relation through which individuals are able to invest in particular nominal groups can be described as affective individuality. The affective individual is not a single unified entity that somehow exists in the same way in every practice; nor is it permanently fractured; nor is it a structured organization of its multiple possibilities. It is the subject, not of identities (nor of unconscious libidinal desires), but of affective states. It is the individual moving through the intensities of mattering maps. The affective individual exists in

its commitments, its mobilities, its movements through the ever-changing places and spaces, vectors and apparatuses of daily life. Its shape and force are never guaranteed; its empowerment (i.e., its possibilities for action—in this case, for investment) depends in part on where it is located, how it occupies its places within specific maps, and how it moves within and between them.

The affective individual always moves along different vectors. Its mobilities are neither random nor subjective; like the nomad, it carries its historical maps (and its places) with it; its course is determined by social, cultural and historical knowledges, but its particular mobilities and stabilities are never entirely directed or guaranteed. The affective individual is both an articulated site and a site of ongoing articulation within its own history. It is always moving between different sites of daily life, with different projects, constantly shaped by its travels, by the roads it traverses. It must struggle to adjust it shape and effectivities. In so doing, it constructs new maps, opens up new roads and identifies new places.

Like subjects, affective individuals are caught in the practices of discourse, but discourse here functions not as a signifying code of differences, but as a system of billboards or empowering signposts. Such billboards not only mark the fact of the individual's existence, they enable it as well. Like "tags" in the world of hip-hop culture, billboards mark the sites of investment and empowerment, mapping the places and spaces, the affective states, of the individual's stabilities and mobilities. The affective individual often speaks in boasts, like a rap song announcing the rapper's existence. His or her rap, the investment itself, becomes the accomplishment, more important than the accomplishments announced. Rap is in fact one of the most powerful and visible statements in contemporary culture (along with heavy metal) of the facticity of the affective individual. To listen to rap is to listen to the almost purely affective sign of the rapper's existence, whether in rage or celebration. Rap is at least in part about the desperate need to establish, not an identity so much as a place, not a subjectivity so much as an affective individuality.

From the perspective of the affective individual, unlike that of agents, it is of the utmost importance who is acting and from where.

The affective individual is always a multiple, taking on the shape and color of the affective state through which it moves. Yet a certain coherence is always possible, even necessary, and always effective, even if it is also always fleeting. While the affective individual is always changing its shape, it always has an effective shape as a result of its struggles to win a temporary space for itself within the contexts that have been prepared for it. It is the nomadic, affective life of the individual which empowers the articulation of the individual into structures of agent-hood and agency, which enables it to move between specific identities and nominal groups. The nomadic affective individual exists within an economy of investment which makes daily life the link between private experience and public struggles.

There are no necessary correspondences between the various elements of this complex economy of individuality and agency, either within any of the planes (e.g., subjectivity, identity, agent-hood, affective individuality) or between them. There are no simple or necessary correlations between, for example, cultural identities and subject-positions, on the one hand, and economic or political sites of agent-hood, on the other. Individuals must be won or articulated into these positions, and they must be taken up (invested in) in specific ways. Only in this way are different positions, identities and places articulated together (so that, for example, a certain cultural or ideological identification appears to pull its subjects into specific political positions). That is to say, there is nothing that guarantees which subjectivities or identities form nominal groups which are then able to become historical agents. Nor are there any rules which can define ahead of time the actual effective relations that a particular agent will have to specific agencies. For example, the New Right, operating in the name of certain moral and political principles, may actually be agents for certain tendencies in the development of capitalism and for more traditional conservative fractions, whether they know it or intend it. It is not that they are being manipulated or duped, but rather that their effectivity, which depends upon their access to specific apparatuses, is articulated by and to capitalism.

ANOTHER BORING DAY IN . . . PARADISE: A ROCK FORMATION

5

ROCK CULTURES AND ROCK FORMATIONS

At the beginning of the 1980s, rock critic Simon Frith wrote: "The most disturbing thing . . . is how little the establishment as such acknowledges what is a kind of continuous guerilla warfare . . . Rock is the only medium that makes any sense of life—aesthetically or politically—at all."[1] Ten years later, I am struck, not only by Frith's faith in rock, but also by his confidence in assuming a common understanding of what is meant by "rock." After all, there is no essence to rock.

As a historical event, rock itself has a history which cannot be reduced to the history of its sonic register. Although an account of rock cannot ignore its musical effectivity, it is also the case that rock cannot be defined in musical terms. There are, for all practical purposes, no musical limits on what can or cannot be rock. Of course, particular fans may have their own sense of constraints on its musical possibilities, but there will always be other fans with different boundaries. What sounds like rock to some will not to others. There is nothing that cannot become a rock song or, perhaps more accurately, there is no sound that cannot become a part of rock. Its musical limits are defined, for particular audiences at particular times and places, by the alliances constructed between selected sounds, images, practices and fans.

Any description of rock must recognize that it is more than just a conjunction of music and lyrics, commodity production and consumption. The popularity and power of rock depend upon the fact

that particular musical and verbal practices—often taken from other traditions and cultural forms—are always received as already having been inserted into a specific formation (and within the formation, a specific alliance). Particular musical and lyrical practices—which will be articulated differently in different alliances—are always located in a complex set of relations, not only to other musical practices but also to images of performers and fans, structures of social and economic relations, aesthetic conventions, styles of language, movement, appearance and dance, ideological commitments, and sometimes media representations of the formations and alliances themselves. In this sense, one might speak of a "rock culture," recognizing of course that there are different—sympathetic, overlapping and antagonistic—articulations or alliances coexisting within this culture. Rock culture cannot be identified with any single alliance, for such an identification would merely normalize one alliance as the "proper" definition of rock. Descriptions of rock culture tend to focus on musical events and relations, and those practices and structures which can be directly correlated with the music itself (e.g., dance, fashion, etc.).

Such descriptions always involve isolating or decontextualizing musical practices, reproducing the structure of a communicative relation between an identifiable set of texts and audiences. Such descriptions are usually interested in commenting on the texts, practices, genres or trends within rock culture.[2] But if one begins to explore the articulation and deployment of these practices, it becomes obvious that rock culture is itself always articulated into relations that extend beyond even a broadly defined musical culture, into the even broader terrain of popular culture and media practices. Cultural studies has to locate rock culture in its articulations to and within the contexts of postwar popular culture. In this sense, one might speak of a "rock formation," which is as much a formation of television, film, advertising, comics, etc. It is this rock formation which in fact has colonized significant spaces within the daily life of contemporary society. Its identity and power cannot be separated from people's relations to popular culture, from the fact that people "live in" popular culture. But of course, there are numerous forma-

tions of postwar popular culture, and numerous ways in which rock culture—or different alliances within it—are articulated to them. A full understanding of the rock formation would involve trying to describe the complex set of relations between the rock culture and different popular formations. I am concerned with what I take to be the most powerful articulation of the rock formation; I might even describe it as dominant, in the sense both that it has been the "mainstream" of rock culture and that it has become the "mainstream" of American popular culture. Two characteristics may help to establish its specificity. The first involves the place of rock culture and music within the formation. Rock culture does not serve the same functions nor hold the same positions within every formation of postwar popular culture. However, within this "dominant" rock formation, I believe rock's place is central in a number of different ways: it is literally at the center of the formation, defining the most commonly shared ground and the most heavily invested sites; it is actively involved in constructing the shape and densities of the formation; its mode of functioning, its effectivity, defines the principles by which the entire formation works. In the end, rock culture is a metonym for the rock formation.

The second characteristic of this specific formation is the articulation of a very powerful and immediate link—which was never necessary or guaranteed—between specific forms of popular music and youth culture. This goes beyond the common statement that "rock" was produced for a particular audience which was located within a self-consciously defined system of generational-social difference. It is of course true that rock culture was largely produced for and marketed to a youth audience, an audience whose identity as youth (and as a youth market) was constructed not only by the members of that audience, but also by the industry, and by other commercial and political institutions, as well as by a wide range of social discourses. In this sense, rock is perhaps the only musical culture in which the identity of its audience (perhaps even more than that of its producers) bleeds into the music. But this ignores a number of issues: first, the significance of youth remains unclear: what are the relations between youth as a chronological and generational marker, a measure of

historical differences, and an affective state or attitude? Second, if rock is to be defined by its audience, isn't that audience always articulated in different ways, at different times and places, to structures of class, race, ethnic, gender and sexual differences?[3]

It is not merely the fact of its audience that defines the articulation of rock and youth cultures, for in this articulation, the interaction between economic, generational and musical structures becomes a new principle by which the social and cultural fields were restructured. This articulation inscribed a generational seam across the surface of daily life and ultimately (at least for a while) across the social formation itself. To describe a rock formation in these terms is to point to its specific conditions of possibility: economic, technological, sociological, cultural, political, ideological and experiential.

More accurately, this rock formation has to be thought of as a historical event which emerged under and in response to specific conditions. Its identity—which is constituted as much by the way it works as by any set of musical parameters—was enabled by a set of conditions which have been and are being dismantled and reshaped, partly as a result of its very success. These conditions, and the specific forms which rock took in response to them, have always been changing. Understanding how rock functions requires that it be continuously placed back into its context to ask what were its conditions of possibility and what were the conditions constantly constraining its possibilities. As its context has been significantly transformed over the past forty years, the conditions which have defined its specificity and its effectivity have themselves been rearticulated. As the structures of its determination have changed, the determined structure of the formation has changed as well.

The possibility of this articulation in the 1950s cannot be explained by merely summing the various (too numerous) elements of its context; there are no simple causal relations linking specific aspects of the context to particular characteristics of the rock formation. Instead, I will identify (in the following chapters) three interdependent vectors which, together, enabled the emergence of this particular formation and, at the same time, constrained its possibilities and effects: (1) the political compromises and contradictions

which defined the horizons and grounds of society's sense of politics, as well as its political horizons; (2) the baby boom and its relation to the changing place of youth in postwar society; and (3) the contradiction between the dominant ideologies of the white middle and working classes, and the postwar appearance of a set of apocalyptic experiences and rhetorics describing the so-called "postmodernity" of contemporary life.[4]

6

ROCK, THE LIBERAL CONSENSUS AND EVERYDAY LIFE

The political possibilities of rock are not inscribed within its musical forms and social relationships. The politics of rock cannot be read off the surface of its texts, or from the economics of its production, or from the social positions of its fans. There is nothing intrinsic to its practices (including its place vis-à-vis the "mainstream") that guarantees that it delivers its audience to a specific political position. This does not mean that rock, or specific practices, cannot be articulated to political positions and struggles. Particular practices may in fact aim to construct some articulations rather than others. But one cannot specify in advance what form such articulations will take. There certainly have been moments when, in different ways and for different reasons, particular sounds, practices or alliances were closely tied to specific ideological and political positions, sometimes even becoming explicit statements of resistance. These positions have been extremely diverse: restructuring the relations between good and bad taste, between pleasure and respectability, between public and private; reconstructing the lines of social differences—across class, gender, sexualities, age and race; constructing new forms of identity, without knowing whether they will be forbidden; offering new narratives of emotion; giving voice and legitimacy to silenced feelings and experiences; politicizing the body and the pleasures of the body; building new systems and languages of values, relations and activities; and even occasionally, but only rarely, taking explicitly political public positions.

In order to make sense of this, one has to take account of the fact that the rock formation emerged out of and was articulated into the particular social, economic and political context of postwar America. It was a time of apparent economic prosperity, and even the "discovery" of poverty and the declaration of a bureaucratic war against it in the 1960s did little to challenge the experiential optimism of the majority of the population. The economic optimism of this moment, which was lived out in the consumerism of the various fractions of the middle and working classes, was symbolized by the U.S.'s unchallenged economic leadership of the "free world" and, most controversially, by its commitment (e.g., in the Marshall Plan) to rebuild the economies, not only of its allies, but of its conquered enemies as well. But it was also lived in the optimism of daily life. As *Time* magazine reported in 1955:

> The people of the U.S. had never been so prosperous . . . Never before had the breadwinner taken home so much money; . . . Not since the first delirious, mistaken weeks after V-J day had there been so much expectancy—with caution, this time—for peace. The fishing was good, too. In the gulf, off the coast of Louisiana, speckled trout were swarming in the bays and bayous, and tarpon appeared a full month earlier than usual. Said Bill Tugman, editor of the weekly Reedsport (Ore.) *Port Umpqua Courier*: "The salmon are running and the trout and striped bass, and they even say the shad feel like taking a fly this year. So let Moscow do its worst."[1]

This prosperity was real, especially for those located in the space between extreme wealth and poverty. Americans' personal income rose 293% between 1940 and 1955, and as if that wasn't enough to finance their consumerist desires, consumer debt rose 55% between 1952 and 1956. In 1950, there were 1.5 million televisions in households; by 1954, there were over 30 million. In 1954, the U.S., with 6% of the world's population, had 60% of the world's cars, 58% of the telephones and 45% of the radios.

It was, however, a radically unstable prosperity, built on a continued war economy (through Korea and Vietnam) which sustained high production at the cost of inflation and low investment, and the forced evacuation of women from the labor pool after the Second

World War. (In fact, much of American postwar life has been based on sustaining the "strategic mobilization" of the war effort, a mobilization of both production and population.) And it was a radically inequitable prosperity, excluding large segments of the Black and working-class populations. This economic boom—partly real, partly artificially sustained and partly illusory—was predicated on the increasing conversion of the economy's productive apparatus to consumerist goals; at the same time, it had to continue sustaining the public cost of military production, rhetorically visible in the cold war but economically hidden. (In fact, it was Johnson's later decision to continue hiding the military costs of Vietnam by borrowing the necessary funds rather than raising taxes that began the current debt crisis.) Expanding the economy depended on realizing the "plan" that had driven much of U.S. capitalism through the century: namely, expanding the market for consumer goods. This meant, not only following Keynes to challenge the middle-class propensity to save, but also expanding the real base of a consumer market by increasing the number of people who had access to that market. It was the logical continuation of Henry Ford's recognition that he could make a greater profit if his workers could also be his consumers. But realizing this required that the competing interests of labor and capital be put aside in favor of a common effort; it required a certain "corporatist" compromise between capital, labor and the government.[2]

This compromise assumed that by linking increased wages to increased productivity, the cycle of productivity would expand and the rate of profit increase. Business and labor were united in a common economic struggle, with the state negotiating the limited power and benefits to be claimed by either side. But the project also required a real political (social-democratic) compromise, for the expanding market demanded that those who had traditionally been excluded from the mainstream labor force, especially Blacks, would now be integrated. Such integration into economic prosperity required the extension of political and civil liberties as well. Once again, the state became the agent of such changes: remember that it was a Republican president who first sent troops into the South

to enforce the Supreme Court's 1954 antidiscrimination decision. Because the state seemed to be operating in everyone's best interest, it appeared to be the neutral guardian of a fair and equitable society. In reality, the state, while not simply controlled by capitalist interests, was still largely subordinated to those interests.

Perhaps even more importantly, this compromise formation—in which the state mediated between the competing but, it was now assumed, basically compatible interests of capital, labor and the underclasses—took on an explicitly ideological form: "American liberalism." The ideological compromise implicit in liberalism can be seen at two levels. At the level of state politics, the two dominant political parties agreed not to disagree, at least over the terms of the economic strategies described above. It was truly the "end of ideology" insofar as the ideological differences between the political positions of the parties no longer carried any real consequences for the activities of the state. It was a moment so compelling that even those on the Left were often swept into its exhilarating rhetoric. For example, the increasing tendency among Left intellectuals throughout the 1950s and '60s to transform ideology into common sense or the lived experience of people helped to erase notions of ideology as explicit political positions, and thus to disarm questions of real political antagonisms.[3] Ideology was transformed into the question of the existence and construction of consensus.

At the level of social politics, liberalism involved a complex solution to questions of the existence and significance of social differences.[4] It entailed the construction of a deeply resonant, highly emotionally charged difference between democratic capitalism and the external threat of communism. Here was the real site of ideological difference, a difference that threatened America's existence, not only from the outside, but as a disease within the liberal society itself. Such difference had to be contained: externally isolated and allowed to destroy itself, internally identified and expunged as the social contaminant that it was. But how was the difference between communism and capitalism to be understood? The answer appeared in the many intellectual and critical analyses of the U.S. produced in the postwar period: communism and fascism, both forms of

totalitarianism, created mass societies in which all social differences were eradicated. The U.S., on the other hand, was a nation whose very essence was to be found in the differences that constituted its diverse population. Liberalism celebrated plurality as the condition of the country's difference from the rest of the world (and from history as well), even as it denied that plurality any political significance. For in fact, the differences between the various fractions of the population could not really matter. They could have no economic or political significance, and if they did, this would soon be overcome with the success of the social democratic compromise, of the liberal society itself. Liberalism walked a tightrope: trying to acknowledge that class, for example, had important cultural consequences, defining differences in taste, activity, style, etc., while denying that it constituted a radically disruptive and oppositional structure of U.S. society.

This paradox was lived out in daily life as well. There was an enormously powerful context of mobility and change, defined by images (in advertising, film, television, etc.), but also, for many, in the experience of their own lives, or at least, in the desire for and imagination of their own futures. In fact, a particular image of mobility was a dominant theme of the period. Such images defined a socially constructed map of the possible and proper trajectory for the individual, the family and even the social group to move up the social ladder. In the 1950s, mobility was defined largely by economic position, by the increasing accumulation of capital (money, investments, property) and was only occasionally and indirectly based on the accumulation of cultural capital. That is, the upwardly mobile fractions of the working and middle classes were not necessarily attempting to become "upper-class;" their mobility was not a radical rejection of their own cultural tastes and styles. Rather, they created their own styles and aesthetics, building upon the available resources of the expanding consumer culture.[5]

This climb up the social ladder of success had to be earned. Success required that one work and pay the dues. Consequently, mobility was assumed to be an incremental process, a gradual movement into and through the various steps of the economic and social ladder. The slowness of this climb might well entail that the process

would have to be continued in future generations. This mobility was supposed to be available across social differences (to anyone who wanted to work hard enough—that old Puritan ethic); it was supposed to allow even the most socially marginal (whether Blacks or immigrants, since liberalism refused to confront the structured inequalities and racist ideologies of U.S. society) to move into the mainstream, assuming that they would take on the appearance of the increasingly dominant face of the new middle class. With this commitment to mobility, it seemed not only that the world was quite literally entering a new age, but that individuals and populations were following right behind. The world was entering a new age through the redistribution, not only of power and wealth on an international scale, but also of the possibilities of the individual's daily life and future.

But this movement into the new world seemed to demand that people "tow the line"; as they sat back and reaped the rewards that the country had earned, they were to remain quiet. In the best of all possible worlds, why would anyone want to rock the boat? And if this was not the best of all possible worlds, it was well on its way. The new generation of children would reap the benefits that their parents would bequeath to them, and they would continue the steady stream of progress, finally realizing the American dream. While the dominant rhetorics were celebrating difference and change, they were also defining a distinctly "American" brand of political, moral and cultural conservatism. Economic prosperity was channeled into and invested in individuals' own lives (experienced largely in and with the family). People bought houses in the suburbs and cars to take them to work in the city and to play in the various resorts and amusement parks located in the country; and they filled their houses with new consumer goods, including the new technologies of mass communication. But this investment in the private (family) was balanced by at least an implicit support for both public spending (in both the welfare state and the military-industrial complex) and corporate profits ("what's good for General Motors . . ."). This contradiction was lived out in the "national project" of returning to what was represented as "normalcy" (but, of course, it was a normalcy that had never existed before). The investment in the family, defined

as the site of and reason for consumer spending, was seen to be part of a larger commitment necessary if the U.S. was to realize its destiny, its dream of peace and prosperity (for all?), not to mention protecting itself from "godless communism."

This quietism and conservatism, which in many ways reproduced a traditional American isolationism at the level of family life, was manifested most clearly in political life, although there were significant breaches in the calm surface of the political consensus (e.g., the civil rights movement, which was supported, at least rhetorically, by the state and public media, and the anti-bomb campaigns). They were also obvious in the mainstream products of the cultural industries, from popular music and television to film and literary production, although again, marginality and opposition were constantly threatening to undermine the complacent representations of daily life in the U.S.

This "liberal" consensus had its influence even on youth. In the early fifties, there seemed little chance that youth would become, in any sense, a problem. Juvenile delinquency, while creating something of a panic, was still assumed to be limited to small segments of the youth population, the product of changeable social and environmental conditions. The real problem seemed to be that youth was not a problem. In comparison with the tumultuous youth of their parents in the 1930s, this generation appeared uninterested in social or political issues, to say nothing about change. Even at the time, these youths were described as the "Silent Generation." They were unexciting and unexcited, motivated only by a desire for security. They certainly had a confident and idyllic vision of their own future, imagined in the minutest detail. A Princeton senior, asked what he would be doing in fifteen years, responded:

> Life will not be a burden for me at thirty-five because I will be securely anchored in my family. My main emotional ties will center on my wife and family—remember, I hope for five children. Yes, I can describe my wife. She will be the Grace Kelly, camel's-hair coat type. Feet on the ground, and not an empty shell or a fake. Although an Ivy League type, she will also be centered in the home, a housewife. Perhaps at forty-five, with the children grown up, she will go in for hospital work and so on . . .[6]

Despite a growing number of images of youth in trouble, the domi-
nant image of youth culture was constructed from ponytails, ped-
alpushers, poodle skirts and bobbysox, the bunnyhop, hoola hoops,
crew cuts, bermuda shorts and Brylcreem. Even a glance at the top
ten songs of the decades offers a frighteningly sedate vision: Bobby
Darren's "Mack the Knife," Les Paul and Mary Ford's "Vaya con
Dios," Tony Bennet's "Because of You," Al Hibbler's "Unchained
Melody," Billy Vaughan's "Melody of Love," The Ames Brothers'
"You You You," Johnny Horton's "Battle of New Orleans," Guy
Mitchell's "Singing the Blues," Elvis Presley's "Love Me Tender,"
and Pat Boone's "Love Letters in the Sand."

I want to emphasize the ways in which this context constrained the
political possibilities of the rock formation, rather than romanticizing
rock as a radical statement of political resistance or an expression of
alienation. Such views make a "proper" ideological position into a
necessary condition of effective rock. This goes hand in hand with
the assumed image of the 1950s rocker as the isolated and agonized
rebel and delinquent, antisocial, antidomestic, and anticonsumerist.
Apart from the fact that this image is simply an inaccurate portrait
of the vast majority of rock fans, there is also little evidence (even
in the songs themselves) that rock rejected the dominant liberal
consensus or the major ideological assumptions (sexism, racism and
classism) of that consensus. It is not merely that many if not most
rock fans lived somewhere inside the vast center of U.S. society; it
is also that they imagined themselves remaining within it. Admit-
tedly, they may have assumed that that center would change. They
did not necessarily want to grow up to live the same boring lives as
their parents—but then what generation does? They knew they
would grow up, and their imaginations of the possibilities of what
that meant were themselves defined in part by the ideologies of the
dominant culture.

This postwar context shaped the initial political possibilities of the
rock formation, its taken-for-granted assumptions and its political
aspirations. And, in my opinion, those constraints have continued
to exert an enormous pressure throughout rock's history, rendering
extremely problematic the claims that it is necessarily antiracist,

antisexist or anticlassist. In fact, rock did not address such questions, or perhaps it simply assumed that such questions could be confidently ignored given the ameliorist sense of mobility operating within the liberal consensus. Rock's articulation within the "end of ideology" made it extremely difficult for it to enter into any explicit ideological struggle or political resistance.

Rock's ideology was squarely located within the commitment to mobility and consumerism, although these may have been constructed as the necessary paths to a life of fun rather than as ends in themselves. Rock did not give up the increasingly normative passion for comfort and success; quite the contrary, it created a new path toward that end (the "rock and roll" dream of success) and it offered a vision of that path which would not merely recreate the failures of the parents' generation. Rock fans, caught in the space between the disciplines (and boredom) of school and family, imagined their own space, a space of enjoyment, pleasure and fun, a space regulated only by the norms of the rock formation itself. But this space was not conceived as a replacement for the school or the family, although it may have occasionally suggested less disciplined organizations for them. The majority of rock fans, as much as they may have preferred fun to school, did not envision the possibility of leaving school, for it was the path to securing the consumerist lifestyle and its associated pleasures.

Nor did rock reject the domestic image of daily life that generally prevailed in the U.S., including the privileged position it gave to the man in both gender and sexual relations. While rock may have remained outside the family, and the image of the rock performer may have positioned him or her outside the family, the vast majority of songs reproduced the desire for love and stable relationships. While rock may have created a space in which women's sexuality and pleasure were legitimated, they were often romanticized and almost always defined in relationship to the male partner, viewer or listener. This is not to deny that the sexual power of rock music and rock performances was new to their fans, nor that it was seen by those outside the formation as a threat to and rupture in the quiet regulation of sexuality and sensuality. Similarly, the dominant class

politics remained largely in place, reinflected only through romantic fantasies of different class experiences, and of the possibilities which these implied for each class to escape its own structures of control and discipline (e.g., middle-class fantasies of street life).

Finally, and perhaps most controversially, rock was firmly located within the consensual ambiguity about race relations: both ameliorist and racist, rock's relationship to Black music, Black performers and Black audiences was always a highly selective one. The apparent absence of a gap between Black and white music and musical tastes in the 1950s rock formation, a gap which has been constantly reinscribed throughout rock's history in different forms, says more about the limited repertoire of available music and the organization of the economics of production and distribution (e.g., the limited number of venues for live and recorded music) than it does about the politics of the formation itself. In comparison, the contemporary situation in which there is both a greater degree of overlapping tastes (crossovers in both directions) than in almost any other period and a significant distance between the Black and white alliances organized around the music, suggests a real and perhaps dangerous evolution of the ways in which rock can be articulated to racial differences. It is dangerous insofar as it suggests a return to an explicit economic exploitation of Black culture in the face of increasing legitimation of the structures and practices of racism (e.g., the tendency to use white actors, especially women, except in close-ups, in contemporary Black videos). Further, paradoxically, the current crossover success of Black street musics—rap, house, etc.—as the site of an alternative street culture, marks a significant transformation of the rock formation.

Rock's existence within the racist ideologies and institutions of U.S. society continually undermined its efforts to realize a populist and antiracist practice. This does not negate the fact that individual rock performers, performances and fans, and perhaps even the formation as a whole, did position themselves significantly further along the ameliorist ladder of improved race relations than the majority of the population and of popular culture. But rock did not actually attempt to challenge the taken-for-granted terms of the ideological

and institutionally constructed racism of the U.S. It did not offer, even implicitly, an ideological critique of racism in the U.S. Yet to the extent that this was seen, not so much by rock fans as by segments of the adult population, as having allowed the interracial mobility implicit in the rhetoric of the liberal consensus to be accomplished more quickly than their racism desired, rock was justifiably seen as something of a political challenge. One should not be surprised at rock's repeated alliances with racism (whether intentional or not, whether manifested in economics or taste). Rather, one has to recognize the work that is required to rearticulate the possibilities of rock's relations to the dominant ideologies and institutions.

It was precisely because rock so innocently accepted its place within the liberal consensus that it was so easily embroiled in, and articulated to, political struggles. I am not claiming that rock did not challenge, upset, distance itself from the dominant social systems of power and discipline. But I am claiming that rock's challenge was rarely articulated by or from within the rock formation itself, but almost always by those outside of, and to some extent opposed to, it. Rock did challenge the apparently serene surfaces of daily life and popular culture. Without concern for the organization of political and economic consensus, rock sought to rock the cultural boat; it did not consider that the latter was connected, in powerful ways, to the former. It sought to open culture to the needs and experiences of its own audiences, not to deny or overturn the consensual and institutional structures which had made those experiences, and its own existence, possible.

Its politicization resulted, not from its own activities (although there were many who at least intuitively understood and perhaps even welcomed what was happening), but as a result of the sustained attacks which it elicited. Those attacks took place both in public and institutional discourses (from the government, from schools, etc.) and in the domestic relationships within which rock's audience was being shaped. The attacks recognized that, whatever else it was, rock was not "quiet," aesthetically, culturally or socially, that its attempt to upset the consensual economy of cultural taste and pleasure had wider ramifications. The attacks moved quickly among a number of

different sites: rock's integrated audiences, its emotive and sexual resonances (for many at the time, its "black-ness"), its challenge to the moral and educative discipline of the mainstream culture (an alliance between family, schools, church and medicine), etc. As a result, the rock formation found itself articulated outside of the consensus in which it still located itself. We might say that rock was politicized "behind its back." In its effort to fight back against its expulsion from the mainstream, the rock formation did sometimes politicize itself further. And this was not always only the result of its attempts to protect itself. Nor was it merely because it occasionally realized that it wanted to fight for the very things for which it was being attacked; it was just as often because it was exciting, if not fun, to be placed—temporarily at least—in the position of troublemaker. It was a way for youth to assert its own place. Ultimately, rock's distance from the mainstream, and its dissonant voice within it, was the result of the way rock mattered to its fans, and of the things that it made matter as well.

THE ROCK FORMATION, EVERYDAY LIFE AND TERRITORIALIZING MACHINES

But rock also distanced itself from the dominant structures of daily life, and it was here that the rock formation really made "noise." In the postwar years, changes in the organization of daily life which had begun decades earlier began to crystallize. Putting it paradoxically, daily life was restructured through the production of "everyday life." The concept of everyday life, as I am using it here, was introduced by Henri Lefebvre to mark a transformation of the very nature of daily life. Everyday life is a historical structure of power:

> Undoubtedly people have always had to be fed, clothed, housed and have had to produce and re-produce that which has been consumed; but until the nineteenth century, until the advent of competitive capitalism and the expansion of the world of trade [the everyday] as such did not exist . . . In the heart of poverty and (direct) oppression there was *style* . . . Style gave significance to the slightest object, to actions and activities, to gestures.[7]

Style gives both coherence and meaning to the specific activities of daily life. It is a principle of transcendence operating within daily life, "a certain unity of form, function and style"[8] which endows every action with value as an expression. But capitalism destroys the possibility of any such style by commodifying every instance of life. The result is everyday life as a historically produced plane of existence which is built upon principles of repetition, redundancy and recurrence. It is a space of boredom and "intolerable tediousness."[9] Everyday life is possible only if every principle of transcendence is eliminated. It involves not only the commodification of spaces and places, but their routinization as well. But the construction of everyday life is not merely a product of capitalism and commodification. It depends as well on the production of a mass popular culture which is incorporated into everyday life itself. And even more importantly, it depends upon specific relations of subordination, including, for example, the exploitation of women's domestic labor. (Thus, as Lefebvre points out, it is ironic that women face far greater threats to their security than men.)

I want to suggest that everyday life can be seen as something of a luxury in two senses. First, there is a real pleasure and comfort in its mundanity, in the stability of its repetitiveness. Not only its practices but also its investments are routinized. In a sense, one need never worry about living within the maps of everyday life. Instead, one gets to "choose" how one instantiates the maps, what matters, where one invests. In everyday life, one has the luxury of investing in the mundane and the trivial, in the consumption of life itself. To offer the simplest example, there is a real security and pleasure in knowing when and where and exactly for what (including brands) one will go shopping next.

Second, everyday life is a luxury because it is not available to everyone. Only those who have the resources can live within its capitalized spaces. And while those resources are largely economic, they are also cultural and social and identificatory. While it is generally true in the modern world that those living in poverty exist outside of everyday life, this is not necessarily or always the case. And similarly, those with minimal economic resources may still not

exist within everyday life (although, at the upper end, one can apparently "buy out" of it: "Lifestyles of the Rich and Famous"). The relation of different people and populations to everyday life is itself historically articulated, the complex results of the distribution of the diverse systems of value and competencies necessary to live within a routinely predictable space.

I realize that, on the surface, it seems extremely paradoxical to claim that not everyone has an everyday life. This is partly the result of the contemporary use of the term and of the problems of translation. Nevertheless, if one but listens to the difference between "daily" and "everyday," the latter surely represents only one possible articulation of the former. It implies a different positioning of the individual in relation to both specific experiences and the more general structure of experience. It describes a different form of people's relations, not only to commodities, but to their own experience, which is itself now commodified. It entails a different structure of commodification of both practices and experiences.

Attali argues that music always transcends the everyday.[10] But Lefebvre draws a close parallel between music and everyday life: "Music is movement, flow, time, and yet it is based on recurrence."[11] When he asks whether music "express[es] the secret nature of everyday life, or compensates, on the contrary, for its triviality and superficiality," the answer would seem to be that it can do both, that it is a question of how specific musical practices, cultures and formations are articulated.

The specificity of the rock formation depended upon the way it was articulated to, and the way it articulated, everyday life. Rock appropriated as its own the markers of places outside of everyday life which other musics, other voices had constructed. These voices and the places they marked became the signs of authenticity within the everyday life of rock culture, but they were the voices of peoples who had no everyday life, who existed outside the privileged spaces of the repetitiously mundane world of the rock formation. Rock then attacked, or at least attempted to transcend, its own everyday life, its own conditions of possibility, by appropriating the images and sounds

of an authenticity constituted outside of, and in part by the very absence of, everyday life.

Rock is not merely white boys singing the blues; it is the sound of those who are imprisoned within everyday life, who cannot imagine its negation (and only ambiguously desire it), trying to produce the sounds of those who have no everyday life. Consequently, rock could only rarely address questions of politics, society or economics directly; its politics were often determined by those moments when political realities impinge upon its everyday life (e.g., the draft rather than the fact of a genocidal war being waged against the Vietnamese) or when they can be reduced to a question of everyday life (e.g., rock can protest the suffering of Blacks under apartheid, but it cannot acknowledge the international political economic system which sustains apartheid and a multitude of other repressive regimes). Its most powerfully resonant music comes when it acknowledges that it can see the realities of such questions only through the structures of its everyday life (e.g., the best countercultural music, and the most powerful punk music). Thus, when Simon Frith writes that "American rock music now is a form of easy listening,"[12] there is a sense in which it has always been true.

It is not surprising that rock in the U.S. has always had an ambiguous relationship to Black music. At those moments (e.g., the various "soul" musics of the 1960s, disco from the late 1970s into the 1990s), when, for a variety of reasons, Black music seems to speak from within its own structures of everyday life, or can be articulated into more generic national structures of everyday life, rock and at least certain versions of R & B seem closely intertwined. At other moments, or when specific forms of Black music operate explicitly and self-consciously outside of any possibility of an everyday life (although this is not simply a question of the biography of the musicians, but also of the articulation of the music), the chasm between the two musical traditions seems unbridgeable. This may help illuminate the peculiarly ambiguous reception of rap within rock culture, and the extraordinary power of rap for many fractions of the Black audience (but notably not the Black middle class). Rap

is about the lack of an everyday life, and hence it is constantly confronting the realities of politics and economics. Rap cannot afford the luxury of rocks' sentimentality. Rap is perhaps the only place in contemporary popular music where politics is and must be constantly marked. This necessity is formally reproduced, since the words are both the source of the rhythm and the site of the politics of rap.

But understanding the relationship of the rock formation to everyday life requires a detour into the question of music's specific power. In a society (and a history) driven to master the power of the word, and mastered by that power, it is difficult, to say the least, to describe the apparently immediate and almost mystical (because, to some extent, universal) relationship that music constitutes, both between itself and its audience, and between its audience and their environment. By describing it as "almost mystical," I mean to register the necessary uncertainty that one must have about the social determination of music's power (remembering its use in ritual and religion), while at the same time acknowledging that the actual historical forms of music are always socially determined. Jacques Attali has written: "Ambiguous and fragile, ostensibly secondary and of minor importance, [music] has invaded our world and daily life. Today, it is unavoidable, as if, in a world now devoid of meaning, a background noise were increasingly necessary to give people a sense of security."[13]

The fact that music gives people a sense of security is obvious in both its domestic and ritual uses; we need only think of the image of the mother singing to her child! But how does music give people a sense of security? To say that the answer has to do with music's enormous and largely inexplicable ability to "move" or stir people is too vapid an understatement, for it treats music's power in purely figurative terms. Obviously, it is true that music somehow calls people emotionally. One need only think of the impact of background and soundtrack musics, whether in media texts (e.g., the differences between the use of music in *Miami Vice* and *Twin Peaks*) or in the places of everyday activities (e.g., muzak).

Music has a unique and striking relationship to the human body, surrounding, enfolding and even invading it within its own rhythms and textures. It incorporates its listeners into its own spaces, trans-

forming passive reception into active production. Similarly, the experience of voicing someone else's words (whether by singing along or reading another's paper) carries with it a seemingly overpowering desire to "own" the words, to claim them as one's own. This materiality makes music "perhaps the most non-signifying and deterritorializing of all"[14] cultural forms. To describe this as "the soundtrack of our lives" too easily trivializes the import of the relation and the power of sonic events. Music, perhaps more directly than any other medium or relationship, brings its audience into an affective space. Music does not so much produce narratives or representations of people's experience as moods which can be attached to them. Greg Tate describes "the greatest soul records" in these terms, claiming they are "about short-lived intimacies and epiphanies, magnifying mundane feelings into the massively felt things they seem when we experience them. In our memories they loom like monuments; dissected, they're fluff."[15] This is music's "excess":

> Why, when I first saw the Grand Canyon and the Piazza San Marco and the Alps, did I feel that things had all been more moving in Cinerama? Why? Because both God and Man forgot to put in the music . . . In one sense, it's no surprise that music grabs us—it's supposed to. But once you look at the process, it seems quite miraculous that people can bowl one another over just by jiggling sound waves. It's a miracle akin to that of language . . . But music is more than a language.[16]

Would it not then be more accurate to say that music is the most powerful affective agency in human life? Music seems, almost independently of our intentions, to produce and orchestrate our moods, both qualitatively and quantitatively. Behind the diverse uses of music is the implicit recognition that, somehow, such musical environments strongly influence the rhythms, tempos and intensities of our lives. They can in fact determine the sorts of investments we make and the activities we undertake in their musically constructed spaces. We might turn, for an image of this power, to Deleuze and Guattari's "refrain" of creation, made manifest in the construction of the musical refrain itself:

> A child in the dark, gripped with fear, comforts himself by singing under his breath. He walks and halts to his song. Lost, he takes

shelter, or orients himself with his little song as best he can. The song is like a rough sketch of a calming and stabilizing, calm and stable, center in the heart of chaos . . . Now we are at home. But home does not preexist: it was necessary to draw a circle around that uncertain and fragile center, to organize a limited space. Many, very diverse, components have a part in this, landmarks and marks of all kinds . . . Sonorous or vocal components are very important: a wall of sound, or at least a wall with some sonic bricks in it. A child hums to summon the strength for the schoolwork she has to hand in. A housewife sings to herself, or listens to the radio, as she marshals the antichaos forces of her work. Radios and television sets are like sound walls around every household and mark territories (the neighbor complains when it gets too loud). For sublime deeds like the foundation of a city or the fabrication of a golem, one draws a circle, or better yet walks in a circle as in a children's dance, combining rhythmic vowels and consonants . . . A mistake in speed, rhythm, or harmony would be catastrophic because it would bring back the forces of chaos, destroying both creator and creation.[17]

Deleuze and Guattari are here attributing to music an enormous territorializing power. In my own terms, it is music which founds place. It is music which calls forth people's investments, and hence their affective anchors into reality. It is music which affectively locates them in the world by constructing the rhythms of their stopping and going. When they stop, when the music enables them to stop, they are positioned, not by an already existing stable identity, but by the wall which music (and affect) constructs around a bit of space. They are protected now to engage in whatever activities are necessary, and enabled to move on in ways that were not possible before, since the wall reconstructs the space outside just as surely as it constitutes a place inside. Everyday life is itself organized by the rhythms of places and spaces, and by the specific configurations of places. Thus, I can describe music as a territorializing machine which articulates the mattering maps by which everyday life becomes navigatable and hence liveable.

Yet as a territorializing machine, music is also deterritorializing; its rhythms inscribe and regulate the relations of place and space, of territorializing and deterritorializing, of lines of flight and lines of articulation. Music destroys the structures which guarantee the

repeatability necessary to both power and everyday life even as it invests in them. Insofar as different musical practices and cultures deploy different forms and uses of rhythms, they embody different economies of lines of articulation and flight. Rap's rhythms—their place in the music (displacing melody), their productive source (as much in the lyrics as the music)—differ sharply from the rhythms of rock and the rock formation. Similarly, the relations between these two forms of music and everyday life on the one hand, and the political and economic forces of the social formation on the other hand, are significantly different. If rap exists outside of everyday life (not as a question of origins but of effects), it is constantly confronting the politics which keeps it outside. "Part of what these young rappers are selling is the bigness of street life . . . It's their *inhuman* side that is so intriguing: the violence, the code, the dogma."[18] Thus, interestingly, the more rap has entered into the "rock" mainstream, the more Afro-centric it has become.

Rock on the other hand, is an example of a music produced by and for a population already living in everyday life; it is always about the possibility of transcending the specific configuration of everyday life within which it is active. Its conditions of possibility in the 1950s articulated the possibilities of the lines of flight of the rock formation; it is these which constitute that moment of its power—not to organize affective alliances, but to place itself outside of the mainstream and of everyday life, even as it is trapped within both. In a way, rock is always trying to escape the prison of its own everyday life, although it never understands what is on the "other side," as it were, or even that there is another side. It never faces the realities of another realm of economic and political power. Instead, rock is constantly seeking to transcend the specific configuration of everyday life, the specific forms of repetition, mundanity and triviality characterizing the everyday life in which it finds itself imprisoned. Rock is constantly producing lines of flight which challenge specific territorializations, and which challenge the very desirability of territoriality itself. It dreams, so to speak, of a life outside of everyday life, but its lines of flight are unable to escape the territories of its own territorializing machines. There are two reasons for this: it takes for granted the

luxury and privilege of everyday life as the condition of possibility of its own struggle against the mundanity of its everyday life; and it fails to articulate a vision of the conditions of possibility for the destruction of everyday life. At best, rock is able to disrupt and perhaps change the possibilities—the rhythms—within everyday life itself. Without constructing a space outside of everyday life for itself, rock can only celebrate insecurity and instability even as it constructs secure spaces. It challenges the particular stabilities of any organization of everyday life, and even the very fact of stability as it is constructed in everyday life itself. But its lines of flight can never do more than temporarily escape the imposed tedium of everyday life. Mobility is given precedence over stability ("It ain't the meat, it's the motion"), space is given precedence over place. Rock cannot escape everyday life, it can only serve as a reminder of its imprisonment, of the meaningfulness of such escape. Rock has to be content rocking the boat of culture and everyday life. It is this disruption of everyday stability, produced by its lines of flight, that provides the basis for rock's appearance as politicized. This is what has, at various moments, enabled it to define, galvanize and articulate a sense of anger, dissatisfaction and even, occasionally, protest.

THE RETURN OF POLITICS

Since the emergence of rock, the political, economic and social context has radically changed; since the 1980s, this has been partly the result of a sustained and direct attack on the very compromises that constituted the postwar liberal consensus. There has been an explicit economic and political attack on the corporate compromise. The state has abandoned its role as the mediator and protector of the various competing interests and openly embraced its relationship to capital and its commitment to act on behalf of the need for increased profits. The demands of social welfare and civil liberties are subordinated in the state's political and economic agenda (although federal spending as a percentage of the GNP and the federal deficit have actually increased). Attacks on labor unions, refusals to raise the minimum wage, increasing reliance on oppressive and exploitative

labor practices (the use of temporary, part-time, minimum-wage and third-world labor—all assigned largely to women and minorities, the return of patriarchal sweat shops and domestic piece work, and the use of subcontracting) are dismantling the place and power of labor, both economically and politically. When coupled with new forms of consumerist production—such as flexible and small-batch production with little inventory, made possible in part by niche and lifestyle marketing—the result is an increasingly stratified distribution of economic wealth.

These changes in public policy and social vision are often justified by appealing to a crisis of American capitalism. This crisis may be described and explained in any number of ways, both economic (e.g., a crisis of capital accumulation, the decreasing rate of profit, new multinational economic relations, changing technologies of production, the saturation of the consumer market, the increasing debt finance of capital expansion, social welfare and military production) and cultural (the decline in individual productivity; the loss of entrepreneurial motivation; a decline of patriotism; the celebration of pleasure over "law and order," etc.). Whatever one may think of these different accounts, the postwar boom, and the optimism that accompanied it, have ended. The continuing expansion of the economy, the ability of capitalism to extend the consumerist dream to the general population, and even the guaranteed economic improvement of individual lives are no longer matters of popular faith. Put simply, the belief in progress—always built upon economic prosperity—can no longer be taken for granted. Pollsters tell us that people no longer believe that their lives are getting better, or that their children's lives will be better than theirs. In a 1990 poll, 70% of 16- to 24-year-olds thought the world was a better place when their parents were their age, and 56% thought the world would be an even worse place for their children.[19]

Nowhere is this changing cultural climate more visible than in the rearticulation of the ideology of mobility which played such an important role in the postwar years. A radically different model of mobility is being put into place in which mobility is defined entirely by the accumulation of wealth (money) and the accoutrements of a

moneyed lifestyle. Capital, whether economic or cultural, merely serves as a sign of the possibilities of money. Consumerism becomes not merely the measure of economic position but its essence as well. A recent television ad presented a visual image of a young infant; across the screen, in front of the infant, his or her entire history and identity pass, captured in all of the commodities which he or she will acquire: "We're born with nothing . . . but soon the process of acquisition begins . . . For those who are born to shop." More importantly, in this new model of mobility, the accumulation of wealth is not an incremental but an instantaneous process. It is not a gradual product of labor but a series of quantum leaps, either for the lucky few (e.g., lottery winners) or for those already wealthy. For example, figures become celebrities, with all of the wealth that accrues to them, merely because they already happen to be in the limelight: scandals produce stars and millionaires (G. Gordon Liddy). "Stars" are increasingly rewarded with a horizontal mobility that aids their accumulation of wealth: famous in one discourse, they smoothly slide into another. Even Donald Trump gets paid to do commercials.

This model of mobility is even transforming the culture industries, especially popular music, which are driven less by the need to create and market individual hits than to produce stars who can move across media to produce markets.[20] The star as an image of lifestyle and/or attitude, as the hook into the new niche- or lifestyle-marketing practice, becomes a primary commodity, delivering the audience to a particular market or product appeal. This appeal commodifies the consumer as a specific identity, defined by a set of consumption practices. In cultural terms, this has resulted in another trajectory of popular success. Traditionally, especially in rock culture, performers were expected to pay their dues. Limited access to the industry meant that a performer had to prove that he or she had already won a respectable local or regional audience, and to demonstrate that this audience would continue to grow as the performer's exposure grew. But this has given way to the rather sudden appearance, often on the international scene, of a performer with no apparent local history of performance or success. It is not that such performers have no

history but that, if they do, it is irrelevant. The new stars are chosen, for different reasons, from a talent pool of surplus performers and immediately placed into a position of maximum visibility, if not stardom. While such marketing ploys would have traditionally caused discomfort within rock culture, they have apparently become acceptable alternatives (e.g., the marketing of the various "authentic" female rockers in the past few years).

Such a trajectory is even more obvious when chance seems to be the only reason for a star's success. Vanna White is the "girl next door" whose only talent is her ability to spin the "wheel of fortune" and smile. Her wholesome image is untarnished by her revealing photo essay in *Playboy* (although a similar event—the result of earlier, more justifiable choices—was enough to make Vanessa Williams lose her title as Miss America). An article in *TV Guide* pointed out the contradictions in Vanna's popularity: she is seen as "some special Hollywood confection, a creature made for the camera, not real life." And yet, "what [her fans] mention most [about her] is her ordinariness." "They know that Vanna isn't really one of them. She is Hollywood. But they forgive her happily because she represents the ordinary person . . . who hits the jackpot. They don't resent her success or consider it undeserved. As [one person] says, 'I should be so lucky.' "[21]

Finally, in this new image of mobility, there is no common social identity defining the goal. Mobility no longer demands a movement into some center based on the renunciation of local or deviant identity. But at the same time, such mobility is not offered equally across the structures of social difference (unless of course through luck, but even then one must be able to afford a lottery ticket.) Perhaps this rearticulated sense of mobility explains the general population's apparent willingness (given the lack of any public protest from either political side) to accept the continuous scandals in which the rich continue to get richer, often through illegal or at least unethical practices (e.g., news reports of the lifestyles of the various "players" in the savings and loans scandal), and the increasing visibility of a small but significantly wealthy and highly consumerist fraction of the population. And perhaps it partly explains why those who

are in the middle—the working and middle classes—seem unwilling to care about the increasingly unequal distribution of wealth (at the expense of the lower, working and middle classes), rising poverty and the creation of a large underclass of exploitable, un- or underemployed and underprotected labor (especially among women, children and various racial and ethnic minorities), and decreasing opportunities for economic and social mobility. They are, after all, the people who provided the support for postwar liberalism and who are now largely caught in a downward spiral or at least excluded from the upward leaps, the people who must work even harder just to remain in the same place.

It no longer makes any sense to speak of the end of ideology. On the contrary, ideological differences have come back with a vengeance. Internal political differences and identities have become more important and more dangerous (according to both sides) than the rapidly diminishing external differences of the cold war. The consensus has collapsed, and with it the unique commitment to the pluralism of the postwar U.S. The celebration of social and cultural differences has been replaced by the construction of different "marketing clusters," defined by the consumption of different lifestyles for those who can afford them. Real differences are again seen to threaten the established systems of privilege and power. The result is an increasingly felt need to police those who, either by their social identity, their economic position, their political commitments or their cultural practices, are seen to challenge what little stability is left in the organization of social and everyday life. Groups identified by ethnic origin, gender, sex and age are all under attack.

The center of life—political, social and cultural—has shifted to the Right. The leading edge of popular political struggle now belongs to the Right. This shift to the Right is not simply a matter of the disappearance or fragmentation of the organized Left opposition. After all, the U.S. has had a two-party political system for some time, and although there have been moments when the distance between the Republicans and the Democrats was greater than at the present, it is true that the differences still matter (e.g., it was partly

Democratic opposition to the war in Nicaragua that forced the Reagan administration to form its underground supply system). Moreover, the distances have rarely been all that great. The Democratic party, while to some extent championing social programs and limited economic redistribution, has rarely offered a radical critique of the basic statist-capitalist premises of U.S. society. At the same time, there has often been a fragmented set of oppositional parties and movements, on both the left and the right, which have influenced public opinion and policy to varying degrees at various times. Such organizations, movements and groups, whether permanent or temporary, still actively exist, and there are many people still actively struggling in the name of various left-wing or progressive causes. More to the point, such lamentations over the supposed collapse of an imaginary Left act as if contemporary political struggles could be won by merely recovering the specific commitments, forms, rhetorics and organizations of the postwar Left (ignoring its many failures in favor of its partial successes).

This shift to the right cannot be described in purely ideological terms; it does not necessarily signal a transformation in the ideological positions of the population. For example, the vast majority of the population have consistently opposed the use of military force in international relations (another reason for Reagan's creation of a second administrative apparatus to supply the Contras) and they have consistently supported taxing the rich to fund more social programs and greater ecological incentives. In fact, it seems that people need not agree with the ideology or the specific programs of the ascending conservative alliance in order to find themselves drawn into its discourses and positions. According to the *Rolling Stone Survey* (1988) of 18- to 45-year-olds, there is "a profound contradiction in the youthful enthusiasm that bubbled up for Reagan [and apparently continued, at least in terms of voting patterns, for Bush]—because he and his admirers wanted very different things."[22] When asked about their images of leaders and heroes, the most popular figures were Martin Luther King and Robert Kennedy because they stood for the values that, according to the survey, these people still believe

in: peace, justice, tolerance and equality. Yet, at the same time, the respondents described themselves as "more conservative" and "more family oriented" and "less politically active" than they had expected.

Thus it is possible that "student attitudes in most issues are moving back to the left" (according to the UCLA Higher Education Institute), even while these same students "know less [about current affairs], care less, vote less and are less critical of their leaders than young people in the past" (according to a report by the Times Mirror Center for People and the Press).[23] As Ellis puts it, "[t]his generation it seems, wants to be 'Wall Street's' Gordon Gekko with the conscience of Abbie Hoffman."[24] How is this possible or even imaginable? Perhaps a hint can be found in this statement offered by a college student: "A lot of times I really don't have any opinions, I have feelings. So I just go by a lot of what other people say."[25]

The new conservatism of the U.S. is, in a certain sense, a matter of public language, of what can be said, of the limits on the allowable. Certain statements—anti-capitalist, pro-communist, anti-family, pro-drugs—simply cannot be made or, if they are, they have no chance of being taken seriously, of entering into the broader channels of public debate. Certain particularly thorny investigations (e.g., the recent revelations linking the CIA with the savings and loans scandal, or the continued charges of a Republican pre-election deal with Iran) are apparently considered inappropriate or unacceptable by the mainstream news media. This may be partly a "conspiracy," but there is more operating here. For it is in fact not a matter of what can be said but of what can matter, of what is worth saying, of what has some chance of mattering to people. It is the public language of what matters that is at stake. Thus, for example, such stories as the secret funding of the contras (and the president's role), or of the alleged deal between Iran and the Republicans to hold the hostages until after the election in order to damage the Democrats' prestige, do not seem anchored in the public's mattering maps.

This has made culture into a crucial terrain on which struggles over power, and the politics of the nation, are waged. Two points are worth noting here: first, the struggles over various cultural practices and tendencies are highly selective and site-specific. It is rarely

all of popular culture, or even rock, that is attacked but selective exemplars, trends and moments. Of course, it is difficult to tell what criteria are being used to draw the line between the acceptable and the unacceptable. This is crucial: while the conservative attacks of the 1970s were often built around their rejection of hedonism and the inability of U.S. youth to appreciate the necessity, even the possibility, of delayed gratification (e.g., in favor of labor),[26] no such obvious principle exists in the 1980s. In the culture of the 1980s, delayed gratification seems the last thing on anyone's mind. Shows like *It's Only Money* make the ability to "outshop" your opponent into a new virtue. Nor is it a simple rejection of antagonistic political positions, as negative representations of both the government and its policies have continued to proliferate within the journalistic and fictionalized spaces of popular culture. While the various images and movements of the 1960s counterculture have been increasingly attacked, it would be a mistake to ignore their continued popularity, under the influence of increasing commercialization. Even the more obvious explanatory principles—anti-social behaviors such as sex and violence are what is attacked—cannot explain the selective eye and tongue of the various critics of popular culture.

Second, the struggles over popular culture cannot be reduced to questions of representation and identity. I do not mean to suggest that questions of ideological difference are unimportant; on the contrary, they are crucial to conservatives' attempts to redefine the maps of economic and political power. But this does not adequately explain the strategies by which culture itself has become a site of struggle. What is at stake here is a practice and principle of redistribution which puts into place a new form of regulation (in the service of both continuous and emergent interests in the surveillance of the population). In this sense, a variety of attacks become tokens of a broader attack, not so much on the freedom of expression as on the freedom of distribution and circulation, most dangerously extended into the current practice of using the RICO (anti-racketeering) statutes to quell dissent. This apparatus of regulation and surveillance is, in the first instance, articulated to a struggle over the ownership, not only of popular culture but of daily life itself through a literal

redistribution of practices and resources. It is not only economic resources that are being moved from one place to another, from one social group to another, from one practice to another: from the poor to the rich, from labor to profit, from manufacturing investment to finance and services, from third to second world; educational and cultural capital are being remobilized as well (both through selective cuts in federal funds and the increasing dependence on corporate funds, and through the rhetorical reemphasis on such categories as "values," "the basics" and "the classics").

This regulatory regime is also being deployed in at least two other realms of everyday life: information and pleasure. As information has become a more important resource (and a form of capital), its economic and political cost is increasing. Yet, its rapid proliferation (which increases the choices people must constantly make) has also resulted in its declining value. While people are sometimes empowered by specific information, an "information overload" can have just the opposite effect. People seem to need ever more guidance and control: from the new magazines which will make popular cultural choices "mistake-free" and efficient (*Entertainment Weekly* will help you "get the most out of your free time") to the renomination of significant social differences into lifestyle clusters (consider the differences between the class conflict of *Pretty in Pink* and the lifestyle conflict of *Some Kind of Wonderful*). As one observer of the contemporary fashion scene describes it:

> Many would argue that in fact women were now drawing their own fashion story and those with a talent for self-styling welcomed the release from fashion's dictatorship. But for those lacking a definite self-image, the multiple and confusing options of dress merely rendered them helpless. The fashion editor's job had therefore changed from simple reporting to that of offering sympathetic and varied advice to his or her readers.[27]

This regime of information has also redistributed the very possibilities and meanings of entertainment: from so-called reality programming, in which real people are placed in unreal situations, to the surprising success of "real-life" crime and emergency programming (e.g., *Emergency, Rescue 911, Unsolved Crimes* and *America's Most Wanted*).

American's Funniest Home Videos relocates the site and power of production to real life, but maintains control over selection and distribution.

Reagan's infamous statement to the 1988 Republican Convention that "facts are stupid things" is often taken as proof of the importance of fantasy, images and desire in contemporary political struggles, as if the majority of the people were satisfied with, even duped by, "the incorporation into policy of the desire the images arouse."[28] While I do not deny the importance of fantasy and desire in relations of power, I do not believe that the new conservatism depends upon a confusion of fantasy and reality. Instead, it involves a struggle to regulate information and entertainment: what is included? how is it to be used? how is it distributed and regulated? People are caught in a situation in which the redistribution of possibilities seems to demand—and they themselves desire—new forms of regulation and surveillance to cope with its limitations and excesses.

The second realm in which this regulatory regime is operating involves the changing place of, and attitudes toward, fun and pleasure. If the 1960s counterculture too naively assumed that transcendence was possible through fun, the 1980s have seen the emergence of a notion of transcendence through discipline itself. This has contributed to a number of devastating consequences: e.g., policing women's bodies (and most recently, religious beliefs) in the name of a reconstituted notion of the mother (and her pleasures), not as a nurturing and valued social producer but as a potential criminal vis-à-vis the fetus. Pleasure becomes selfish abuse, even as having a child becomes, on the one hand, a social responsibility, and on the other, the only legitimate pleasurable experience for the mother. Similarly, "Just say no"—whether to drugs, alcohol, nicotine, sex or cholesterol—becomes a new moral principle, and addiction (of any sort) becomes that which, above all else, must be surveilled. All of this is done in the name of health, happiness and responsibility. Stephen O'Shea describes this as "pleasure anorexia" in which "moderation . . . has been taken to extremes":

> The simple fact is that many people now feel such an overwhelming dread of excess that they're willing to give up pleasure . . .

> What is relatively new is the widespread suspicion that if something pleasurable—however commonplace it may be—can lend itself to abuse and overindulgence, you are far better off to leave it alone entirely.[29]

Such attacks, while reasonable and well-motivated on one level (e.g., MADD), too quickly become attacks on the sites of pleasure rather than their abuses. Monitoring cholesterol becomes a way of surveilling and disciplining consumption practices and ultimately lifestyles. A 1989 report, conducted at the University of Illinois, found alarmingly high rates of sexual harassment and molestation; but the debates and actions which followed focused on the sexually enticing actions of the cheerleading squad and, even more powerfully, on the evils of alcohol consumption (disregarding the fact that alcohol consumption has been prevalent for a long time on many colleges, presumably without bringing about such frighteningly regressive sexual politics).

In this new regime of discipline, real social problems are rearticulated into a war on pleasure: e.g., the current attempt to move the discourse from addiction to casual use (in the case of both alcohol and drugs, reproducing the logic of "low-intensity warfare" promulgated in the 1980s Republican foreign policy); a recent news report suggested that occasional or moderate drinkers may cause more social problems than alcoholics—this category includes almost two-thirds of the population; the regulation of cigarette smoking in the name of social health displaces concerns with other major sources of pollution in the contemporary world (e.g., as Congress and the president continually delay serious regulation of the auto industry). Sobriety and health—a new kind of disciplined purity—replace popular culture as the site of a promised transcendence. This trend is further noticeable on college campuses, where traditional social celebrations like Halloween or Hash Wednesday (originally a party to support the legalization of marijuana, it increasingly became an occasion for a campus-wide party) are regulated, often "voluntarily" self-regulated, in the name of either "good clean fun" or responsible fiscal management (e.g., for insurance reasons). It is not coincidental that, once again, Greek systems are under attack, but unlike the

1960s, this time the attack does not focus on their socially regressive relations and practices, but on their function as sites for the organization of parties and pleasure. On a more frightening note:

> I was entering the age of Fatal Attractions, when powerful cultural and political forces would link the sexual outlaw with pollution and peril . . .
> If AIDS did not exist, we would have had to invent another pretext for repression, so compelling was the idea that punishment must follow from illicit pleasure. At times, it seemed as if an edict had come down from the White House that, henceforth, all representations of sex outside marriage must be laced with danger.[30]

These regimes of regulation depend upon the material redistribution of cultural practices, and the changing meanings assigned to specific forms of practice and experience within different formations. They incarnate systems of bureaucratic control within the space of daily life. They regulate both people's access to specific events and their abilities to participate in specific acts of consumption. But perhaps more importantly, they embody, in very specific ways, the claim to the right (or power) to regulate popular culture and everyday life, to speak for and in "the popular." Thus, it is not surprising that the PMRC often opposes those attempting to legislate the sale of popular recordings or criminalize musical performance.

ROCK AND THE COLLAPSE OF LIBERALISM

It is curious, to say the least, how little response the renewed attacks on rock have elicited. One might have at least expected the industry to respond to the possibility of lower profits (e.g., labelling is likely to increase home taping). And in the past, rock fans have often reinflected such attacks to reinforce rock's difference, importance and power. In fact, this has been one of the most effective ways of articulating rock to explicit political struggles (e.g., the Payola hearings of the late 1950s helped create a consciousness of rock as oppositional; Vice President Spiro Agnew's attack in the late 1960s helped fuel the counterculture). The contemporary situation seems

strikingly different. Not only have the attacks on rock not strengthened its position among its fans, but it is increasingly difficult to see how rock can be articulated to political positions and struggles. The most obvious exceptions (rap bands such as Public Enemy) are often caught in the contradictions of popular politics (see chapter 16), while, at the same time, their politics rarely crosses over with the commercial success of their music.

I do not mean to merely reproduce the more common claims that rock has become establishment culture, or that it has been colonized by corporate interests. Such claims assume that rock is no longer motivated by a sense of political resistance. But this seems to miss what is most paradoxical: on the one hand, so much activity is attempting to explicitly articulate rock to political activism; on the other hand, this activity seems to have little impact on the rock formation, its various audiences or its relations to larger social struggles. The celebration of the success of contemporary political performers like Tracy Chapman simply ignores the question of effects. There is no evidence that her politically oppositional songs, which have millions of fans, have won anyone to an ideologically different position, or to any form of political resistance. The popularity of such politically motivated groups as U2, REM or Midnight Oil often depends upon a radical disassociation of the music's political content and the band's political position from their emotionally and affectively powerful appeals.

Similarly, the increasing political activism of many rock performers (e.g., in environmental issues, Amnesty International, etc.) has shown little tangible effect. In fact, to the extent that rock is still political, it seems to be the musicians and not the music or the formation itself that is articulated in that way. Rock mega-events (where stars are used to draw large international audiences) have raised money and disseminated T-shirts (an important political medium in the modern world) for various charities and political causes. But they have had little impact on people's willingness or desire to actively participate in political struggle or even to voice controversial oppositional opinions. While such events may serve a valuable educational and public relations function, the causes often guarantee

the audience's sympathy and agreement: it is hard to be for torture, starvation or apartheid. And there is no evidence that those same people do not identify politically with the conservative interests of the New Right, or corporate capitalism, or of jingoistic nationalism.

Everyone has his or her own anecdotes which illustrate the point. Here are just three personal examples: (1) When I saw U2 play before a crowd of twenty thousand fans, mostly college students, Bono dedicated a song to Winnie Mandella. Unfortunately, most of the audience did not know who she is. One young man asked if she was his latest girlfriend. He turned away in boredom when I explained. (2) A local review of a Midnight Oil concert asked why they just don't leave their politics home and let rock be rock, at the same time extolling the virtues of "Beds Are Burning," a song about aboriginal rights. (3) During a local performance, Fred Frith, avant-garde guitarist and radical organizer, a cult figure with an explicitly opposi- tional image, asked his audience, again almost entirely college stu- dents, who had voted for Reagan in 1983. Imagine his surprise to find that over three-quarters of his fans had. Recent events offer other, less personal examples. In *Apocalypse Now*, Coppola at- tempted to demonstrate that the energy of rock was the same as the energy which fueled the slaughter in Vietnam. The news coverage of the U.S. invasion of Panama included the "Panama Rock Festi- val," as the army blasted rock music into Noriega's sanctuary and U.S. radio stations collected requests to be included on tapes to entertain the troops (the latter was repeated for the war with Iraq). In neither war did rock music play an important or very visible oppositional role.

Consider one more example, a statement by a member of UB40, a racially mixed English reggae band which won a large following partly based on "its message of social equality":

> We've had to grow up a bit . . . We came out of the punk movement. When we started, we thought we could change the world. Now, when we look back, it seems we've gone further away from the ideal and moved closer to reality . . . Perhaps we're a little more sensitive to other people's feelings . . . We're allowing our feelings to show instead of shielding them behind this macho bravado.[31]

Notice the interesting, even curious, rhetorical dichotomy which is offered here: on the one side—the new club dance sounds, growing up, the real, being sensitive to other people's feelings, showing your own feelings; on the other side—punk, thinking you can change the world, the ideal, insensitivity and macho bravado. It is not a question of whether this is an accurate representation or account of the changes in the band's attitudes and practices. Rather, it is a question of how such a self-description could be made and accepted within the rock formation. And, in the last instance, it is a question of understanding the complex relationship between the effectivity of the rock formation—its affective power—and the specific attempts to politicize it. For it is only if we begin by acknowledging the reasons fans invest themselves in rock—why they sing along so passionately with U2, why they dance so manically to Midnight Oil, why they listen so intensely to Fred Frith—that we can begin to unravel its significance in contemporary political struggles.

7

ROCK AND YOUTH

Perhaps the most obvious aspect of rock and the rock formation has been their connection with youth. In fact, "youth" is the most powerful determinant of the audience, not only of rock in general, but of particular alliances as well. This determination is always inflected by generational identity (where one plugs into the history of rock), regional location (both in terms of geographical regions and the different forms of social space—e.g., urban, suburban, rural and small-town), race, gender, sexuality and class. But the meaning of youth is, and must remain, uncertain. It is not merely a question of the historical construction of the category, nor of its ambiguous relation to other categories preceding adulthood (childhood, adolescence, "young adulthood"). It is not merely that the referent of youth is a site of struggle; for the very register of that reference is itself constantly at stake. Youth can be a matter of chronology, sociology, ideology, experience, style, attitude. My argument is that a particular generation was identified with "youth" and invested with a certain power by a broad range of social discourses. The rock formation transformed that identity into a resource of affective power, determined by one's ability to invest in and live within the terms of the formation itself. In this way, the changing configuration of youth has played a major role in constructing the historical existence of rock, just as rock has had a complex and changing relationship to the various configurations of youth.

THE BABY BOOM AND THE DISCIPLINING OF YOUTH

The baby boom in America (and elsewhere) that occurred between 1946 and 1964 was a crucial condition of the rearticulation of the formations of popular culture after the Second World War and the Korean War.[1] In this eighteen-year period, 77 million babies were born; there were one million more babies born in 1946 than in 1945. The comparison is rather startling: there were less than 11 million people under 5 in 1940, and the number of 5- to 17-year-olds increased by only 52,000 during the 1940s. By 1950, there were 16 million under 5, and 20 million by 1960; and the 5- to 17-year-old population increased by 8.3 million during the 1950s. By 1964, 40 percent of the population of the U.S. was under 20. This resulted from an increase, not in the size of the average family but in the number of families. The baby boom was spread across the entire population but the most spectacular increase was among educated women. The "youthing" of the population, while perhaps replaced as a problem in the U.S. by the aging of the "baby boomers," continues globally: it is estimated that by the mid-1990s, over half the world's population will be under 20.

The baby boom was not fortuitous; it can be traced to the desires and experiences of a generation, raised during the Depression, who had fought and won two wars. In this postwar context, having a family became the patriotic thing to do, if for no other reason than that it produced "more consumers."[2] An ad in the New York subways during the early 1950s declared, "Your future is great in a growing America. Every day 11,000 babies are born in America. This means new business, new jobs, new opportunities."[3] And a cover of *Life* magazine in 1958 was even more forthright about the social significance of the baby boom: "Kids: Built in Recession Cure. How 4 million a year make millions in business."[4]

It is as if the baby boom were called into existence as part of the postwar Keynesian strategy: it would increase consumption, not only by creating a huge demand for all sorts of products to service the needs of the children and to construct the family life-style which was

being promulgated through the media and the national rhetoric, but also by creating an entirely new market. By 1957, the juvenile market was worth over $30 billion a year. This was the first generation of children isolated by business (and especially by advertising and marketing agencies) as an identifiable market; despite the sociological differences within the generation, and the cultural diversity of its tastes and styles, the economic strategies were surprisingly successful in constructing a rather coherent generational identity and a singular marketing cluster.

But while it was a generation constructed for economic reasons, economics was not the only basis for its privileged position in society. If the wars had been fought, rhetorically at least, to protect the American dream, it was the conjunction of the family and consumerism that defined the postwar images of that dream. Thus, for example, the baby boom cannot be separated from the largely middle-class flight from the city to suburbia. During the 1950s, suburbia grew 15 times faster than any other geographical sector of the country, and 83% of the total population growth of the decade was located there. There was no great mystery about the motives: the suburbs were imagined as "a better place" to bring up the kids.

There is something paradoxical in this seemingly trivial statement. On the one hand, parents have always tried to give their children the best they could and better than they had, especially in the context of American immigration and mobility. On the other hand, the "baby boomers" were "overvalued."[5] Parents were supposed to—and apparently thought it quite reasonable that they—live for their children. The children were "pampered" as the center of attention and devotion, not only within the family but within social circles, cultural discourses and national rhetorics. Children seemed to become "the whole point"[6] of America's victory and vitality. This position was not just emblematic of the enduring strength of familial values, for it was also a statement of new national priorities, a crucial moment in the history of American identity. As postwar America struggled to understand its new position in the world—the kid among nations who had suddenly grown up and become the leader—it needed to find some way to relocate its own sense of difference. If

America had always defined itself by its open-ended future, by its ongoing effort to realize the American dream as a still undefined and certainly unrealized possibility, by the fact that it had not and could not grow up, it needed now to understand how that was still possible.[7] Its response was to continue investing its identity in the future by finding a more definitive, already existing embodiment of that future. The baby boomers became the living promise of the possibility of actually achieving the American dream. They were to be the best-fed, best-dressed, best-educated generation in the history of the world. They were to be the living proof of the success of the American experiment. They were to conquer the challenges and overcome the barriers that still eluded the nation's grasp on its own future. Not just physically and economically superior, they enjoyed an education and a social milieu that would enable them to overcome the prejudices and fears of every generation that had preceded them.

So their parents sought childrearing advice from Dr. Spock and medical advice from pediatricians; they turned their education over to specialists—whether educators or encyclopedias; they furnished their children's environments with toys and commodities designed especially for them; and they gave them more and more money to purchase their own commodities. If their prolonged education was partly the consequence of the economic need to keep them out of the job market for as long as possible, it was also the result of a real commitment to produce a generation which would be better prepared to handle its place in history. It was a generation that was told, over and over again, in so many different ways, that it was unique. And it was true, for the baby boomers were a nation within a nation, a microcosm that stood for the aspirations of the larger nation, a generation that embodied the very meaning of America. The cultural images of its uniqueness and importance were everywhere, from the new television domestic sitcoms to emerging paranoia over its potential failures (e.g., in the moral panic around juvenile delinquency).

But however special the baby boomers were, and however much their parents wanted to give them, the nation was unprepared for the consequences of this bulge in the population curve. As they entered

society and placed new demands on it, the institutional structures which had to respond to these challenges—from hospitals to schools, from recreational facilities to potential employers—were simply overwhelmed. Even the enormous capital investments which enabled these institutions to expand during the 1950s and 1960s were insufficient. For example, while the baby boomers were supposed to be the best educated generation ever, schools were unprepared to handle them, not only in terms of facilities and teachers (in the early 1950s, it was estimated that U.S. schools were short 72,000 teachers) but also in terms of the new educational demands that life in the postwar context seemed to impose (with new sciences, new technologies, new worldwide political struggles, new forms of cultural production and language, and so on).

The experiment was a rather dismal failure, not only at the level of the institutional location of the baby boomers; failure was also structured into the very environment which had been constructed for them. In its most visible form, this environment was defined by the geographies of suburbia. But suburbia represented anything but the desires of youth. The new suburban sprawl did not take account of the recreational needs and pleasures of youth. Physically, it was repetitious and boring. Even in the cities, schools were rarely located in areas with rich resources aimed at the commercial and cultural desires of youth. And the schools, like the other institutions devoted to the shaping and disciplining of this generation (the family, medicine and counseling), were often experienced as further instances of a foreign authority with little understanding of the experiences, desires and fears of this generation of youth. Life was, at best, another boring day in paradise (paraphrasing Elvis Costello) and, at worst, a rat race at a snail's pace (paraphrasing Elvis Presley).

THE IDENTITY OF YOUTH AND THE POLITICS OF FUN

In some sense, the social identity of "youth" is undefinable. Related to childhood, closely linked with adolescence—the two were identified in the 1950s—"youth" is a term without its own center. It

is a signifier of change and transition, caught between the ignorance and innocence of the child, and the perceived dogmatism and inflexibility (perhaps even the corruption) of the adult. Youth is the last and almost always ignored category in the traditional list of subordinated populations (servants—i.e., racial and colonized minorities, women and children) who, in the name of protection, are silenced. But youth cannot be represented, for it is an identity defined solely by and for the adults who, in a variety of ways, invest in it and use it to locate themselves.

Contemporary society often thinks of youth as a transitional period during which individuals search for a viable adult identity, a moment of initiation. Against this commonsense view, Erik Erikson argued that youth searches for "fidelity," for something worth believing in and trusting. Erikson emphasizes youth as a time of passion and intensity.[8] Youth is "impelled to find a faith, a point of rest and defense, a touchstone by which they can accept or reject, love or hate, act or not act."[9] Youth involves not so much an ideological search for identity as an affective search for appropriate maps of daily life, for appropriate sites of involvement, investment and absorption.

This makes it seem to be a period of constant shuttling between extremes. Searching for something worthy of their passion, they "have no choice but to talk in extremes; they're being wrenched and buffeted"[10] by all of the competing (and, in the contemporary world, unworthy) demands of the historical formation. In the climate of the 1950s, this affective extremism had to be normalized: consider the different images of the relations between adults and children which dominated popular culture. In *Father Knows Best*, an archetypal 1950s television image, adults and youth were constructed as radically different; yet each was normal within its own terms. With perhaps a slightly different inflection, one could imagine Bud or Cathy repeating, at the end of any episode, the closing lines of *King Lear*: "We that are young, shall never see so much. . . ."[11]

This process of normalization was carried out in part in the cultural struggles to construct the meaning of the youth of the baby boomers, for youth is a cultural rather than a biological category. It is not a universally present moment of human life, nor is there some

essential meaning to it. It is as much a question of style as either age or social position or experience, but style is itself determined by cultural and institutional contexts, as well as by the structures of capital investment. Youth is not merely an ideological construction, and what is at stake is not merely a question of what it means to different groups. The baby boom made clear that there were real material stakes in the struggle to construct youth in particular ways. The baby boomers had not only to be located within a meaningful system of social differences; they had to be organized, disciplined, controlled, distributed and subjugated to the needs and narratives of the dominant social visions. For youth is always more than childhood, more than a time of growing up, more than the innocent passing of time. Youth involves an excessiveness, an impulsiveness, a maniacal irresponsibility which escape time and potentially go on forever.[12] Youth was a material problem; it was a body—the body of the adolescent and the social body of the baby boom—that had to be properly inserted into the dominant system of economic and social relationships. As a body, it had to be located in its own proper places and its movements had to be surveilled and constrained. And as a body, its gendered identity had to be neatly defined, its behavior regulated and its sexuality policed.[13]

Of course, the body which was being constructed was never passive, nor were such processes of disciplinization ever totally successful. Youth struggled to express its frustrations, to realize its own desires, to enable its own activities. And all of this was made possible by the way youth was constructed in the postwar years. Thus, youth has to be understood as a complex, interactive and often contradictory set of social formations and apparatuses within which the lives of the baby boomers were shaped and in which its bodies were positioned. The fragility of this process meant that youth would be ambivalently valued: on the one hand, nurtured as a time directed beyond the present (the American dream), a time for constructing new mattering maps projected into an unknown future; on the other hand, envied and feared as a heightened experience of the present, as a challenge to the viability and necessity of existing social norms and regulations. This ambiguity was reconciled by making youth

comparable in some ways to childhood, and developing appropriate structures of disciplinization. Like children, youth had to be confined within privileged institutions qualified to lead them into the appropriate adult identities. But youth is not quite a "state" or period like childhood; it is a transition, a seam and seeming gap, between childhood and adulthood. Society had to develop strategies to "program" the mobility, the "otherness" and the uncertainty of youth into the normalcy of adulthood (through the specific historical alliance of family, school, psychology, medicine and criminal justice systems, as well as economic and cultural discourses), a trajectory most fully and nostalgically imagined in *Happy Days*.

As society attempted to shape the body of youth—to organize its material, ideological and affective life, to monitor its needs, aspirations and behavior, the baby boomers gained an independent existence as youth apart from these social institutions. After all, such practices can never fully control their effects. This left a space within which the privileged place of youth enabled it to resist its own subordination by foregrounding the sense of its own difference, a difference which had already been constructed for it. If youth represented the promise and identity of "America", its most valued commodity, then why shouldn't it celebrate itself as an end in itself, as a distinct and independent formation standing apart from, if not in radical opposition to, the adult world which had created it and endowed it, unknowingly, with such powers? It is not that youth was somehow inherently rebellious but that its identity was given, at a particular moment, by its very self-incarnation of a radical alternative.

This unique position was formed at the intersection of youth's alienation from the adult world, and the sense of its difference which had been constructed by that world. This position was articulated into a series of struggles against the adult realities of everyday life. If society demanded that youth be under constant surveillance, then youth would constantly expose itself in order to hide in the very surfaces, not only of its different styles (Hebdige describes this politics of youth as "spectacle"[14]) but of its moral and sociological indeterminacy. If society demanded that youth be consumers, they could

consume themselves as fetish-objects. If society located the body of youth in the spaces of domesticity, consumption and education (with any transgressions resulting in specific sites of incarceration for the youthful offender), then youth could construct its own places in the space of transition between these institutions: in the street, around the jukebox, at the hop (and later, at the mall).[15] These are all spaces located between the domestic, public and social spaces of the adult world. What the dominant society assumed to be no place at all—merely a transition—became the privileged site of youth's investment and, eventually, the spatial coordinates of rock culture. The anonymity of the street offered the possibility of avoiding social surveillance, a social version of the desperate effort to construct an absolute privacy in one's room, surrounded by the music.

This was the context of the emergence of rock, and the beginning of the rock formation. The articulation of rock and youth transformed a transitional culture into a culture of transitions (and the transitional body of youth into a body of transitions). Rock emerged as a way of mapping the specific structures of youth's affective alienation on the geographies of everyday life, and the specific differences of youth's social identity on the grid of socially defined differences. Rock was a response to a certain kind of loneliness and uncertainty: it was about the ways in which youth itself offers new possibilities of identification and belonging through the construction of temporary mattering maps. For youth inhabited a place in the social order which demands that they live daily life according to some one else's maps, someone else's dreams, someone else's trajectories. Youth was subordinated to its already defined place within a social narrative that was told before it arrived.

Rock actively foregrounded that subordination as the source, not only of its own empowerment, but of the possibility that youth could empower itself as youth, that it could place itself into a position of power and desire, that it could live out its alienation in ways that would increase its own sense of control over its everyday life. The articulation of rock and youth made rock into an affective statement—a cry and a demand—uttered from particular places in society, a statement of the continuing dialectic between a certain sort of

affective alienation and a struggle for empowerment. The articulation of rock and youth enabled the construction of a real difference marking that which, in other terms, could only be experienced as the fact of subordination. Youth, in the rock formation, became its very difference from the adult world, a world that, above all else, was regulated, disciplined and boring. It was the radical rejection of boredom as the very negation of youth that came, in the 1950s, to define both youth and rock. Rock's territorializing machine was deployed in the service of a differentiating project.

Rock declared youth's rejection of the boredom, surveillance, control and normalcy of the straight world as their own imagined future. Its politics consisted of its constant effort to differentiate itself from that other world, the normal, which was defined, not solely by a chronology of age but by a phenomenology of boredom. Rock refused to identify with an everyday life which was ordinary and boring. It celebrated instead the extraordinary moments within the youth's everyday life. Its power lay precisely in its ability to magically transform the ordinary into the extraordinary and the extraordinary into the ordinary through the very fact of its investments.

For rock was always about the transitions between investments and differences. It was not only a territorializing, but a differentiating machine as well. It displaced the question of identity and self-identity into the narcissistic production of difference within rock itself. Instead of being different because one had a socially guaranteed identity, rock constructed temporary differences through people's places within different alliances. Investment became the source of a transitory difference. Anonymity and difference replaced identity itself as transition became the key value. Rock was about the control one gained by taking the risk of losing control, the identity one had by refusing identities. Its only stability was in the investment one made into the formation itself. It reified its own transitional status, locating itself as the permanent "between." It constituted itself as a space of "magical transformations" in the face of youth's own necessary transformation into its own other, adulthood. Youth celebrated its own impossibility in rock. And this was, in some respects, mirrored by its internal struggles, for the practice of every fan entailed con-

stantly marking differences within rock, identifying their own invest-ment as constitutive of rock itself, and therefore as marking their own difference. For a rock fan, difference was all: if you don't like this song, you don't like rock, and if you do like that song, you don't like rock.

Ultimately, the register of that difference was the body and its politics was fun. The body was not merely the site of a static system of pleasures; rather, pleasure was always located within an economy of movement: dance, sexuality, style and taste are all inseparable pieces of a common body. The music itself, in its volumes and rhythms, in the particular tones, colors and grains of voice to which it is always returning, not only foregrounded the body in motion, but continuously undermined the ability of any identity to control or even claim the body as its own. The body of youth in rock was always a body on display, to others and itself, as the mark of a celebration of energy and fun. They mattered because they were at the heart of rock, and rock mattered. Rock touched, fragmented, multiplied and propelled the bodies of its fans. It created a flexible and transitory body which was put into place against the various emotional narratives and alienating experiences of youth's everyday lives. Of course, fun is not the same as pleasure. Rock was not about pleasure—it was just as often about displeasure and pain, and it did not always seek to transform the latter into pleasure. Rather, it celebrated its ability to avoid—or rather, to rearticulate—the domi-nant structures of everyday life (noise, repetition, etc.) into a new economy, an economy of the affective deployment of energy against the debilitating economies of boredom.

THE STRUGGLE OVER YOUTH

But as rock is about to turn forty, the construction of youth and its articulation to rock has changed; it is, increasingly, a contested relationship. After all, the baby-boom generation which had placed their own youthfulness at the center of their existence has had to confront the fact that they have become the adults and the parents, and society is increasingly focused on the problems this will cause.

As the *Chicago Tribune Sunday Magazine* warned in 1988, "Brace yourself America, for the Aging of the Baby Boom."[16] The effects of this can be seen in the following two quotes. The first is from a review of the 1989 Who Reunion tour by Dave Marsh, one of the "fathers" of rock criticism:

> The central dilemma of rock and roll isn't how to sustain youth into middle age, it's how to age with grace and humanity: how to get old before you die . . . The Who . . . played straight into the face of their own version of that problem and by doing so they brought rock into a new place, one where the apostles of permanent revolution can never travel. It is not and never will be as immediately gratifying to see rock bands work out their middle-age crazies as it was to watch Pete Townshend smash his guitar or see Keith Moon trash one of his guitarist's carefully worked out acts of pretension. But if all rock has to offer is immediate gratification, then Allen Bloom and Albert Goldman are right and I quit . . . So knowing something I could never have imagined when I set out—that the kids *are* all right and that I'm no kid anymore but that *that's* all right because neither are my friends.[17]

Marsh seems to be waging a generational struggle over the ownership of rock, which means that he has to disarticulate rock from youth. The following excerpt from a column by *New Republic* editor Charles Krauthammer points to the alternative possibility of struggling over the very meaning of youth itself:

> Among the several causes for the decline of the West cited by Alexander Solzhenitsyn in his infamous 1978 Harvard commencement address were "the revolting invasion of publicity" and "TV stupor." When he got to "intolerable music," the snickers grew loud and helped to smooth Solzhenitsyn's transition in the public mind from universal hero to antimodern crank.
>
> It's 1985 and Solzhenitsyn does not look quite so quaint. The music has now proved intolerable for a group of thoroughly modern women [the PMRC] . . . The time is right for this kind of censorship. For reasons as yet obscure we have decided to treat kids as kids. . . . For a long time kids were either wise guys who told the bumbling parents where to get off . . . or, in the more sentimental version . . . parents' best friends. After a long sabbatical kids have become our wards again.[18]

The two strategies are really not that different, for those who hold on to rock rarely renounce their youth. They transform the struggle

over who "owns" rock into a struggle over who "owns" youth. For example, I have often heard teachers complain that their students are not young, that they can't be because they are so straight and boring. Implicitly, the teachers are congratulating themselves for their continued loyalty to their own youthfulness.

Youth itself has become a battlefield on which the current generations of adolescents, baby boomers, parents and corporate media interests are fighting for control of its meanings, investments and powers, fighting to articulate and thereby construct its experiences, identities, practices, discourses and social differences. "Youth" encompasses a fractious and often contradictory set of social formations, defined not only by the proliferation of postwar generations but also by the attenuation of the relationship between age and "youth" (*Rolling Stone*'s "Survey of Young Americans" included 18- to 45-year-olds[19]) in favor of youth as an affective identity stitched onto a generational history. Youth today is caught in the contradiction between those who experience the powerlessness of their age (adolescents and college students) and the generations of baby boomers who have attached the category of youth to their life trajectory, in part by redefining it as an attitude ("You're only as old as you feel"). For the baby boomers, youth is something to be held on to by cultural and physical effort.

Youth is not only a state of the mind but a state of the body which, in the contemporary world, has to be worked for. But the whole point about being young is that one doesn't have to work for it. In the drive to stay young, there is rarely any mention of some reward in pleasure; apparently the goal of looking and feeling young is an end in itself. It is a constant struggle against the assumption embraced by an ad for VH-1, broadcast on MTV: "The generation that dropped acid to escape reality is now the generation that drops antacid to cope with it." Thus the struggle over youth bleeds into all those activities, images and representations of the enormous investment in health, sport and the body—working to stay young—especially since it is not clear why generations which are increasingly reluctant to describe themselves as happy or as believing in progress are so anxious to live longer.

At the same time, the status of the contemporary generations of chronological youth has also become a problem. The baby boomers won't let go of youth. In their cultural identifications, the baby boomers actively resist and even erase the generations which might more justifiably claim "youth" as their own. In the video for Mike and the Mechanics "In the Living Years," a song about the baby boomers' desire to reconcile with their parents before they die, the only age group not represented is the older children of the baby boomers, from twelve to twenty-five. As Brett Easton Ellis says, "Given the conflicting images of our upbringing, it's not surprising that this generation has defied categorization, or that American culture . . . resists mirroring it . . . we have fractured into splinter groups connected only by birthdates."[19]

When people point to the increasingly troubled and adult-like qualities of young people, they are also observing the failure of the baby boomers to embrace traditional notions of adulthood. But these relations cannot be reduced to simple questions—Is youth disappearing? Are youth and adulthood merging?[20] Such questions ignore the real struggles and frustrations that still characterize different groups and their relations to each other. Young people have rarely contemplated their impending adulthood, but this may be the result of their secure knowledge that the move was inevitable and that the shape and meaning of their adulthood had already been prepared for them. But the baby boomers were different: not only had they located their identity in their youth, but they grew up in a society increasingly centered upon the image of youth. What did they think? How were they going to escape adulthood? In fact, they didn't think about it because it was never an imagined possibility.

The specific configuration of youth which was articulated in the postwar rock formation is being displaced and reshaped. (Consider that hip hop is the only available model for an alternative youth culture today; hence youth-oriented media and even rock culture itself find that they must increasingly use its styles and rhythms, although this has not always forced them to question their racism.) The structure of normalcy which had disciplined and controlled the "extremism" of youth depended on the construction of a stable

difference between youth and adults. And this is collapsing (e.g., *Married . . . with Children*). The difference can only be re-established (e.g., *The Bill Cosby Show,* or the discourses of Tipper Gore and William Bennett) by rendering both categories unreal in their perfection. One finds images which, while echoing the 1950s, actually suggest that neither adulthood nor youth is normal and predictable: children are often older than their parents (*Family Ties*), and when they are not, we cannot imagine how those children can possibly end up as those adults. This is not nostalgia, or if it is, it is a nostalgia for an imaginary past, a past we know we did not live through even as we desire to relive it. All of the generations of postwar youth are caught in this inability to choose or even differentiate between youth and adult. As David Polonoff has observed, some may pose as adults while retaining their youth; others "pose as youths to prove they are adults"; and still others "do not need to fake their adulthood to enjoy their immaturity."[21]

If the baby boomers have refused to give up their youth, contemporary youth increasingly demands its adulthood: "The goal seems to be to get to thirty as fast as possible, and stay there. Starting out, we are eager, above all else, to be finished."[22] This reversal of desires is manifested in the changing relations to the newly developed technologies which have invaded the space of everyday life: youths are the masters and teachers of these technologies. On an episode of *Saturday Night with Connie Chung* (September 30, 1989), a 14-year-old crack dealer spoke for his generation: what he wanted was "money, power, control." He wanted to be exactly like the "yuppie executive" he had seen in a downtown office building. And in many ways, he already was. Recent news reports have commented on the changing nature and cost of adolescent dating; it is increasingly indistinguishable from adult practices. And youth violence and crime are almost indistinguishable in both form and frequency from adult crimes.

The difference is further obscured by the changing structures of knowledge and cynicism of the younger generations. To put it quite simply, kids today know too much and they are, at some deep level, too cynical to mark any difference from older generations. While I

will discuss this in more detail in the following section, it is worth invoking these changes here. Not only do many young people not believe in the inevitability of progress, they do not place any particular faith in traditional institutions, images or authorities. Nor do they believe in the elusive search for something worthy of their faith and investment; no longer privileging the transitions, they deny the specific identity of youth:

> If you will indulge the generalizations of one member of the twentysomething generation: our style is assimilation, our attitude reaction, even if some visceral rebelliousness remains. While "Thirtysomething" has become high-concept, twentysomething lacks coherence; we are clueless yet wizened, too unopinionated to voice concern, purposefully enigmatic and indecisive.
> Since contemporary subversiveness is all on the surface popular culture doesn't, it can't, jolt us in ways it did previous generations. We're basically unshockable. And so culture doesn't play the same role in our lives that it did for previous generations: to liberate, break boundaries, show the unshowable.[23]

They have returned to a conception of youth as training for adulthood, with its own leisure activities. They seem to expect fun as if it were their right. Nintendo is perhaps as incomprehensible today as rock was in the 1950s. Yet in the end, fun no longer seems to matter, and all their efforts are likely to produce—nothing. In *Meatballs*, Bill Murray motivates the kids in his camp to defeat another camp (the other camp, of course, is populated with rich snobs who win at everything) by leading them in a chant of "It just doesn't matter" since they already know that the victory will not in fact get them any of the things they want. In *Bless the Beasts and the Children*, a group of working-class adolescents from the city struggle to free a herd of buffalo about to be slaughtered. When they finally succeed, one of the younger children imagines that they are safe to roam the prairie (having seen it in movies, no doubt). The leader of the group, a teenager himself, says, "I wish I were young enough to believe that." Whether this cynicism is in fact justified is irrelevant, although it is worth pointing out that many of the institutions which have primary responsibility for disciplining youth have come under attack in the past decade: for example, the family has

been attacked not only by feminists, but because of its obvious failures to adequately protect children (e.g., child abuse). Similarly schools, daycare centers and even churches have lost whatever aura they might have had, either for youth or for society.

Even the struggle of existence has become more difficult. Consider some of the more frightening examples: the suicide rate has tripled since 1950; current estimates are that four hundred thousand attempt it each year. Every year, over a million kids run away from home. The teen homicide rate has increased by 232% since 1950. Each year, over a million teenage girls get pregnant. And it is estimated that the rate of substance abuse has doubled in the past decade, including the staggering estimate that over 20% of teenagers are alcoholics. The report of the National Commission on the Role of the School and the Community in Improving Adolescent Health (formed by the American Medical Association and the National Association of State Boards of Education) states:

> The emergency we are facing is an unprecedented adolescent health crisis—one that has serious repercussions for our economy and our social well-being. For the first time in the history of this country, young people are *less* healthy and less prepared to take their places in society than were their parents . . .
>
> Unhealthy teenagers—those who are alienated or depressed, who feel that nobody cares, who are distracted by family or emotional problems, who are drinking or using drugs, who are sick or hungry or abused or feel they have no chance to succeed in this world—are unlikely to attain the high levels of education achievement required for success in the 21st century. And thousands of these young people will experience school failure, which for many will be a precursor to an adult life of crime, unemployment, or welfare dependency.[24]

There is also shocking evidence that the institutionalized relations between the adult population and youth are changing. In 1985, there were over two million reported cases of child abuse and neglect, and over five thousand deaths. Psychologists have noted that the rate of adolescent depression has been constantly increasing since the 1950s. And children now constitute the larger fraction of those living in poverty, both in the United States and around the world. There

is also more subtle evidence: the apparent lack of willingness to support taxation for education and other child welfare needs; despite increasing number of child-care bills introduced in Congress, there is still no significant legislative program to support child care or to protect children from advertising; the debates over teachers' right to use corporeal punishment; the increasing infringement of youths' constitutional rights; the increasing tendency for the courts to treat juvenile offenders as adults; the proliferation of practices attempting to both accelerate and control the socialization process.

Commonsense perceptions of youth and their environment are changing as well. Consider the following comparison of the major perceived disciplinary problems in schools. In 1940, the major problems were listed as, in order: talking, chewing gum, making noise, running in the halls, getting out of turn in line, wearing improper clothing, not putting paper in wastebaskets. And in 1982: rape, robbery, assault, burglary, arson, bombings, murder, suicide, absenteeism, vandalism, extortion, drug abuse, alcohol abuse, gang warfare, pregnancy, abortion and venereal disease.[25] At least according to one observer, such perceptions have become fact, "creating a climate of fear" which is likely to "impede students' job training."[26] Since 1970, youth has been implicated in what seems to be a never-ending series of discursively constructed panics, only some of which have any anchor in reality: Halloween sadists, child sexual abuse, prostitution, pornography, kidnapping, murder and, most recently, satanic cults. The last embodies the ambiguities of the contemporary position of youth, for youth are both the members and the victims of these cults.[27] Increasingly, youth is represented as not the victim of suicide but the perpetrator of homicide, not the user but the seller of drugs, not the delinquent but the criminal, not the member of a subculture but of a gang. And yet, throughout this discourse, youth continues to be represented as victimized and endangered.

The struggles over youth are being enacted in the media as well, in a broad range of texts that are clearly punctuated by images and relations of youth. The television screen is filled with baby boomers' nostalgic look back on their own youth (e.g., *The Wonder Years*), on the images from their youth (e.g., *Nik at Nite*) and on their own

youthfulness (*thirty something*). It is difficult to make sense of the explosion of films in just the past few years which deal with transgressions of age: young people becoming old, old people becoming young, old and young people switching places. But even more clearly, we can see the struggle over youth in the different and, in some cases, new ways in which youths—their experiences, practices and discourses—are represented: youth as embodying all of the (negative) characteristics of adulthood (e.g., in the currently popular horror/slasher movies, as well as in certain recent TV series such as *Family Ties*); youth as radically different from adults (e.g., *Children of the Corn, River's Edge* or *Heathers*); youth as the repository of adult fantasies of innocence and of irresponsibility (e.g., *Animal House, Porky's* and even *Fast Times at Ridgement High*); youth as the salvation of the world (e.g., *The Last Starfighter*) or of parents (e.g., *Back to the Future* and *Iron Eagle*); youth as the site of victory (e.g., *Top Gun* and *Ferris Bueller's Day Off*); youth as the last champions of justice (e.g., *The Legend of Billie Jean* and *Pump up the Volume*); youth as possibility (e.g., *Quicksilver*); youth as utter failure (Pee Wee Herman and Bart Simpson); and youth as unavoidable closure (e.g., *Peggy Sue Got Married* and *Wild at Heart*). This diversity signals, at the very least, the contradictions in people's feelings about youth. While youth has become increasingly dominant as both topic and audience for popular culture, the media seem unable to deal with the problematic relation between youth as part of a peer culture (i.e., in school and on the streets) and as part of a domestic culture (i.e., in the home).

The fragmented audiences for these various texts, as well as their hyper-stereotypical forms, suggests that traditional explanations of the identification between spectators and characters cannot totally explain their popularity. Heroes and nerds, jocks and technobrats, urban martyrs and valley girls, punks and rednecks, hippies at Woodstock and yuppies at the US festival—diversity seems to have overpowered any sense of a representable unity of youth (however illusory that sense was). The so-called yuppies were a perfect icon of youth in the 1980s. For being a yuppie is, more than anything, a commitment to being able to afford (unlike style-cultures, yuppie culture is

an economic matter) to play with identity, to change one's tastes and style. Youth has become a description neither of age nor of affect and attitude, but of image and life-style, caught between perhaps three dominant poses of urban street life: the 30-year-old yuppie (e.g., *Miami Vice* or *Moonlighting*); the pseudonostalgic images of 1950s and 1960s youth cultures; and the ambiguously aged homeboy (from hip hop).

This veritable explosion of discourses is all the more startling given the failure of such youth movies (and their stars) only a decade ago (e.g., *The Wanderers, Over the Edge*). The ease with which 1980s "Brat Pack" stars moved between playing high school students measuring the reality of their lives against the momentary possibility of an almost enforced openness (*The Breakfast Club*) and post-college yuppies confronting a terrifyingly unromanticized reality (*St. Elmo's Fire*) marks their youthfulness by the undecidability of their ages and class loyalties. Other films, such as *Hiding Out,* similarly depend upon the absolute lack of any recognizable signs of age. These new icons are, in fact, surprisingly diverse—from nerds to tough guys— and, even more surprisingly, articulate. Whatever happened to the inarticulate image of James Dean? Never has youth talked so much, nor had so much expertise and knowledge. What seems to be offered is not a definition of youth, but a definition of what youth cannot be; youth is defined in increasingly negative, if not oppositional, terms. These terms need not define their experience, values or identity, but they do define the plane or register within which their experiences, values and identities must be understood.

Yet youth is often represented in its absence, as if it made no difference that characters are young. There is an almost incomprehensible distance between *Blackboard Jungle* and *The Class of 1984* or, even more recently, *The Class of 1999*. In the latter, as in many recent popular horror movies, youth is represented either as pure victim or as pure evil. But it actually makes little narrative difference that they are young, unless it is as the victims of some unnamed social rage; if youth is wasted on the young, why not make them suffer for and even from it? It only deconstructs the very difference being obliterated. Tom Carson has described the "sour view of

children" in which either "negative characteristics usually associated with adulthood" are displaced onto children—"children are treated as mercenary and calculating while parents are seen as passive, endearingly hapless"—or they are seen as "alien, inherently Other."[28] This is the adolescent absorbed, a few years ago anyway, in video games. A closed world with no reality of its own except the play between fun and risk, video games offer a significant form of empowerment if only because their lack of reality does not stop them from being a matter of life and death (e.g., the commercial for the video game Saxon, in which the child-player disappears in a puff of smoke). These are truly "strangers in a strange land," so strange that they have to be described and explained to an uncomprehending adult world, as in *Newsweek*'s special edition devoted to the "New Teens."[29]

But perhaps they are no stranger than those creatures who inhabit Spielberg films (*Close Encounters, ET, Poltergeist, Gremlins*). These films are all structured around the disappearance of children or childhood and their eventual return. They offer themselves as a new "fountain of youth"; they project adult fantasies of youth on a surface of advertising. Pee Wee Herman is another example in which the category of youth has been appropriated by others who not only define it but struggle to essentialize it. They speak as if from a position of youth, for youth, but they speak as adults, for adults. Thus it is increasingly common to find the baby-boomer heroes and heroines of prime time television confronting their ambiguous relations to both youth and adulthood, appropriating the former category and dissolving it into their reluctance to enter into the latter. Perhaps all this encodes a new resentment of youth by a generation that was never taught to be adults or even to value that identity, and whose identity is still implicated in their investment in youth.

The struggle of youth begins with real problems, defined elsewhere, and deflects them into struggles directed elsewhere. The contemporary concern with youth is largely a consequence of the changing needs and interests of the baby-boom generations (who are now producing something of a mini baby boom). As these generations have grown up, their desires, fears and pleasures have become dominant national themes. It is not surprising that they would seek

ways to continue representing themselves as young, or seek practices which will enable them to feel young, or seek forms to construct an indefinite future for their youthfulness. Nor is it surprising that these generations would publicly rethink the dominant institutions of adulthood (the family and work) to find new models of their possibilities. And equally understandable is their desire to rethink and represent their history, to try to remember and make sense, not only of an incomprehensible war but of a moment in which their alienation from the adult world was written in absolute terms upon the screens of their own families, to try to relive a past that they know they never had (e.g., in the variety of nostalgia films which are obviously and often self-consciously imaginary but consumed as if real) in which their youthfulness was unproblematic and somehow seemed to be guaranteed forever.

These struggles over youth are, I believe, a powerful vector in the contemporary cultural scene, often pulling popular culture and everyday life along with it, because it brings together and reinflects very real—and reasonable—struggles, for different fractions of the populations. These struggles have their effects across the entire social formation, in changing economic, legal and political practices. Precisely because youth cannot be contained, the struggles over youth leak into so many other places in the cultural milieu: most obviously, into the new and numerous images of the family—both potentially radical and extremely conservative. These include not only programs about the family, but the construction of nondomestic groups as explicit if ersatz families. For example, while *Mash* always talked about the family back home, *China Beach* constructed itself from the very beginning as an alternative and even more real family for its characters, erasing almost any mark of the family back home; when the characters finally went "home," the series fell apart. Even in popular music, families and relationships have replaced sex as the dominant topic of many songs outside of the teen-directed top forty, and many of the leading baby-boom writers (e.g., Bobbie Ann Mason and David Leavitt) are increasingly fascinated with family narratives.

There is little consistency here in the meanings and images of the family. If we consider even the network sitcoms, we have to conclude

that these are not merely reproductions of the attempts, in the 1950s, to construct images of a mythical perfect family (images which were always outside most people's experience). Not only are the parents always plagued by all of the doubts and insecurities of their collective histories as youth, they are commonly constructed, in some essential respects, as themselves youthful and even young. Even Bill Cosby, the most perfect of all the new fathers, is a far cry from Jim Anderson. And the kids? They are neither innocent nor always immature; they are often smarter than their parents, although more commonly they are little more than the occasion for their parents' wit. The most noticeable feature of these programs is, in fact, the decreasing narrative role of the children. The icon of the popular family is no longer Disneyland but Pee Wee's Playhouse, where age is undecidable and its relations to behavior are unpredictable, or perhaps the dysfunctional space of the Simpsons' family home. The recent Gitano ads (introduced under the title of "Home Movies") celebrate "the spirit of the family"; yet in a typical ad, an apparently adolescent couple, dressed in white hip hop style, is the focus of the camera's admiration. It remains unclear whether they have a child, or even if they are supposed to be a family in any literal sense. A perfect image of the new articulation of family and youth!

But this multiplicity should not disguise the powerful articulation of youth and specific images of the family in the discourses of the Right. When Zinsmeister writes that "there is no fully adequate substitute, public or private, for intact families,"[30] he has a particular political agenda, a patriarchal agenda which defines the family by the power of "male direction"[31] without which "there will be no brake on our slide toward family forms that are economically, socially and emotionally less tenable for children."[32] In this new conservative articulation of the struggle over youth, a third term enters into the discourse: namely, the crisis of the nation.

Tipper Gore's *Raising PG Kids in an X-Rated World* is not concerned with childrearing practices, or with the condition of children, but with "re-asserting some control over the cultural environment in which our children are raised."[33] Here the regulation of youth and the regulation of cultural consumption collapse into a

project of rescuing the moral fabric of the nation and rethinking the liberal conception of America:

> The dilemma for society is how to preserve personal and family values in a nation of diverse tastes. Tensions exist in any free society. But the freedom we enjoy rests on a foundation of individual liberty and shared moral values. Even as the shifting structure of the family and other social changes disrupt old patterns, we must reassert our values . . . People of all political persuasions—conservatives, moderates and liberals alike—need to dedicate themselves once again to preserving the moral foundation of our society.[34]

Gore's strategy is threefold: first, she refuses to distinguish between children and adolescents. Even though she acknowledges that "teenagers are endowed with the emotions, passions, and physical capabilities of adults," she emphasizes that they lack "the adult judgment to harness them." Consequently, they can be treated as nothing more than "children in transition."[35] Second, she suggests that children need "the security of definable boundaries."[36] No one would quarrel with that; it is after all as true for adults as it is for children. The problem is where one locates those boundaries, and how one puts them into place in the modern world.

This requires a conception of childhood and it is this, more than anything, that Gore offers: an image of "fragility and innocence . . . children are special gifts and deserve to be treated with love and respect, gentleness and honesty. They deserve security and guidance about living, loving and relating to other people. And they deserve vigilant protection from the excesses of adult society."[37] Her third strategy displaces the problem from adult society (although she acknowledges problems in the ways society relates to children and vice versa) to the culture of youth. It is all a matter of the cultural environment, those popular media messages which children take as their own, and which Gore finds so reprehensible.

An even more telling conservative foray into the struggle over youth is Allen Bloom's *The Closing of the American Mind*. Bloom is concerned with the "impoverished souls of today's students"[38] (read "youths"). Bloom's argument, while explicitly concerned with an

elitist minority—"the good students in the better universities, those to whom a liberal education is primarily directed and who are the objects of a training which presupposes the best possible material"[39]— is a broad attack on the current generations of youth and even more, on the current position of youth. In 1965, Bloom wrote optimistically about his students:

> These students are a kind of democratic version of an aristocracy. The unbroken prosperity of the last twenty years gives them the confidence that they can always make a living. So they are ready to undertake any career or adventure if it can be made to appear serious. The ties of tradition, family and financial responsibility are weak. And along with all this, goes an open, generous character. They tend to be excellent students and extremely grateful for anything they learn. A look at this social group tends to favor a hopeful prognosis for the country's moral and intellectual health.[40]

Twenty years later, Bloom's prognosis had altered: "Today's select students know so much less, are so much more cut off from the tradition, are so much slacker intellectually, that they make their predecessors look like prodigies of culture."[41] What are the causes of this crisis? And what are its stakes? In the first instance, the youth culture of the 1960s is to blame. Bloom offhandedly dismisses the politics of the 1960s as merely the result of the absence of a liberal education, "the one thing the universities were unequipped and unwilling to offer them. The students' wandering and wayward energies finally found a political context."[42] As if, had they only been reading the classics and thinking Socratically, they would not have fallen into the political positions which came to define an important part of their lives, political positions which "wasted that marvelous energy and tension, leaving the students' souls exhausted and flaccid, capable of calculating, but not of passionate insight."[43]

But there is more at stake, for the real question is "what it means to be an American." Bloom argues that the political tradition of the United States "is unambiguous; its meaning is articulated in simple, rational speech that is immediately comprehensible and powerfully persuasive to all normal human beings. America tells one story: the unbroken, ineluctable progress of freedom and equality."[44] To be

an American thus requires an "ethnocentric" celebration of the American (i.e., rational) view of natural rights. "It is possible to become an American in a day. And this is not to make light of what it means to be an American."[45] In America, there are "no real outsiders"[46] for our national identity depends only on the history of our commitment to freedom and equality rather than to any shared culture or tradition. This is very different from the kinds of attachment required for traditional communities where myth and passion as well as severe discipline, authority and the extended family produced an instinctive, unqualified, even fanatical patriotism, unlike the reflected, rational, calm, even self-interested loyalty—not so much to the country but to the form of government and its rational principles—required in the United States.[47]

But the devil has entered America in the form of a new "openness" which has driven out the local deities, "leaving only the speechless, meaningless country."[48] After all, "all such teachers of openness had either no interest in or were actively hostile to the Declaration of Independence and the Constitution."[49] Openness is, according to Bloom, antithetical to natural rights: "Liberalism without natural rights, the kind that we knew from John Stuart Mill and John Dewey, taught us that the only danger confronting us is being closed to the emergent, the new, the manifestations of progress."[50] This new openness is "progressive and forward-looking." While one might have thought these terms to be positively associated with America, Bloom argues that such openness

> does not demand fundamental agreement or the abandonment of old or new beliefs in favor of the natural ones. It is open to all kinds of men [sic], all kinds of life-styles, all ideologies. There is no enemy other than the man who is not open to everything. But when there are no shared goals or visions of the public good, is the social contract any longer possible?[51]

Bloom's politics, despite his explicit focus, is not really about education at all. For the real stakes involve a struggle around youth and popular culture. He begins the book by acknowledging that the sources of this openness are outside of and prior to the academy: "There is one thing a professor can be absolutely certain of: almost

every student entering the university believes, and says he believes, that truth is relative."[52] The real target of Bloom's political venom is other than his academic foes:

> Along with the constant newness of everything and the ceaseless moving from place to place, first radio, then television, have assaulted and overturned *the privacy of the home, the real American privacy*, which permitted the development of a higher and more independent life within democratic society. . . . It is not so much the low quality of the fare provided that is troubling. It is much more the difficulty of imagining any order of taste, any way of life with pleasures and learning that naturally fit the lives of the family's members, keeping itself distinct from the popular culture and resisting the visions of what is admirable and interesting with which they are bombarded from within the household itself. (italics added)[53]

Bloom reserves his most passionate attacks for rock. He makes a point of telling us that he had originally supported his students' tastes in rock, because such music appealed to real feelings. But somewhere, as rock came to dominate the "meaningful inner life" of his students, Bloom concluded that it was merely "barbaric." Great music is, after all, supposed to harness the passions to reason, but rock appeals only to "sexual desire undeveloped and untutored"[54] and has dispelled "any clear view of what adulthood or maturity is."[55] In the end, rock apparently destroys any capacity for what Bloom considers to be the "correct" passions: "It ruins the imagination of young people and makes it very difficult for them to have a passionate relationship to the art and thought that are the substance of liberal education."[56] But Bloom is even more pessimistic, and the effects of rock music are even more serious.

> Rock music provides premature ecstasy and, in this respect, it is like the drugs with which it is allied. The student will get over this music, or at least the exclusive passion for it. But they will do so in the same way Freud says that men accept the reality principle— as something harsh, grim and essentially unattractive, a mere necessity. These students will assiduously study economics or the professions and the Michael Jackson costume will slip off to reveal a Brooks Brothers suit beneath. They will want to get ahead and live comfortably. But this life is as empty and false as the one they

> left behind . . . as long as they have the Walkman on, they cannot
> hear what the great tradition has to say. And after its prolonged
> use, when they take it off, they find they are deaf.[57]

It is the immaturity of rock's passion, the fact that, somehow, it places youth outside of social control, the family, the academy and even the nation, that frightens Bloom most. Curiously, the link between rock and drugs as threats to youth's health has recently been reiterated by the American Medical Association.[58]

Bloom's strategy of identifying "America" with the commitment to "natural rights" is offered against the postwar identification of America with youth. In a sense, as early as the 1950s, the American identity slid from a contentless image of the future to a powerful, emotionally invested image of a generation. America found itself by identifying with a generation whose identity was articulated by the meanings and promises of youth. Youth, as it came to define a generation, also came to define American itself. And this generation took up the identification as its own fantasy. Not only was its own youthfulness identified with the perpetual youthfulness of the nation, but its own generational identity was defined by its necessary and continued youthfulness. However, youth in this equation was not measured simply in terms of age; it was an ideological and cultural signifier, connected to utopian images of the future and of this generation's ability to control the forces of change and to make the world over in its own images. But it was also articulated by economic images of the teenager as consumer, and by images of the specific sensibilities, styles and forms of popular culture which this generation took as its own (hence, the necessary myth that rock was made by American youth). Thus what was placed as the new defining center of the nation was a generation, an ideological commitment to youth and a specific popular cultural formation.

Bloom is correct to see this as a problematic solution to America's search for an identity, not merely because any generation of youth has to grow up and, one assumes, renounce its youthfulness, but also because youth was largely, even in the 1950s, an empty signifier. Following Steedman, we can see youth as "always episodes in someone else's narratives, not their own people, but rather brought into

being for someone else's purposes."[59] Youth has no meaning except perhaps its lack of meaning, its energy, its commitment to openness and change, its celebratory relation to the present and its promise of the future. Youth offers no structure of its own with which it can organize and give some permanence to a national identity. That is, youth, like America itself, can only be defined in a forever-receding future. How could this generation possibly have fulfilled its own identity and become the American dream, become a future which is always as yet unrealized and unrealizable? How could a generation hold onto its own self-identity as youth and, at the same time, fulfill the responsibility of its identification with the nation? What does it mean to have constructed a concrete yet entirely mobile center for a centerless nation? Perhaps this paradoxical positions explains the sense of failure that characterizes the postwar generations despite the fact that they did succeed in reshaping the cultural and political terrain of the United States. Perhaps it explains why Bloom is so driven to deconstruct the relations of youth to the nation, and to dispel any possible value that the rock formation might have in that equation.

The category and body of youth are being reshaped. I am neither proclaiming the end of youth nor interpreting a mere change in its meaning. I am pointing to its rearticulation, not only as a cultural category but as a social and material body as well. That body is torn apart by the contradictions between the different generations of youth: baby boomers; post–baby boomers who look back with nostalgia upon a history they never had (as Lester Bangs once said, growing up in the 1970s was like going into town the day after the circus left);[60] and contemporary adolescents, terrifyingly different and rhetorically incomprehensible. The very sites and forms of its public existence are being restructured (from marches to malls); its rhythms and drugs are changing as well. The issue is not whether the various discourses about youth are referentially accurate, but that they are themselves part of the context in which youth is organized. The discourses and practices that interpenetrate, surround and shape youth have now become a major battleground. Those generations which have invested their identities in the category of youth are now attempting to

produce new articulations in an attempt to control or resist or alter or sustain the dominant conceptions of their own identities and futures. And those generations of "children" and "young people" who might assume the category for themselves not only confront new demands from the world but also new discourses which offer them little guidance or solace.

But this struggle is not merely sociological, for it is transversed by another project, one which is attempting to articulate the uncertainty of youth into a larger struggle over the political possibilities of the nation. These politically inflected attacks on youth and youth culture cannot be reduced to a mere token of a more universal struggle to discipline youth because it is such a powerful—if potential—site of antagonism and resistance. This is, at best, a romantic desire based on images of youth from specific times and places. There is nothing intrinsic about youth which makes it politically resistant. To say that youth is a time of transition when change and experimentation are encouraged, to say even that it is a moment of a certain kind of rebellion, is not the same as saying that it constitutes some sort of political undercurrent or threat. And there is little evidence, especially in the past decade, that contemporary generations of youth pose any such radical challenge to the status quo. What there is evidence of is that the material, social and mental state of youth in America is in crisis. Yet these discourses largely ignore the actual condition of youth. Even the *New York Times* has acknowledged that America is "failing its children" and compares the status of children in America unfavorably with some third world nations: "Children endure more deprivation than any other segment of society. Yet . . . the U.S. could reduce this tragedy with remedies that are available right now."[61] Conservative attempts to reinflect and redeploy the place of youth in American society and culture must be determined elsewhere, by a trajectory which connects youth to the struggle over the politics of culture.

8

ROCK, POSTMODERNITY AND AUTHENTICITY

ROCK AND AUTHENTICITY

The third condition of rock's emergence involves the nascent appearance of a certain sensibility formed in the contradiction between the optimism of the postwar years and the cynicism engendered by the appearance of a number of rather disturbing images, events and rhetorics. If rock is "about" growing up in the U.S. (at least that is the only context I am talking about), it does not describe or represent that experience; rather, it is a set of strategies which enable its fans to reorganize the demands of everyday life by restructuring its very contours. Children born after the war—especially but not only the white working and middle classes—found themselves in a world that quite literally seemed to be entering a new age, through the redistribution, not only of power and wealth on an international scale, but also of the possibilities of the individual's life and future. New communications media redistributed social knowledge, making visible what had heretofore been invisible, rendering vulnerable that which had always been protected. But the media were implicated in other changes as well, including the increasing commercialization of leisure (which helped to define the majority of the population as cultural consumers) and the beginnings of the commodification of the social imagination. In addition, the move to the suburbs reorganized social space around principles of repetition, marginalization and racism. New structures of technological, economic and social practices contributed to a radical reorgani-

zation of everyday life. It was not only that the world was changing but that it seemed to be characterized by an accelerating rate of change—literally, a moment in which "everything that is solid melts into the air."[1] In a sense, change appeared to be all that existed. It seemed as if "we are obliged to remake from scratch the foundation of our taste, as of our politics and our very lives. Old ways of judging linger [only as] unexamined habits, comforting defenses against the recognition of our common lostness."[2] If youth was transitional, then it stood in direct relationship to a historical moment that was apparently the embodiment of transition itself.

This identity in the lack of identity—a sense of perpetual transition—was augmented and negated by a set of apocalyptic images and events. While such self-representations are not uncommon, their dissemination through the popular languages of the mass media gave them a unique presence and a more powerfully felt claim to truth. That these images connected to real historical changes is undeniable; whether the rupture was as total or radical as its representations claimed, or even whether it was experienced as such, is more questionable.

A generation which had never known another world had suddenly to confront the possibility of the end of the world. Obviously, the most powerful of these images was the atomic bomb, especially given its insertion into the militaristic metaphor of containment that organized the cold war. Imagine the skepticism of a schoolchild who is simultaneously given a brass bracelet (so that his or her body can be identified should the bomb fall) and told to participate in bomb drills where schoolchildren hide under desks. Jim Carroll described it this way:

> When they dropped them A-bombs on Japsville I wasn't even an idea, but I paid for it anyhow all through growing up and I'm still paying. The "war baby" gig ain't no smartass headshrinkers dumb theory, and all the people who grew up when I did can tell you that. I used to have horrible dreams of goblins in tiny planes circling my room and bombing my bed most every night age six or seven; every time a fire truck or an ambulance passed the house I was pissing with fear in my mother's arms with the idea that it was the air raid finally come, and *real* air raid drills *still* freak me

when I'm stoned. The worst is that the old buggers can't believe its real, that it could ever happen to us.[3]

But it was not just the bomb that threatened the security of the future, for there were other events and discourses which disrupted the very meaning of the future. The Holocaust made insanity an inescapable fact of human history and undermined the possibility of any faith in some ultimate principle of value (even as it eventually normalized a discourse of the death of god). Even more positive events like the conquering of space had their traumatic side, for in negating the sanctity of the earth, they also demonstrated that it was dispensable. As everything became disposable, the U.S. became a "throwaway" society in which nothing was ever really at stake. Such thoughts, which may have terrified older generations even as they elicited nostalgia for a different world, were the only reality for a generation which had no alternative world to remember or imagine. They were part of the taken-for-granted reality of the baby boomers. What seemed to many to be a threat to their sanity was, for the younger generations, the ground on which they had to construct their own sanity and survival.

Consequently, the public images and ideals which might have enabled youth to make its lives congruent with the rest of the world's seemed to fail. Society seemed unable to provide any narratives or meanings which could allow youth to understand, or even imagine, a significant place for themselves in history. Instead, there were few stable values and truths which could give meaning to youths' lives and define the future as a worthy goal. If traditional models of people's place in society no longer worked, then the significance of such heroes as Holden Caulfield, James Dean and Marlon Brando lay precisely in their struggle to achieve some identity consistent with this new set of experiences. But perhaps the only identity that could be achieved was that of the "identity crisis," where the uncertainty of what lay beneath the surface of social roles and images, where the question of how to identify a "real me," was diagnosed as a psychological disorder.

This "alienation" was of course contradicted by the optimistic liberalism of the postwar years which, by repressing social and cul-

tural differences, promised a utopian future. But for youth, that future was already inextricably linked to the terror and boredom of an as yet unexpressed and inexpressible apocalyptic sense of history. The liberal consensus seemed to guarantee that they would become the ultimate replicants of the very world they rejected. And its postmodern inflection suggested that their only alternative was their imminent self-destruction. Nowhere in this contradiction was there a place for their own sense of difference, for their need to construct a sense of belonging which could make sense of the twin poles of terror and boredom which they confronted.

This lived contradiction became the taken-for-granted source and marker of an affective difference that, at the deepest levels, separated youth from their parents and from the straight world around them. That is, a public generational crisis came to define the content of youth's identity. But the rupture which separated youth from adults was not a matter of ideology or interpretation. It was a crisis in the relation between affect and signification, in the possibilities of investing in the meanings and values being offered to them. It was a crisis, not of faith, but of the relationship between faith and common sense; it was a crisis which denied their ability to anchor faith in common sense. For the structures of meaning which the world offered them seemed incapable of being articulated to their own sense of commitment and passion. It was as if one had to live two lives: one defined by the interpretations and institutions of the adult world and their attempts to incorporate youth into them; the other defined by an affective uncertainty that gradually became the common discourse of youth. It is not that youth did not live the ideological values of their parents; rather, they found it impossible to represent their mood, their own "affective" relationship to the world, in those terms and to seriously invest themselves in such values. It was difficult to bring together the affective organization of experience and the dominant ideological appeals which attempted to cement and make sense of that social mood. The result was youth's inability to connect the supposedly natural and universal meanings and values which they inherited—the languages they had to speak and in which they had to live their public lives—to the historically

defined affective or volitional possibilities of survival and empowerment. Public life seemed to be marked more and more by places where youth was unable to anchor its maps of what could and should matter into the dominant maps of what the world means.

Whether this was merely the latest example of "fin de siècle" rhetoric is irrelevant for, in the postwar context, it had very real effects. It was, however, largely a public event, lived more in the context of the conflict of generations than in youth's experiences; and it was lived with a sense of seriousness and desperation; there was little room for irony (e.g., the image of their "heroes" and the seriousness with which teenage love and angst were treated in songs, especially when compared to the 1980s).

The rock formation emerged as an articulation of this historical sensibility to the specific context of postwar youth. It became a site at which the gap between affect and ideology could be transcended. Rock mattered so much precisely because it was one place—and it constructed other places—where ideological and affective maps could be stitched together (although significant fractions of the Black and female populations found other sites). Rock opened up the possibility of investing in the present without the necessity of a future which transcends it. It offered salvation without transcendence or, perhaps more accurately, it located transcendence in the immediacy of the salvation offered by rock itself. By offering itself as something that mattered, rock continuously constructed and reconstructed new mattering maps which empowered fans in new ways by specifying the different forms, sites and intensities of what could matter. It determined how other aspects of everyday life could matter. For example, the fact that rock was usually located outside of the ideological institutions of the family and school did not guarantee its inherent opposition to these institutions. Rock worked by offering youth places within the transitional spaces of youth where they could find some sense of identification and belonging, where they could invest and empower themselves in specific ways.

Rock's special place was enabled by its articulation to an ideology of "authenticity." Rock appropriated an older middle-class obsession with "authenticity" as a way of responding to the absence of its own

authentic past (and future). But rock's authenticity was defined not by any claim to historical origins or ideological purity but by the very conditions which enabled its particular forms of aural, visual and behavioral excess. It was defined by rock's ability to articulate the historical condition to the experience of postwar youth. Only by making youth belong somewhere could it speak to both the identity and the difference of its audience. Because it mattered, rock constituted a generational identity and empowered that generation to define its own ways of articulating meaning into its mattering maps. A differentiating machine is deployed in the service of rock's territorializing work.

The ideology of authenticity legitimated the fact that rock mattered by providing the measure of its difference from other cultural forms—rock differed absolutely from mere entertainment—and grounding that difference in rock's claim to have an excess. The ideology of authenticity renders the musical form and lyrical content of rock secondary to, or at least dependent upon, an excess which may be defined stylistically, or by rock's youthfulness and fun, or by the fact that rock matters. This excess distinguishes between musical/cultural practices and between fans, although the two dimensions do not always correspond. It can be marked in a number of ways: inauthentic vs. authentic; center vs. margin; mainstream vs. underground; commercial vs. independent; coopted vs. resistant; pop vs. rock. The same distinction can be applied in very different ways to describe the same music, and in different alliances the difference can be explained in different ways. The line between rock and entertainment can be justified aesthetically or ideologically, or in terms of the social position of the audiences, or by the economics of its production, or through the measure of its popularity or the statement of its politics. In all of these cases, the line "properly" distributes musical practices and alliances: on the one side, entertainment; on the other, something more—an excess by virtue of which rock can become a significant and powerful investment. The excess marks the reality and even the legitimacy of the fan's difference, which is often interpreted as rock's inextricable tie to resistance, refusal, alienation, marginality, etc. "Inauthentic rock" is "establish-

ment culture," rock that is dominated by economic interest, rock that has lost its political edge, bubblegum music, etc. "Authentic rock" depends on its ability to articulate private but common desires, feelings and experiences into a shared public language. It demands that the performer have a real relation to his or her audience—based on their common experiences defined in terms of youth and a postmodern sensibility rather than class, race, etc.—and to their music—which must somehow "express" and transcend that experience. It constructs or expresses a "community" predicated on images of urban mobility, delinquency and bohemian life.

This ideology of authenticity has determined the structure of the various histories of rock, whether they are produced by fans or critics. At every moment in rock's history, people have identified some musics, audiences or alliances as inauthentic. These are dismissed, not merely as bad or inferior rock, but as mere entertainment, as not really rock at all. From within any particular alliance, people assume that they can read the ability of rock to matter off the taste of the audience or the sound of the music. Consequently, alliances are constantly judging each other, placing particular alliances on either side of the line separating rock from entertainment: i.e., that music can't possibly matter to anyone. Such judgments are not merely judgments of taste: what do I like? They are judgments about the very possibility of taste; they offer distinctions which question the right of a particular practice or alliance to be included within the formation. At certain moments, from certain places within the rock formation, these inauthentic alliances appear to define the dominant form of rock. The result is that the history of rock is always seen as a cyclical movement between high (authentic) and low (coopted) points, although different fans will disagree over which moments constitute the high and the low points. Fans or critics who find themselves living in what they construct as a low point almost inevitably begin to predict the imminent "death" of rock. It is less important, for my purposes, where the cycles are located than that such cycles are a constitutive part of the ideology of rock's excess and authenticity.[4]

The authenticity of rock was measured by its sound and, most

commonly, its voice. Given the contexts in which rock was originally made available to the majority of fans (through radio and records rather than live performance), it is not surprising that its ideology would focus on sound. Moreover, its appeal to its Black roots further secured the primacy of sound. The eye has always been suspect in rock culture; after all, visually, rock often borders on the inauthentic. Visual style as conceived in rock culture is usually the stage for an outrageous and self-conscious inauthenticity (which can be made consistent with its authenticity through its celebration of excessive difference). It was here—in its visual presentation—that rock often most explicitly manifested both an ironic resistance to the dominant culture and its sympathies with the business of entertainment. The importance of live performances lies precisely in the fact that it is only here that one can see the actual production of the sound, and the emotional work carried in the voice. The demand for live performance has always expressed the desire for the visual mark (and proof) of authenticity.

The ideology of authenticity was a strategy by which youth culture could rearticulate the lived contradiction between optimism and cynicism. It redefined that sensibility as one which they could appropriate as their own. It empowered them to escape the boredom of everyday life by making rock and their relation to it events that mattered. And, at the same time, it empowered them to escape the shadow of a public terror by reconstructing the contours of that space around rock and youth itself. The ideology of authenticity defined the working of rock as a formation and an apparatus; it circumscribed the ways in which rock produces lines of articulation and flight. Rock constantly articulates its own authentic center, which is always on the way to becoming inauthentic. Sometimes this center is constructed for the entire formation; at other times different alliances may produce their own center. But because that center is always threatened both internally (from other alliances: e.g., teenyboppers) and externally (commercialization), rock is constantly seeking to escape its own centeredness, to produce lines of flight which open up new spaces, new possibilities, new centers. Thus, unlike other musical forms, rock's very existence depends upon a certain instabil-

ity or, more accurately, a certain mobility in the service of stability. Rock must constantly change to survive; it must seek to reproduce its authenticity in new forms, in new places, in new alliances. It must constantly move from one center to another, transforming what had been authentic into the inauthentic, in order to constantly project its claim to authenticity. For it is this claim which enables rock to matter, to make a difference, to empower its fans. Rock constantly produces its own lines of flight which reproduce the very structure of its sensibility in an-other place.

POSTMODERNITY

The relationship between rock and the ideology of authenticity depended on a particular sensibility which negotiated the relation between optimism and cynicism. That sensibility has itself been transformed into what I will call a postmodern sensibility or a structure of feeling.[5] This is not merely the result of the explosion, staggering though it may be, of events and knowledges which challenge any sense of stability, history, the future or identity. The very nature of rock's sensibility, as well as the way it is lived, have changed. Its public and discursive existence has been transformed from a crisis of social rhetorics and shared historical events to a powerful and pervasive popular sensibility, infiltrating many of the spaces of social and everyday life, rearticulating many of the possibilities of people's cultural investments. The cynicism which had been lived with an attitude of desperation is increasingly inflected through an overwhelming sense of irony. What had appeared as the failure of a specific historical ideology now signals the impossibility of any ideology, or of any articulation between affect and ideology. And what had been a privileged possession of the baby boomers has moved both up and down the generational ladder. Its proudest subjects today are the children of the 1990s.

The anchoring crisis has become inescapable. A crisis brought on by structures of global terror and local boredom now finds that neither distinction holds: the global and the local are increasingly indistinguishable; and at the same time, terror (the uncontrollability

of affect) has become boring while boredom (the absence of affect) has become terrifying. The end of the world has become a requisite conversation topic and everyone has their own local evidence of the impending disaster. The postmodern sensibility articulates the uncertainties that many people feel, the fact that life *does* feel different.

I want to describe the world according to this sensibility, although it still remains only one dimension of our lives, and it still defines only one sensibility among many. If history depends upon a rational narrative which gets people from the past to the present (and, one hopes, to a future), it does seem that history is no longer available. Surrealism—the absurd, the horrific, the contradictory—defines the decor of everyday life. It is not merely that people are reasonably afraid: because all the scenarios for the future are at best depressing, or because everything is dangerous (AIDS makes sex deadly, radon makes the home deadly); or because they have lost their faith in any meaning, value or authority which could make sense of reality; or because they live with a constant uncertainty about their personal identities and possibilities. After all, presumably, every age has had its own terrors. It is more that such emotional terrorism has become part of the infrastructure of everyday existence. The commonplace has become dangerous and this edifice of terror defines the only collective sense of direction: whatever you are doing, you would be scared (or cynical) if you knew the truth (a lot of knowledge can be an emotionally dangerous thing), or if you just wait a little longer (tomorrow is the last day of somebody's life). Perhaps the most terrifying thing is that one is not terrified by the terror; people are not driven mad, although, increasingly, everyone seems to agree that everyone they know is going crazy in some way. After all, if every story is irrational, then so is the one they are living. Nightmares become fantasies, the only source of pleasures. In the end, the only possible story is the one that does not let you take any story too seriously. Hopelessness has become the new (and perhaps only) source of humor because life itself feels threatening: "More than any other time in history, mankind [*sic*] faces a crossroad. One path leads

to despair and utter hopelessness. The other, to total extinction. Let us pray we have the wisdom to choose correctly."[6]

What does it mean when the only way people have to make sense of their lives is that they are oppressed by history itself. The future looks uncannily like the present and the present is already depressing. In a *Bloom County* cartoon depicting the "premature arrival of the future" (Toffler), Binkley finds himself "all dressed up with no place to go." Binkley, whose stories often involve visits from his nightmares hiding in the closet, is confronted by his worst nightmare yet: he is visited by his future self and shown his future:

> Young Binkley: We married Lizzie "The Lizard" Blackhead?
>
> Old Binkley: We call her "Queen Elizabeth." Now come . . . follow me into your future world, younger self. . . . This ugly little dwelling is our house. We call it "Binkley Manor." We moved here in 1998. That's our '93 Volkswagon. We call it our "Little Lamborghini." It's all our way of somehow dealing with the mediocrity of our adult life. . . . And the failed dreams of our youth. *Your* youth.
>
> Young Binkley: Hey . . . there's a gopher wetting on my foot . . .
>
> Old Binkley: *Bad dog, Rambo . . . Bad dog!*[7]

There is in this, like so many other contemporary statements, something that rings depressingly true. Binkley will have to face the next morning and, despite the terror and pessimism, find a way of negotiating his way into the future. Are we so different? One evening in 1989, a CBS national reporter finished the news by pointing out that "time was in this country when you knew what you could count on." He then proceeded to describe all of the things that have fallen from grace: motherhood, the flag, even apples (referring to a recent panic over chemicals sprayed on apple crops). He continued, "It used to be so simple—just don't do too much of this or that. . . . Listen to the experts and you'd think the sky is falling. It isn't, it's dissolving." As the screen dissolves to the local news, the anchorman laughs: "I'm just so depressed." What can you do? Go to happy hour? No, go to an "attitude adjustment hour."

People are more than capable of recognizing that there is something "sick" about many of their cultural tastes. If they had been produced in the 1950s, the producers of such cultural texts (as well as those who consume them) would certainly have been judged either madpersons or geniuses. Such "postmodern" statements are located elsewhere: on T-shirts, buttons, records, advertisements, movies and television, but also in concrete choices, self-accounts, practices, relationships and commitments. They are simultaneously ironic and cynical, celebratory and horrified, like Crocket's admission that "I get these occasional urges for stability in my life"; or T-shirts that proclaim: "Life is hard and then you die," or "It's hopeless but not serious," or "I like it better on the other planet"; or the marketing firm whose logo is "Fake it till you make it." Postmodernity's statements exhibit an ironic, knowing distance, coupled with a sense of emotional urgency. The problem is to identify what is unique in them and to understand the historical conditions which have enabled and magnified the popularity of such statements.

It is not merely the atomic bomb and the threat of nuclear holocaust that is at issue here. The possibilities of the last cause have so proliferated (and continue to do so) that one can never escape the news of the impending (and often self-imposed) doom. That threat is increasingly personalized as the fact of terrorism and random death become taken for granted events. Any single event might reasonably define a narrative of fear and opposition; but collectively they have a different effect. As various fables of death continue to appear with increasing rapidity, the stories (images) themselves become banal, as clichéd as every other social reality. The images of social destruction on a planetary scale created in the 1950s and 1960s (whether through nuclear holocaust or the childishly mechanical post-holocaust monsters and space invaders) are so many clichés of an innocence which can only belong to some strange other. Instead, the end can only be written in an ironic and gruesome destruction of the body. It is not merely that people's tolerance for horror and violence has expanded (it has) but that they demand increasingly realistic representations of heretofore unimaginable possibilities. A Halloween episode of *The Cosby Show*, that bastion of middle-class

normality, had Cosby shopping for "scary" party props. All of his purchases were greeted with utter indifference by his children until he pulled out a power saw he had purchased for himself. *Texas Chain Saw Massacre* has become a children's story; its gruesome realism the only necessary proof of its validity. Everyone is at least a little worried that Freddy or Jason lives next door, or is coming to the same restaurant.

In these contemporary visions of horror, reality is made up of unpredictable and inexplicable acts of carnage, wrought by the most mundane monsters without motivation or blame upon hapless victims whose only mistake was being alive. The contemporary vision of horror denies both the viability of resistance and the possibility of escape. Life is a slapstick comedy played out in a minefield. This goes beyond the experience of being "damaged by the recent past and uncertain about the future."[8] History—both past and future—is neither rejected nor challenged; it is seen to be simply irrelevant, an unfortunate but inevitable entanglement with the "cultural debris" of others' lives. As a fictional Vietnam vet says, "You can't learn from the past. The main thing you learn from history is that you can't learn from history. That's what history is."[9] It is the irony of this that is troubling: the vet's claim is both paradoxical and, at the same time, so obviously right. Even the possible acts of redemption are always revealed as destructive: not only are we destroying the planet, but every day we learn that the ecologically proper alternatives (e.g., biodegradable plastics) create new problems while failing to actually answer the old ones. What once appeared to be better for you (e.g., decaffeinated coffee) is not revealed to have its own dangers. That terror extends to all aspects of life: as the new *Entertainment Weekly* (which is advertised as the "postmodern Farmer's Almanac") seems to demand, we must now ensure that even our leisure choices are "mistake-free." After all, who knows what the consequences could be?

Reality seems to have disappeared into its images or perhaps more accurately, the difference between reality and image seems not to make a difference. You don't need to have a car phone for status, you just need to look like you have one. The difference between

them has disappeared and they have become equally effective. The latest movie sets (e.g., *Batman*, *Dick Tracy* and even *Roger Rabbit*) all depend on people's inability or unwillingness to distinguish reality from the comics. It is not that reality has no meaning, but that it has any meaning they give to it. A promo for the Cable News Network justifies 24-hour news "because nothing is more touching, more shocking, more dramatic than real life." A promo for *Late Night with David Letterman* proudly describes itself as "an hour of celebrities talking about themselves constantly interrupted by commercials. Hey America, the pride is back." It is not a question of how the media represent reality, only of the means by which they construct the images which increasingly replace the sense of familiarity with reality. Think of the common experience of seeing a news report and vaguely remembering having seen it before as a television movie, only to see it again as a television movie and vaguely remember having seen it on the news. Which is the real, the original? At best, "you have to make allowances for the fact that everything we see tonight is real."[10] Even intellectuals have to conclude that "reality is the set of statements too costly to modify."[11] Images are often more important, if not more real, than reality. Reality is measured by the images on television: Ollie North is a hero because he looks and acts like a hero, despite people's rejection of his beliefs and actions. When the set of *Cheers* is offered as a Boston sports bar during the World Series, no one is fooled; no one finds the technique deceptive because in fact that is what a Boston bar looks like. And when Geraldo Rivera hosts a documentary on drugs—*American Vice*—built around live coverage of "real" drug busts which were planned, staged and even orchestrated for their visual power on the program, no one objects; no one seems to find this a rather odd extension of American justice. Images are so much more comfortable; reality is so constraining. A spectator at FarmAid complained that it was a P.R. hype. A friend responded that "the whole world's a P.R. hype." The American dream was first transformed into suburbia as the media's image of the "good life" and now into a designer label—its own medium, something which is simultaneously available to everyone but unavailable to many.

Similarly, what once was thought of as an "identity crisis" has become an advertising slogan: "Is there a real me or am I just what you see?" Or more accurately, the question Who am I? seems to have become either Who am I to judge? or Where am I? as if one can no longer invest in any stable identity. David Leavitt describes his generation (college students in the 1980s) by declaring, "At least we don't pretend we're not wearing costumes. . . . At least [we're] not faking it."[12] What they are not faking is the fact that they are faking. It doesn't matter what you are but what you are not. "If we are without passion or affect, it is because we have decided that passion and affect are simply not worth the trouble. If we stand crouched in the shadows of a history in which we refuse to take part, it is because that's exactly where we've chosen to stand."[13] After all, "characterlessness takes work. It is defiance and defense all at once."[14] Burger King's proud proclamation that modern people have a different style and attitude for every day (and of course, a different sandwich to go with it) is the mirror side of AT&T's celebration of the fact that "I hate to follow rules." Radicalism has become the basis of stardom, and history has become a bestselling game.

Living in this historical condition does not render people passive; or perhaps, it defines a form of active and even aggressive indifference. People must always ironically remove themselves from the very idea of commitment. As Richard Goldstein claims, "Postmodern lovers are as prudent about displaying commitment as their parents were about showing wealth."[15] Even contemporary advertisements often rely on the "selling of unbelief." Describing students' response to such ad campaigns (e.g., Joe Isuzu, Bartles and Jaymes), a teacher writes: "They don't have to make any commitments; they don't have to listen closely; most importantly, they don't have to believe anyone. And the only thing better, it appears, is to get them to laugh at the idea that anyone would even try."[16]

In this postmodern condition, one acts but with minimal expectations (often coupled with maximal desires): "This is a generation that inherited the cry, 'I can't get no satisfaction.' And they live its contradictions, grabbing at satisfactions while rejecting the possibility itself. It's a punk method, nihilism constructed punishingly with the

tools of consumer passion."[17] Postmodernity demands that any action be defined cautiously, located within a personal cost-benefit calculation: "Seek small passions. Big ones are too risky."[18] The only viable philosophy of life says, "Don't sweat the small stuff" and "It's all small stuff."[19] It works in a world in which even the smallest stuff makes you sweat (e.g., driving to work, eating Girl Scout cookies or even growing up), but it works, not by simply escaping from the real but by recognizing that, in reality, it makes no difference.

The devastating impact of the divorce rate on the experience of contemporary youth has to be juxtaposed with their continuing histories of love, like Chloe in *The Big Chill*, who characterizes her relationship with a residual countercultural suicide victim as "wonderful. I had no expectations and he had too many." While people seem to "revere the model of the nuclear family, they don't live it."[20] And when they do, it is against the background of the assumption of divorce as a normal if not likely outcome. They maintain their own individual ability to escape the norm, but they are confident that others will not escape it and, if pressed, are likely to admit the precariousness of their own confidence. As "The Rolling Stone Survey: Portrait of a Generation" put it:

> Remarkably those polled expressed a strong sense of personal contentment. Sixty-one percent said they are quite or extremely satisfied with their lives. The vast majority of them—regardless of race, age, sex, income, marital status or political ideology—said, to varying degrees, that they are optimistic. . . . But a closer look suggests this is a generation at odds with itself. Pressed on specifics, they express concern about subjects ranging from the quality of family life to disillusionment with their own high expectations for themselves. Their avowed optimism, in the face of their specific concerns, resembles a refrain from the Randy Newman song, "My Life is Good," in which the protagonist cheerfully ignores all evidence to the contrary.[21]

People do seem to prefer more traditional forms of behavior where, like retro and New Wave fashions, the rules, the stakes and the artificiality are all the more evident. These images are more ambiguous and less constraining on our lifestyles precisely because they are so obviously unreal.

People act increasingly on the basis of a strategy defined by ambivalence and irreverence. "Ambivalence toward life is their only myth, their only dream, the only context in which they can find comfort."[22] One always hedges one's bets, holds back a little. As Madonna says about her own act, "It's not insincere—you just can't take it seriously."[23] The Pet Shop Boys sing songs knowingly confronting the fact that they are condemned: "Everything thing I've ever done, everything I ever will do, it's a sin."[24] But rather than choose to suffer, they reaffirm their life: "I love you, you pay the rent."[25] A perfectly reasonable approach to love in the 1980s! It's all right to invest yourself in something as long as you realize that there is really nothing to invest. You play the game for whatever the stakes, without taking either the game or the stakes too seriously (although seriousness is a perfectly acceptable game to play as well). A transfigured notion of your own subjectivity makes originality and authenticity into another act, but no worse for it (e.g., *Putting on the Hits*, in which people lip-synch hit records; the first major "new romantic" hit in America was the Human League's "Love Action:" "I believe in the truth though I lie a lot. No matter what you put me through, I'll still believe in love"[26]). Everything becomes a game: "Transcendence may sound silly, but I'm ready to try something new."[27] Everything can be taken seriously and simultaneously, made into a joke.

> This is the era of the permanent smirk, the knowing chuckle, of jokey ambivalence as a way of life. This is the irony epidemic . . . [It] does not celebrate or savage; it does not get its hands dirty . . . [It] is about avoidance . . . [It] lives in terror of becoming . . . *anything*. . . . If everything is a pose, a sitcom riff, then you're still a kid, just goofing around.[28]

Such irony affirms difference by reaffirming that everything is the same, by making everything even more the same, leaving the present behind by entering into it more fully. Becoming an object is a way of resisting the constant demand to reaffirm one's subjectivity (e.g., recent slogans like "Born to Buy" and "If you can't take the heat, order a pizza" [Lifetime Network]). Or "If you're sailing on the Titanic, go first class." This ambiguous slogan advocates a temporary

celebration of comfort, not because it is intrinsically and transcendentally valuable, but because the end is inevitably coming. It advocates an individual search for victory, but leaves open the possibilities of other's victories, and even of one's relations to them. It is the simulacrum of a politics in the image of a struggle within daily life for both survival and victory. There are no identifiable enemies and no grounds for confidence in the possibilities of change. Yet one feels threatened, under constant attack, simultaneously antagonistic and powerless.

Even pleasure and desire have become a risky business, and the demand for them appears ultimately as unreasonable as any other. "To be modern is to be hard-edged, coolly aggressive; to celebrate the synthetic and the artificial; to reject softness and easy intimacy and fuzzy-headed visions of what life has to offer; to feel the pull of polarization in every fiber."[29] For neither pleasure nor desire can last for very long: "People want to know everything about sex . . . except the possibility that desire can endure."[30] After all, in the 1980s, all pleasures were guilty pleasures and "all of our excesses were conducted in the shadow of some impending calamity."[31] Perhaps the only pleasure left is to "put your best face forward and plot your revenge."[32] There are obviously many reasons why pleasure and desire (libido) have become threatening: the apparent failures of the counterculture and its attempt to create an ideology out of pleasure and desire; the important successes of feminism in pointing out that libidinal relations, like gender relations, are overcoded by relations of power; the major redistribution, sometimes involuntarily enforced, of the relations of labor and leisure; and, most recently, the appearance of a number of diseases (most spectacularly, AIDS) associated with sexual relations. We are thus increasingly suspicious of any object of desire, as well as of desire itself. Increasingly, the libido has become the enemy, not only for the new conservatives who seek to attack such pleasures, but for those who are drawn to them as well: "Sex is now a conceptual act; it's probably only in terms of the perversions that we can make contact with each other at all. The perversions are completely neutral, cut off from any suggestion of psychopathology—in fact, most of the ones I've tried

are out of date."[33] Sex has become a terminal illness, perverse in its very pleasures. As *People* magazine put it, "Too frightened to make love, we made war."[34] Or, more accurately, we cheered others going off to make war. For this is not a space in which people seek risks or seek to live on the edge. It is rather a space in which people seek to feel the thrill without the reality because the reality of the edge threatens to make the thrill itself too real and too dangerous. As Glenn O'Brien suggests, it is enough to know someone who lives life on the edge and who is only a phone call away.[35]

A recently popular "book of freaks"—contemporary freaks are defined by neurological deficiencies and excesses—offers a wonderful metaphor for the postmodern condition. Mr. Thompson, a patient with radical amnesia, suffers both the tragedy and exuberance of life in postmodernity:

> He remembered nothing for more than a few seconds. He was continually disoriented. Abysses of amnesia continually opened beneath him, but he would bridge them nimbly, by fluent confabulations and fictions of all kind. For him they were not fictions, but how he suddenly saw, or interpreted, the world. Its radical flux and incoherence could not be tolerated, acknowledged, for an instant—there was, instead, this strange delirious, quasi-coherence, as Mr. Thompson, with his ceaseless, unconscious, quickfire inventions, continually improvised a world around him. . . . For Mr. Thompson, however, it was not a tissue of ever-changing, evanescent fancies and illusion, but a wholly normal, stable and factual world. So far as *he* was concerned, there was nothing the matter . . .
>
> Such a patient *must literally make himself (and his world) up every moment.* . . .What saves Mr. Thompson in a sense, and in another sense damns him, *is* the forced or defensive superficiality of his life: the way in which it is, in effect, reduced to a surface, brilliant, shimmering, iridescent, ever-changing, but for all that a surface, a mass of illusions, a delirium, without depth. . . . Under his fluency, even his frenzy, is a strange loss of feeling— that feeling, or judgment, which distinguishes between "real" and "unreal," "true" and "untrue," . . . important and trivial, relevant or irrelevant. What comes out, torrentially, in his ceaseless confabulation, has, finally, a peculiar quality of indifference . . . as if it didn't really matter what he said, or what anyone else did or said; as if nothing really mattered anymore . . .

> For William—with his brilliant, brassy surface, the unending joke which he substitutes for the world (which if it covers over a desperation, is a desperation he does not feel); for William with his manifest indifference to relation and reality caught in an unending verbosity, there may be nothing "redeeming" at all—his confabulations, his apparitions, his frantic search for meanings, being the ultimate barrier *to* any meaning.[36]

This case study could have been written by a postmodernist, albeit one with a strong sense of nostalgia for what has been lost. It would then tell the story, first of contemporary social and historical existence and only secondarily of an experiential reality. But despite the author-neurologist-therapist's continuing commitment to a lost humanism (in which we all have our own true and coherent stories), he classifies Mr. Thompson's disorder as one of excess rather than loss or tragedy because Mr. Thompson does not know the difference. But would it matter? In another story of excess, Mrs. B. completes the postmodernist tale:

> "I know the difference, but it means nothing to me . . . *Nothing means anything* . . . at least to me."
> "And . . . this meaning nothing . . ." I [Sacks] hesitated, afraid to go on. "This meaningless . . . does *this* bother you? Does this mean anything to you?"
> "Nothing at all . . ."[37]

Sacks, the author, describes her condition: "Her world had been voided of feeling and meaning. Nothing any longer felt 'real' (or 'unreal'). Everything was now equivalent or equal—the whole world reduced to a facetious insignificance."[38] Speaking of a similar patient, Sacks describes her response, one remarkably similar to Mr. Thompson's: "She speaks very quickly, impulsively, and (it seems) indifferently . . . so that the important and the trivial, the true and the false, the serious and the joking, are poured out in a rapid, unselective, half-confabulatory stream. . . . She may contradict herself completely within a few seconds."[39]

Just as, in a real sense, these patients do not "experience" their condition, so too postmodernity does not refer to an experience per se, nor to a structure of consciousness, for this simply hides the real

effects of the postmodern sensibility. Postmodernity is a story about the historical collapse of specific relations within everyday life, about the "fact" that certain differences no longer matter. It is not that everything has been reduced to a single plane, but that the articulations between the planes are beginning to disintegrate. Each plane becomes increasingly indifferent to the others—affective organizations, ideologies, libidinal economies. That indifference is not a matter of some metaphysical reality but of one of the ways in which people live in historical reality. This collapse of difference is real in that it has specific effects, but it is not their only reality, nor the totality of their lives. Nor is it merely a description of the ways people interpret their lives. To speak about postmodernity as if people experienced it already brings it back into maps of intelligibility and meaning, already makes it signify as if its indifference were always meaningful. Undeniably, postmodernity can be articulated with certain experiences of both texts and events, but it can be articulated elsewhere as well, for example, to the economy (as in Black Monday). For in the last analysis, postmodernity points to a sensibility which responds to and constructs a different set of articulations and a different set of possibilities for organizing and living everyday life.

The postmodern condition manifests the increasingly distant and precarious relations between affect on the one hand and ideology and desire on the other. It reflects the historical appearance of an expanding series of ruptures or gaps between these planes, between the available meanings, values and objects of desire which socially organize our existence and identity, and the possibilities for affectively investing in them. This goes beyond the increasing difficulty, and even the impossibility at certain moments, of making sense of our affective relations or of putting any faith in our ideological constructions. It is not the content of common sense that is at issue but its place in our everyday lives. People do not trust their common sense even as they are compelled to live it. It is increasingly difficult to locate places where it is possible to care about something enough, to have enough faith that it matters, so that one can actually make a commitment to it and invest oneself in it. Whatever the reality of such perceptions, the future has become increasingly uncertain (and

its images bear a striking resemblance to contemporary Beirut!). It has become increasingly difficult, or perhaps irrelevant, to differentiate between reality and its images, and most of the traditional values and pleasures (love, family, sex) which may have given people's lives some meaning or purpose have become treacherous traps which never seem to deliver on their promise.

Postmodernity, then, points to a crisis in our ability to locate any meaning as a possible and appropriate source for an empassioned commitment. It is a dissolution of the "anchoring effect" that articulates meaning and desire to affect. It is not merely a recreation of the split between thought and feeling so commonly blamed for the ills of Western society by generations of intellectuals. Nor is it, as Jameson has claimed,[40] a waning of affect but rather, an inability to anchor our will in something else. It is not that nothing matters— for something has to matter—but that there is no way of choosing, or of finding something to warrant the investment. The nascent postmodernity of the 1950s was contained by its articulation to a generational struggle, but that has given way to an explicit struggle between two planes, one defined ideologically, libidinally and subjectively (after all, the conscious and the unconscious are the product of the same history), and the other defined by the affective sense that life can no longer be made sense of.

Postmodernity signals a new cynical relationship to the ideological. The notion of mystification is central to ideology, and too quickly surrendered in the rush to deny the elitism of many versions of Marxism: "They don't know it but they are doing it anyway."[41] That is, ideology entails a gap between one's beliefs and one's actions. People know how things really are, but they act, for example, as if they had mystical beliefs (e.g., in capital as universal value). But there is, increasingly, a cynical logic operating in the realm of contemporary ideology because the gap has disappeared into another gap. People know what they are doing but they continue to do it anyway. They are aware of ideological mystification, but since they have no grounds to question their investment, they feel free to enter into it. Such investments of course no longer confer the status of naturalized, necessary and universal values on ideological positions.

The distance between belief and action is absorbed into the gap between affect and ideology. One simply refuses to take any ideological position too seriously. In fact, the only real evil is believing in something too seriously, whatever its politics. Still, postmodernity cannot be located entirely in the gap between affect and ideology, for, as I have already suggested, it points as well to the gap between affect and desire, and to that between ideology and desire where, increasingly, ideology as the systems of meanings and beliefs seems incapable of disciplining desire, thus weakening the walls that separate fantasy and behavior.

It is likely that many of the "markers" of postmodernity (e.g., the fragmentation of identity) have characterized other periods as well. But I believe that in the past it was possible to respond by constructing an affective unity around specific ideological terms. This strategy is no longer available, and it is this which has called postmodernity into existence. If life has always been to some extent incoherent, the question is precisely whether and how one manufactures lines between the fragments. While affect has traditionally functioned as the energy which mediated and linked the fragments, it is its ability to construct such effects which is historically disappearing. The new status of the affective as the unrepresentable defines the postmodern rupture. Or rather, the effect of the postmodern sensibility is precisely to reinflect the context people cannot live. It is not a crisis resulting from the fact that people's "mattering maps" no longer correspond to the available maps of meanings. Meaning and affect—historically so closely intertwined—have broken apart, each going off in its own direction. Each takes on its own autonomy, even as sanity demands that they be reintegrated. Of course, the gap is never complete and stable, but always multiple, mobile and temporary, like the contractions and expansions of the ozone holes that present one of the scenarios of contemporary doom. Even the promise of "sex and drugs and rock 'n' roll" has given way to "romance, rejection and rock 'n' roll." People are condemned to live out an impossible relationship to their own experience, "doomed to speak about life in structures contrary to [our] experience."[42] Any investment becomes suspect: caring about anything, if not entirely impossible, is always

too easy (to be real) or too dangerous (to be desirable). Compare Jack Nicholson and Dennis Hopper. The former, an icon of the 1970s, was always invested in a mission, always in search of a cause (even as The Joker in 1990). The latter, an icon of the 1980s, seems to function as pure intensity or affect. In a similar vein, we might understand "love in the '80s" as an intense investment without the ideological framework which would enable us to make sense of the experience and legitimate the commitment.

Thus, postmodernity refers to the changing nature of the articulation between the different planes of life. However cynically, the contemporary formations of ideology and desire remain committed to their own systems of difference and to the fact that these differences matter. On the other hand, without the anchor of affective investments, such differences cannot matter. Without these articulations, it doesn't matter what matters for, in the end, nothing matters. The postmodern dilemma then can be described in terms of the need to make something, anything, matter; to care about, to make a commitment to, something. But now this must be accomplished outside of the social systems of difference, through an affective indifference. Its difference, the site of its own investments, must be defined without a system of identity and difference. It is not that we have entered a new time or the end of history, nor is it a question of the accuracy of such representations. Postmodernity is not a representation of external reality. It is an active player, a discursive sensibility, changing the possibilities of experience and everyday life.

THE POSTMODERN SENSIBILITY

The sensibility of postmodernity defines a logic of "ironic nihilism" or "authentic inauthenticity" (not to be confused with inauthentic authenticity). By calling it a logic, I mean to mark the fact that it is not an ideology: it is not so much a resource within the rock formation as a rearticulation of it. Within this logic, a cultural practice renounces both its claim to represent reality and its place in a representational economy; its value is no longer that of the real or the imaginable—whether fantasy or utopia. It does not provide rules

for learning because the question of its credibility (or incredibility) is irrelevant; narratives, when present, go nowhere. These are no longer situations people can imagine themselves into, despite the fact that all situations are personalized and presented as if they were ideologically related to their own lives (i.e., the characters are often "just like us," yet fantastically different). Within this logic, cultural practices refuse to make judgments or even to involve themselves in the world. Authentic inauthenticity starts by assuming a distance from the other which allows it to refuse any claim or demand which might be made on it. This "hip" attitude is an ironic nihilism in which distance is offered as the only reasonable relation to a reality which is no longer reasonable. Popular culture, however unreasonable (and it certainly is strange these days), is as reasonable as reality. In fact, reality is already stranger than any fantasy. And consequently, the strange is always disturbingly familiar. This estrangement from the familiar and familiarization of the estranged means that the lines separating the comic and the terrifying, the mundane and the exotic, the boring and the exciting, the ordinary and the extraordinary, disappear. If reality is already clichéd, the clichés can be taken as reality. If people are totally alienated, then alienation is the taken-for-granted ground upon which they build their lives.

The fact that all images become equal, that all styles are temporary and likely to be deconstructed even as they are celebrated, and that perhaps everything is an image, does not necessarily negate the necessity and importance of images. But it does deconstruct the inherent possibility of investing in any single image. Authentic inauthenticity is in-different to difference. It does not deny differences; it merely assumes that since there are no grounds for distinguishing between the relative claims of alternatives, one cannot read beyond the fact of investment. To appropriate, enjoy or invest in a particular style, image or set of images no longer necessarily implies any faith that such investments make a significant (even affective) difference. Instead, we celebrate the affective ambiguity of images, images which are "well developed in their shallowness, fascinating in their emptiness."[43]

With this logic, one celebrates a difference knowing that its status

depends on nothing but its being celebrated. In the end, only the affective commitment, however temporary or superficial, matters. Authentic inauthenticity, as a popular sensibility, is a specific logic which cannot locate differences outside the fact of its own temporary investment. If every identity is equally fake, a pose taken, then authentic inauthenticity celebrates the possibilities of poses without denying that that is all they are. It is a logic which seeks satisfactions knowing that they can never be satisfied, and that any particular pleasure is likely, in the end, to be disappointing. For even if all images are equally artificial, and all satisfactions equally unsatisfying, people still need some images, still seek some satisfactions. Although no particular pose can make a claim to some intrinsic status, any pose can gain a status by virtue of the commitment to it.

Difference is relocated so that only affect matters. And all images, all realities, are affectively equal—equally serious, equally deserving and undeserving of being allowed to matter, of being made into sites of investment, of being incorporated into mattering maps. If the equality of all images assures a perpetual search for difference, the irony of this sensibility ensures not merely the impossibility but the absurdity of such difference. That nothing matters itself does not matter! But this "nihilism" is always inflected by its affective knowledge that the only possibility for difference is in the fact that something—it does not matter what—matters. Or, more accurately, the only difference that the specific content makes is that, because it matters, it makes a difference. All that can matter, in purely affective terms, is the quality and quantity of mattering itself. It is not surprising, then, that so many of the most successful images and heroes of the 1980s depend solely on an affective power. As a recent billboard advertising Geraldo Rivera's show decried: "Passion at 5!" Oprah Winfrey and Mort Downey, Jr., despite their significant differences, are both adept at cutting into the affective moods of their audiences.

There are no hidden truths within authentic inauthenticity. Any secret is instantly available and constantly repeated for any viewer. The only secret is the irony that there are no secrets because there is nothing behind the screen, nothing written upon below surfaces. While this doesn't guarantee that everyone will "get it," its elitism

does not depend upon constructing a privileged audience, for it is not a question of its limited availability but rather of the irony and fragility of the appropriation itself. Its "hipness" is democratic and, in a sense, unimportant. Secret knowledge is dissolved into the distinctions within public taste. But these distinctions are themselves as tenuous and undeserving as any other image. Authentic inauthenticity, then, undermines the very possibility of a privileged marginality which can separate itself from and measure itself (favorably) against an apparently homogeneous mainstream. It marks the collapse, or at least the irrelevance, of the difference between the authentic and the inauthentic. It signals the absence of alternative spaces: we are all in the same space, already coopted.

There are real and important differences within the possibilities of authentic inauthenticity, different strategic relationships to any particular affective investment, different ways in which difference can be marked affectively. I want to distinguish four such variants (although there may be more): ironic, sentimental, hyperreal and grotesque inauthenticity. These different articulations of the postmodern sensibility are an integral part of the contemporary diversity of the rock formation.

Ironic inauthenticity is perhaps the most pervasive strategy. It is the most purely ironic, celebrating the fleeting moments of its temporary investments. It refuses to make any distinctions between investments on any basis, either qualitative or quantitative. Although it seems to celebrate the absence of any center or identity, it actually locates that absence as a new center. That is, it celebrates the fragmentary, the contradictory, the temporary. And it celebrates them with all the seriousness (or lack of seriousness) that is necessary. It can take everything equally seriously or equally humorously because the difference is less important than the temporary construction of an image of the center. David Letterman, Pee Wee Herman, Madonna, all invest themselves in the image, but the image itself is unimportant. What is important is the fact of the investment itself, with no claim beyond that. For example, while Madonna's music is the sign of her investment and the vehicle of her success, it is neither the sign nor the vehicle of her popularity. While a number

of critics have recently argued against readings which focus on her image rather than her music,[44] it is worth pointing out that the music is entirely taken for granted, its production erased, in Madonna's documentary of her tour *Truth or Dare*. Neither the band nor the engineers are ever introduced or even visible, nor are they included in the preconcert "prayer meetings." The film—Madonna's "post-modern" denial of the difference between public image and private self—is about fashion and movement, costumes and dance. It doesn't matter what image one takes; take any image and live it for as long as you want. It is the construction of any identity as absolutely real and totally ironic. One can deconstruct gender at the moment of celebrating it (and celebrate it precisely because one can deconstruct it). One can take on an identity predicated on the deconstruction of identity itself (cyborgs such as Max Headroom).

The point is not to invest in the ideological consequences of particular images, but the fact is that one must inevitably invest in some images, regardless of what they are. HBO can construct a presidential candidate who becomes indistinguishable from the real candidates (*Tanner*), while MTV offers us a series of ads promoting Randee (the imaginary leader of an imaginary rock group, Randee and the Redwoods) for president. His entire media campaign is composed of clichéd paradoxes: e.g., Randee at a press conference says that he was misunderstood when he said that "first there is a mountain, then there is no mountain, then there is." He points out that he did not mean to say that there is no mountain. "There is one," he says to thunderous applause. "And after I'm elected, there will be one." Feeling something, anything, is better than feeling nothing. Living some identity, however temporary, is better than living none. And the choice may have little relation to the signifi-cance of the identity itself. It merely refers to its temporary ability to mark some affective difference and distance. Ironic inauthenticity celebrates its own investment in the image precisely because it is self-consciously taken as an image, no more and no less. In the end, crocodile tears are as good as real ones, perhaps even better because they require no anchor in the real in order to be effective. Of course,

if one fails to see the irony, one is left with only the despair of illusions and lies, a depoliticized nihilism.

The second strategy, sentimental inauthenticity, begins with the inability to distinguish the relative merit of any site of investment. One does not, and cannot, trust the content of an image, identity or activity, even the most temporary and ironic one. Certainly, this cannot mark any difference; certainly, it does not mark any difference in a world which has increasingly appropriated ironic inauthenticity. Yet sentimental inauthenticity celebrates the magical possibility of making a difference against impossible odds. What enables that possibility is not any specific affective investment but rather the intensity, the quantitative measure, of the investment itself. Cultural practices become merely the occasion for a temporary but intense affective investment, for a constant movement between emotional highs and lows. Such investments need not be located in the possibilities of people's lives, nor even in the believability of someone else's. Heroes can accomplish the fantastic within the conventions of realism. For example, it is becoming increasingly common (e.g., *Crime Story*, *The Predator*) for individuals, whether good or bad, to survive atomic blasts, without any suggestion that this is a real possibility.

Such practices become the occasion of an overindulgence of affect. The particular investment is liberated from any significant anchoring in reality or intelligibility. It is only the site of emotions that are experienced as more real because they are more extreme, more excessive. That the excess is constructed precisely through the unbelievability and unintelligibility of the message makes it all the more powerful. In such practices, people get to live out affective relations which exceed their lives and always will (perhaps because they will have already experienced them on television). It is as if it were only necessary to feel something more intensely than is available to them. While it is necessary to feel something—anything—that strongly, it is irrelevant what one feels because no particular feeling matters in itself. What matters is affective excess. Faulkner's poetic choice of grief over nothing has become culture's unquenchable

need, not only to never feel nothing, but to constantly raise the stakes by which feeling something—anything—is measured. The result is a democracy of affect which can only be traversed by an ever-spiraling search for an excessive affect necessarily divorced from the contingencies of daily life.

This strategy requires the absolute ordinariness of the subject: the heroes' only difference is that they care about something, that something matters to them so much that they are reidentified with and empowered by it regardless of what it is. This is a strategy which constructs images of victory, but the site and stake of the battle, or even whether one recognizes the moral rectitude of the hero, are irrelevant. Rather, the hero is just like us except that he or she cares about the struggle, believes in something to a degree which makes it beyond people's sense of their own realities. One wears one's affect, one's passion, on one's sleeve, and it is this which converts ordinary skills into magical victories. Such "ordinary heroes" abound in contemporary culture: Springsteen, Rocky, Reagan and Rambo come to mind. Sentimental inauthenticity is often the dominant strategy in many contemporary youth movies (e.g., *Top Gun*, *The Secret of My Success*, *Quicksilver*), so that whatever the ideology of the hero, their heroism is not tainted by the reality of their position. One need never agree with, or identify with, the particular content of a commitment; it can seem to be entirely trivial. One need only recognize that something matters so much that it can transform an ordinary individual into something heroic, if not superhuman. As Ellis explains, "Our coming of age in the 80's leaves us yearning for reassurance, gratification and the unearned glory in the freeze-frame that ends so many of today's movies. We want to be Tom Cruise characters—unambiguous winners."[45] The current popularity of the talk show host Mort Downey makes little sense apart from the sheer passion of his diatribes and attacks; he has no ideologically consistent position of his own. This strategy can even transform the events of everyday life. As an ad on MTV for a cassette of "skate-board culture" promises: "Psychoskate . . . where the terrain of everyday life becomes an adventure land of amazing proportions." Of course, the danger of such statements is that one can confuse the celebration of

the intense commitment with an identification with the content of the commitment, which often involves fairly traditional activities and values.

The third strategy, hyperreal inauthenticity, distrusts and often rejects the very fact of affect itself, not only the specific form of any affective investment. It is staunchly neutral, refusing affect itself. Its tone is bleak, its practice super-objective. Portraying a grim reality in all its dismal, gritty and meaningless detail, with no affective difference inscribed upon it, is the only statement possible. And it matters little whether that reality is contemporary or futuristic: all images have become post-holocaust because the true holocaust is the very destruction of any possibility of caring, of making a difference. In fact, affect has become impossible because the last site of potential investment—desire and pleasure—has become the enemy. Caring too much is dangerous and often destructive (*The Name of the Rose*) and desire kills (AIDS). There is no transcendence, no possibility of moving to a position outside of the grainy detail of reality. No narrative voice is capable of any judgment or discrimination. Thus, even the grandeur of existential meaninglessness is denied in favor of the sheer facticity of existence. Making a difference is no longer a matter of inserting oneself into even a temporarily privileged position; nor is it a matter of controlling a chaotic world. For there are no longer any guarantees that chaos is not more deserving of affective commitment than order. There is only individual survival and normality (however abnormal).

One sees this in movies such as *Star 80* (perhaps the precursor), *The River's Edge, Full Metal Jacket, The Boys Next Door* and *Blue Velvet* (although this last is perhaps also surreal), and television programs like *The Max Headroom Story, The Days & Nights of Molly Dodd* (at least as it has attempted to frame itself) and *Miami Vice* (especially in those episodes in which the cops confront the impenetrable machinations of the multinational/government apparatuses, or in which romantic involvements always end in Peckinpah-type killings). But it is perhaps most visible in a new generation of ads and promotions (e.g., Jordache's film noir ads, Converse's scene of a young couple breaking up, and MTV's promo in which a young

yuppie woman in front of a computer contemplates all those people younger than her who have accomplished something and asks, "What do you do when you realize you aren't going to change the world?").

The final strategy I want to describe is grotesque inauthenticity. In such practices, the only allowable affective investment is a negative one. That is, one celebrates the terrifying, the destructive, the horrific. Reality becomes a meaningless and dangerous place in which the only possible response is to further attack the last vestiges of meaning and pleasure so that nothing but the sheer spectacle of a negative affect remains. Grotesque inauthenticity delights in the threat to normality. Normality can be located in domesticity, community, public spaces (e.g., the city) or everyday life. Such sites of normality are all going to be destroyed anyway and presumably they deserve it (although one cannot say why). The threat itself is no longer defined by some monster which does not belong on earth, nor by some flawed human (e.g., *Psycho*), nor even by some menace of our own making (e.g., *Them*) which really has no interest in humans but will likely replace us. Rather, the grotesque threat comes from within the spaces of everyday life, without explanation. In fact, there cannot be a reason which could account for the level of the threat itself. Reality itself has become the only justification possible, and all that it can justify is nihilism. Jon Crane describes some of the parameters and assumptions of grotesque inauthenticity in the contemporary horror film:

> The horrific constructs available do not offer any possibilities beyond that of being able to confront terror. The engagement with such images is neither cathartic nor reassuring. . . . Watching a horror film is a reality check. . . . For the horror film, and everyday life, today is the last day of the rest of your life. . . . [The] truly repellent creatures do not come from outside our nebulous social networks; . . . They are us, and we never know when we will act as monsters. . . . The central operation of contemporary horror films, the inexorable splintering of meaning [of the body and of any site which purports to remain "good" or valued] is abetted by some standard codes which help organize meaning's demise: . . . All collective action will fail; knowledge and experience have no value when one is engaged with the horrible; the

destruction of menace, should it occur, carries no guarantee that the future will be safe: the menace will return.[46]

Horror films are only the most obvious site of this celebration of negative affect. Grotesque inauthenticity makes the very site of "gore"—the more realistic, the better, even if people know it is produced by special effects—the most important moment of many texts, even rendering the narrative and the characters irrelevant. It has recently entered television through such programs as *America's Most Wanted*, which, despite its supposed intentions of aiding the police, seems to end up celebrating the threatening possibilities of everyday life: your neighbor could be a wanted criminal. It also plays an important part in the new generation of comic superheroes in which the hero is simply a destructive, often paranoid killing machine (e.g., *The Dark Knight Returns, Elektra Assassin*), reducing all issues of justice and value to a question of who remains alive at the end.

Each of these strategies can be empowering, reconstituting the ability to make a difference when nothing makes a difference. Each enables a difference to be defined when there is no center to measure it against, to proffer strategies for being different predicated on the absence of difference. Each of them creates a series of images of stars who embody, not authentic instances of subjectivity and political resistance, or even ideological statements, but temporary moods which can be appropriated by fans as temporary places rather than as impossible identities. They offer strategies by which individuals can continue to locate themselves within affective maps, and continue to struggle to make a difference, if not in the world, at least in their lives, even though difference has become impossible and possibly irrelevant. Such strategies do not offer people positions as identities from which they can judge themselves and the world, but as places in which they can temporarily install themselves so that they can act, so that they can gain some control over their lives, so that they can negotiate the spaces between pain and comfort, between terror and boredom. What distinguishes them from one another is the ways they use affect as a strategy for enacting their own authentic inauthenticity, and perhaps even more importantly, the particular

possibilities opened by each. Sentimental inauthenticity is perhaps the most emotion-laden moment, but it constantly walks the edge of a certain nostalgia. Ironic inauthenticity is not only the most playful but the most disorientating as well, the statement of a certain luxury which denies the very need for places. Hyperreal inauthenticity is perhaps the most powerful statement of anger, and it is often filled with quite explicit attacks on the agents (e.g., corporations and governments) which have rendered the future obsolete. Finally, grotesque inauthenticity confronts the inescapable terror, a terror which perhaps could be mobilized in the attempt to escape the boundaries of everyday life.

ROCK AND THE POSTMODERN SENSIBILITY

The logic of authentic inauthenticity is foregrounded most visibly in the contradiction and conjunction of punk and disco which has resulted in the variety of forms referred to as post-punk or New Wave. In fact, all of contemporary rock has to be located in this conjuncture. In a reversal of the traditional privileging of rock over pop, these alliances are often self-conscious parodies of the ideology of authenticity; they make the artificiality of rock's construction less a matter of aesthetics than of image-marketing. In the end, rock, like everything else in the 1990s, is a business. The result is that style is celebrated over authenticity, or rather, that authenticity is seen as just another style. It has become increasingly important for performers and directors to incorporate signs of their ironic cynicism. Within the emerging languages of these formations, authenticity is no better than and no worse than the most ironically constructed images of inauthenticity. The notion of authenticity is constantly reduced to a signifier of the performer's place within the rock culture; it marks the generic investments of the performer and affirms his or her commitment to particular alliances within the rock formation. Even rap, which is often taken to be the last site of an affective authenticity, has to be located in the space between postmodernity and the imaginary community which it purports to, and may occa-

sionally, construct. According to Frith, rap is part of "a shared subculture of dressing up and strutting free, of house calls and designer charms. This is the performance of identity in which the face behind the mask (all those names) is just another mask."[47]

The contemporary rock formation involves the proliferation of authenticities: compare the various contemporary performers who might qualify as authentic rockers: Springsteen, U2, REM, Tracy Chapman, Sting, Prince, Public Enemy, Talking Heads and even the Pet Shop Boys. This signals new and contradictory notions of authenticity: e.g., Tracy Chapman's "authenticity" would seem to be of the rockist-folk kind, but the form of her success, and the fact that she has obviously been produced and marketed by and for commercial interests (which are not necessarily the same as her own intentions) seems to locate her authenticity elsewhere. Sting's "authenticity" is a purely sentimental category, through his recent identification with oppressed populations. U2's authenticity is an obviously staged appeal to the nostalgic possibilities of the ideology of authenticity, as they construct a community that no longer exists (and in fact never did). Even Michael Jackson can be granted a certain "soul" authenticity, located in his rhythmic and sexualized body, as he constructs a fantasy of the tortured individual struggling to transcend the conditions of his inadequacy.

Rock has always, at least implicitly, played with the idea of authentic inauthenticity. But its commitment to and celebration of youth and fun contained the effects of this postmodern sensibility. Rock can no longer rely on its articulation to youth. As youth itself has been rearticulated, rock has become

> a reflection of straight aspirations, a normative agent. The utopian dreams of youth culture have been excluded from the center stage, outflanked and outmoded. Dreams of transformation have shifted from the public to the private sector; personal transfiguration rather than collective revolution. Transcendence can only be momentary, tragically confined to the here and now.[48]

Rock's excess, the grounds of its affective power, is increasingly separated from its ideology of authenticity. The result is that while rock still matters, it no longer matters in quite the same ways. Or,

to put it differently, while rock is still different from entertainment, the difference doesn't matter in the same way. Increasingly, it is not so much that rock's difference matters, but rather the fact that it matters that defines its difference. I do not mean to assert that fans do not distinguish, within their own alliances, between authentic and coopted rock, but rather, that they do not invest the difference with any power of its own. While the music may still matter to them, it matters in a different way and its place in their lives is changing. If the ideology of authenticity is becoming irrelevant, then the difference doesn't make a difference; it no longer matters and one can, in very noticeable ways, become rather blasé about the configurations of rock taste.

In a recent column, Frith challenges the various views of the 1980s which begin with the contradiction between the "triumph" and the "death" of rock. The history of rock no longer can be convincingly constructed according to the traditional cyclical map. Such narratives, which often end up trying to localize the judgment—this triumphed, that died—fail to see that "the 1980s actually marked a change in the very sense of pop time and space. The underlying rock model of past and present, nostalgia and new, doesn't apply to the digital age."[49] For Frith, the story of the 1980s is the move into the dance clubs. He describes a student who, having grown up on the indie-pop of the Jesus and Mary Chain, had "gone clubbing for social, not musical reasons, to meet boys, to have a laugh. Actually she's loathed the sounds she'd dance to . . . music for the mindless."[50] By the end of the decade, she and her friends were still going to clubs to dance, sometimes for weekends at a time. "Somehow—and she could not precisely date this—this mindless music had become 'theirs.' "[51] While Frith still wants to read into this narrative the rock dreams of the dissolution of class, gender and racial differences, it seems to point more clearly to a changing investment in rock, and to the changing stakes of that investment. Rock matters for reasons external to rock itself: e.g., for social reasons rather than the empowerment of the apparatus itself. It is not that dance is external to rock; on the contrary, it has often been a crucial element in a variety of rock alliances and dance clubs have often

been a dominant site of rock culture. But it seems that their current popularity depends less on their place within and relation to specific rock alliances than on their existence as a venue for other sorts of social relationships.

There is a very real "crisis of taste" in the rock formation where, for many fans, no single alliance, no single organization of taste seems more authentic than any other. This is manifested, not only in the increasing tolerance of fans and in the increasing number of cross-genre musics, but also in the proliferation of radio formats including: Mainstream AOR, Classic Rock, Eclectic AOR, Heavy Metal, Mainstream Adult Contemporary, Oldies, Adult Contemporary, Soft Adult Contemporary, Classic Hits, Contemporary Hits Radio (CHR), Adult CHR, Dance CHR, High Energy CHR, Mainstream Urban, Adult Urban, Heart and Soul, New Wave, Nostalgia, Easy Listening and, most recently, an all–Led Zeppelin format! It is impossible today to define any model of rock which could serve as a definition of the center, or as a vector pointing to its future. It is not merely that there is a proliferation of tastes and musics, and an increasing tolerance, but that alliances themselves have become fluid and fragmented. Identity can no longer be constructed around a singular alliance—both radio stations and bands play an almost incomprehensible diversity of musics. Rock responded to the assumption of 1950s liberalism that differences don't matter precisely by making them matter; the pluralism of contemporary rock seems to echo the 1950s image of differences without any power.

Rock confronts a new demand: that it articulate the need for investing in something to the rationality of disinvestment, that it offer itself as a site of investment in the face of the irrationality of any act of investment. Rock offers neither salvation nor transcendence, neither an anarchy of fun nor a narcotic of bliss. Rock is a site of temporary investment, without the power to restructure everyday life. But it still produces lines of flight, not only in the face of nihilism but precisely through the forms of nihilism itself. If rock is no longer the force behind the mattering maps of people's everyday life, it continues to produce energy and mobility, even if it can take people nowhere except out of the spaces and places of everyday life:

"[It is as if] the motive of this scavenging is *to go on*; not to progress, because we no longer believe in progress . . . [It is] the desperate determination to go on at any cost."[52] Rock empowers people to act in the face of the assumption that actions cannot make a difference, even though it itself may no longer inscribe its own difference. Without a center, rock can only produce an endless mobility, spaces without any places, a paradoxical strategy by which people live an impossible relation to their own everyday lives. Rock will, by placing you within its own spaces, free you from the moment, but it will not promise any alternative spaces. It remains forever ensconced in its own reproduction of the very conditions of everyday life it once sought to transcend. But it still promises, however briefly and weakly, that there is something beyond everyday life. But as both youth and authenticity have been problematized, the relations between these differentiating machines and rock's territorializing machine has itself been weakened, if not broken.

I have attempted to map out the different structures of the rock formation at two historical moments by looking at its changing conditions of possibility. It would be tempting to construct a simple narrative connecting these two moments, to assume a single trajectory which would explain these discontinuous appearances of the rock formation as a transformation, as if I were telling the "story" of postmodernity. But I do not intend my description to provide the *proper* or exemplary site for an analysis of contemporary structures of power, as if the relation of the rock formation to the new conservatism could be read from the vectors of this map. These vectors cannot provide a map of the terrain that still needs to be traveled; instead, they are attempts to referentially mark a piece of the terrain, the place from which I begin. If rock is a site on specific cultural maps, I am interested in how it is deployed as both a field of struggle and as a strategic practice in the struggle itself. One must start with (an analysis of) where rock is in the contemporary articulations of everyday life and power: "The band[s] take a stand for home, sanity and love but look no further than the end of their own mystery road. They may change their world, site-specific as it is, but they will not change yours."[53]

My argument is that the new conservatism is using its ambiguous relation to popular culture and the rock formation to reconstitute the structure of authority and the configuration of everyday life. The struggle to restructure life, to change what matters in the contemporary U.S., depends upon the very things which made postwar popular culture different and which gave it its central place in everyday life.[54] The new conservatism uses the very logic (of this formation) to both attack and rearticulate it into a specific structure of depoliticization. The territorializing/differentiating effects of rock are rearticulated according to a different set of vectors and projects to produce different effects. This is at least one way in which *culture leads politics* in this complex struggle.

My question is simple: How is this reconfiguration of rock (and the broader reconfigurations of popular culture and everyday life with which it is implicated) itself involved in the emergence of what appears to be a kind of popular (which is not to say populist) conservatism? This conservatism is not the same as the ideologically explicit conservatism of the New Right, although it may be deployed into these struggles. It is this popular conservatism which, I believe, underlies the increasing sense that people support a conservative government even while they remain programmatically liberal, that the "center," not only politically and economically, but culturally and socially, of life has shifted significantly toward the Right. When *Tour of Duty*, the first network program on Vietnam, first appeared on television, the street-wise sergeant confronted a soldier who declared that "the war's wrong." The response was not neoconservative ideology: "Maybe, but that's not the point." The point was never identified. The point is precisely what needs to be somehow understood, and this requires us to traverse the field of cultural forces, to map out the state of play in these cultural relations. Only then will the stakes in these struggles be clear.

"WHERE THE STREETS HAVE NO NAME": HEGEMONY AND TERRITORIALIZATION

NATION, HEGEMONY
AND CULTURE

A number of features of the new conservatism, especially when taken together, offer a perplexing scenario. First, and perhaps most important, the new conservative formations seem to have broadly based popular and emotional appeal. Second, this appeal is often quite distinct from popular support for the specific programs and positions of the new conservatism, although such support is often mobilized and orchestrated. Third, there is often an obvious contradiction between the new conservatism's explicitly stated projects and its actions (e.g., its antistatist project of deconstructing the social-democratic compromise of the postwar years versus its reconstruction of powerful politically aligned state apparatuses; its rhetoric of economic prosperity versus the real economic devastation resulting from its policies; and its rhetoric of individual liberty versus its "war" on civil liberties). Fourth, this formation is able to win the electoral support of class fractions which would seem to have strong reasons to oppose the interests and policies of the new conservatives. Yet, this scenario of the U.S. cannot be treated in isolation. Many other advanced industrial societies, including Canada, France, Britain and Germany (and Australia, although it does not quite fit the model) have had similarly successful conservative struggles in the past decade.

HEGEMONY BY ANY OTHER NAME . . .[1]

Cultural studies has often used Gramsci's concept of hegemony to describe these historical modes of national political struggle, but the term remains ambiguous. For some, hegemony refers to an almost universal process by which domination is achieved through the construction of an ideological consensus.[2] Alternatively, Stuart Hall takes it as a specific, historically emergent project of restructuration with its own conditions of possibility and its own strategies of struggle.[3] As a "conjunctural" politics, hegemonic struggles can have radically different forms in different social formations and national contexts. Consequently, one needs to undertake the arduous and, at this stage, speculative task of bringing the concept to bear upon the particular context of the U.S.

Still, there are some characteristics of all hegemonic struggles. Hall distinguishes a hegemonic struggle from the attempt to establish power through consensual agreement.[4] While both are responses to the increasing complexity and importance of civil society as a site of political struggle, their structures and strategies are significantly different. Struggles to establish consensus divide the social formation into two mutually exclusive worlds corresponding to two social groups, each with its own realities, experiences, cultures and politics. The relations between the two social groups are defined hierarchically and maintained through processes of incorporation. The dominant group organizes the subordinate population and culture "from above"; the dominant group struggles to impose (win the consent of the subordinate population to) its ideological vision of reality. Such consent disarms any resistance by making the subordinate population over in the image of the dominant group.

In a hegemonic struggle, on the other hand, the social field cannot easily be divided into two competing groups. The diversity of "the people" confounds any such simple divisions; for while the masses appear to be undifferentiated, social differences actually proliferate. The difference between the subordinate and the dominant cannot be understood on a single dimension. Power has to be organized along many different, analytically equal axes: class, gender, eth-

nicity, race, age, etc., each of which produces disturbances in the others. At the same time, those seeking to hold the dominant position do not constitute a single coherent group or class. Instead, a specific alliance of class fractions, a "bloc" which must already have significant economic power, attempts to win a position of leadership by rearticulating the social and cultural landscape and their position within it. This rearticulation is never a single battle. It is a continuous "war of positions" dispersed across the entire terrain of social and cultural life. At each site, in each battle, the "ruling bloc" must rearticulate the possibilities and recreate a new alliance of support which places it in the leading position. It must win, not consensus, but consent:

> The "spontaneous" consent given by the great masses of the population to the general direction imposed on social life by the dominant fundamental group; this consent is "historically" caused by the prestige (and consequent confidence) which the dominant group enjoys by virtue of its position and function in the world of production.[5]

In the contemporary world, it is less clear that the confidence in the ruling bloc is the result of its economic position, although the power of that position is necessary. Increasingly, that confidence has itself to be won and even constructed.

The hegemonic struggle for power takes place on and across an already constituted field, within which the identities and positions of the contesting groups are already being defined but are never fixed once and for all. Hegemonic politics always involves the ongoing rearticulation of the relations between, and the identity and positions of, the ruling bloc and the subordinate fractions within the larger social formation. If it is to win hegemonic leadership, the ruling bloc cannot ignore resistances to its specific struggle, nor to its longer-term projects. It has to recognize and negotiate with at least some of the resistant fractions. It need not incorporate them into its own position, nor entirely disarm the differences. These fractions can remain outside the hegemony, apart from the ruling bloc, retaining their subordinate position. Their subordinate relationship to the ruling bloc, however, is an active, empowered one, even to the point

where they can redefine and restructure the hegemonic project itself. A hegemonic politics does not incorporate resistance but constructs positions of subordination which enable active, real and effective resistance. The ruling bloc will also attempt to define the position of the excluded: those resistant fractions with whom it cannot or will not negotiate, which it therefore seeks to place outside the hegemonically restructured social formation. Hegemony is not, then, the construction of a consensus in which all resistance is incorporated into the dominant ideological positions; it is the ruling bloc securing the position of leadership for itself, across the terrain of political, social and cultural life.

Laclau and Mouffe describe this as the construction of an internal frontier within the social formation.[6] The ruling bloc (or its counter-hegemonic opponents) struggles to organize different and often antagonistic social and political groups into two opposing camps, each defined by an "imaginary" equivalence among its own fractions and, as a result, a common opposition to the other camp. (It is unclear which comes first.) Hegemony constructs a fundamental boundary, an organizing difference, within a society, through the distribution of social fractions. Such a "frontier" requires a principle of ideological articulation which is able to define the equivalences on either side of the boundary. For example, for Laclau and Mouffe, the possibility of a contemporary counter-hegemonic struggle rests upon the ability to construct a system of equivalences among various fractions opposed to both the status quo and the growing conservative hegemony according to the principle of democratic interests.[7] Those on each side of the frontier must struggle, not only against those on the other side, but also to constantly increase the size and space of their own alliance.

Hegemonic leadership has to operate where people live their lives. It has to take account of and even allow itself to be modified by its engagement with the fragmentary and contradictory terrain of common sense and popular culture. This is where the social imaginary is defined and changed; where people construct personal identities, identifications, priorities and possibilities; where people form and formulate moral and political agendas for themselves and their

societies. It is here that people constantly reconstruct their future in the light of their sense of the present, that they decide what matters, what is worth investing in, what they are, can be or should be committed to. Hall, following Gramsci, describes this as the need for any hegemonic struggle to ground itself in or to pass through "the popular."[8] The popular here is not a fixed set of texts or practices, nor a coherent ideology, nor some necessarily celebratory and subversive structure. It is the complex and contradictory terrain, the multidimensional context, within which people live out their daily lives. Although it always has a political registration, that registration is never guaranteed in advance. Hegemony always involves a struggle to rearticulate the popular. There can be no assurance ahead of time what the results will be, for it depends upon the concrete contexts and practices of struggle and resistance. Speaking in the vocabulary of popular ideologies, using the logics by which people attempt to calculate their most advantageous position, celebrating the pleasures of popular culture, appropriating the practices of daily life—this is where hegemony is fought and what it is fought over.

Consequently, hegemony cannot be approached in purely ideological terms; it is the result of economic, political, cultural and ideological struggles. Hegemony involves an attempt to rearticulate the complex relations among the state, the economy and culture. And within this project, particular ideological appeals may be deployed as both the site of and weapon in a hegemonic struggle. For example, in the attempt to construct its own leadership, Thatcherism deployed race and racism as "one of the means through which hegemonic relations are secured in a period of structural crisis management." Such racism was "not a simple extension of repression but a recomposition of relations of power at all levels of society."[9]

Hegemony is organized around an explicitly defined national project of restructuring the social formation, a project which mobilizes the struggles of popular culture and daily life. This project is, finally, an attempt to reconstruct daily life and its relationship to the social formation. But it always remains a project, rarely completed, always changing in relation to its changing circumstances and always needing further work.

While this general model describes some aspects of the rise of a contemporary conservatism within the world of late capitalism, it does not describe how they have been articulated into specific national struggles. Here one must begin to look at the conditions and characteristics which define and enable their differences. To begin, I will summarize some of the major features of Hall's exemplary analysis of Thatcherism in Britain as a hegemonic struggle involving the ideological reconstruction of common sense as the cultural reconstruction of a "national popular."[10] Hall emphasizes the need to articulate such popular struggles to the attempt to win control, first of the economic sector, and subsequently, of the state apparatuses.

First, Thatcherism arose and gained ascendency in response to a very real, very particular and very powerfully experienced sense of national economic crisis. Thatcher's project—despite its ideological, cultural and moral dimensions—was primarily directed to the very real economic changes both within Britain and internationally. The project of Thatcherism was partly defensive, an effort to fend off some of the more drastic challenges to the older forms of capitalism still operating in England. What emerged was a fairly specific national project which demanded sacrifice in return for the imaginary construction of a promised community of prosperity. Second, the alliance which Thatcher put together and installed in a position of leadership was remarkably consistent; to the extent that contradictions arose within the ruling bloc, Thatcher seemed quite willing and capable of purging specific fractions. Third, Thatcherism operated within a political system in which the political, legislative and executive functions are combined into a single process. This not only enabled the enormous success of Thatcher's program and proposals, it also guaranteed an ongoing public debate around her legislative agenda.

Finally, there is the figure of Thatcher herself. She was extremely powerful, positioned as both the originator and representative of the ruling bloc and its project; consequently, she was identified with every specific proposal and with each victory (and defeat). Moreover, her success rested not only on legislative control nor a taken-for-granted popular constituency, but rather on her ability to forge a

different temporary popular political alliance around any particular issue. For example, Thatcher's attack on education condensed a conservative articulation of parent power, a popular economy of education and a pragmatic view of the curriculum. At the same time, her power was quite personalized, depending in part on her female positioning: Thatcher was not merely the "Iron Lady," she was the lower-middle-class housewife with authority—the English "school-marm." (Not coincidentally perhaps, she used to be the minister of education.) This image, perhaps the most redolent, largely defined the homology that existed between Thatcher's personal authority, the hegemonic project of Thatcherism, and its struggle over the popular. Whether her personal authority (as well as a number of unpopular programs) led to her declining popularity, she was replaced. It remains to be seen whether "Thatcherism" will continue to define a conservative hegemony.

Hall has described the Thatcherite project as "authoritarian populism": "a movement towards a dominative and 'authoritarian' form of democratic class politics—paradoxically, apparently rooted in the 'transformism' . . . of populist discontents."[11] Thatcherism is a struggle to reshape the very terrain of common sense according to an imaginary vision of British culture, a partly defensive response to the real sociological changes which have significantly altered the face of British culture and society. Across the range of social positions, practices and identities, Thatcherism attempted to reshape common sense by constructing a frontier within the social formation, a boundary of permissible identities: on the one side, a reconstructed "England" organized around an imaginary past, an imaginary definition of "Englishness"; on the other side, the enemy within, "the alien wedge." In this particular hegemonic struggle, *politics leads culture*.

Thatcherism had a somewhat perplexing relation to popular culture; some cultural institutions, such as education, universities and state apparatuses which supported marginal cultural production (such as the Greater London Council) were significant concerns to the extent that they appeared to be powerful sites of oppositional discourses. While Thatcherism constantly policed popular media (e.g., public television), this was apparently an attempt to protect

itself and to open up the field to a free-market economy. Rarely did it attempt to occupy the ground or resonances of mainstream popular culture (as opposed to popular languages, fears, etc.); and the attacks on the forms of popular culture often came from residual conservative groups and figures (e.g., Mary Whitehouse). One result of this complex relation to popular culture was that both mainstream popular culture, and the culture of various marginalized fractions (especially those Black and immigrant populations excluded from Thatcherism's "English"), have been able to articulate widespread and popular dissatisfaction.

In significant ways, this analysis does not work in the context of the contemporary U.S. despite the very real similarities that can be identified. It is not just a matter of the differential success of the two conservative movements. Both are the product of real historical work within their respective parties—in the U.S., this began immediately after the defeat of Goldwater in 1964—and in the intellectual sphere (through various privately endowed think tanks). Both can be seen as responding, in the first instance, to changing economic conditions; both are fundamentally committed to the centrality and primacy of capitalism (and to the power of finance capital and a service economy rather than manufacturing); both have attacked the corporatist state and the social-democratic compromise of the postwar era; both have sought to install economic definitions of freedom over individual rights and civil liberties (i.e., the right to compete and fail); and both, for a while at least, were embodied in the figure of a single person—a national leader.

There were very real economic problems which presented a significant challenge to U.S.-based multinational corporate interests; the "disorganization" and reorganization of late capitalism involves: changing relations between national and world economies; changing social organizations and distributions of the working population (including the emergence of new forms, locations and organizations of labor, the rise of the service class, and the changing ethnic and gender composition of the labor force); and a declining rate of profit. In the U.S., this challenge could not be resisted or even merely accommodated; it required a radical restructuring of the place of

economic interests in the political, cultural and daily life of the nation. It was met, in the first instance, by the direct involvement of corporate capital in political activities and its publically expressed dissatisfaction with the state—and the state—of the nation. This new involvement took a variety of forms (e.g., funding PACs and various think tanks, direct national advertising campaigns) which were crucial elements in the construction of a conservative hegemony in the U.S.

The economic crisis facing the U.S. was not immediately experienced as a radical collapse of the economy. It was, in fact, not particularly obvious for the majority of the middle classes until the beginning of the 1980s, and even then it was often perceived in terms of the recurrent problems of recession, unemployment and inflation. For the general public, the problem was often constructed and understood in terms of the changing position of the U.S. in international relations. The crisis was perceived as the loss of America's economic, political and military leadership in the world. It was a problem of national ego and international hegemony rather than survival. Consequently, it was most powerfully marked by specific events (e.g., the oil embargo, the Iranian hostage crisis, etc.) and responded to with a decidedly nationalistic rhetoric.

A second major difference can be seen in the struggle to win control of the Republican party and the alliance that was constructed. The new conservative alliance in the U.S. was always a much more fragile and potentially temporary political bloc. While its public face was often dominated by the so-called New Right, it included more traditional bureaucratic conservatives from the Republican party, as well as "big business" capitalists.[12] It has required enormous effort for this alliance to successfully constitute a "ruling bloc"; often this work went beyond consensus building within the alliance to the active suppression of the differences between the fractions. Even the image of a unified New Right covers over numerous ideological contradictions, for it involves a range of different groups in complex alliances and antagonisms. The project of the moral traditionalists involves redirecting the nation's cultural agenda according to their own religious fundamentalism. They are perhaps the most success-

fully populist group, having combined the techniques of televangel-
ism and direct mail appeals (for letter writing campaigns and fund-
raising) in single issue antiliberal campaigns. The rhetoric of the
neoconservatives (many of whom were New Left liberals in the
1960s) overlaps with the cold war conservatives, focusing on the
"world mission" of the U.S. and the need to reinscribe powerfully
nationalistic feelings in order to recapture the "traditional" values of
the nation (usually defined only by its assumed difference from an
imaginary threat), which were undermined by internal forces in the
1960s. The economic neoliberals are committed to the free play of
market forces—anything is permissible if, under free market condi-
tions, it makes a profit—but their influence is limited by the presence
of both monetarists and supply-siders. Three projects, three ene-
mies—the antichrist, geopolitical others and state regulation. The
construction of the "unity" of the New Right, and beyond that of
the new conservative alliance, depended partly on the precarious
ability, at any moment, to condense these three enemies into a single
figure (e.g., Arabs, Communists, Japanese, South American drug
dealers, etc.) and on the active work of overlooking the contradictions
between the projects.

A third difference stems from the separation of the executive and
legislative functions and from the unstable role of political popularity
in these functions in the U.S. political system. The result is that the
new conservative alliance has been much less successful in legislating
its programs and policies (since, despite its popularity at the level of
national politics, the new conservatism seems weaker at the level of
local and state elections). Ironically, its major effects have come
through the executive's control over the state apparatus: through a
refusal to allocate budgeted funds and through appointments to
various state agencies (including, most frighteningly, the Supreme
Court). Through executive and judicial action, it has selectively
strengthened or weakened, regulated or deregulated various aspects
of social life. It has also been successful through secret, if not illegal,
executive orders and actions. One immediate consequence of this
unique form of influence has been the decided absence of public
debates about many policies and proposals, except in the context of

already enacted decisions or scandals. This has made it more difficult to organize a highly visible set of struggles aimed directly against the hegemonic Right on a wide-scale and permanent basis. Even the marginalized and oppressed populations have been largely incapable of organizing an oppositional alliance, or even of producing popular oppositional discourses.

Finally, consider the figure of Ronald Reagan as the first president who embodied the sentiment, passion and ideology of the new conservatism. A great deal of the popular support for the new conservative alliance was organized around the personal popularity, power and image of the president. And a large part of the work of holding the various fractions of the ruling bloc together was accomplished through the figure of Reagan. In fact, although Bush's victory in 1988 continues the Republican control of the White House and the hegemony of the new conservative alliance, it is not at all clear that the balance of power within the alliance has remained unchanged. Bush's administration is largely staffed by regular Republican party bureaucrats rather than representatives of the various New Right fractions. Bush is, in the worst sense of the term, a cold war bureaucrat, with little direct and immediate appeal to any of the major fractions. A recent column by Richard Berke in the *New York Times* carried the headline: "Conservatives content with Bush, but not policies."[13] In the past year, there have been serious breaks within the alliance, between the new conservatives, the old-line conservatives, and the New Right, over such issues as the Iraq war, the budget and even the significance of the 1990 election results.

Even today, the source of Reagan's popularity and political success remains unclear (although his popularity was never as great as it was often felt or represented at any particular moment[14]). Nor was his relationship to the hegemony of the Right ever direct and straightforward. Reagan was neither the founder of, nor the most articulate spokesperson for, nor even always a representative of, the policies and ideologies of the new conservatism. He was, metaphorically, their celebrity spokesperson, harking back to a day when people assumed that an endorsement meant a real commitment to the product. If he lost a battle, it did not diminish his position. If he

acted in ways that contradicted his image or his public posture, his power remained intact. In fact, it was never clear what his image was for it was full of ideological and personal contradictions. Reagan was an anticommunist who helped construct a second detente; a militarist who negotiated a disarmament treaty; a free-enterprise capitalist whose administration often intervened directly into the market; a moralist whose administration was riddled with scandal and dishonesty; a strongly profamily father whose own family was the source of scandals; a strong leader who often seemed unprepared and even incapable of actually managing the reins of state; an intelligent man who consistently confused movies and realities, forgetting not only the details of U.S. military and foreign policy, but even the facts of his own biography; a sincere man who was often exposed as having lied to his public.

Perhaps the source of his popularity was his relation to popular culture and daily life. He was the living realization of every elitist intellectual's worst nightmare, the living proof that their disdain for the popular imagination was justified: a television star as president. Reagan never articulated a national project, never constructed a coherent historical (or even imaginary) vision of American glory which could define a project of restoration. His different visions were at best composed of bits and pieces of history. But what may be most significant is that his images of America were always taken from popular culture and daily life: whether appeals to the heroism enacted in Hollywood movies or to the ongoing struggles of families attempting to survive and succeed. Reagan, whether considering issues of policy or of identity, was apparently untroubled by the difference between public and private, fact and fiction.

Reagan—and consequently, to some extent, the ruling bloc he stood in for—did not stand outside of the formations of popular taste and popular culture. They were as much implicated within the distribution of popular taste as the audiences to which they spoke. Its spokespersons (even the most elitist, like William Bennett, who went from education secretary to government drug czar) were often more comfortable quoting Bob Dylan, the Beachboys or Bruce Springsteen than posing as representatives of the elitist canon they

defended. Yet, at the same time, they were actively involved in policing and even attacking, not the media per se, so much as the forms and specific texts of popular culture. It is in this specific weighting of and relationship to the popular that the new conservatism struggles to constitute, not a popular elitism, but an elitism of and within the popular—a populist elitism. It is less a matter of the ideological meanings of popular culture than of their material distribution, the ways they are presented and used, how they are taken up, and the forms of people's commitments to them. Popular culture becomes the ground, the tactics and the first stake of hegemonic struggle.

THE "STRATEGIES" OF THE NEW CONSERVATISM

All of this suggests that, in some ways, the struggle for a new conservative hegemony in the U.S. operates differently from, and on a different ground than, its related struggle in Great Britain. Rather than attempting to win the minds of the nation, there is a struggle over its heart and body. This project works at the intersections of politics, everyday life and popular culture. The question is how people's affect—their attention, volition, mood, passion—is organized, disciplined, mobilized and ultimately put into the service of specific political agendas. Here the struggle for hegemony foregrounds popular culture and languages; it attempts to transform popular mattering maps and the nature and sites of authority in contemporary life. It operates on the very ground on which affect and politics are linked together, rather than on the terrain of ideology and common sense. In this contest, *culture leads politics*.

I am proposing a disjunction between two hegemonic sites: the rearticulation of common sense and the reconstruction of a "national popular." When Gramsci spoke of the "national popular" as a primary field in which hegemonic power is constructed, at least sometimes he referred to the collection of material cultural practices which were taken to constitute both the common culture of the people, and a national identity.[15] That is, what novels, films, etc.

do a particular people consume and how is this assemblage itself articulatable to a national identity? In this sense, the national popular is directly connected to struggles over the shape and deployment of cultural formations and apparatuses, over how they empower particular population fractions and cultural practices.

The new conservative alliance recognized (or more accurately, articulated) the national crisis in affective rather than economic or ideological terms. The crisis is the product of a lack of passion, of the fact that people do not care enough about the values they hold to do "what is necessary." It is a crisis of nihilism which, while not restructuring ideological beliefs, has undermined the ability to organize effective action. Americans are not working hard enough— at their jobs, in their families, for their nation, or in the service of their values. The struggles to put a new conservatism into place, insofar as they represent a partially successful hegemonic moment, do not begin by restructuring commonsense assumptions about the world. They are largely built on a generally shared mistrust of common sense; they use ideological differences to redistribute the passions of popular commitment. Instead, they restructure people's investments in the sites of the popular. Thus, for example, Reaganism did not reconstruct an ideology of anticommunism; if anything it (unintentionally?) parodied a taken for granted ideology which had lost its powerful affective resonance. Precisely by rendering the explicit ideology irrelevant—no one could take it too seriously—Reaganism made it possible again to affectively invest in it. This is neither anticommunism as a political platform nor as an ideological interpretation, but as an emotionally empowering state. This perhaps explains why it was so easy to dispense with it, both nationally and from the conservative platform.

This vision of the hegemonic project of the new conservatism challenges two common assumptions: that the struggle is a political one seeking control of the state; and that it operates primarily by redeploying classist, racist, homophobic, masculinist and nationalist ideologies. In one sense, I do not want to disagree with either of these. It is certainly true that the new conservatism has redeployed ideological differences in a very powerful way. And it is certainly

true that these are having significant and often devastating consequences on many fractions of the population. Yet these appeals are often contradictory (e.g., not only around race but, even more obviously, around sex). More importantly, their success has been *too* easy, especially given that so many people explicitly oppose these forms of ideological subordination. Nor can one overlook the fact that these ideological appeals have been extremely visible, almost blatant (as in Bush's election appeals to racism), but at the same time their material reality seems to remain hidden. However, too often, this is taken to suggest one of two analyses: Either the conservatives, having won political dominance, are now moving to eliminate cultural resistance. Or, in the attempt to hide the economic misery resulting from their policies, the conservatives are attempting to distract the public's attention by turning it to ideological issues. But one must look elsewhere for an explanation of the power and effects of these ideological tactics.

The assumption that the new conservative alliance has been primarily a political group seeking to control the state apparatuses is concisely stated by Patrick Buchanan, who calls upon conservatives "to wage a cultural revolution in the 90s as sweeping as the political revolution in the 80s."[16] Again, I believe this is too simple, for the fact of the matter is that the conservatives have won and held political power only by waging a cultural war. It is true that most of their energies have been directed at political institutions and only recently have they turned their resources toward cultural institutions (such as universities, museums, etc.). But it would be a mistake to identify the visible targets of the new conservative alliance with its weapons and strategies. Control of the state enabled the conservatives to accomplish many specific tasks, and gave them an important base of operations. It also gave them privileged access to the institutions of public opinion, in response to which one needs to reintroduce a good dose of conspiracy and manipulation theory. The public is being lied to and events are apparently quite consciously selectively described and reported. One need not assume any intentionality on the part of the news media in this process; it is rationalized in the terms of the close relations between popular sentiment and sales on

the one hand and between the press and the state bureaucracy (as sources of information) on the other. The result is not only that it is increasingly difficult to differentiate between political reporting and human interest stories, but also that the line between facts and statements is increasingly ignored (e.g., "the President denies . . ." becomes a story without a description of the charges). But the apparent success of such manipulation cannot be explained by falling back on images of the masses as intrinsically manipulatable, as cultural and ideological dopes. In fact, vast numbers know or assume that they are being lied to, or else they seem not to care.

This is precisely the paradox at the heart of contemporary U.S. politics and of the new conservatism's successes. A large proportion of the population is outraged by at least some of what is going on, yet—with the exception of those active on the Right—they remain largely inactive and uncommitted. There is a feeling of helplessness: what can anyone do? Even if you could get enough people involved, would it do any good? And if it did, then the whole thing would no doubt be quickly corrupted by its own success. When people do protest or struggle, it is often so specific and local that it cannot be mobilized into a larger national alliance. The depoliticization of the population, its disinvestment from active political issues and struggles—its apathy, as it were—is very real and I believe that it has to be constantly produced. This is at least one crucial element within the contemporary hegemonic struggle.

In fact, controlling the state may not be a necessary condition for the current conservative hegemony. I am aware that this sounds rather strange, and I do not mean to suggest either that the new conservative alliance does not want state power or that there are not devastating consequences of the alliance's use of the state apparatuses. But the question of how it has achieved and maintained this control has to be considered. If the new conservatism can accomplish its victory directly within the space of culture and everyday life, it will have already won the terrain on which any democratic state, no matter who controls it and with what ideology, must operate. The new conservatism is an attempt to reconstitute the very ground— and hence the possibility—of American life. It is an attempt to

restructure all of the planes and domains of people's lives, all of the institutions and practices of the social formation; it is an attempt to reconstruct the very meaning of America and the vectors of its future. To this end, it employs a vast array of institutions and apparatuses, popular discourses and public movements, individuals and social groups, most of which exist outside of the space of the state.

The paradox described above can be rewritten: precisely by repoliticizing and re-ideologizing all of the social relations and cultural practices of everyday life, the new conservatism is effectively depoliticizing a large part of the population. It is creating a "demilitarized zone" within everyday life through a series of "strategies" directed at the national popular. This is a hegemonic struggle carried on through a redistribution of the cultural sites of people's affective investment, aimed in part, but only in part, at a reconstruction of their political investment in the nation. A struggle over the places and spaces of everyday life is articulated into the conjunctural relations of power. By reducing the popular to structures of common sense, and the social formation to a distribution of ideological subjects, theorists of hegemony often ignore the possibility of hegemony operating through systems of identification and belonging other than the normalizing systems of identity and difference, including those with which people traditionally distinguish political possibilities: Republican and Democrat, liberal and conservative, communist and anticommunist.

My fear is that this struggle to reconstruct and reorganize the structures of everyday life may have been more successfully established than the Left optimistically assumes; and it has been established elsewhere than where the Left pessimistically assumes. The Left may be losing ground to the nihilism of postmodernity, or to the commodification of late capitalism, or to the ideological conservatism of political positions. But these depend on another set of battles over the affective possibilities of political life, and unless the Left begins to examine the mechanisms and consequences of this contest, it will be unable to struggle against it.

Here an entirely different set of questions arise: How are cultural practices deployed into hegemonic struggles? How can popular cul-

ture be a strategic weapon in, as well as the ground of, hegemonic struggles? How can the reconfiguration of cultural spaces, places and tempos itself become a principle of the rearticulation of structures of power? How are the dominant structures of power constituted and put into place? By questioning the ways in which culture is articulated to economic and political struggles, I want to map some of the ways in which, in the contemporary context, popular culture is articulated against itself and in favor of specific economic and political relations. I am interested in how a certain kind of apathy is actively being produced as the necessary ground for further political, economic and social transformations. This project cannot be read off of the ideological struggles of culture, nor even from the politics of cultural trends. It involves the rearticulation of the politics of ownership, anchorage and territorialization by which new maps are established on top of the dispersed cultural field. I want to identify three "strategies" which have carried this project forward, although I do not assume that they are the product of intentional efforts by the new conservative alliance. The Right has not created them, but it is working with and on them, attempting to place them in the service of their own project and to articulate their effects.

The first involves appropriating the territorializing logic of the rock formation to produce a frontier which works as a differentiating machine. The frontier as an image has always been part of America's social imaginary, for it has defined the open-endedness of its identity; it has been the always uncertain location of the American dream. A frontier is a border which can be transgressed and colonized; it is something to be crossed into another space. The postmodern frontier, inscribed by and on popular culture, defines an impermeable yet ambiguous gap between the livable and the unlivable, the possible and the impossible, the real and the unreal. Its ambiguity is the result of the uncertainty of which side of the frontier is the site of a positive investment. It distributes people and practices (and the investments that connect them) in a specific way. It divides the population by identifications, locations and investments rather than identities and differences. No enemy is constructed, but those who apparently live on the other side of the frontier, within entirely

different maps are excluded from certain relations. Similarly, cultural practices are distributed in such a way that neither time nor space is available for those located outside the popular—for the non- and the un-popular.

The second strategy involves reinvesting particular sites along the frontier with authority. For as much as the new conservatism may appropriate the postmodern sensibility of the rock formation, it does not assent to the particular mattering maps which it offers. Instead, it re-ideologizes particular identities, relations and practices. For example, a commitment to "the family" becomes the measure of one's existence within the properly "American." Similarly, "addiction" becomes a powerful, negatively charged activity which can authoritatively explain a broad range of events and reconfigure people's everyday lives. But in each case, the meaning of these sites remains undefined, for it is less a case of constructing new mattering maps than of using these maps to construct the lines of the differentiating machine. The ideological values of the Right produce "affective epidemics" which reestablish the authority of the Right to speak for others while making it difficult if not impossible to locate the source of that authority. By constructing a mobile authority, the frontier is reconstituted as a constantly changing map of everyday life and authority.

Finally, the territorializing-differentiating machine is made into a new form of machine, a "disciplined mobilization," which puts the excluded under erasure. It is not so much a question of what the specific points on the frontier mean but of the context of possibility they construct, the parameters of mobility and stability they enable. The frontier becomes the limit of the lines of flight of the rock formation, bending them back onto the formation itself, creating everyday life as a closed space with no exterior. The disciplined mobilization creates its own "disappeared," replacing the terror of those who have been made to disappear with the depoliticization of those who remain within the reconfigured geography of everyday life. For not only are those outside of everyday life denied any reality, but the reality of power outside of everyday life is also erased. The disciplined mobilization is the final realization of rock's nightmare—

imprisoned within everyday life, without promise of an outside. The frontier is transformed from something which is crossed in order to enter into another space into a self-enclosing interiority with no exteriority. The territorializing machine of rock has been rearticulated, through a series of strategies, into an apparatus of power or, more particularly, an apparatus of disempowerment and depoliticization.

I do not mean to claim that these strategies tell the complete story about the increasing conservatism of the United States, for they only describe one of its conditions of possibility. A more complete analysis would have to examine how this popular depoliticization is itself articulated to the ideological and economic work of the new conservative alliance. It would have to examine how different historical forces, including commodification, fragmentation, religion, etc., articulate each other and the conjuncture. But I am concerned here only with the strategies by which the "normal" is being regulated and reconstructed within a particular political trajectory, in a movement toward the Right. For the moment, I will content myself with examining this aspect of the move to the right. Together, the three strategies describe a set of historical events which, whether consciously manipulated by the new conservatives or not, are remaking the geography of power by remaking the maps of people's affective possibilities. Precisely by rearticulating specific practices and attitudes—attacking them, appropriating them, moving them somewhere else—an entire affective organization (popular formation) is being transformed and transported, at least in part, to the right. The new conservatism is built upon the possibility of using the contemporary crisis of authority to define its own credibility; it operates on and within the popular, or more specifically, on and within the contradictions of the contemporary popular sensibilities. The next three chapters address these strategies directly.

10

HEGEMONY AND THE
POSTMODERN FRONTIER

I want to return to the question of how the United States con-
structed its own sense of identity in the postwar years. In particular,
how was a boundary drawn which could mark its difference from
the rest of the world? Traditionally, the answer to this question has
assumed the construction of an external boundary separating the
U.S. from some external threat, usually communism. This was, after
all, the power behind the rhetoric of containment and contamination
which so pervaded postwar popular culture and political discourse.[1]
While I do not want to dispute the importance of this construction,
problems remain: Why would the conservatives, at least since the
end of the 1960s, take the leading role in dismantling the cold war?
This does seem to be against the apparent interests of the powerful
military-economic alliance which provided so much of their support.
It also threatened what had been one of its most successful rhetorical
appeals (e.g., Reagan's big bear waiting to come out of the forest).
Part of the answer surely depends upon understanding the tensions
not only within the new conservative alliance but also between the
political and economic agendas of the various conservative fractions.
But it depends as well on the failure, after the collapse of McCar-
thyism, of such a boundary to function internally. The fact is that
the various rhetorical efforts to construct a new external enemy (e.g.,
the Arab world, the economic threat of Japan and the vague military
threat of the "irrational" and uncontrollable "third world") have
failed to take hold of the popular imagination for more than just a

fleeting moment. Often these threats have ended up as images of particular persons: Khadafi, Saddam Hussein, etc.

The notion that an "American identity" has been and could be constructed out of a set of external differences ignores the unique dilemmas that have always confronted the nation, given the enormity of its space, its active negation of history, and its continuous sense of multi-culturalism. Here one can take a lesson from the contemporary struggle for hegemony in Britain, where Thatcherism constructed itself as the defender of "Englishness" against "the enemy within." The British new conservatives have had the "luxury" of a temporal appeal to some imaginary moment when England was innocent and powerful and pristine, free of the "polluting" influences of multicultural immigrations. They construct a frontier which depends upon the identification of an "authentic" Englishness which can be defined explicitly in terms of social and cultural practices, but implicitly in terms of racial and ethnic differences.

In the United States, the construction of such an enemy within has rarely been successful as a strategy for constituting an identity of "American-ness" (which is not to deny that it has worked temporarily at various moments). Its success today is limited to the frightening but still narrow appeal of the various right-wing extremist militant groups which have grown rapidly in the last two decades (from the KKK to the Posse Comitatus). These groups have, with varying degrees of success, attached themselves to the borders of the new conservative alliance, and applauded the increase in racism, anti-Semitism and homophobia. Even the blatant racism of a number of Republican campaigns seems less an actual call for racism than a blatantly cynical attempt to deploy and manipulate racism as an advertising strategy which is getting out of hand. (Hence the distinction between David Duke in Louisiana and Kirk Fordice in Mississippi. The Republican party renounced the former fearing that he took his racism too seriously while it supported and celebrated the latter, who used racism cynically and strategically.)

Nevertheless, the postwar years have seen the very real deployment of a frontier within U.S. society defined affectively by the postmodern sensibility. This sensibility constructs a difference within society

which, while initially generational, has infiltrated every social and cultural space. Its boundary is increasingly taken for granted: the failure to comprehend its response to history is a sign of one's place outside the appropriate formations of contemporary culture:

> We inhabit a wild world in which the future has vanished before everyday signs of the last things. These signs, billboards loudly proclaiming our imminent erasure, are openly available to all; no one is illiterate or otherwise incapable of recognizing these tokens of quotidian damnation. Anyone who does not recognize at least some of these signs is either insane or retarded.[2]

The last sentence announces a principle of difference by which the population can be redistributed on either side of the postmodern sensibility, of what Bloom correctly described as "nihilism with a happy ending."[3] This frontier, of course, is not innocent. It is largely, if unintentionally, one that continues to define white middle-class experience as the norm (although forms of Black and working-class cynicism have often provided its model).

The new conservative alliance has appropriated this vision of a nation bifurcated by a cultural frontier. The new conservative's rhetoric often reproduces the postmodern sensibility. The apocalyptic tone of much of their discourse, especially in the "identity theology" which sees Armageddon as an imminent historical event, replaces the social and historical visions of human responsibility. Nor is it entirely coincidental that so much of its rhetoric starts with a "ruptural theory of history," locating the "fall" of "America" somewhere between 1965 and 1975, marked by such events as the counterculture, Vietnam, Watergate, and the growing power of the media/popular culture. Moreover, it is not the events themselves which bear the burden of guilt. It is the way in which they linger as important billboards of people's affective lives that poses the real threat:

> Some people, often through no fault of their own, are trapped by memory, a phenomenon that can be national, even international, in scope. The war in Vietnam, the struggle for civil rights and the women's movement are good examples of the kinds of events that can create entrapping memories. Such memories [are] intimately

tied to the images that emanate from our huge common television set.[4]

The notion of "entrapping memories" points to the way that popular culture and the media have placed them into contemporary mattering maps. The new conservative rhetoric refuses to allow that such events and the rupture which they produce mark a failure of institutions, or as in Britain, a crisis of economic and social relations.

This frontier is an attitudinal one. The "fall" came at that moment when a certain cynicism, often labeled "relativism" by the new conservatives, became the dominant attitude with which Americans approached their country, their lives and their history. The new conservatives cannot allow the frontier to be reduced to an assumed failure of the nation, or even to the belief in such a failure (although such a belief may have certainly contributed to the construction of the frontier). Hence they are left with no alternative but to attack the memory of specific events, and the centrality of popular culture. It is the memory of these events which has moved the postmodern sensibility beyond an innocent and isolated realm of leisure into the very source of political and national identities.

But the operative strategy of this attack is not transparent. The frontier itself is not rejected but strategically redeployed. This no doubt partly explains the ambivalent relation which the new conservative alliance has to the rock formation, simultaneously attacking and embracing it. After all, the rock formation, perhaps more than any other formation of contemporary culture, claims ownership of the postmodern frontier, an ownership that must be undermined if the frontier is to be appropriated by and articulated to a new political hegemony. Hence, the success of the new conservatism depends on and even reinforces the very postmodern logic it attacks. The struggle over rock and youth has effects beyond the explicit ideological agendas of those waging the battle.

While the new conservatism often appeals to a moment before the existence of this frontier (e.g., the various nostalgic images of the 1950s and 1960s), its images have to be whitewashed, and all the nasty traces of the conditions which later gave rise to the postmodern sensibility have to be erased. Moreover, the images have to be

"pumped up," injected with a strong dose of affective identity since they offer no better definition of the meaning and identity of "America." Such images still attempt to refer to a moment which many of those caught in their nostalgic appeal have lived through. These audiences must consciously repress their own sense of history in order to give in to the appeal of the nostalgia. It is not merely a question of a nostalgia for the innocent before-times when people still believed in specific "American" virtues and values. Rather, what needs to be recovered is the possibility of such investments in the face of the postmodern sensibility: a nostalgia for nostalgia. Thus, the new conservatism has to engage in a struggle over the ownership of the frontier itself, and with that, the ways its differences can be explicitly mapped onto national, social and political identities.

The new conservatism operates by a strategy of reversal which appropriates the postmodern sensibility as a frontier and rearticulates it, both to different sites and to different possibilities. In this way, it challenges the authority of popular culture and with it, the mattering maps it has established (HBO describes movies as "your best friends"). It simultaneously uses and attacks a logic that is apparently contradictory to its political rhetoric and agenda. In redeploying the very practices of popular culture which they attack, the new conservatism articulates a new national popular. This ambiguous relation to the postmodern frontier enables the new conservatives to contain any attack on them and even to redirect such attacks.

This appropriation was emblematically displayed in Bush's speech announcing the "war on drugs" when a staged drug bust outside the White House was used as the image of imminent danger, even terrifying threats, outside the very doors of our most protected places. It is not the fact of the staged event which is significant here, but the ease with which Bush, the administration, the media and even the public could accept (and take as quite unproblematic) the public revelation of its having been staged. It offered no challenge to the credibility of the White House, nor did the fact of its "untruth" bleed into the need for a war on drugs. How do we make sense of the ironic cynicism implicit in both the event and its (lack of) effects? It seemed to function, in the end, less as a sign of a real threat and

more as a sign that the war on drugs mattered so much that any action was legitimated. This reduction of politics to affect was certainly a powerful tool in the staging of the Iraq war and the disarming of the population's ambivalence.

The new conservatives place themselves inside the logic of the postmodern sensibility and at the same time, use the display of affect to deny or at least hide their cynicism and their ideological inconsistency. The various strategists of the new conservatism are quite open about their close connection to, and reliance upon, strategies of popular culture. There can be little doubt that a large part of the new conservatives' success depends upon their willing appropriation of the techniques of marketing and advertising as popular languages (e.g., the work of Robert Ailes, Robert Teeker and Lee Atwater). Their strategy[5] radically separates policy and politics; the latter is entirely a marketing problem directed at popular sensibilities. This is not merely a matter of letting public opinion define political positions, for there is a great deal of evidence that contradicts this interpretation of the strategy (e.g., both Reagan and Bush remained staunch opponents of abortion even when it became clear that the majority of people supported the right to an abortion). It is rather a matter of reducing politics to campaigning, of considering how specific appeals will "play" into popular sensibilities.

Reagan obviously played an important role in articulating the new conservatism to popular consciousness. He consciously placed himself within the popular, not only rhetorically (in terms of his appeals to popular narratives and fantasies) but also socially. He presented himself as quite ordinary so that he could make an emotional appeal to be treated just like one of his audience, even while his position defined him as different. Perhaps this is why the public was so willing to forgive him his flaws and failures. But more importantly, Reagan's relations with the audience were constituted in popular and ultimately, affective terms. As Robert Stone notes,

> It is not entirely facetious to speak of [Reagan's] voice as dear and familiar . . . In the Superdome on August 15, he was giving the assembled delegates and their guests enormous pleasure, making them laugh, bringing them to their feet with fierce patriotic cries,

and occasionally reducing them to tears . . . a happy mating of *Ursprache* and musak . . . It's the primal voice of the electronic age . . . the voice of American popular culture.[6]

It is not quite accurate to say that Reagan wore his heart on his sleeve; rather, he wore the fact that things mattered to him on his face. Consider the often told story of a network news report which juxtaposed pictures of Reagan playing the part of "the education president," the "environment president," the president who cares about Blacks, etc., with explicit descriptions of the administration's actual programs and accomplishments in these areas. The reporter thought the story was explicitly critical. He was surprised that Reagan's aides had liked it, but they understood that the visual images were more effective than the words because the images pointed to Reagan's affective investments, his caring, the fact that these things mattered to him. The words only point out his failures, failures which have to be expected within the postmodern sensibility. Thus, even while large numbers never took Reagan very seriously, he was granted enormous power because of how much he seemed to care. And this appeal was not limited to those "on the right"; few people were entirely immune to this logic.[7] Interestingly, Bush, despite his obvious failure as a popular icon, has continued to try to establish a similar relationship, one which is apparently working better than anyone might have predicted. A few days before the "victory parade," news media headlined a story that Bush had discovered he was not afraid to cry. In fact, it was revealed, he had cried before he sent troops to the Gulf!

The victory, however limited, of the new conservatism has been built on an affective politics, on sentimentality and passion, in which meaning and political positions have become secondary. Consider the Bush-Dukakis election campaign. Two moments present themselves as key turning points, both of them entirely affective. First, when Bush stood up to Dan Rather, he demonstrated that he was not a wimp (i.e., that he had passion). Second, during the debates, when Dukakis attempted to answer a question about rape without demonstrating any passion, he demonstrated that he was little more than a petty bureaucrat. Evidence suggests that the first was engi-

neered and planned by the campaign marketing advisers, but that does not seem to matter.

Richard Viguerie, a key figure of the New Right, has located the political success of the conservatives in their turn to "gut-level issues."[8] But it is perhaps more accurate to say that the conservative strategy transforms political struggles into "gut" issues. After all, no issue is intrinsically a gut issue; it is produced as such only by reducing the complexity of the debates, the various interpretations and contradictions that surround it, to a matter of affective investment. The conservative strategy depends upon a logic in which the fact of the "gut commitment" becomes more important than the content of the commitment itself. It is a strategy which seeks political power by tactically dissociating itself from politics. In the end, political realities seem to matter less than political commitments. Politics itself is depoliticized even as it is given an increasing affective power. Appeals to charity, for example, displace any consideration of the scale of the problem, or of the actual commitment that is made, even while it poses as a real solution. Consider also the contradiction between two statistics: on the one hand, the issue most cited by voters after the last election was abortion, and most of those who cited it voted for Bush.[9] On the other hand, abortion was sixth on the list of issues which are most important to women.[10] It is not merely a matter of playing to the polls, to public opinion, but of voiding opinion in the face of passion.

Although some key Republican advisers argued that their campaigns should avoid "divisive" issues, the strategy that prevailed recognized that the only issues that matter are the divisive ones—the "gut-level issues." The point is not to make arguments about the issues, or to attempt to change people's minds. Obviously, some segments of the population will find their ideological commitments consistent with, or opposed to, the positions taken on these affective issues. Those groups for whom these relations will matter often provide the resources for the formation of an activist and committed core of both conservative and progressive political constituencies. In the new conservative alliance, they are often organized around single issues. For example, the anti-abortion movement has built a cam-

paign of affectively powerful moral appeals ("the right to life") which ignores the medical and political resonances of the issue. More importantly, such appeals displace their commitment and enable them to refuse any real concern for the actual condition of life of the millions of children, in this country and around the world, who are starving to death or dying from curable diseases, wars, etc. In fact, anti-abortion advocates' passion for the unborn seems more important than the inconsistency of their position, which often ignores the right to life of anyone else after they are born.

Remember Dan Quayle's statement that he wanted to be vice president because it was a good career move. As politics as a system of meaningful choices and positions becomes irrelevant, all that matters is the ability to make a commitment in the face of the increasing fear of any specific commitment. The new conservatism does not replace a lost source of optimism, but rather speaks directly to a desire for optimism in the face of the postmodern frontier. It is not coincidental that, according to the *Rolling Stone* survey, the event which had the greatest impact on people was the space shuttle Challenger disaster, an event which burst the last bubble of optimism.[11] The new conservative alliance does not need to deploy specific commitments or beliefs, but it has to foreground the need to believe in belief, to make a commitment to commitment. This strategy bears a striking resemblance to so-called sleeze TV which has become so popular, especially in talk and "real-life" shows. Despite their often conservative appearance, a careful look suggests that they have no consistent political position: rather, they seem to consistently take the position, on whatever topic, which enabled and even called forth the maximum passion. The new conservatism makes politics into a marketing problem, but it is passion or sentimentality itself that is marketed.

Even the economy is treated less as a real social dilemma which could be analyzed and debated than as a psychological site of passion, chiming with people's contemporary fears of the insolvency of their own households, if not now, then in the future. Again, the *Rolling Stone* survey provides some insight into the importance of the fear of "downward mobility," of whether "they are going to share in the

same American dream as past generations. The statistical evidence is that the members of this generation are already falling behind, forced to settle for less."[12] And while other evidence in the survey would surely suggest that the people questioned know this to be the case, nevertheless, the authors of the survey conclude that "most still insist that it isn't so." They maintain that they have a strong sense of personal contentment despite all the contrary evidence. "Many simply want to believe that they're better off than the evidence shows."[13] In fact, the image of the economy and of those who profited from it during the 1980s is largely responsible for people's sense of the increasing role of greed in the society (reflected perhaps in the growing popularity of *American Gladiators*). Yet images of economic success themselves became sites of passion and investment. Unlike the "ugly American" businessman of previous decades, contemporary success stories were increasingly stories of young cowboys, sexy figures who were yet not unlike the rest of the population. Quite often, with few exceptions, their success did not depend on professionalism and hard work:

> They were, instead, extremely lucky, reaping the benefits of market conditions created by the U.S. Federal Reserve. The game having been rigged in their favor, all that was left was to strike the proper pose. Attitude, more than experience, counted.[14]

Marketing passion and the belief in belief is not the same as playing to people's fantasies. The former wins people affectively, rendering the actual content of the commitment secondary. This is the approach which the new conservative discourse puts into place: whether it is Bush's "thousand points of light," or movies like *Lean on Me*, or ad campaigns like "Where there's a will, there's a A," the complex issues of, e.g., education in our society are reduced to the quantity of someone's passion, to their commitment to the empty appeal of education.

Governance itself becomes irrelevant as a popular and public activity. Government itself, both as activity and party, does not matter except as a symbol of the sentimentality of the struggle to make a difference. Its only consequence is a kind of aggressive

chauvinism. This is not, despite the rhetoric, a policy of laissez faire—that government is best which governs least—for that makes the glaring contradictions in the past two administrations visible (e.g., the fact that the percent of the GNP spent by the government has actually increased, despite their rhetoric to the contrary). It is an affective condition: that government is best which demands and distracts the least. The new conservative strategy places people in a position where they need do nothing other than affirm, in some always undefined way, the fact of their commitment. Even the Iraq war seemed to be presented in a way which demanded nothing of the majority of the middle classes except celebration and prayer.

In such a "mood politics," meaning must not only be depoliticized but rendered ineffective. When Reagan declared to the Republican party that "facts are boring," he was reaffirming the need to constantly reproduce a sense of cynicism within which ignorance and misinformation become reasonable states: knowing that you don't know the truth—and making a commitment nevertheless—becomes an assumed, if not desirable, condition of activity. Meaning, truth, facts—nothing can be allowed to contradict or get in the way of the necessary affective investments which such a mood politics demands. Even the fact that one lacks confidence in the government (according to *Harper's*, only 16% of the population has "a great deal of confidence" in the executive[15]) and the future cannot interfere with one's commitment and passion (82% of Americans believe God still performs miracles!). Here we might consider the popular skepticism toward news. Less than a third of 18- to 45-year-olds follow news regularly.[16] And what stories did the general population follow most closely during the 1980s? According to *TV Guide*: the Challenger disaster, Jessica McClure trapped in a well, the air strike against Libya, the TWA hostage crisis in Beirut and the Chernobyl meltdown.[17] These have less to do with political choices than with sentimental investments in the news and the world. They are not so much "feel-good" stories which enable people to escape their reality as affective stories which demand that people feel and demonstrate real passions.

This cynicism is by no means limited to the relation between the

population, government and the news; it is even more prevalent within politics itself. As the *New York Times* suggested:

> Cynicism by citizens towards politicians is hardly new. What is striking is the unanimity among the consumers and practitioners of politics, and how the practitioners, even as they bemoan the process they foster, are feeding the cynicism back to the consumers.[18]

The *Times* quotes Lee Atwater, then chairman of the Republican party: "Bull permeates everything."[19] Not surprisingly, the *Times* blames this situation, and the resulting failures and lack of vision of contemporary politicians, on three things: the high cost of campaigning; the incorporation of political campaign reporting into the practices of media culture; and the negative campaign practice ("slash-and-burn" tactics) which dominated the past few campaigns. Also not surprisingly, it is Lee Atwater who presents the only dissent to this too easy vision of culpability: "If you want to look at a solid trend for the last 15 or 20 years it is that the American people are cynical and turned off about all the institutions, and politics is one."[20]

The popularization of the new conservatism depends on this recognition and on its ability to articulate this cynicism into a particular political relationship. Its various agencies use a variety of strategies, not to negate or challenge this cynicism, but to articulate its effects. Popular conservative intellectuals constantly remind people of how bad things are and blame it all on the relativism of postmodern cynicism. At the same time, they speak the language of that cynicism.[21] Popular media (from the spate of recent Vietnam movies to the various political exposes) reinscribe the irrationality, not only of our political system, but of the world in which it must operate. The only response to such a condition is to reduce one's claims to understand and intervene intelligently, and retreat into one's commitments. As politics becomes freed from the constraints of meaning and reconstructed within the terms of contemporary cynicism, as people increasingly accept their ignorance and the affective nature of political choices, their commitments carry little or no responsibility with them. But the cynicism never stands alone within the new

conservative discourse: it is always inflected by an ironic glance: Reagan's "most effective public gesture is the humorous shrug of incomprehension, a mannerism that appears strangely genuine. To see him do it is to laugh with him, to share his amused befuddlement at the mess the world's in."[22]

This ironic cynicism not only divides the population into two groups on either side of the frontier. It also divides that population articulated to the frontier into two groups, each with a different relation to the frontier: those who actively oppose its logic even as they perhaps unknowingly live in it, and those who surrender to that logic. The first group actively participates in conservative political struggles (embodied in Operation Rescue, for example), believing not only in their own affective commitment to specific gut issues, but in the ideological correctness of their positions. Their passion is directed against their own place within the frontier as much as it is against the mythic enemies which the new conservatism has created. The second group is unable or unwilling to struggle against their place in the frontier. They may find themselves caught in the discursive trap of the new conservative articulation of the frontier. This involves a reversal by which social concern is translated into selfishness and special interests. For example, the press release for a recent ad campaign with the slogan "Do Life" describes itself as reflecting "the transformation in outlook from the 'me' generation to the 'we' generation . . . 'Do Life' means don't waste your life. It's about *self-actualization*" (emphasis added).[23] This reversal enables one fan of *Beauty and the Beast*, a theologian who defends the show as a catalyst of change, to justify her own inactivity: "I might be able to help 15 people . . . But if the show survives, there will be millions who are inspired to go out and help others."[24] What is lacking here is any sense of political action aimed at changing the world.

This logic of reversal foregrounds the futility of struggle as a tactic for one of the most explicit social and political struggles in recent history. The proliferation of statements suggesting, not only that the various movements of the 1960s and 1970s are dead but that their struggles were largely ineffective, is part of a larger rhetoric of helplessness which entails that control has always to be surrendered to

someone else, whether corporate technology or the new conservatives. At the same time, it ignores and even hides the fact that these agents are actively struggling to gain control (e.g., the often noted irony in the active struggles of antifeminists who defend the claim that a woman's place is in the home while they are organizing and campaigning). Here activity is used in the name of passivity, and passivity is constructed as a new form of activism. Surely it is not coincidental that a powerfully visible rhetoric of the end of feminism has appeared alongside the explosion of struggles over abortion.

Perhaps the most pernicious example of this ironic reversal is the rhetoric which locates people's freedom in their ability to choose to reject change. No where has this logic been more actively deployed than in various attempts to rearticulate the trajectory of the women's movements. *Good Housekeeping* describes "the leading edge of America's newest life-style" as belonging to the woman who "is part of the powerful social movement that researchers call 'neo-traditionalism.' "[25] The campaign suggests that it is a woman's right to choose to ignore the arguments and gains of the feminist movement. Marketer Daniel Yankelovich says, "It's a combination of the best parts of the '40s and '50s—security, safety and family values—with the '60s and '70s emphasis on personal freedom of choice. It's the first major change in the basic way we want to organize our society since the '60s."[26] Its best images are perhaps Vanna White and Tammy Faye Bakker. Leslie Savan comments: "Simply insisting that nothing has really changed—divorce, abuse, drugs, etc. notwithstanding—does two things: It makes the traditional virtuous—it must *deserve* its longevity. And it presents a solution—eternity is the ultimate security."[27] Despite their real political differences, the so-called new postfeminists in rock culture (from Sinead O'Connor to Madonna) can be articulated into a similar logic of reversal. Not only do they offer a vision of authenticity as a marketable image, but their image of "becoming feminist" is often defined by images or simple reversals of a countercultural traditionalism.

Ultimately, the impact of this ironic reversal is that politics becomes an act of investment in a position where one does not have to do anything, whatever one's own relation is to what is happening,

however one might feel about events. This goes beyond image politics, for the logic of images is itself reversed in the new conservatism. The current power of images in politics is not an end in itself. Mood politics is not image politics, for the latter privatizes politics, while the former takes politics out of the realm of public debate. One can debate about images, but how can you debate moods? Scandal replaces debates, and emotional confessions become the dominant form of political self-definition. Why, after all, do scandals arise in certain places and not others? And why, when they have appeared, is it so unpredictable whether they will have any consequences? In the end, this is less important than the fact that public life itself is increasingly constituted as the space of scandal, and scandal is the ambiguous machinery by which stars are made, remade and only rarely undone.

Scandal redefines the kinds of investments that are possible, not only in public life but in everyday life as well. It becomes a strategy whereby a depoliticized politics becomes the site of postmodern passion, disinvesting popular culture. While the fact that popular culture matters does not matter, the fact that nothing matters does matter. The new conservatism offers a happy ending to put on your nihilism: "You can only sing about being in love with your walls for so long before you realize your room'd be a little prettier, a little more fun to be alone in, with some decorations."[28] Scandal makes a politics out of the pure investment in a "kinder, gentler nation" even though it has no consequences for action. Politics is relocated from the realm of social conditions to that of the affective and the scandalous. It is scandalous that people smoking can poison others; it is scandalous that people kill animals for their own pleasure; it is scandalous that a woman's pleasure could be more important than the health of her unborn child. These sites produce enormous passions but not real political debate, for that would require discussions about priorities and resources, about real social conditions and real struggles to reorganize people's lives.

Even nostalgia is suspect in a scandalized public domain, for it can be measured and judged. But the nostalgia for nostalgia, the nostalgia for a mood, both requires and recognizes its own misrecog-

nition. The incantation of "The pride is back" or "It is morning in America again," for example, never identified when they had left or what exactly had been recovered. Instead, both slogans offered an affective possibility, and it would have been scandalous to negate them. It is scandalous, but somehow acceptable, when network news covers Douglas's defeat of Tyson by showing a teacher comparing Douglas to Martin Luther King, Jr. After all, they both had a dream! AT&T decides to withdraw its support of Planned Parenthood, justifying its actions in the name of remaining neutral and fair within the political arena. But of course, its action supports one side and weakens another; moreover, the strategy is selectively practiced, and its parameters are defined by the threat of scandal. Scandal is the administration of the postmodern sensibility, its articulation to a politics which replaces the space of popular culture as a site of investment.

Finally, the frontier itself is transformed. It is still partly defined by an attitude in which we are all implicated. In this sense, the frontier is in everyone—and with it, the possibility of evil. But now its popular resonance is rearticulated to "activities" that have to be affectively and morally judged and policed. The enemy is not within people but in specific activities that construct the frontier over in the image of the new conservatism. The frontier becomes a seductive machine, seducing people not only into the need to invest, but ultimately into a series of temporary and mobile investments which locate them within a popular conservatism. The frontier's articulation by the logic of scandal marks a real break with older conservatisms built on some notion of tradition. Here politics is not a solution to problems, but a machine which organizes the population and its practices. What is on the "right" (in both senses) side of the frontier, on the other side of politics, is a purely affective morality (ie., one which leaves no space within which specific actions can be judged as anything other than scandalous).

The new conservatism embodies, not a political rebellion but a rebellion against politics. It makes politics into an other, located on the other side of the frontier. Anyone who actually talks about serious problems and their solutions is a dreamer; anyone who celebrates

the mood in which the problem is at once terrifying and boring is a realist. It is no longer believing too strongly that is dangerous, but actually thinking that one is supposed to make one's dreams come true. The failure of Earth Day cannot be explained by merely pointing to its status as a feel-good media event, nor by pointing out the increasingly hypocritical appropriation of "green politics" by corporate polluters. It is rather that ecology, like any "politics," has become a question of attitude and investment, as if investing in the "correct" ideological beliefs, even demonstrating it, was an adequate construction of the political. Within the new conservative articulation of the frontier, political positions only exist as entirely affective investments, separated from any ability to act.

11

IDEOLOGY AND
AFFECTIVE EPIDEMICS

If the new conservatism depoliticizes politics, it also repoliticizes everyday life. The struggle over the place of politics is extended by transforming it into a struggle over the politics of place. The new conservative alliance's efforts to link itself—both positively and negatively—with the postmodern frontier is often eclipsed by its various fractions' attempts to restructure the field of values. This is not merely an ideological question of the meanings articulated to specific social experiences, identities and relations. The second strategy of the new conservative hegemony involves a struggle over the particular places that carry some weight, that pull people's discourse, actions and lives along certain vectors and away from others.

The success of the new conservatism depends on an effort to disarticulate people's (and the nation's) investments from the mattering maps of postwar popular culture. This struggle to change what matters in the U.S. depends upon the very sensibilities which made postwar pop culture different and which gave it its central place in our lives. If the new conservatism strategically attacks the affective investment in the rock formation, it also attacks rock's affective authority. It attempts to replace the various mattering maps which the rock formation put into place and the specific sites of investment and authority which it empowered: youth, pleasure/fun, the body, the celebration of change and experience, sex and drugs, the public declaration of certain forms of alienation and displeasure, etc. As Hugo Burnham, ex-member of the Gang of Four, describes it, one

gets "old" in the rock formation when "the rest of your life becomes more important than 'rocking out.' Growing old . . . means accepting that preserving one's health, brain cells, job, marriage, etc. is more important than (but not entirely at the expense of) being or doing your thing . . ."[1] The new conservatism attempts to control the spaces within which people operate, to incorporate them back (were they ever actually there? did they every actually escape?) into the socially sanctioned places of social relations (e.g., the family, school, etc.) It attempts to redistribute the spaces and places of the rock formation in which, for example, the family is a highly circumscribed site surrounded by a multiplicity of spaces defined as other to or outside of the family. This structure challenges the very specific forms of investment which the new conservatism would put into place. There is a very real antagonism between the two configurations of everyday life.

This is more than an ideological question because it involves the very possibility and nature of authority, of who or what has the right to speak for others, to stand in their place, to construct their mattering maps. The affective "crisis" of America is a crisis of authority—not merely that specific figures and sites of authority have been challenged but that the very authority of authority has itself become suspect. Whether or not there is a crisis, which seems to imply some preexisting moment of normality, the postmodern sensibility certainly made the rather sudden perception of a crisis real. The new conservatism has to struggle, not only to strategically reconstruct authority in certain dimensions, places and times, but also to reinvest the very possibility of authority in a way which will protect it from the constant deconstructive cynicism of the postmodern sensibility.

The new conservatism produces its own ideological places—affective magnets—which organize people's mattering maps. These maps not only represent a coherent system of values but also organize and prioritize people's investments. Many of these valued places apparently come from other, sometimes older, sometimes competing formations. Their importance has often been determined elsewhere (e.g., by demographic or economic changes). But their location within the new conservative maps changes their inflection, and

increasingly they appear to belong to these maps. Any investment in these charged sites seems inevitably to implicate people with the new conservatism which claims ownership, not only of the particular site, but of the field in which it identified.

This produces an increasingly common experience: once someone enters the field, they find themselves almost uncontrollably situated on or at least pulled toward "the right," regardless of their ideological relations (or lack of relations) with the Right. For example, a friend who recently became a father described feeling as though every time he speaks of his concerns as a parent, he "sounds" like a conservative. It is not merely that the Right seems to "own" the discourse of the family, but that the discourse itself, which belongs to no one, pulls one affectively over to the right. It is as if the affective investment called an ideological position into its place as its (illusory but necessary) alibi.

It seems that the new conservatives mobilize ideology to restructure the mattering maps of everyday life, redistributing the places that matter and redefining their political inflections. On this view, the new conservatism is an ideological struggle over the specific content or meaning which surrounds people once they are called to the appropriate places. But this does not explain how people are called to these places, nor how they are "trapped" within them despite their political and ideological disagreements. I want to suggest that while the new conservatives see themselves engaged in a series of ideological battles, they are not in control of the effects of their practices. Their strategy entails a much greater challenge to the very structure of authority and everyday life, for what are called by these magnetic sites are not individuals but other places on people's mattering maps. The specific magnets function, not as stable sites of investment, but as structural principles which discipline the very nature and possibility of mattering maps. They have no clear or single meaning or identity. They operate less as references to some image or value, to specific "places" within which particular investments can be made and specific activities or relations enacted, than as "transit lines" which control the trajectories and define the spaces of everyday life. They direct people's movements, constructing lines

of flight across the space of their mattering maps. This strategy goes beyond recognizing the structure of investment created by the rock formation; it reorganizes the very possibilities of structuring such investments. It creates a new kind of mattering map which depends less on specific investments (places) than on the assumption that any stable set of investments is impossible (given that people live along the postmodern frontier). And it make it extremely difficult to contest specific organizations and values.

Such ideological sites work as "affective epidemics." Rather than an organization differentiated by places and spaces, such epidemics produce everyday life as a series of trajectories or mobilities which, while apparently leading to specific concerns, actually constantly redistribute and disperse investments. Affective epidemics define empty sites which, as they travel, can be contextually rearticulated. These mobile sites are constantly fetishized, invested with values disproportionate to their actual worth. Their most important function is to proliferate wildly so that, like a moral panic,[2] once an affective epidemic is put into place, it is seen everywhere, displacing every other possible investment. But unlike moral panics, such epidemics are not always negatively charged and they have no specific focal point of identity, working instead through structures of identification and belonging. Mattering places are transformed into vectors so that the concerns and investments of real social history become the ruins of a displaced, perhaps even misplaced, paranoia. In response to a condition that has been often characterized as "cultural weightlessness,"[3] the new conservatism establishes a daily economy of saturated panics. This leaves only two possibilities: either fanaticism or sentimentality, both struggling to make a difference within a condition of affective excess.

I will give a few examples of these epidemics. The most obvious is the war on drugs, or more generally on addiction. It is not just that one suddenly sees drugs everywhere, as the new universal culprit. More importantly, as soon as "drugs" are found, nothing else seems to matter. All other questions or concerns have to be set aside, disappearing in the face of the drug epidemic. The need to end drug use erases not only the poverty and alienation which leads people to

it, but also the economic and political interests which have and continue to sustain the drug traffic. In the name of protecting people from drugs, individual liberties can be sacrificed. As soon as drugs or alcohol are mentioned, the original crime which may have led to an investigation takes a back seat. In the name of eradicating the drug trade from Black ghettos, one can ignore the contradictions that operate within this illegal economy, and the further devastation that removing drug money might do to these neighborhoods. Political careers take a second place to drug use; in fact, everything takes second place to the implied threat of drugs, as the epidemic spreads. Even our most basic standards of compassion and decency: for example, in the shadow of the drug panic, some states have proposed bringing back public—televised—whipping as an adjunct, not even an alternative, to prison. And typically, once such epidemics have been deployed, they continue to operate whether the panic continues or not. Thus, the attack on addiction has not decreased, despite the fact that the number of Americans who rated drugs as the "number one domestic problem" fell from 64% to 10% in just over a year.[4]

The most powerful affective epidemic in the contemporary U.S. is organized around and across the family. The power and presence of images of the family depend in part on the fact that there is little content to what is increasingly seen as a threatened, besieged space rather than a specific place. The family is suddenly everywhere, appearing, for no reason, in a wildly unpredictable range of places: including films (e.g., *Dick Tracy*, *Pretty Woman*), television programs (e.g., the new westerns such as *Paradise*) and ads (e.g., mothers take charge in ads for both Arsenio Hall and Richard Simmons). Even popular music seems to be paying more attention to the family.[5] At the same time, the contemporary images are so varied and often, in the best postmodern tradition, strange (e.g., the popularity of *The Simpsons* and the cult status granted to *Twin Peaks*).

Traditional discourses and debates around the family centered on issues of the social arrangements in the home, and the nuclear family (mommy, daddy, child) was taken to define the family as a site worthy of investment. But today a minority of "families" in the U.S. fit the model of the nuclear family. Contemporary images and

discourses of the family do not rely on such normative images. While the initial formulation of the "crisis" of the family in the 1970s was often framed in terms of the collapse of the nuclear family, this was less true of the 1980s. It is not a matter of social relationships but of, as a recent Gitano ad puts it, of "the spirit of the family." The family has come to define the language in which other relationships have to be made to matter; "familialization" frames more and more of contemporary social space. Even the discourses of AIDS groups are increasingly organized around the validity of homosexual relations as "families."

Similarly, the range of familial arrangements has become utterly unpredictable. For example, the family which is at the center, both narratively and ideologically, of *Teenage Mutant Ninja Turtles* is composed of an aging rat and four adolescent turtles. The family of *Alien Nation* often explicitly criticizes contemporary values and disrupts gender and sexual roles. The family no longer has an identity which can be protected. What we are dealing with, as Arthur Silverblatt has described it, are places "for convenient, disposable, fast famil[ies]."[6]

Consequently, it is no longer a matter of "the family in crisis." Rather, all social problems are increasingly linked or rather reduced, not to individual failures, but to the absence of the family as a determining force. It is not the structure or state of the family that is at stake, but its affective power to redirect our investments and movements. After all, to talk about the family in crisis would inevitably raise questions currently excluded from the possibilities of daily talk, about the material conditions and suffering of families and especially children. The epidemic of the family somehow obviates the need for a more critical relation to the family itself. The family in the U.S. has increasingly come to be the billboard of the possibility of security, displacing the home, which too many can no longer afford anyway.

The family has become a life-style choice, representing little more than a set of experiences (e.g., consider the statement that one wants to have a child because it is an experience that shouldn't be missed). The rhetoric of women's biological time-clock is a part of this larger

formation. One has only a certain period of time in which to choose to have the experience of children and, if missed, the opportunity is lost. There is little space in these images to discuss the desirability of such choices in the contemporary world. As Ellen Willis puts it, babies have become "a socially acceptable source of joy."[7] The debates over the pressure on women to marry (and whether it is necessary or even possible) have continuously moved back and forth, allowing no conclusion other than that women are and should be constantly panicked. One of the characters in *thirty something* has a nightmare that she is on *Geraldo* (the talk show) as an example of a woman over thirty who has been "left on the shelf." And Madonna, in her self-produced concert documentary *Truth or Dare,* constantly chats about how she wanted to surround herself with emotionally crippled people so that she could fulfill her need and desire to be a mother.

The new family is at the center of the nation, but unlike the 1950s, the new family is not child-centered. As a life-style, it represents a consumer practice (what Ehrenreich calls "suburban pastoralism"[8]) which is, quite simply, diametrically opposed to the consumerism of the rock formation and its contemporary negative rearticulations (e.g., the yuppie or the postmodern youth of *Less Than Zero*). On the other hand, the increasing public debates about the need for "open adoption" place the family squarely within an ambiguous biology, leaving the parameters of parental identity always undecidable.

But the family does even more. Reagan's rhetoric redefined and relocated the first settlers and the founding experience of "America": the country's origins were located neither in the individual pioneer (Turner's frontier hypothesis) nor in the founding of communities (Dewey's democratic theory) but in the union of families. As the new primary unit of social definition, the family displaces the individual as the site of rights and liberties. This enables an attack on individual civil liberties and the constitutional protections of the Bill of Rights. In the name of the family, the space of individual rights can be sacrificed, even though it apparently violates Americans' supposed ideological commitment to individualism. Similarly, the

child becomes nothing but a position within the space of the family. Tipper Gore wants the family to control the possibilities of childhood, rearticulating the family as the source of social discipline (e.g., the increasing turn from a concern with child and teen suicide to a paranoia over teen crimes, from drug dealing to gang wars and murder) and even of corporal punishment. The current spectacle of child abuse trials, not coincidentally, tends to focus on institutional abuses, leaving unexamined the concrete places of the family as sites of child abuse. Not only is the latter hidden, but the rhetoric of the failure of the public institutions regarding childhood ensures that the child must always be returned into the family.

There is even an increasing propensity to expand the space of the family beyond that of consumption and morality. The home can colonize all of our activities: it can become the site of both cultural production (as in *America's Funniest Home Videos*) and material production (in the return to piece production and sweatshops). Such expansions of the family are legitimated by replaying and rearticulating an old and familiar theme: the brutality and hostility of the outside world. At the same time, contemporary discourses gleefully appropriate such images of brutality (e.g., the increasing use of images of business as a battle between animals: one ad casts competition as a shadow play of the *good* wolf baring his fangs over the helpless sheep). *People* described the 1980s as "the decade of brutishness unchained, 10 perilous years when the whole of public life took on the atmosphere of a slam dance being cheered by a hockey crowd."[9] The nation learned to survive "free-floating aggravation" of public life: "the flower generation tore tradition to shreds, but in the 1980s some magic sewing machine has stitched it all up again."[10] That magic sewing machine was the family.

Other epidemics are constructed around the vector of the family: for example, the contemporary fascination with health. As in classical Greece, the health of the body has become the visible sign of the worth of the individual. Health has, in its epidemic form, become a moral issue. To fail to invest in the health of the body is to forsake any moral worth. The panic continues to spread through the necessary attempt to keep up with the constant flow of information

about what is good for you and what is not. But it is impossible, for the information continually changes and contradicts itself. One invests in the body, not for the sake of the pleasures that it may produce, but simply to "be healthy" (which is not quite the same as feeling healthy). It demands an increasing vigilance over one's activities and an increasing commitment to activities that have no other purpose than to prolong the ability to participate in those same activities (or perhaps in the activities such as work which provide you with the leisure time to continue to seek the healthy body). The health epidemic can also be seen as a rearticulation of the investment in youth. Ads proliferate which announce, simultaneously, the end of childhood and the beginning of health as pleasure. For example, in one ad (for Doritos), a group of kids announce that "once you hit thirty, your life is shot," but their declaration is followed by a series of images of over-30s engaging in a variety of "youthful" activities.

The economy has itself become a site of an affective epidemic. The debt, for example, whenever invoked, strikes terror into the hearts and minds of the population. It leads them to take positions and actions that, at least many of them claim, they do not wish to take. But they have no choice. The debt is itself a complex issue, both in terms of its causes and its effects. Unlike the threat of inflation, the debt has little *direct* impact on consumer practices and life-style choices (while it has a profound impact on the international economy and, most especially, on the economies of third world countries, for it takes money out of circulation and relocates it back within the comfortable boundaries of the U.S.). But this is not what panics Americans; it is rather the concept of owing someone so much money. Of course, this is an entirely inadequate model of how contemporary finance economies work, but that does not seem to matter. It is not an ideological problem but an affective epidemic.

On the other side of the economy, consumerism itself has been transformed into a purely affective investment which incorporates everything into its spaces. Rather than an activity, it becomes an investment in itself. One invests in capital. One no loner consumes to keep up with the Jones, or even to be different from them. One no longer buys a dream. Consumption becomes an end in itself

(e.g., television games shows in which you "try to outshop your opponents") and shopping takes on a weight all its own. It has become a vector along which people invest in their own lives—buying themselves, as it were, investing in themselves as capital. They no longer define themselves through their relations with or differences from others (whether people or capital). They do not shop for value, or even for symbols of status, but as a space of mobility. Consumerism does not signal or produce mobility; it is identical with mobility. The consumer moves among the other commodities. Consumerism marks an affective investment in capital, an investment within which people are themselves located as both the subject and the agent. Consumerism provides something like a moment of stability insofar as it offers a sense of control, even though its stability is only the stability of mobility, and its control is only that of moving in the spaces opened by capitalism.

Even "America"—the nation itself—has been transformed from a specific site of investment into the vector of an affective epidemic. It is not merely an instance of "nihilism masquerading as patriotism"[11] but of the necessary erasure of any meaning that might inform the sign of "America." The nation operates in the future perfect tense. It has become a dispersed sign of investment which constructs a "distanced and mobile patriotism" that nevertheless functions as an immediate investment. America is reduced so that it can be held up as an object, a spectacle to itself, held in awe. Whether on the movie screen or in contemporary writing, America is inevitably reduced to its detail without any claim of typicality. In fact, its images are increasingly images of the chicness of its hickness, of the ordinariness of its weirdness and the weirdness of its ordinariness. (*Twin Peaks* and the films of Jonathan Demme are only the clearest examples of this.) It is the heartland which, always on a small scale (none of the grand scale of *The Way the West Was Won* here) comes to speak softly about our increasing obsession with the nation, not as a search for identity or commonality but as a desire to be transfixed by our own self-conscious artificiality.[12]

For the first time, just as the myth of America is fading around the world, Americans seem to treat America as the rest of the world

treated it at least since the end of the Second World War, when the U.S. became a world power without actually intending or desiring to. America is an icon of empty mobility (captured in the image of consumerism). A panic is organized around the fear of America's own Americanization. Americans have traditionally had little sense of time or history except in the form of the nation's transcendental future. As this has collapsed, as the American dream has dissolved into the postmodern frontier, the nation has been left with only an empty paranoia about America. Consequently, without knowing what it is they are to defend, people can only defend its symbols— emptied of any meaning or difference: the Constitution, the Statue of Liberty, the flag, and even its language. And these symbols, wherever they are, become little more than the signs of a staunch defense against something that they cannot name, something that they know was not supposed to happen to them, but has already happened: we have become American. The new conservatism does not offer a new definition of America. It does not relocate its center. It disperses it once again into its regional voices, while refusing the logical consequence of multiculturalism. The new conservatism locates people within a space in which they can neither challenge the embodied meaning of the nation, nor offer an alternative. They can only try to escape the empty spaces of its power as a seductive investment.

This is a nationalism with no content. America as an affective epidemic has no entailments, although it has powerful consequences. If America does not stand for anything except the appropriate and even necessary vector of its population's nationalism, it becomes impossible to argue against any action taken in its name. This is not the same as "my country right or wrong" for that still allows the possibility of moral judgments which transcend nationalism, even if they are always to be refused. Reagan and Rambo mark a nationalism which is indifferent to any moral difference. Thus, even while there may always be moral discourses in this new nationalism (e.g, Rambo is defending freedom; Arnold Schwarzenegger in *Predator* is a mercenary who only takes on rescue missions and refuses assassinations, so he has to be tricked into this one), they

remain contentless, with no criteria by which any instance can be judged. Consider the conservative morality which justifies children (or anonymous strangers) turning in their parents for drug possession. This affective epidemic constructs an "empty fullness" at the center of the nation which merely guarantees that there is always a center and that it can never be identified. Whatever people's affective response (whether to specific incidents or to broad agendas), there are no grounds on which to imagine constructing an oppositional nationalism.

The effect of transforming the terrain of ideological sites into affective epidemics is that it is no longer possible to treat them as the occasion for public debates. Questions of fact and representation become secondary to the articulation of people's emotional fears and hopes. This partly explains the new conservatism's "ideological" successes: they have been able to control specific vectors without having to confront the demands of policy and public action. Similarly, they have been able to construct issues with enormous public passion (such as the current attacks on universities, curricula and "political correctness") without leaving any space for public engagement.

12

THE DISCIPLINED
MOBILIZATION OF
EVERYDAY LIFE

While there have been important studies of the politics of contemporary culture, little effort has been made to draw the lines that connect culture to the specific projects of the new conservative alliance and the larger struggles over power taking place in the contemporary world.[1] Such studies, whatever their theoretical or political commitments, have generally reproduced analyses offered over the past century: the narcotization of the population; escapism, if not manipulation and deception; the individualization of the social and political; the disappearance of the public; the regulation and disciplinization of the practices of the population. In a sense, all of these are true, but they ignore the specific forms which such strategies may take (e.g., the power of a logic which not only enables deception but makes it reasonable and even desirable). And more importantly, they ignore the ways in which such cultural strategies are themselves deployed by specific historical agencies into hegemonic struggles over the distribution of resources, values and power.

When *People* published its retrospective of the 1980s, the publisher introduced the issue by noting "how much mental and emotional terrain we've covered."[2] That terrain is partly measured by the two strategies I have described: the rearticulation of the postmodern frontier and the construction of affective epidemics. But the real effects of these strategies, and ultimately, I believe, the real source of both contemporary forms of depoliticization and of the increasingly conservative tone of life in the United States, depend upon the

production of a new regime of everyday life. Lefebvre predicted such a strategy: "Modern society tries to control the changes that take place in everyday life . . . To subdivide and organize everyday life was not enough; now it has to be *programmed* . . . to cybernitize society by the indirect agency of everyday life."[3] It is the contemporary form of this control, the attempt to produce "a closed circuit"[4] of everyday life, that defines the third strategy of the new conservatism: not merely the reconstruction and reorganization of everyday life, but the transformation of everyday life into a specific form of structured mobility, a disciplined mobilization. Everyday life becomes the site for and the mode of a new apparatus of power, aimed at depoliticizing significant segments of the population by erasing the lines that connect everyday life to the political and economic realities that are its conditions of possibility. While this opens the possibility of a politics of everyday life, it closes off the possibility of organizing a sustained counter-hegemonic struggle.

This restructuring of the field of power and politics by the operation of a disciplined mobilization resembles the counterculture of the 1960s in some ways. Many segments of the counterculture were less concerned with questions of state and economic policy (Vietnam being the most obvious exception, but even there it was a war which impinged immediately upon the everyday lives of those involved in the protest) than with questions of alienation and life-style. Ultimately, the popular face of the protest movement suggested that the transformation of everyday life would itself lead to a transcendence of both power and politics. The new conservatism might be seen, then, not merely as an attack on the counterculture but as an explicit reversal of its program using the same logic and many of the same strategies. The major political struggles are located within everyday life: they are the matters of the values which our life-styles embody, and questions of state values become largely irrelevant except insofar as they impinge upon, determine or sanction specific everyday values and life-styles. Even economics has to be reduced to images and questions of everyday life; for example, in Reagan's identification of the national economy with that of "the" family. Or consider the recent advertising campaign in which *Fortune* claims to "discuss

business in terms of what matters," and of course, the list of "what matters" could serve as a litany of current images and debates about life-style and values.[5]

As the counterculture was shaped by the rock formation, it is possible to see the new conservative deployment of a disciplined mobilization as an attempt to both disempower and rearticulate the rock formation itself. In chapter 4, I described the abstract structure of daily life (and, by extension, everyday life) as a map of spaces and places, a structured mobility. Places are the sites of stability where people can stop and act, the markers of their affective investments. They define the possibilities of people's identifications and belongings and construct the systems of authority in which they live. Spaces are the parameters of the mobility of people and practices. They define the trajectories along which different groups can travel and the vectors which make different connections possible or impossible. Every organization of places and spaces is constantly being constructed—territorialized—by lines of articulation and escaped—deterritorialized—by lines of flight. In chapter 6, I suggested that the power of music could be located in its ability to produce such structured mobilities, and in its popular formations, mattering maps. The mattering maps of the rock formation privilege mobility and space over stability and place. This is not surprising, given that the rock formation was defined for and by a population which was constructed by being shuttled around, which had no place of its own. Its places were the sites where it could escape the discipline of other places and find the space for its mobility, its rhythms and its dance. Punk not only helped undermine the claim of authenticity (as a site of investment), it also further privileged space over place. Thus, it is not surprising that post-punk rock would so quickly and totally return to its roots in rhythms and dance and turn its melodies and lyrics into little more than sentimental soundtracks.[6]

The increasingly rapid rhythms—both literally and figuratively— of the contemporary versions of the rock formation signal its constant love/hate relationship with the postmodern sensibility which has reinflected its possibilities. This sensibility has undermined its ability to construct anything but the most temporary and contentless sites

of investment and authority, even to the point where the culture increasingly appropriates places taken from the dominant culture which it has traditionally opposed (e.g., rock's turn to the family). The contemporary rock formation only lets one feel at home for a moment. It produces maps of spaces with no places or at least, its places are increasingly called into the service of its spaces, its stabilities into the service of its attempt to continue to find lines of mobility. It is as if mobility had become the only source of empowerment and security available in the face of postmodernity. But the rock formation also produces its own discomfort with this situation. The solution demands a particular resolution of rock's ambivalent relation to everyday life: on the one hand, refusing to leave its comfortable spaces; on the other hand, always producing lines of flight which point to the possibility of another space even as it denies the possibility of transcendence and salvation.

It is this ambivalence which the new conservatism has challenged. By rearticulating rock's structured mobility to a specific hegemonic struggle, it has constructed a different territorialization of everyday life. In this new apparatus of power, the homelessness of the rock formation is normalized. And more importantly, the rock formation's lines of flight are disciplined so that they can no longer point to another space. They must always return into everyday life, reterritorializing themselves without becoming lines of articulation. It is simply that their flight now has to be enclosed within the space of everyday life.

Everyday life is already a reification produced by and as a relation of power. There is no innocent moment when everyday life escapes power. The relations of spaces and places which constitute the maps of everyday lives are the scene in which power enacts itself through apparatuses of territorialization and deterritorialization. A disciplined mobilization is a strategy by which the very possibility of stabilities (identities, authorities) is negated through the reification of mobility and space. A disciplined mobilization transforms everyday life into an apparatus which produces spaces with no places, mobility with no stability, investments with no permanence, belonging with no identity, authority with no legitimation. Once one enters

its spaces, there is no longer a frontier to cross, for even the frontier would constitute the possibility of a place. Instead, everyday life becomes a transit-compulsion in which sites of investment are transformed into epidemics and ultimately into pure mobilities. One can only continue to move along the frontier of everyday life, as along a Moebius strip. There is no longer an outside or an inside, only the constant movement within everyday life itself. Every line of flight which signals the possibility of an outside is stopped at the frontier, bent back upon itself. Lines of flight are deployed in the service of a new territorialization which deterritorializes only the limited space of everyday life. A disciplined mobilization signals the triumph of an unconstrained mobility which is nothing but a principle of constraint. But it is neither individuals nor communities but affective alliances, marked by different durations and intensities, which travel along the Moebius strip.[7]

A disciplined mobilization entails a radical reorganization of the very structure of everyday life in relation to people's sociopolitical existence. It restructures and transforms the very nature of people's affective relationship to the world so that such investments can no longer anchor them into something outside of everyday life. Instead, affective investments only traverse the surfaces of everyday life. Affect now constructs smooth and fluid transit lines along the surfaces of a minimalist configuration of people's everyday environment. The postmodern frontier is narratively transformed: "nihilism with a happy face" has become "nihilism with a happy ending." Survival itself has been renarrativized, for the only affective response to this disciplined mobilization, the only strategy for surviving in this structure of everyday life, is, "Don't worry, be happy"—and keep moving! This can be seen in the design and fashion aesthetics of the 1980s: "The pressure on us to change and change and change again has, in the end, numbed the eye and destroyed the contemporary aesthetic itself."[8]

A disciplined mobilization is a specific structuring of everyday life according to the dictates of a specific struggle for power: deterritorialization itself becomes the form of its territorialization. The places and spaces which constrain mobility disappear in favor of a boundary

which produces a mobility always circling back on itself, always caught within the compulsions of the frontier within which it has been constructed. Perhaps the best embodiment of a disciplined mobilization is Disney World, which, even as it puts business on display, erases corporations (including its own existence). In Disney World, the entire game is to keep moving through its infinitely filled, expanding spaces. Like the growing tourist trade in the U.S., Disney World makes everyday life into a mobile closed display.

Unlike other hegemonic strategies, a disciplined mobilization is neither dialogic nor expansive. It does not seek to construct alliances. It is an organization of social space through a regime of movement or performativity. It is an arational, affective space within which ideological differences make no difference. It need not oppose their continued activity since their affective authority is undermined. If it were ever to be completely realized, if it were ever to occupy the entire social space, people as affective subjects would be completely vulnerable to and within its circuits.[9]

It is at least as dangerous as any temporary victory by a conservative ideology or party because the Left has often acceded to its operation. Consider one of the more interesting and paradoxical political events in recent years: the emergence of left-wing anti-free speech movements. While attempts to limit speech are too often assumed to be implicitly right-wing, the current scene makes obvious the variations within, and the complexities among, such practices. Many of these campaigns are located on college campuses around the country, where the issue is not banning speech that is critical of authority, but rather banning speech which in some way "harms" the atmosphere within which such critical speech can flourish. (Another example is the "boycott" of Andrew Dice Clay. Neither of these is quite the same as the antipornography movement.) There is an increasing call to censor various discourses which undermine the calm, rational and, most importantly, hospitable environment of the academy. In the name of opposing a discursively hostile environment in which various minorities (whether racially, ethnically, sexually or gender marked) are discomfited, some people challenge the right of such obnoxious speech to exist.

Interestingly, the challenge is not made in the terms of an intellectual attack on the position, or on any legal or political ground. Rather, it is offered on the grounds of ensuring that students gain the maximum education possible by making sure that they "feel at home" in school. The question is not framed in terms of whether such obnoxious speech challenges a minority student's existence within the institution; it is enough that it undermines his or her ability to invest themselves, to feel comfortable there. This utterly comprehensible if somewhat politically contradictory position actually transforms the labor of investment, of place-making, into the labor of mobility. Instead of arguing about the politics of language and representation, the debate focuses on people's ability to live and invest in, to move among, the practices of its discursive environment. But by claiming to eliminate the barriers of mobility into and within the place (i.e., the intellectual life and professional training of the university), it also denies the specificity of the investment in the place itself.

The frontier, now defining the boundary of a seemingly unconstrained mobility—unconstrained within the everyday life, entirely constrained by the frontier—is itself transformed from a differentiating machine which excludes the other (yet in the very process reaffirms the other's presence) into an excising machine which erases or "disappears" the other. More accurately, a disciplined mobilization is a machine which performs a double erasure. It erases those living outside of everyday life and the existence of a political terrain outside of everyday life. But if there is nothing outside, no other side, then the frontier is no longer a boundary.

First, it erases those fractions of the population which cannot be located within, and hence dealt within in terms of, the structures of everyday life. It is not merely that contemporary society has condemned a significant portion of the population to existing within a new economic "underclass"; it is also that, to a large extent, those living within everyday life must be blind to their very existence except insofar as their oppression can be presented within the terms of the suffering of everyday life. The underclass can matter only insofar as its collective experience can be measured against that of those within

everyday life; it can never be recognized as a necessary condition of everyday life. It can only be located as both the subject and the object of new organizations of fear and hatred.

Such an erasure is not predicated on any essential identity, or even upon a system of ideological differences. In fact, it operates through inclusion more than exclusion. It is determined instead by whether one is already within the space of everyday life or, by some quirk of fate, can enter into its transit by "buying into" its logic. Once there, "freedom" abounds. But there is little opportunity to enter. In this way, the transit-compulsion of everyday life offers itself as its own principle of existence: the frontier reinscribes itself according to the distribution of the population. If everyday life is a rare thing, historically determined and available only to certain privileged populations, that privilege is no longer identifiable with any traditional social difference. It is not a matter of class, race or gender, but of what segments of the different classes, races and genders have access to, or already exist within, the disciplined mobilization of everyday life. The frontier, then, is not racist, although it puts many different racisms into place; it is not sexist, although it puts many different sexisms into place. These specific, often local, sometimes civil and sometimes violent, forms of racism, sexism and classism proliferate when and where the hostile spaces outside of everyday life challenge its self-enclosedness. But the distance between the frontier and that which remains outside cannot even begin to be measured, and certainly cannot be understood by those within everyday life except according to principles of inequality or caring.

Second, the disciplined mobilization of everyday life secures the erasure of any reality which is outside of its maps. Everyday life expands to encompass all of existence, becoming the entirety of space and the only place. Everything becomes comprehensible only within the mobile terms of everyday experience. Thus, what is erased is the very possibility of the political as a domain which both exceeds and transcends the everyday. Mort and Green, perhaps too naively, note

> rapid changes in time-honoured distinctions between something called politics on the one hand and leisure, pleasure and personal

life on the other. That is to say that politics in a formal sense is being challenged by a series of "cultural revolutions" taking place beyond its boundaries . . . Opinion polls and research confirm that "depoliticisation" registers not only a deep pessimism about politics itself, but a growing disengagement of "life" (where people choose to put their energies) from politics.[10]

Too often, descriptions of the contemporary political scene fall back onto general descriptions of the disappearance of public life and civil society, or of the depoliticization of the masses.[11] But such descriptions, however accurate, are also too predictable; their generality guarantees their impotence. Rather than providing a specific understanding of contemporary conservatism, they substitute a mechanical rhetoric which locates the blame elsewhere and fails to find any viable oppositional practice. But the contemporary forms of conservatism are defined by powerful affective lines and practices; moreover, without assuming any single or simple conspiracy, we must nevertheless recognize that such changes are powerfully articulated to specific political agents and agendas.

Many people have noted the similarities between the 1950s and the 1980s; both were characterized by a certain depoliticization of the general population. But few have commented upon the different forms of that depoliticization, and on the different modes by which they were constructed. The 1950s, after all, have to be understood in part in the context of the attempt to construct a culture of consumption in which increasing domestic consumer demand was to fuel continuing economic growth. In terms of this economic project, everyday life was increasingly commodified, treated as little more than a site for the accumulation of commodities. Politics had to be excluded from this realm of existence, and it was: politics was a dangerous game, one which could easily come back to haunt you. Involvement in political activities outside of everyday life (and at the time, there was little sense of a politics within everyday life) was a threatening and potentially terrifying commitment. The terror was not only personal (the threat of public attack and humiliation) but public as well (the threat to the American way of life). But politics had not disappeared. While the depoliticization of the 1950s represented a turn into everyday life, the lines which could take one into

the public realm of politics and the state remained available. And the very possibility of following such lines enabled the emergence of at least some fractions of the counterculture, and produced the almost inevitable split between the youth who followed those lines and their liberal parents. Perhaps everyday life in the 1950s was too seductive in its own right and, in the end, it did lull people into a certain passivity, helped along by a good dose of fear.

Civil society is that space between the domain of the state and economic apparatuses and the domain of private (which is not to say nonsocial) life and experience. It is here that public forms of interaction and cooperation are forged, that individuals and groups find forms of language and association by which they are able to evaluate and struggle to change the social order. In the 1950s, civil society did not disappear, but it was caught in a battle. When it was losing, it was pushed aside, overshadowed by the increasingly safe and seductive preoccupation with an everyday life which was not quite the same as the domain of private life. But occasionally it reappeared to offer possibilities for genuinely public forms of social action and rhetoric (e.g., the civil rights movement, however limited its successes).

But in the 1980s, both civil society and private life have collapsed into the domain of everyday life and, as a result, the very possibility of lines of flight from everyday life into the public arena of state and economic apparatuses is disappearing. It is not just that capitalism or the state has come to dominate civil society or that the languages of civil society (along with those of people's private lives) have been commodified. Rather, it is becoming harder to locate the differences on people's mattering maps. It a very real sense, this exclusion of politics is itself built upon the postmodern refusal of taking things too seriously. It is precisely the sense of helplessness in the face of political and economic relations that justifies the retreat into everyday life; if you can't change the world, change the little piece of it that is within your constant reach. But that reach must be limited, not only to a specific geographic region, but to a specific plane as well. If it is too dangerous to care about the world, too difficult to change it, care about everyday life, change your life-style. Thus, for exam-

ple, even the leader of INFACT (an activist group which actually does enter into battle with economic institutions) defines the enemy in anything but structural terms: "The enemy is not capitalism but the 'abuses' of multinational corporations." She describes her own position as follows: "This isn't a job . . . It's a commitment; it's a life-style . . . that is based on the 'philosophy of living simply,' that makes a statement about how money gets distributed in the world."[12] Political activism is being replaced by "human activism."[13] The distance between life-style (as a statement) and political struggle appears to be disappearing, so that the condition of children living in poverty can be seen as the result of the "lack of responsible parenting."

It is not that politics is privatized but that it disappears from the perspective of those moving within the transits of the everyday life. The place of politics is itself transformed into a space which is inaccessible from everyday life, and hence it remains invisible to those within everyday life. Politics as the realm of governance itself—the issues, interests, complexities and compromises involved in state and economic policy—cannot matter. To put it simply, there is no quicker way to end a conversation or ruin a party these days than to start "talking politics." The worst thing to be labeled is a "politico," not merely because "they" take things so seriously, but because they take seriously things outside the boundaries of everyday life.[14]

It is increasingly common to hear people say that "it takes all their time and energy to get through the day," as if that accounted for their avoidance of politics as well as of the depressing information which might lead them back into politics. It is as if, somehow, people are too involved in everyday life to notice that which shapes it. There seems to be no way out of everyday life, as if maintaining a life-style was a full-time job which absorbed all of people's energy and time. The very practices of everyday life—the speed and direction of their mobilities—seem to lock people into the disciplined mobilization's expanding exclusivities. And the only source of mobility within its circuits is capital itself. As Lefebvre correctly points out, "nowadays everyday life has taken the place of economics,"[15] not only in the sense that it is the object which power struggles to

construct and regulate, but also that it has become the field on which struggles are increasingly confined.

This disappearance of politics, its encapsulation within everyday life, may help to explain the successful mobilization of popular support for the Iraq war. Because the images of the war so saturated people's lives in real time, they quickly became fascinating, banal and even comfortable rather than horrifying. This is not a question of whether the image "accurately" represented the reality of the war or whether its reality disappeared into its image. These questions raise important issues about other strategies, although it would be a mistake to assume that they were obvious and simple: while the military manipulated and even lied to the press and the population, they did so only by creating an appearance of total honesty (e.g., what they had to lie about in Vietnam—friendly fire, they revealed in Iraq). Rather, it has to do with the place of the image in—as part of—reality. The images of the war were articulated and deployed into people's lives so as not to disrupt or break into the closed space of everyday life. Instead, the war was absorbed into its rhythms, tempos and intensities, into its mattering maps.

Everything outside of everyday life—the site of what I might uncomfortably refer to as real or practical politics—is now disinvested, placed in no place, with no lines connecting it to the space of mobility through which we navigate everyday life. But to say that politics has been reinscribed into everyday life, and that a whole other realm of politics has thereby been expelled from people's mattering maps, is not the same as saying that the political has become individualized. Everyday life is not totally organized in individual terms; it is the site of many forms of social and collective organization. It can involve community action and reach into the forums of public life. Hence, it is quite possible to organize "political" movements within and around issues of everyday life.

If the postmodern frontier defines the impossibility of affective investments, everyday life and practices are all that can matter. This is not as unreasonable as it may sound, for, after all, the recognition that there is a politics to everyday life is a crucial challenge to the micro-workings of power. Everyday life has become the site of

empowerment, the only place where one can find the energy to act in any way against the grain of social tendencies, the only place where one can struggle to gain a bit of control over one's life. But practices which may be empowering on one plane are now rearticulated into the disempowering structure of a disciplined mobilization. It is easy to recognize that people actively use specific popular cultural practices to meet their own needs and to empower themselves against the debilitating demands of their postmodern condition. And perhaps they use them against the experience of their own subordination. But this does not itself guarantee that such relations are not themselves hijacked into larger structures which, in the end, make it impossible (or at least unlikely) that such relations can ever be used to challenge the conditions within which people's lives are shaped and determined. Popular culture can be an important source of empowerment in a number of different ways. So can struggles over the politics of everyday life. But this "empowerment" (even when it involves struggles) is caught up within the disciplined mobilization of everyday life, so that the very activities which empower us—in fact, the very forms of empowerment—become partly responsible for the disciplined mobilization itself. Empowerment becomes politically disabling, a weapon to be used against people. The very practices which empower people in everyday life also disempower them by rendering them unable to get out of everyday life itself.

For example, ecology as a political struggle is increasingly displaced from questions of national and international policy and economics to the immediate micro-habits of everyday consumerism (e.g., recycling). Without denying the importance of changing individual consciousness and practices, it is still imperative to recognize that the ecological disaster cannot be averted unless individuals can be mobilized, on an international scale, to change the economic and political structures which allow and even encourage the continued pollution of the environment and the destruction of its (not our) resources. To say that ecology can be politicized only within the terms of everyday life means that it is a matter of collective life-styles and social actions, but that it cannot be treated as a question of state,

corporate and economic policy. Such movements seem incapable of mounting a sustained critique of the forces which impinge upon and organize the structured ways people move through their lives. Thus, the very empowerment which struggles within everyday life make available can be articulated into larger structures of disempowerment which continue to subordinate people by erasing the possibility of political struggles in another space. It is as if the feminist insight that "the personal is political" had been magically transformed into the statement that the personal is the political, the only political realm that can matter.

On the other side of everyday life, the realm of the individual (i.e., private life)—admittedly a historical construct, but one with certain empowering consequences—is also collapsing into everyday life; the result is that it becomes increasingly politicized even as it opens up important issues and sites to be incorporated into the politics of everyday life. Thus, while everyone and everything moving within the spaces of everyday life is equal, they are all equally uncomfortable, equally vulnerable. They are constantly under the surveillance of the other. They are never able to stop and construct a place for themselves for fear of offending someone else (when every statement or gesture can be taken to violate some norm of appropriate behavior within the particular space, and the norms themselves are constantly changing), and of being disciplined in the only way possible—being expelled from the mobile space of everyday life. The widespread influence of what might be loosely called "New Age philosophy," from ecology to corporate management techniques to self-help programs (e.g., Alcoholics and Narcotics Anonymous) similarly signals the collapse of questions of personal lives and values into the more public issues of life-style and everyday life. This has certainly contributed to the legitimacy of the various strategies of disciplinization of the new conservatives (see chapter 6).

Actually, it is not quite true to say that there is no longer a space outside of everyday life, for, increasingly, the possibility of escaping the postmodern frontier and everyday life is invested in the space of the "otherworldly." Consider the enormous popularity of such films as *Flatliners* and *Ghosts*. The latter's black-and-white morality, as

well as its faith that love conquers all, are anchored in the existence of a spiritual reality which is devoid of any politics. Similarly, the overwhelming horror of the Iraq war, its threatening "otherness," was transformed into the otherworldly rhetoric of the mystical evil and the apocalyptic. It was as if Nostradamus had suddenly re-emerged to be the prophet of this war: only nine years to go, according to his count. And if this was a war and a protest movement without any apparent music of their own (even the invasion of Panama had its own place for music), if this was an army of youth without any sex, drugs or rock 'n' roll, Madonna may yet emerge as having provided their only soundtrack—in the "orientalist" sounds of both the remade "Like a Virgin" and the "Beast within Mix" of "Justify My Love." Both resonate—the latter explicitly, the former implicitly—with what can only be heard by American ears as an appeal to the "otherworld" of spirituality (which embodies the ambiguous relation to the other, both spiritual and evil).

The most powerful billboard of this new popular space is David Lynch's *Twin Peaks*. Laura Palmer in the figure of a corpse was one of *People* magazine's twenty-five most intriguing people of 1990. There is obviously something postmodern about this fetishism of a corpse, although it lacks the sense of postholocaust horror that framed a similar image in *The River's Edge*. *Twin Peaks* deconstructed the calm surfaces of small-town life and offered a supernatural mystery. Nothing new about either of these. But it also constructed a universe in which every disruption of the surface pointed beyond the hypocrisy of human relations, beyond the existence of evil within human beings, to a transcendent supernatural. By the end of the series, the stakes in the battle transcended even the existence of the planet. The program embodied many of the features of the postmodern sensibility, yet perhaps its most striking feature was the sheer beauty of its photography, its characters and, most noticeably, its sound-track. The music was so much more than theme or mood music, it was almost another character. It was both sensuous and boring. Like New Age music, it was music to come down from a trip for a generation that doesn't trip. It always pointed beyond itself, not just to the characters (with different songs serving as signatures) or to the

visual surfaces of the program. It pointed to a powerfully haunting reality, always standing beyond everyday life, threatening to shatter it. Yet simultaneously, it closed in on itself, forcing the listener/viewer back into the surfaces of its world, and into the comfortable insecurity of everyday life.

The collapse of all political space, civil society and private life into everyday life and the transformation of everyday life into a disciplined mobilization not only depoliticizes large segments of the population, it also eviscerates the recognition of popular culture as a terrain and weapon of struggle. Instead, culture seems to exist almost entirely free of or entirely reduced to entanglements with both economic and political relations. It is merely the "stuff" of everyday life. But the politics of popular culture extends far beyond the space of everyday life, far beyond its contribution as a commodity to profits, and far beyond its textual and ideological work. It extends into the hegemonic struggle to reconfigure both everyday life and the contemporary relations of people, resources and capital. However, I must reiterate that I am not dismissing the importance of struggles over and within the politics of everyday life. I want only to contextualize them, to argue that their importance has itself become a weapon within, and the object of, other political battles. Nor am I suggesting that we should not resist the inequalities of the contemporary organization of everyday life. But those relations are articulated to and sustained by other—structural—relations of power that intersect with but do not exist primarily within the relations of everyday life.

I want to begin to question the function of the disciplined mobilization of everyday life in the contemporary struggle for a new conservative hegemony, and the relations between the mobility of everyday life and the changing structures and possibilities of capitalism. This will involve trying to understand the effects of the conservative hegemony as I have described it on people's and the nation's changing place in the space of capitalism, both locally and globally. Contemporary intellectuals—myself included—are at a distinct disadvantage here since, too often, the very strengths of contemporary cultural theory have driven a wedge between culture and those domains (including politics and economics) which escape the cul-

tural domain. The disciplinarity, even of the interdisciplinary work of cultural studies, has resulted in a overavailability of information and an underavailability of knowledge. But equally important, the current generations of intellectuals are as much implicated in and subordinated by the disciplined mobilization as any other segment of the population. Nevertheless, it is still possible and necessary to make some initial effort in this direction. For in the end, *People* may have gotten it right: "Money: Rich or poor, it was how everyone in the 80s kept score."[16]

"REAL POWER DOESN'T MAKE ANY NOISE": CAPITALISM AND THE LEFT

13

LIFE DURING WARTIME

Enormous changes, many with devastating consequences, have taken place in the political, economic, cultural and social life of the United States during the past decade. The leading definition of the agenda of U.S. politics and the trajectory of U.S. society have been transformed. Relations of inequality, domination and oppression, many of which were beginning to be dismantled, have become the taken-for-granted structure of social organization. Commanding political alliances have been fractured and assumed political allegiances have been shattered. The lines dividing the population have been redrawn, sometimes in new ways, but always with less flexibility and mobility. The most visible manifestation of these changes is the redistribution of income which is now as dangerously skewed as that of many third world economies. In the 1980s, the gap between the richest and the poorest families became wider than at any time since the 1940s: the take home income of the poorest fifth of the nation fell 5.2%, while that of the wealthiest fifth grew 32.5% and the middle fifth's grew only 2.7%. The inflation adjusted, after-tax income of the richest 1% grew 87% and nearly equals the total income of the poorest 40%. In 1990, according to a report by the Center on Budget and Policy Priorities, the top fifth's after-tax income will equal that of the rest of the population combined.[1] And looking at the other side, while U.S. corporations paid 26% of all local, state and federal taxes in 1950, they paid only 8% in 1990. The difference accounts for $329 billion at the present time for one

year. Part of this is the result of the growing business servicing "capital-flight" and money laundering, which is estimated to involve as much as $660 billion a year.[2] The degree of this disparity and the speed with which it has been accomplished is almost less shocking than the fact that it has been so unquestionably accepted.

If we are to find ways of aiding the struggles that have been and can be organized against these changes, if we are perhaps to aid in the search for more effective sites and practices of resistance and opposition, we have to understand what the stakes are, what agents are involved, and what agencies are operating. The stakes are too high for an optimism too easily won, such as the already numerous predictions about the imminent collapse of the fragile conservative alliances. While it may be true that many conservative ideologues and moralists "report widespread 'discouragement' with the accomplishments of the Reagan revolution," while they may "suffer from 'demoralization,' 'malaise' " because the new conservatism has done little to rescue "traditional values,"[3] this should not eclipse the Right's complicity in these failures.

Similarly, predictions of the failure of Bush's leadership failed to consider the position into which he entered, a position which empowered him to continue many of the questionable practices of Ronald Reagan: to limit, by whatever means necessary, the availability of public information; to live with and even exploit the power of contradictions (e.g., while he tells Cuba there must be free elections before trade can begin, he proposes most-favored-nation status for China; while he says that money is not the solution to our domestic problems, he spends ever more money on rescuing the economy and America's international prestige; while "begging" for international financial support of the war in Nicaragua was illegal, the dismal scene of America begging for money to pay for the war in Iraq was never allowed to register on the American public). Without Reagan's popularity and media savvy, Bush has nevertheless succeeded in maintaining enormous popularity and support for his illusory leadership: everyone knows that there was a litmus test—a number of them, in fact—for the nomination of Clarence Thomas to the Supreme Court, despite his denials, but the majority of the country

apparently supports his decision and his masterful management of the hearings (including Anita Hill's revelation) as a problem in public relations. In the end, the Republicans got everything: Thomas' confirmation; further fragmentation of the opposition; negative publicity for both Congress and the Democratic party, and further fuel for the backlash against feminist groups. In fact, Bush has succeeded in making mediocrity an assumed advantage for nominees to the highest court. There are obviously many more examples that could be given, but the real question is how Bush has been able to accomplish this. The answer must have something to do with his ability to operate through an apparatus of power already largely in place in the nation.

Bush's presidency is significantly different from Reagan's. To put it simply, Reagan governed affectively. His power rested on his popularity, and his politics was defined by his commitment: even reality could not interfere with his commitments. The world was simply coded: right and wrong, Black and white, rich and poor, masculine and feminine, us and them. Both Reagan's politics and his popularity depended upon his sheer faith in visions (even if they had little content). Bush has often maintained a higher popularity than Reagan, yet it is difficult to know exactly why and it is only the failure of the economy at the level of daily life that has challenged his leadership. But, as I shall suggest later, this is precisely the result of the fact that Bush is caught between the needs of U.S. capitalism and those of global capital. He is certainly not charismatic; he has no vision of the world, and he does not seem to have the passion of commitment that carried Reagan for so long (despite the fact that his rhetoric continues Reagan's emphasis on "will" over money as the necessary cure for the problems facing the U.S.). Bush's world is not coded the way Reagan's was: here is a president who called for greater tolerance after running the most negative national campaign the U.S. has seen for some time.

Yet there is a certain similarity. Here is a president whose image changes as often as his appointments: from rich wimp (under Reagan's shadow), to "nasty boy" campaigner (under Lee Atwater's direction) to worldly statesman (under the politics of, e.g., James

Baker). This uncertainty, which can also be seen as a certain mobility or fluidity, is evidenced in Bush's relation to the New Right: he is what one might describe as a mild-mannered supporter, standing up with them but rarely leading the charge or committing all of his resources. Thus, while many of his most visible appointments have been arch-conservatives (e.g., Quayle, Atwater, Sununu), the real power in the administration remains in the hands of more pragmatically directed Republicans.

At the same time, predictions about the increasing liberalization of popular ideology and activism in the 1990s are also too easy, for they lack an analysis of the organization of domination and the limits of the contemporary forms of activism. The fact of the matter is that many of these resistances are unable to articulate any coherent opposition.

On the other hand, the stakes are also too high for any smug resignation to pessimism. Those who would argue that the traditional distinctions between Left and Right, between liberal and conservative, no longer hold any sway too easily conflate the limits of political debates with people's understandings and commitments. Perhaps the meaning of conservatism has changed, becoming less of a stance for the restoration of moral order and more of a call to acquisitive progress (embodied in Skytel's image of the businessperson as "Jaws"). But the real problem is not that the Left has lost its meaningfulness but that it has lost its meaning. And the fault belongs to the Left itself, not only because it has failed to offer a progressive agenda, but because it has refused the necessity of an institutionalized movement, of leadership and authority, and of affective politics.

A number of interpretations of the new conservative hegemony have already become part of people's common sense. It is worth considering some of the more compelling of these. The most common emphasizes the New Right's leadership of the Republican party and the state, seeing it as both the agent and cause (agency) of the contemporary political scene. The origins of this movement are often located in 1974, when the Conservative Caucus, RAVCO (a direct-mail fundraising company), the Committee for the Survival of a Free Congress and the National Conservative Political Action

Committee began coordinating their activities. (This originary moment is largely mythical, since it was the outcome of political work that began as early as 1964.[4]) This movement, which developed its own cultural institutions (journals, think tanks, commentators, etc.) through corporate funding, brought together free-market and anti– "big business" capitalists, cold war anticommunists, grass roots organizations often devoted to single issue campaigns and various populist religious groups which came to public visibility with the appearance, in 1979, of the Moral Majority.

The story goes on: the New Right is primarily opposed to the liberal state which had been set up after World War II and to those postwar developments which had eroded "American" institutions and values (e.g., the various social movements and resistances that had emerged in the 1960s, including the revival of labor struggles of the late 1960s and early 1970s). With Reagan's victories in 1979 and 1983, the New Right gained control of the Republican party and the national state apparatus, respectively. Once in power, however, it did not dismantle the state, but rather redirected its interventions into public life. Evacuating the space of economic regulation and the distribution of civil rights (e.g., its opposition to affirmative action), the Republican state turned its attention to the international communist threat, and to the increasing regulation of the domestic population and of civil society. It is using the state to attack the taken-for-granted attitudes of permissiveness and tolerance in the U.S. These attitudes are responsible for "America's" inability to meet the challenges facing it, and even to find the will needed to fight those battles. This new political leadership increased its authority, and its ability to act in decidedly authoritarian ways, by appealing to the populist mistrust of the state on the one hand, and to a series of popular fears (e.g., crime, communism, the loss of the U.S.'s political and economic leadership and, most recently, the fear of the white majority that its position, if not power, is threatened).

While there is some truth in the account—the New Right was and is a major actor in the historical struggles taking place in the U.S.—the account simply glosses over too many of the complexities of politics in the U.S., not only in the 1980s but also since the

postwar years. In the first place, the New Right is neither internally coherent nor the only participant in the broader new conservative alliance. In that sense, it never actually won control of either the state apparatus or the Republican party. The New Right sees itself— accurately, I might add—as a subordinate formation attempting to win a position of power by contesting and overthrowing the dominant liberalism, bureaucracy and big business commitments already in place (in the Republican party as well). At best, it gained a certain fragile role as public spokesperson (through the influence of New Right intellectuals and media experts), while the actual mechanisms of governance were still largely held by the representatives of more traditional conservative positions, and by the vast army of traditional Republican bureaucrats. The result was a government filled with contradictions and conflicts. This is nowhere more visible than in the fact that the same administration which won popular approval with its staunch anticommunism was also the administration which, through a series of policies, negotiations, actions and inactions, helped to bring about an end to the cold war. Even if this could be explained (which I doubt) as the inevitable result of capitalism's need for new markets, it still points to real conflicts within the administration's agenda.

I have argued that the new conservatism is built on a spectaculari-zation of everyday life which is accomplished through the conflation of civil society, personal experience and life-style. In such a politics, the state can only play one role: it is that which impinges upon everyday life and consequently becomes an extrinsic and unnecessary element to be expunged. Here, the rhetoric becomes one of the government interfering with—rather than guaranteeing or even cre-ating—people's rights (to their chosen life-style) and the demand is that "the government get off our backs." Of course, life-styles must be judged, but even that judgment can only be grounded in the commitments of everyday life and, within limits, "individual rights". The demand for "rights" brings together fractions of both the Left and the Right against the government (as in the movement to stop Robert Bork's nomination to the Supreme Court.) Yet the Left locates rights in collective identities and expects the state to protect

every group's freedom to . . . , while the Right locates them in competitive individualism and expects the state to keep individuals free from . . . In fact, the demand for rights in the new conservatism rearticulates the assumption that the aim of politics is the protection of individual liberties by policing the boundary it has constructed between everyday life and politics; such a boundary need not deny that power relations exist within everyday life. On the contrary, it says that those are the only structures of power that matter, and the only possible relation of the state is a negatively constitutive one.

The "myth" of the New Right's ascendency further ignores its connections with, and its breaks from, earlier moments of conservative success during the postwar years: e.g., Nixon's victory, built upon a campaign of "law and order," and the saliency of popular conservative appeals which saturated the media throughout the 1960s and 1970s. Most importantly, the assumption that the New Right's agenda has won popular support ignores the evidence of both voting patterns and public opinion polls which suggest that a majority of people did not vote and that those who did split their votes between a conservative national leadership and slightly more "liberal" representatives in both national and local legislatures.[5] The population often followed the Republicans only into national politics, and there is little evidence of widespread explicit support for the New Right's agenda. And such support, when it does exist, is often strategically manufactured, often after the fact (e.g., the Iraq war).

A second major interpretation sees the ascendency of the new conservatism as little more than a cover or front for the continuing expansion of capitalism's power in the U.S., the reassertion of its hegemonic power both nationally and internationally. It emphasizes capitalism's efforts, supported by the Republican state, to extend the reach of free-market relations and commodification into all aspects and activities of social existence and private life. As market relations come to define the only possible model of social existence, as social relations are privatized and collective institutions are individualized, the viability of a commitment to collective possibilities (the basis of the Left as a political alternative) disappears. A slight variation of this position sees the new conservatism as the political face of the

changing structures of "late" capitalism through such notions as postindustrialism, the service or information economy. Again, there is a good deal of truth in this description of the changing climate of life in the U.S. Increasingly, the processes by which people construct their own sense of a "private" self are commodified as life-style choices and marketed as "therapy." And concepts of justice and equality are understood in purely commercial and bureaucratic terms (e.g., the overlitiginous society).

While it is certainly true that free-market relations have expanded, and practices of consumption have become a crucial determinant of life, the general statement leaves too many contradictions unmarked. After all, if everything is commodified, then presumably new differences have to be invented. But the real question is when quantitative change becomes qualitative. For consumption and commodification do not expand equally into every domain and for every segment of the population. Moreover, not every form of consumption is encouraged. Here we can perhaps distinguish among three competing practices of consumerism: first, a consumerism devoted to the maximization of pleasure and experience (e.g., the image of the counterculture); second, a consumerism devoted to the untrammeled accumulation of signs of status, measured less by one's similarity to others (keeping up with the Jones) than by one's difference from them (e.g., the yuppie); and third, a consumerism organized around specific social and political values (e.g., the suburban puritanism of the postwar years now often championed by the new conservatives). Of course, the three may overlap, not only in their general focus on leisure, but also in specific "life-style clusters." The new conservatism's opposition to the first ("Just Say No") from the position of the third seems to make the second into the actual trajectory of capitalist expansion. But why would capitalism want to discourage the consumption of pleasure? Certainly not to get the population back to work, given the current levels of unemployment. Why would leisure corporations not actively oppose movements which threaten their profits? At the very least, this would suggest a radically different vision of discipline and regulation which remains unexplicated.

Even more important, the identification of class with life-style clusters should not blind us to the irony of referring to various levels of poverty as "life-styles," nor should it hide the continuous exploitation of and struggles between various economic groups and class fractions. The expansion of the free market is crucially constrained: the ability of some to live within its spaces depends upon the increasing exploitation and exclusion of other populations, both internally and internationally. Many interpretations of the "new" capitalism ignore the continuing exploitation of labor, the class-specificity of service economies and the multinational system of capitalism which relocates (but does not erase) industrial production. Such interpretations merely trace assumptions about the changing state of culture onto equally simple assumptions about the changing state of capitalist relations. They ignore the relations of pre-economic and economic forms of power and control.

A third major interpretation of the conservative victories of the past decade focuses on the relations of popular culture and politics. Both the Left and the Right often blame the media for the "crisis" of the contemporary U.S. The Left assumes that the conservatives' "victories" largely depended on their willingness and ability to use popular media and marketing strategies. But, so the argument goes, their ability to use these techniques and the ease with which the nation has been moved to the ideological right must reflect some intrinsic relations between the messages, forms and tendencies of contemporary popular culture, and the ideology of the new conservatism. This common ground can be located in the basic motivations of capitalism unleashed by the absence of common codes of ideological respect: greed, selfishness and even brutality. The collapse of political conscience and the resulting implosion of the limits of the acceptable have been built on the media's tolerance (if not active production) of complacency, ignorance and misinformation. This has made it possible—in fact, inevitable—that money and selfishness would become the new and only virtues of the population.

On the other hand, the new conservative alliance speaks quite confidently of the role which the media and popular culture have played in creating the crisis to which it is responding, a crisis of values

and malaise, a crisis which is itself responsible for the popularity of the new conservative agenda. The media have not only destroyed people's faith in the basic values of the nation and in the nation itself, but also in the symbols of those values (and of the nation) as well. Without anything to struggle for, they have lost the will to fight. The new conservatism has become the most visible site of an active will to struggle. It is here, on the right, that people endeavor to struggle against a context both frightening and frustrating. The American Bar Association reversed its support of abortion rights in the name of "professional neutrality and responsibility" (as if such an action would have neutral effects!) as a result of conservative efforts and pressures (from within the organization as conservatives threatened to resign, from the state and from the organized Right). It is the apparent absence of such *effective* pressures (e.g., substantial numbers of resignations) from the pro-choice advocates, or at least their public invisibility, that is so perplexing.

In rejecting such views, we must not overlook the power of the media and the fact that they have, in many cases, established taken-for-granted narratives which often encode debilitating relations of power and expectation (e.g., representations of the desirability of excessive wealth regardless of how it is obtained; representations of minorities; and representations of unequal and ultimately destructive forms of sexual and romantic relationships). Nor can we overlook the systematic misinforming of the American population which seems to have become the media's primary goal. Still, we have to avoid the oversimplified vision of the relations between popular culture, politics and economics which these "stories" assume. They see every instance of the media as merely a particular manifestation of some more universal cultural and (they assume) social logic. They treat such terms as *greed*, *ignorance* and *selfishness* as if they were transparent and universal. Ignoring their relations to larger logics and structures, they ignore the fact that both the Left and the Right condemn the rise of such values. The contradictions characterizing contemporary popular culture remain outside the agenda of analysis: e.g., the fear of commitment versus the desire to believe; the assumption of the power of knowledge versus the celebration of ignorance.

Too often, critics on the left who are committed to avoiding the pitfalls of economic determinism, of assuming that the causal agency of the economic base is always written into the very form and content of the cultural superstructure, merely eliminate any notion of intentionality or determination. The difficult questions of how the contemporary formations of culture are articulated to the forms of capitalism within specific national and international contexts remain unexamined.[6] The problem is that questions of history, causality and intentionality are treated in terms of the relations or mediations between intrinsically distinct domains: the economic, the political and the cultural. If culture exists in some sense independent of the economy, then the economy of culture is limited to questions of production and consumption. But within the terms of the model of levels, if they are not independent, then all analysis can do is textualize the economy. Rarely is the assumed division of society into levels questioned, even though the assumption inevitably draws criticism into metaphorical and metonymical modes of analysis. Metaphorically, criticism seeks out the formal similarities or correspondences between practices across levels (e.g., observing that both contemporary capitalism and postmodern culture emphasize differences and differentiation) without giving any account of how the two are conjoined. Metonymically, it takes specific events within each domain as exemplary and representative of the totality of practices (e.g., postmodernist texts), never looking at either the contradictions between different practices or the ways specific practices are inserted into concrete social, economic and political relations.

Such logics infiltrate even the most interesting progressive politics. For example, Barbara Ehrenreich describes the professional (educated) middle class's "retreat from liberalism" as the result of its increasing self-consciousness as an elite class when faced with the difficulties of reproducing itself. Treating class as an independent system of social differences which corresponds to particular cultural attitudes, Ehrenreich isolates this class fraction and makes it serve as a metonym for contemporary popular conservatism. The result is that the problem of contemporary politics is reduced to the fact that "we simply care less, or we find the have-nots less worthy of our

concern."[7] There is an important truth in this argument: the increasing recognition by both the professional middle class and the general population of their own complicity and even guilt in history has changed the nature, not only of politics and of people's investment in it, but of the relations between popular culture and politics. Yet Ehrenreich confuses the question of whether and how people care about politics with a politics of caring. Meaghan Morris opposes such a politics, which merely reproduces the assumption of a privileged subject (in this case, the white middle class in advanced industrial societies) instead of rethinking politics in the face of the increasing fragility of such subjects and their place in the changing relations of contemporary capitalism.[8]

If we are to begin to think through Morris's suggestion and understand the stakes in the contemporary political arena, then we must look not only at the players but also at the forces at play. We must move our gaze beyond those who stand to gain to where those gains are located in the tenuously balanced field of historical forces. I want to take seriously the possibility that the various conservative actors, as agents, are attempting to resist, harness and bend circumstances not of their own making. And then I want to go one step further, to argue that capitalism is the agency of these struggles and to explore a possible articulation between the disciplined mobilization of everyday life and the contemporary context of capitalist relations. I want to propose that the effort to construct a new hegemony within the United States is itself part of a larger struggle to construct a new world order. But that new world order, while decidedly capitalist, is not the reconstitution of America's hegemony in the world. On the contrary, it entails somehow putting America in its place!

14

"IF YOU'RE SAILING ON THE TITANIC, GO FIRST CLASS": THE STRUGGLE OVER CAPITALISM

It may seem regressive, after cultural studies has overthrown the Marxist myth that everything is determined by, if not reducible to, economic relations, to claim that the agency of this (not all) historical struggle has to be located in the economic realm. However, we need not fall into regressive "economistic" models of agency and determination which equate agency, causality and control. We do need to avoid the paranoid assumption that capitalism, or capitalists, or anyone else for that matter, are able to direct history by strategically manipulating events, including people's fears, anxieties, hopes, etc. It may be the case that capitalism, while the agency of history, succeeds despite itself.

But exploring this possibility requires us to question two assumptions which, despite the sophisticated theories of the Left, still animate much of its analysis and politics. First, we have to reject the assumption that the nature of capitalism is fixed, or at least operates in a single trajectory. Capitalism (like capitalists) is neither rational nor coherent; it is rather a site of struggle, constantly forging its own trajectories out of its internally competing definitions. This is not merely to say that capitalism is contradictory, for that statement often locates the contradictions in the same place over and over again; the contradictions themselves are constantly changing shape and place, sometimes strategically. Rejecting the second assumption—that there is a single relationship between capitalism and culture (e.g., between late capitalism and postmodernism)—opens the possibility

of different struggles and articulations existing within different spatial and temporal logics.

CAPITALISM AND HISTORY

Althusser drew a distinction between the determining and the dominant forces within a social formation.[1] The power of the former—determination—is to put the latter—the dominant—in place. In different societies and periods, religion or politics have provided the crucial force which organizes society, and the critical grounds on which change must be fought for and won. For example, the enormous power of science and engineering in the U.S. during the twentieth century defined them as ideological agents of history (both discursively and institutionally). Yet they were put into that place by the agency of capitalism. In a slightly different way, the contemporary state is an agent of history, again put in place according to the determinations of specific articulations of capitalism. For Althusser, this meant that the economy is only determining "in the last instance."

I want to propose that, in the contemporary struggle for hegemony, capitalism is determining in both the first and the last instance. It is capitalism itself which has placed its own interests and struggles at the center of the historical and political agenda. However, capitalism is not an agent standing outside and above the terrain of social life, directing or at least attempting to direct its development according to some coherent plan derived from its own necessary and singular identity and interest. For it is neither capitalism itself nor the capitalist which is manipulating history; in fact, lots of agents are attempting to manipulate history in an effort to respond to the historical changes taking place partly within capitalism. But even change is, to some extent, too innocent a term—for the changes are precisely the site of various struggles between competing interests, loyalties and investments—to determine the future, including that of capitalism itself.

Thus, we are faced with a situation in which the agency of historical struggles is itself the terrain on which different groups are

struggling. Agency—capitalism here—is itself immanent to history; it is not outside of it, directing political and cultural developments. Rather, political and cultural struggles are intimately involved in, and deployed into, capitalism's own struggles over its future shape and direction. The noise may appear elsewhere—in the redeployment of ideological and economic differences, so that "the people who live within the U.S. borders less and less share a common fate or common interests." Yet, as a cartoon once suggested (a well-groomed man talking to a kid carrying a boom box): "Big Power—Real Power, young man, doesn't make any noise."

The real power may involve the relationship between a particular territorializing of everyday life and capitalism's own struggle. Economists are beginning to explore

> the implications of the swiftly increasing power that the global marketplace has gained over everyone's life. With transnational corporations growing in importance and public policy influenced more and more by the dictates of international trade and finance, what will be the fate of nations, democratic politics and the welfare of the world's citizens?[2]

Such issues often lead to discussions of new forms of economic citizenship[3] and of new policies by which nations can continue to intervene into their own economic development. But if "American corporations no longer mediate between Americans and the world economy,"[4] then a more fundamental issue has to be considered: What is the place of the once economically and politically hegemonic United States in the global formations of capital?

I do not mean to suggest that capitalism's stake and role in contemporary political struggles is hidden. In fact, if traditional theories of capitalism's role in history assumed that it mystified the population by hiding itself and its agency, contemporary capitalism (or at least specific sectors) mystifies by its overly abundant presence rather than its absence. The overvisibility of the economic in everyday life, however, takes a particular form. While it continues to define the major variable in determining people's political positions—those who think they are doing well or better support the Republicans—as I have already suggested, this is often a matter, not of people's

actual economic position, but of their desperate need to convince themselves that they are prospering. More to the point, the economy itself has become the site of affective epidemics. It is powerfully affectively charged. On the positive side, American culture seems to celebrate images of money and wealth even more than it celebrates wealth itself (e.g., Donald Trump). It is as if it were the idea of money that was somehow seductive, and people get giddy at the thought of making it. But the images of making money have less and less to do with knowledge, understanding or even labor. The ending of the narrative has been transformed once again: Don't worry, be rich!

But this affective site works only by refashioning the relations between capital and labor: being rich does not seem to be an option that is open to just anyone. Individuals do not appear to appropriate capital but to be appropriated to it. People are caught in its circuits, moving in and out of its paths of mobility, seeking the opportunistic moment (luck, fate, fame or crime) which will enable them, not to redistribute wealth, but to relocate themselves within the distributional networks of capital. Labor becomes reconstituted as the place of the consumer in space, a place in a distributional system.[5] It is here that we can begin to see the relation between capitalism and the construction of everyday life as a transit-mobility which constructs the space for the free movement of capital and for the capitalization, rather than the commodification, of everyday life. For within that transit-space, people are not the producers of wealth but a potential site of capital investment. People become capital itself. And within these circuits, the only thing they can be sure of is that capitalism is going first-class.

The negative side of the affective overpresence of the economic is most clearly visible in the way in which images of the debt have been deployed in the past decade. This issue has become a leading symbol of America's postmodern anxiety, embodying people's uncertainty, terror and ambiguous selfishness. People are panicked about the federal debt, although few have any understanding of why they should or should not be worried. The debt functions as an icon of the fear produced by the incomprehensibility of our situation. For

the fact of the matter is that, whatever else may be true of the overvisibility of the economy, it is incomprehensible! Does anyone actually understand the constant flow of economic indicators, diagnoses and prognoses? While people are constantly told what various sectors think, or what various measures foretell, the contradictions within and between them are never resolved. Anyone attempting to actually learn about the current economic situation is confronted, not merely by the technicalities of economic analyses, but with a dizzying and delirious explosion of contradictory data, multiple explanations and diametrically opposed prognoses.

It is not simply a matter of competing economic theories, each with its own account of and solution to the current situation, each with its own political allegiances already defined. For it is not even merely a question of cause and remedy; it is a question of value, of the significance of the debt. Economists cannot even agree on whether the debt—the fact that the U.S. is now the largest debtor nation in the world—is a good or a bad thing. Some economists have argued that the debt is actually a sign of the nation's health, since people invest only where they have confidence. Further, since so much of it is in bonds which are constantly turned over, and which are still domestically owned, there is little real danger. Others point to the financial instability which the debt creates internally, with the government draining the available investment capital. And still others argue that the real consequences of the debt have to be seen in international terms: the foreign ownership of the U.S., the international monetary and trade crisis, or the collapse of third world economies as a result of the absence of foreign capital, which is all going to sustain the national debt.

There are fractions of the new conservative alliance which are defined more by their commitment to capitalism than by their necessary support of the moral and even political agenda of other more visible fractions. Their commitment is simply to the continuing growth of capital, and hence to the continuing growth of productivity for its own sake (and not limited, by any means, to the industrial manufacturing sectors). The new conservative's vision of the capitalist market is no longer that of a regulatory relation between supply

and demand but of an unregulated mechanism for maximizing the mobility of capital which extends to and governs everything. Time, information, and human capital (i.e., not only labor but all human activities, including everyday life, consumption and leisure) can be incorporated into the systems of finance and monetization by which capital is increasingly produced and circulated.[6] Of course, there are differences even among the neoconservative capitalists: free market-eers favor deregulation and privatization everywhere (even to the point of allowing morality itself to be determined by capital accumulation), although there are conflicts between the nationalists and the internationalists. The latter are willing to subordinate national interests to the demands of multinational corporations and global capital. Monetarists would regulate the supply of money and deregulate financial sectors. Supply-siders would reduce taxes to transfer capital from consumption and domestic economies to business (assuming savings guarantees investments) while controlling inflation. All of these fractions oppose the more traditional conservative remedy, which Davis associates with Thatcherism in Britain: the intentional production of recession and deflation as a way of gaining control over wages and demand.[7]

Whatever the new conservative agenda, the vector of its actual effects may be nothing more than the attempt to put a specific— if somewhat uncertain—economic agenda into place, an agenda defined by free trade, monopolistic competition and the evacuation of any government support or planning for the industrial or agricultural sectors. Bush has systematically undercut any support of industrial research (e.g., the Commerce Department's and the Defense Advanced Research Projects Agency's investment in technologies such as high-definition television, or computers). Even the recent moves to disarmament can be seen as furthering an economic rather than a political agenda. Not only do they eradicate trade barriers, but they also withdraw the ongoing subsidization of U.S. industry through defense spending. On the other hand, of course, Bush has overseen the largest economic subsidization ever: rescuing the savings and loan industry at the expense of the government debt, interest rates and taxes. (And he is apparently laying the ground for

the necessity of a similar bail-out of the banking industry.) For the most part, the only issues which Bush actually addresses are the economic ones; other issues remain constantly unresolved, although they may be constantly mined for their rhetorical populism (e.g., the war on drugs, Noriega, etc.) A recent example was the 1990 summit meeting with Gorbachev, in which all of the real political issues—the future of Germany, the fate of the Baltic nations, the proliferation of nuclear arms—remained unresolved after the summit. It is as if Bush's administration were itself involved in the depoliticization of the state apparatus, except for issues of economic policy and the increasing mobility of world capital.

CAPITALISM IN CRISIS?

Nevertheless, a certain consensus of crisis has emerged within the economic sectors. Even the conservative *Financial Times* notes that

> it is ironic that just as much of Eastern Europe is consigning Communist economic doctrine unlamented to the dustbin of history, Western capitalist economies should be in the throes of their most turbulent upheavals for half a century.
>
> One after another, comfortable assumptions about economic and business life which evolved in the industrialised West after the Second World War have been exploded or discarded during the 1980s . . .
>
> As a result, the practice of Western capitalism does not offer a stable model, with clearly agreed rules. Rather, it is a moving target, caught between the pull of complex and often opposing forces, whose longer-term direction is difficult to define.[8]

Of course, how one defines and evaluates this longer-term direction will have important political implications, and various economic institutions and agents, recognizing the importance of political decisions and policy in determining the future of capitalism, have become directly involved in political and cultural struggles. At the same time, they have maintained the illusion, bolstered by the overpresence of economics in the public realm, that politics and economics are distinct and separable realms (so that, e.g., economic

policies do not relate to or impinge upon issues of democratic power and rights).

There is little doubt that something is going on in the economy. While most economists agree that there are close and important connections between national and international economies in the current context, there are significant disagreements about the extent to which one can separate these questions, and the forms in which they are interconnected. For many, including unfortunately some of the leading leftists in the U.S. and Britain, national economies require only a gesture to the international crisis, and nationalist rhetoric often saturates their analyses. For example, many in the U.S. start with the apparent impending collapse of "the American" empire in the face of the Pacific Rim and European empires. Others, acknowledging the importance of such regional supernations as new structures of trade and competition, emphasize the changing nature of the relations between the local and the global at all levels, making the transformation of the nation's place (whether in general or in specific cases) in a global economy only one question among many.[9]

However, more and more economists agree that capitalism is, in some significant and even structural ways, rapidly changing. They disagree over the specific changes and their relative importance, over which are causes and which are effects; they disagree over whether these changes signal a crisis in contemporary capitalism and whether they point to a fundamental reconfiguration of the basic structures of capitalism. Even among those who agree that there is such a crisis, there is still disagreement about the relations between the specific forms of the crisis and the specific changes in capitalism that one can observe.

For some, it is merely a matter of recurring economic cycles or contingent historical factors. For example, Lester Thurow, the dean of MIT's Sloan School of Management, argues that the problem lies in the trade deficit rather than the debt, i.e., in the fact that Americans are consuming more than they produce. According to Thurow, the current crisis is one of productivity which dropped precipitously in 1973, and continues to grow more slowly than in other countries. (Thurow seems to have no explanation for this drop: "There's some-

thing going on now that was not going on prior to 1973.") This problem is then magnified by the fact that it is "more expensive" to invest in the United States than in other countries, and this can only be remedied by either raising taxes or cutting expenditures. But ultimately, Thurow argues, the crisis is the result of the nation's failure to create "an establishment" which "recognizes that its long-term interests may require it now and then to take smaller profits in the present."[10]

Others see the United States gaining from what they envision as the coming global boom, heralded by a sharp increase in manufacturing productivity and a steady decline in interest rates, and evidenced by an entirely different set of economic statistics (e.g., that the percent of manufacturing income in the GNP has remained steady). For such economists, the problems with the American economy can largely be blamed on the peculiar demographics of the nation as a result of the postwar baby boom (and its culture).[11]

In fact, the crisis has been linked to such a wide range of factors and areas—whether as the cause or the response—that it is difficult to make any sense of contemporary economic discourses. Some economists argue that it involves monetary policy; others locate it in the realm of productivity (e.g., the declining rate of profit as a supply-side crisis; changing industrial techniques in the relations between design, decision and communication); and still others argue that it is in some way a failure of the market itself (either in terms of its regulation or in terms of the model itself and the need to shift accountability from the market to the integrity of the product). Some economists emphasize the emergence of new forms of economic practices and relations, while others emphasize the continued potency of enduring features of capitalism.

Yet it is hard to disagree with David Harvey's statement that there has been "a sea-change in the surface appearance of capitalism since 1973."[12] To understand these changes, it may help to look at how, in the postwar period, the Western industrial nations organized and orchestrated one of the longest and most effective periods of sustained economic growth. This success is often attributed to the formation of a specific complex of economic and social relations referred to

as "Fordism."[13] Although there are many different definitions of Fordism, it is possible to identify its major elements. First, it combines "Fordist" techniques of mass assembly line production with the Taylorist rationalization of production time. As Lipietz describes it, it is based on "radical and constant change in the labour process, such that workers' 'know-how' is incorporated in the form of machinery."[14] In other words, it is a capital-intensive system, depending upon huge investments in capital goods (e.g., large factories, machinery, etc.) in order to produce standardized products within an economy of scale. Second, it adopts a model of "intensive accumulation" in which mass production is matched by the intentional growth of mass consumption in the metropolitan industrial societies. This growth is largely the result of a system of negotiated relations between capital and labor in which wages are tied to productivity. As productivity increases (through the accumulation of capital investment and relative surplus value), wages increase, increasing the domestic market for consumer goods and capital investments.

In the postwar U.S., the traditional capitalist problem of locating new and expanding markets was solved internally, by integrating the life-style of workers into the equation for the accumulation of capital and stimulating domestic consumption across a broad spectrum of the population. During this period, the share of exports in the GNP reached a historical low (although this has been changing since 1965). But not all of the growth resulted from increased wages; there was also a "tax-led growth" resulting from government policies which favored expansion in particular regions and economic sectors: e.g., the emergence of "the sunbelt."[15]

Finally, Fordism depends upon a specific organization and deployment of state power according to a weakened Keynesian model. The state is the regulator of and negotiator between the competing interests of both capital and labor. It is supposed to create a harmonious system of relations and to limit the self-interest of both unions and corporations. But the state is also responsible for continuously fine-tuning the economy through its variable "injections" into the economy, aimed ideally at creating full employment without inflation.

There were, however, a number of problems with this system in practice. While there was a real, albeit limited, attempt to redistribute wealth and to eliminate the extremes of poverty remaining in the society (e.g., the war on poverty begun by Kennedy and lasting through the mid-1970s), it was a redistribution funded largely out of growth. Hence, the apparent decrease in the poverty levels was not the result of structural changes which guaranteed the poor access to the labor market, but rather of a redistribution (largely through taxes) of working- and middle-class income. The result was actually quite disappointing: while in 1965, the poorest 40% of the U.S. earned 11% of the total market income, by 1978 that figure had dropped to 8.5%.[16] Even more important, when Reagan eliminated these state-mediated transfers in his attack on the "welfare state," poverty levels quickly rose even higher. This failed system of social equalization was itself the expression of a larger system of compromises aimed at quelling the struggle between the demands placed on the economy by increasing working- and middle-class consumption (centered in the suburbs) and the need for public expenditure in the inner cities. By the mid- and late-1960s, this conflict grew into a series of public crises and protests by both Blacks and labor.

Other developments challenged the continued success of Fordism and its high rate of growth. As the market for consumer goods became saturated, the ability of the domestic market to fuel continued growth steadily declined. The rise of the "newly industrializing countries" presented real competition even within the domestic markets, competition which could not be refused since it was "Western capital" which had largely financed their growth. As Davis puts it,

> The giddiest of post-war expansion was based on the export of metropolitan debts, magically recycled by the international banking system [under the system imposed by the U.S. at Bretton Woods in 1944] as credit money to industrializing countries whose future export growth was, in turn, pledged as collateral.[17]

And finally, as capital became increasingly multinationalized (only partly as a result of the growing international status of corporations), it became more difficult for any national government to regulate its

practices and to fine-tune the economy through traditional Keynesian means in order to strike an acceptable balance between growth and inflation.

Such fine tuning, however, was even more necessary precisely because of the capital intensive nature of Fordist growth and its accumulation of capital. What is often referred to as the "rigidity" of the Fordist system is the result of its necessary large-scale and long-term investment in both fixed capital goods (machinery, factories) and labor (union contracts). The rising technical composition of capital meant an expanding proportion of immobilized assets, which could only be offset by increasing productivity in the producer goods sector. At the same time, rising mass purchasing power meant that wages were an ever increasing proportion of value added, which could only be offset by increasing productivity in the consumer goods sector.[18] The result, since the late 1960s, was an insufficient profit ratio (surplus value) and a decreasing rate of growth.

Lipietz has identified two aspects of this crisis:[19] a supply-side crisis, resulting from the declining rate of profit, led to a decline in investment and a rapid growth in unemployment, which in turn rendered the government unable to continue financing the welfare state. A demand-side crisis resulted as world trade grew faster than both internal markets and international production; it became increasingly difficult for national governments to act in way which could successfully regulate both supply and demand, a problem seriously exacerbated by the 1973 oil crisis. This crisis had another important effect: it brought about a rapid redistribution of capital within the core economies and strengthened the finance interests of the Western industrialized nations "at the expense of the productive economy as a whole."[20] As Harvey puts it, the state

> was called upon to regulate the activities of corporate capital in the national interest at the same time as it is forced, in the national interest, to create a "good business climate" to act as an inducement to transnational and global finance capital.[21]

The result was a crisis of "overaccumulation," a situation in which, despite the existence of a surplus of both capital and labor, the system was unable to bring the two together to produce growth.

STRATEGIES AND STRUGGLES
WITHIN CAPITALISM

There are only a limited number of strategies available to respond to these crises. First, remaining within Fordism, the only tool of flexible response is apparently monetary policy. "Consumer, corporate and government debts are much more tightly tied in with each other, permitting the simultaneous regulation of both consumption and production."[22] The attempt to use this system has resulted in a series of constant oscillations between increased inflation and increased interest rates (beginning with Nixon's decision to break Bretton Woods and float the dollar, and ending with Reagan's decision to increase real interest rates in the early 1980s), with a general tendency to "stagflation." The result was high unemployment—in fact, levels which would have been thought intolerable during the postwar boom, weak growth and spiraling indebtedness as conservative policy makers attempted to control inflation and stimulate investment. By sustaining unprecedented interest rates, the administration was able to maintain the dollar at an artificially high value, thus making it possible for the government to control inflation and finance its debt.

The "consumer-led growth" of the past decade was financed by a spiraling national debt which effectively drained international capital from other (usually third world, especially in the southern hemisphere) economies. The result has been the collapse of many commodity-exporting developing countries.[23] Further, "the appreciation of the dollar has erased any competitive advantage that might have accrued from [an] increase in industrial production."[24] And finally, the current monetary situation, if unchanged, might easily produce an even more serious problem: as Japanese surplus capital decreases and German surplus capital is increasingly used to meet the European deficit, the world may find itself short of any lending capital, creating not only a supply-side crisis of investment but a massive default of the international debt.

The failure of such monetary policy may be due precisely to the very thing which makes it such a powerful element of the

contemporary economic situation: the increasing power and flexibility of the system of finance capital and its increasing autonomy from systems of industrial production and capital. The power of finance capital in the 1980s is not unique; it was also paramount during the period of 1890–1929. But today, it is "not so much the concentration of power in financial institutions as the explosion in new financial instruments and markets, coupled with the rise of highly sophisticated systems of financial coordination on a global scale."[25] The success of the finance sector has led many corporations to diversify from industrial capital into financial and service markets. It has also resulted, at one extreme, in the creation of a system of capital production in which capital is entirely divorced from any relation to the social reproduction of labor, resulting in a powerful system of illegal economies—from drugs to the manipulation of financial markets. At the same time, individual investors are rapidly replaced by institutional investors (pension funds, mutual funds, insurance companies and banks) which have little interest in (and no legal responsibility to) anything but short-term profits. In fact, this contradiction between immediate profit and capital investments is the result of the efforts by conservative economists to deregulate the financial sector, which in turn dismantled those very structures which had subordinated money to productive capital. Finally, finance capital has invented new forms and sites of investment (e.g., futures markets, not only new commodities such as wine, but in stocks themselves).[26]

A second strategy—"global Fordism"—extends Fordism to countries peripheral to the core industrialized nations. This has often meant the creation of a small consumerist population and the exploitation of local labor markets, especially women, through pre-Fordist labor practices including sweat shops and domestic piecework. For the most part, such countries have failed to raise domestic demand or to achieve a regional trade system within which they can balance their trade economy. The result, even for as strong an economy as Japan's, is that they remain vulnerable to recessions in the Western importing nations. Furthermore, such systems of absolute exploitation (as opposed to systems of relative exploitation built upon the

development of the productive forces) are implicated in the Western Fordist economies. First, the threat of the exportation of jobs is often used as a way of disciplining domestic labor. Second, the crisis of contemporary capitalism results in fierce competition between regions within the core countries for capital investment, and hence localities need to construct sites where inexpensive labor is available, literally underdeveloped regions or "third world enclaves" within the first world, with pre-Fordist labor practices and without the benefits of strong labor unions.

Global Fordism also constructs international networks of integrated assembly lines and global corporations (e.g., 60% of Honda's earnings are in the U.S., while 60% of Coca-Cola's earnings are outside of the U.S.). This makes it difficult to develop systems of decisionmaking and regulation which can effectively intervene into the interconnected spaces of economic and trade policy, finance markets and industrial production. The global circuits of capital have, after all, not been greeted by an international political spirit:

> Many long-standing barriers around national economies are being challenged by fiercer international competition, more efficient communications and the pressure on industries . . . to seek growth beyond the restricting confines of their home markets [also by the growth of international corporations and the development of new forms of cooperation between companies operating in different national contexts] . . . However, national and regional economic rivalry and the desire to defend special interests remain close to the surface—and may even be increasing . . . [as are] pressures for neomercantilist policies and greater involvement by governments in support of their producer industries.[27]

Finally, the increasingly "hi-tech" nature of product design and production has enabled many countries to escape their "natural comparative advantage" and enter into new markets. The internationalization of the economy is partly the result of competition to construct artificial and even temporary structures of comparative advantage, a process which, at the very least, suggests the permanent destabilization of international trade relations.

A third "neo-Fordist" strategy follows a traditional capitalist response to crisis: it devalues labor power in the domestic market. It

339

develops techniques to exploit labor, including the increasing reliance on subcontracting to businesses small enough to avoid labor regulations, and the production of part-time, minimum wage jobs, with neither security nor benefits; it is these which have been increasing at a significant rate. The result is higher employment at decreasing costs, and the growth of a hidden segment of the labor force—the "working poor." Such strategies depend upon devoting greater resources to the service and information economies. Mike Davis describes this as a new regime of accumulation based on overconsumption and expanded low-wage employment. In his analysis, much of neoconservative economic policy has been designed to benefit the "nouveau riche" subclass of managers, professionals and new entrepreneurs who have profited from both inflation and expanded state expenditures at the expense of the working class: in the 1980s, low-income families lost $23 billion in income and federal benefits, while high-income families gained $35 billion.[28]

Yet it remains unclear whether this transfer can be seen in traditional class terms, e.g., as the disappearance of the middle class, for it is also a transfer of wealth from households to businesses (e.g., telephone rates for homes have risen as business rates have declined). While the real (inflation-adjusted) GNP more than doubled between 1972 and 1985, real wages declined 15%. Much of the middle class is caught in this redistribution, and while there is a highly visible fraction which is strongly upwardly mobile, there is a larger fraction (DINKS, for example, including many professionals, managers and entrepreneurs) who struggle to stay in the same place or not to decline too rapidly.

The fourth "post-Fordist" strategy actually proposes to break with Fordism by introducing new more flexible systems of production of both commodities and capital (profit). Such systems of "flexible accumulation"[29] and, more narrowly, "flexible specialization"[30] involve "new systems of production and marketing, characterized by more flexible labor processes and markets, of geographical mobility and rapid shifts in consumer practices."[31] If Fordism controlled consumption to create demand for standardized mass-produced

products, post-Fordism makes production conform to the continually changing demands of consumption.

This assumes a form of marketing and consumerism based on the production of commodified life-styles in which products fill specific "niches." Its exploitation of diversity and differentiation is organized through "economies of scope" rather than scale. Instead of seeking cost reduction, such economies increase costs in the name of specialized demand. Production is organized around small batches (limited runs), thus eliminating the need for and danger of maintaining large inventories. This requires hyper-adaptable machinery and labor practices capable of being retooled with a minimum investment of time, labor and capital for different production runs. Post-Fordism embodies "the search for higher value added through product differentiation, flexible organisation and more speedy product development"[32] rather than through high capital investment or increased labor power. Systems of automation and systemization which operate both inside and outside of the plant itself apply computer technology, "not only to each stage of the production process, from design to retailing, but also to the integration of all stages of the process into a single co-ordinated system."[33] Post-Fordism controls time, not by reducing the time of any single step, but by compressing the time between design, manufacture and sales (which may also require compressing the distance between plants and markets, even while plants may be geographically quite separated).

It also involves a different relationship between capital and labor and a different labor practice. "Multiskilling" increases the cultural capital of workers, not only because they must perform different jobs in different production runs, but also because they should be able to intervene into the design and production process itself. It makes perfect sense that, for example, Rank Xerox would attempt to change its accounting systems so that machinery becomes a cost and labor its fixed asset, since labor is the key asset of post-Fordist production.[34] Lipietz describes this as a

> new "social contract" to be negotiated on the shopfloor itself, whether on a collective basis (as in Sweden) or with a more

individual inflection (as in Japan). Wage-earners were called upon to join the battle for quality and productivity.[35]

In return they are compensated with high wages and benefits, and job security. (There are other significant differences between the Japanese and the European practice of post-Fordism, but they are not directly relevant here.) Of course, this social contract applies only to a small segment of the labor force.

Because post-Fordism already assumes a relationship between changing forms of social relations and identities and its strategy of economic retooling, it easily becomes a metaphor for broader social and political change. "Post-Fordists"[36] need not deny the complexity and contradictions of contemporary economic relations, but they maintain that post-Fordist strategies represent the leading edge of change. They recognize that this system, while predominantly located in the West, has global consequences. Stuart Hall lists the following characteristics of a broad concept of post-Fordism: the rise of information technologies; "a shift towards a more flexible specialised and decentralised form of labour process and work organisation and, as a consequence, a decline of the old manufacturing base"; subcontracting; "a leading role for consumption"; "a decline in the proportion of the skilled, male manual working class and the corresponding rise of the service and white-collar classes. In the domain of paid work itself, there is more flexi-time and part-time working, coupled with the 'feminisation' and 'ethnicisation' of the workforce"; the rise of multinational corporations; "the globalisation of the new financial markets"; "the emergence of new patterns of social divisions—especially those between 'public' and 'private' sectors and between the two-thirds who have rising expectations and the 'new poor' and underclasses of the one-third that is left behind on every significant dimension of social opportunity."[37]

As both Paul Hirst and John Clarke have pointed out, there is little that holds this list together.[38] But more importantly, economic post-Fordism, with its emphasis on diversity and flexibility, becomes a metonym for the emergence of a "whole shift in capitalist civilisation"[39] in which social and cultural relationships play a key constitutive role. This is based upon Gramsci's observation that "the new

methods of work [Fordism] are unseparable from a specific mode of living and of thinking and feeling life. One cannot have success in one field without tangible results in the other."[40] Fordism, then, encompasses the entire social formation: "Mass production meant mass consumption, a new system of the reproduction of labour power, a new politics of labour control and management, a new aesthetics and psychology, in short a new kind of rationalised, modernist and populist democratic society."[41] Fordism is characterized by systems of social organization, knowledge, power, art and architecture which are hierarchical and authoritarian (top down), standardized and massive. The post-Fordists point to the disintegration of this cultural and social system of power and authority, and to the appearance of new and fragmented subjects, new social movements and new collective identities. Contemporary culture (in the form of postmodernism) is characterized by diversity, differentiation and fragmentation rather than homogeneity and standardization.

The attraction of this metonymy is that it provides a real ground for optimism in the face of an extraordinary expansion of capitalism and capitalist relations. The problem with it is that its optimism is won too easily. First, it assumes that the apparent structural parallel between postmodern culture and post-Fordist economic practices is enough to ensure that they are seamlessly stitched together into a coherent vector of social transformation. Second, it provides little reason to assume that the "clean" practices of flexible specialization will become the dominant form of capitalist production across the different global regions. Moreover, it overlooks the forms of exploitation which are an integral part of such practices, as well as those which, while existing outside the spaces of post-Fordism, provides its conditions of possibility. A fleeting gesture toward the complex global relations of the economy succumbs to a nationalistic search for the possibilities of local economies. Third, it ignores the relations between economic practices and the decision made by specific institutions. Economic relations are, after all, not merely the inevitable result of changing market conditions but matters of policy negotiated between and among different states and economic institutions.[42]

Finally, it takes for granted the political progressiveness of the

social and cultural fragmentations it describes. This might be justi-
fied if one assumes that the fact that production follows consumption
means that consumption itself is not implicated in and even produced
through economic and political forces. But if consumption is impli-
cated in these practices (e.g., the mobilization of fashion in mass
markets across a wide range of "life-style products" and the produc-
tion of ephemeral and highly adoptable service products), then the
assumption that such identities offer radically new political possibili-
ties is, at best, as John Clarke has described it, overly voluntaristic
and, at worst, rather naive.[43]

Underlying all of these problems is the basic assumption of post-
Fordist analyses, however much it is rhetorically tempered or even
occasionally denied: what we are witnessing represents (at least the
first signs of) a radical rupture in the practice and organization of
capitalism and of capitalist society. This assumption needs to be
balanced against Harvey's observation of capitalism's "penchant for
fragmentation and ephemerality in the midst of universals of moneti-
sation, market exchange and the circulation of capital."[44] This sug-
gests a different interpretation of the current situation and crisis of
capitalism, one which would attempt to interrogate the conditions
of the possibility of its contemporary formations against the backdrop
of its continued principles of effectivity.

CAPITALISM AND FORDISM

We must inquire, then, into the conditions of possibility of capi-
talism and its contemporary formation if we are to understand how
the national and global crises of capitalism provide the motor force
of history. Returning to Fordism, I want to discuss five features
which may help clarify the specific nature of the crisis of productivity
which it currently faces. That is, I want to treat Fordism as a
specific articulation of capitalism, one which is not merely the logical
extension of principles inherent in capitalism itself. In this way, I
hope to argue that the current vector of change cannot be seen
simply as a break with Fordism or as a simple transformation of
capitalism. It entails, on the one hand, the elaboration of certain

principles (or axiomatics) introduced under Fordism and, on the other hand, the return of axiomatics of capitalism which Fordism attempted to overturn.

First, Fordism represented "a new mechanism of accumulation of finance capital based directly on industrial production."[45] Gramsci also argued that Fordism makes "the whole life of the nation revolve around production. Hegemony here is born in the factory"[46] which offers "a more rapid rhythm of capital accumulation within the enterprise rather than through the intermediary of the 'producers of savings.' "[47] If value itself is firmly anchored in the production of industrial commodities, the accumulation of debt is an ambiguous event. On the one hand, temporary state debt created through its injections into the economy is necessary, while the existence of a permanent international debt which extends beyond the state into corporate economies defines a crisis. It marks the absence of sufficient industrial collateral.

Second, Fordism broke with the long history of capitalism by retreating from international trade and focusing its energies on the stimulation of domestic markets. Third, Fordism attempted to increase both the return on investment and the ability to discipline labor by bringing together practices regulating space (the assembly line, the factory, suburbia) and time (Taylorism, the sharp division between work and leisure as coextensive with the difference between public and private lives). Fourth, Fordism required "a particular social structure (or at least a determined intention to create it) and a certain type of State."[48] That social structure involved the constitution of everyday life as the site of capital accumulation through mass consumption; and that state structure is the Keynesian—interventionist—state.

Finally, Fordism embodied "the biggest collective effort to date to create, with unprecedented speed, and with a consciousness of purpose unmatched in history, a new type of worker and of man."[49] The Fordist worker is the "user" of the means of production, remaining always outside of the machinery itself, devoid of knowledge and individuality. The machine itself contains all of the knowledge necessary to production. The worker exists outside of any codes, as

the labor power necessary to run the machinery, more like electricity than a subject. The laborer's identity as a laborer is only that provided by the guarantee of the right to work. On the other hand, the subject of Fordism is defined by his or her freedom to move between the different domains of the social formation: worker, consumer and citizen.

To appreciate the specificity of Fordism, we have to rethink the nature of capitalism as a mode of social organization and of the production of value within it. Deleuze and Guattari define capitalism "by the generalized decoding of flows, the new massive deterritorialization."[50] Rather than assuming value to be the product of codes, they see capital as the product of its own mobility, of mobility itself. That is, value is always and only value in process, value begetting itself. They describe this as the "filiative" nature of capital: "money begets money."[51] The relation of capitalism and decoding is central:

> Capitalism differentiates itself from any other [social formation] . . . inasmuch as capital itself figures as the directly economic instance, and falls back on production without interposing extra-economic factors that would be inscribed in the form of a code.[52]

Codes bind apparently independent realms together. They provide each term with its external and objective referent, its alibi and source. A code then binds the power of one element to its other: state power is linked to a religious order; the body is linked to a psychoanalytic order. But capitalism refuses any such coding; the value and legitimation of capital comes only from its continuous self-production. Its productivity is defined by its ability to reproduce itself, and hence any attempt to tie the productivity of value to some extra-economic force must not only be resisted but actively negated and deconstructed.

Hence, capitalism is not primarily about the production of goods but about the production of value itself: "Capital has no industrial essence functioning other than as merchant, financial and commercial capital."[53] Industrial capital functions productively only through its "alliance" with commercial and financial capital. But "it is the bank that controls the whole system,"[54] for it is in the realm of finance capital—the banking system—that capital becomes "filiative," that

money is able to "beget" money. For the system of banking is based upon the continuous reproduction of capital through the creation of "fictitious" capital—fictitious, not as opposed to "real" capital but in the sense of the constant availability of its productivity. Money enables credit (in the form of loans), and credit produces money that did not exist prior to its being loaned. Finance capital—banking— is the purest form of the productivity of capital.

The capitalist economy is perpetually "in need of monetariza- tion,"[55] for it is predicated on the coexistence of two fundamentally incommensurable flows "that are nonetheless immanent to each other . . . the one measuring the true economic force, the other measuring a purchasing power determined as 'income.' "[56] Of these two forms of money—financing and payment—financing is the form of productive capital, which is not income "and is not assigned to purchases." It is "a pure availability."[57] Consequently, what the circulation of money actually produces is "an infinite debt" or at least "the means for rendering the debt infinite."[58] The debt does not represent the failure of industrial capital but the decoded flows of money, capitalism's unrestricted ability to create more money which is constantly owed to itself.

According to this admittedly abstract model of capitalism, the contemporary decline of industrial capital and the increasing power and autonomy of finance capital can be seen as a response to the declining productivity of capital in general within the Fordist system which attempted to base all surplus value in manufacturing. It is possible, then, that the production of an international economy based upon debt financing is not some aberration or failure of capitalism but, to put it metaphorically, the beginning of a cycle of capital rejuvenation. Of course, this process is no more benign than previous articulations of capitalism. On the contrary, it is often based on the expanding deployment of the most primitive and exploitative techniques of accumulation.

This has been made possible through the creation of an increas- ingly interconnected global economy built upon the international- ization of an ever spiraling debt which paradoxically includes both the poorest and the richest nations in the world:

> Today we can depict an enormous, so-called stateless, monetary mass that circulates through foreign exchange and across borders, eluding control by the States, forging a multinational ecumenical organization, constituting a de facto supranational power untouched by governmental decisions.[59]

Such an "ecumenical organization" is defined, like capital itself, by its mobility, its ability to move across time and space, through different social formations (including noncapitalist ones). Thus, the contemporary internationalization of capitalism is neither a matter of organizations containing a variety of national elements or interests (e.g., multinational corporations and regulatory bodies), nor a mere geographical description. It is capitalism's mobility that is at stake, and the current globalization of capitalism signals its increasing mobility as it moves into and through every social formation, decoding whatever obstacles stand in the way of its own productivity. As Meaghan Morris has argued, the new forms of global capitalism do not make more limited spaces irrelevant or subservient to the international flows; rather, global mobility makes localities, regions and nations both more and less important.[60] And similarly, capitalism has no particular affective investments. It does not care about its particular identity—as steel, lumber, banking or public relations—other than as capital.

Deleuze and Guattari suggest that capitalism "has no exterior limit, but only an interior limit that is capital itself and that it does not encounter, but reproduces by always displacing it."[61] That is, capital cannot recognize any other because the other would always be able to recode it. But at any moment, capitalism always constructs its own limits and takes on a shape of its own. It exists only as a specific social formation. Its decoded flows turn back at certain points that define and enable its specific modes of production and organizations of capital accumulation:

> On the one hand, capitalism can proceed only by continually developing . . . production for the sake of production, that is, production as an end in itself; . . . but on the other hand . . . it can do so only in the framework of its own limited purpose, as a determinate mode of production, "production of capital," "the self-expansion of existing capital." Under the first aspect capitalism

is continually surpassing its own limits, always deterritorializing further, "displaying a cosmopolitan, universal energy which overthrows every restriction and bond;" but under the second, strictly complementary, aspect, capitalism is continually confronting limits and barriers that are interior and immanent to itself, and that, precisely because they are immanent, let themselves be overcome only provided they are reproduced on a wider scale (always more reterritorialization—local, world-wide, planetary).[62]

These barriers which bind and bound the flows of capital are constructed through "axiomatics": "How much flexibility there is in the axiomatic of capitalism, always ready to widen its own limits so as to add a new axiom to a previously saturated system."[63] Every capitalist formation constructs or, more accurately, is constituted as and enabled by its specific axiomatics. Axiomatics are immanent to capitalism itself, defining its attempt to reshape itself in response to the particular situations it confronts. But unlike codes, they do not refer to some external entity or domain; they are principles dealing "directly with purely functional elements and relations whose nature is not specified [independently of capital] and which are immediately realized in highly varied domains simultaneously."[64] For example, the Fordist response to labour unions constituted everyday life as an axiomatic which incorporated the free time of labor into the accumulation of capital through the dispersal of consumption. Similarly, the Fordist response to the relation of labor and machine involved an axiomatic of the regulation of space and time within the factory.

In the face of the crisis of Fordism, new axiomatics are being put into place: e.g., "the excess consumption of a class" is displaced, "making luxury itself into a means of investment."[65] And an axiomatic of regulation has been extended into everyday life itself, transforming it from a site of consumption into a disciplined mobilization. This is partly accomplished through a reterritorialization based upon codes which "are often artificial, residual, archaic; but they are archaisms having a perfectly current function."[66] These are the sites of the affective epidemics which the new conservatism deploys but which, in the final instance, operate "for the benefit of the capitalist system and in the service of its ends."[67] Similarly, the disinvestment

of capital from industry and back into finance is partly a return to pre-Fordist axiomatics.

Capitalism always involves a specific axiomatically defined relation to the state. For the state not only produces, disseminates and deploys the axiomatics of the particular capitalist formation. It is itself built upon a system of "overcoding" which stands against the axiomatic organization of capitalism. The state "overcodes" the system of social relations in order to produce "the transcendence of a formal Unity."[68] This state maintains the coherence of the society by redirecting all investments and identifications through its own symbolic references as a transcendental set of principles. In order to protect that unity and its power within the social formation, the state also organizes and directs "the activity of antiproduction that drives the entire productive system,"[69] an activity which not only limits but absorbs the capacity of capital to reproduce itself. The system of antiproduction includes, for example, not only the military machine but all those who produce the necessary commodities which keep the military machine in action; it includes the various state apparatuses and bureaucracies whose only function is to absorb capital and guarantee the continued existence of the state (including the welfare state).

The Keynesian contribution to Fordism placed the axiomatizing role of the state at the center of its existence and displaced its overcoding function; further, it made the state's support of the systems of antiproduction into an axiomatic so that the state could become the instrument of adjustment and adjudication within capitalism. The activities of antiproduction became the mechanisms of government injections of money into the economy and the sites at which they were possible. But with the crisis of Fordism and the rise of a new conservatism, the state itself is undergoing significant transformations. The state appears to have entirely given up its overcoding power, renouncing the attempt to construct a unity and coherence for the social formation: "Never before has a State lost so much of its power in order to enter with so much force into the service of the signs of economic power."[70] It has depoliticized itself, becoming little more than the agent of capitalist axiomatization.

At the same time, the state finds itself in an ambiguous relation to its own antiproduction systems. No longer the source of free capital, it is under increasing pressure to dismantle its mechanisms of capital absorption. The commitment to de-bureaucratization, while largely hollow thus far, may become real in the future. More importantly, the move to disarmament and the government's uncertainty about subsidizing the armaments, signals the beginning of the end of the defense industry as a megamachine of antiproduction. (In this context, the Iraq war takes on a different set of meanings.) These changes are hardly coincidental, implicated as they are in the struggles taking place over and with global capitalism: the state divests itself of any power than that granted to it by and within capitalism. The demand for increasing productivity requires that the state begin to reflect rather than absorb capital, augmenting rather than limiting the mobility of capital. (Perhaps the disciplined mobilization of everyday life has become a new principle of antiproduction.)

Fordism also introduced a new axiomatic of the individual: no longer "enslaved by the machine," the worker is "subjected" to it.[71] Fordism created a regime of social subjection in which individuals were users who, rather than being internally implicated in the codes of the machine, were now external to the machine and responsible for the application of codes to it. The transition from slave to subject is also a transition from public individual to a private abstraction: "The person has become 'private' in reality, insofar as he derives from abstract quantities It is these abstract quantities (e.g., labor power) that are marked, no longer the persons themselves."[72] This transition has its economic correlative: private property "is no longer ownership of the land or the soil, nor even of the means of production as such, but of convertible abstract rights"[73] (e.g., the right to work). This social subjection provided the basis of the postwar liberal-democratic state and the foundations of the various postwar struggles for civil rights.

The movement away from Fordism produces a new regime of individuality:

> The axiomatic itself, of which the States are models of realization, restores or reinvents, in new and now technical forms, an entire

system of machinic enslavement . . . It is the reinvention of a machine of which human beings are constituent parts, instead of subjected workers or users . . . It could also be said that a small amount of subjectification took us away from machinic enslavement, but a large amount brings us back to it. For example, one is subjected to TV insofar as one uses and consumes it, in the very particular situation of a subject of the statement that more or less mistakes itself for a subject of enunciation ("you, dear television viewers, who make TV what it is . . ."). But one is enslaved by TV as a human machine insofar as the television viewers are no longer consumers or users, nor even subjects who supposedly "make" it, but intrinsic component pieces.[74]

In this new structure of enslavement, the individual is trapped within the spaces of everyday life. It is not merely that free time has become profitable, but that the individual him- or herself has become human capital. (For example, in the film *Pretty Woman*, the prostitute serves as nothing but a site for capital investment, through which more capital is produced. Ultimately, it is money, not knowledge, which re-"makes" the individual into a new person.) The individual can no longer claim possession of abstract rights, for it is only as specific sites of capital production that such property rights can be asserted. The individual is no longer a singular social subject who always maintains an abstract existence, but a fragmented and mobile structure of capital. If Fordism produced a subject out of the fragments of an individual's existence (worker, consumer, citizen), the contemporary capitalist formation refuses any such subjectification. Instead, the individual is an assemblage of concrete fragments which are reified by their direct relation to capital.

In other words, contemporary capitalism produces differences within and among us, refusing the possibility of the Fordist modes of abstract unification. Yet, at the same time, capitalism deflates those differences, refusing to allow any difference to be privileged outside of its local relation to capital. Consequently, the new forms of social segmentation—of race, class, gender, age, etc.—do not exactly replicate older structures of social difference. Remembering Deleuze and Guattari's interest in "the type of organization within which that status results,"[75] we can understand that such differences are no longer produced through binary machines of subjectification

but rather, through fragmenting machines of capitalization (territori-alization). If the former organizes the mobility of the subject through various domains, the latter disciplines the mobility of capital within everyday life. In this sense, such identities are not subject-ed but rather constitute "minorities" which are "not necessarily defined by the smallness of their numbers [or even by their subordination to another group] but . . . by the gap that separates them from this or that axiom constituting a redundant majority."[76] Minorities are multiplicities rather than identities, universal and mobile fragments rather than subjects.

CAPITALISM AND AMERICAN POLITICS

I want to suggest that the struggles implicit in the transition I have begun to describe here define the agency operating within the political and cultural rearticulations of everyday life in the contempo-rary U.S. It is the transition itself which defines the crisis of capital-ism, a crisis in which the old has passed away but the new is unable to be born.[77] In that sense, we do not know what the new formation of capitalism will look like although we do know something about both its vectors (axiomatics) and the resistances to it. These axiomat-ics describe the new conditions of possibility for an increasing circula-tion of capital, increasing both because it is organized globally and financially and because it is freed from the constraints of industrial capital, subjective labor and the overcoding state. In this transition, the New Right, like other fractions of the new conservative alliance, is but one of capitalism's agents. Equally important, although op-erating partly outside the space of national politics, are the various international regulatory institutions of economic management: e.g., the International Monetary Fund, the World Bank, the Paris Club, the London Club, the General Agreement on Tariffs and Trade, the Organization for Economic Cooperation and Development, the Group of Seven, and the European Economic Community.[78]

This struggle itself cannot be understood in the simple terms of the class struggle, no matter how the classes are redefined. For the very place of class within capitalist relations is up for grabs (which

is not to say that the question of the unequal distribution of wealth has become irrelevant, but then, class must be more than that). Class itself is being rearticulated by the expanding commodification of life-style and the disciplined mobilization of everyday life. Moreover, if class is defined by the contradiction between labor and capital, than we must rethink the relation between class and the "fundamental" contradiction of capitalism: between the forces and relations of production. Fordism was a particular resolution to that contradiction which, not coincidentally, attempted to ameliorate the class conflict in a corporatist compromise. Fordism operated on the assumption (grounded in Marx) that the two contradictions were necessarily coextensive; but there is no guarantee that this specific relationship will continue in the future. The contemporary rearticulation of capitalism promises to seriously challenge both the Fordist fit between the forces and relations of production and the way that contradiction is articulated to the class contradiction.

New forms of capital accumulation (pre-Fordist, Fordist, global Fordist, neo-Fordist and post-Fordist) are being deployed throughout the world. They are simultaneously present. The labor force of the contemporary world is increasingly divided into segments: elite skilled workers (post-Fordist), unionized labor (Fordist), a non-unionized exploited unskilled labor force (pre-Fordist) and a deskilled underclass living in various states of poverty (neo-Fordist and global Fordist). These are themselves distributed unevenly into core, intermediate and peripheral regions, which no longer easily correspond (but still do to some extent) with nations and global regions. On the one hand, these different strategies build and, to varying degrees, depend upon each other. Even something which, on the surface, sounds as positive as post-Fordist production techniques depends upon the absolute exploitation of labor through such practices as subcontracting and the exportation of industrial labor into the third world. On the other hand, the different strategies represent different positions in a struggle over the future of capitalism. Contemporary capitalism is operating neither coherently nor harmoniously; its various sectors and theorists are at war with each other.

The specific nature of these struggles over and within capitalism

depends upon the complex relations that exist between capitalism, with its commitment to growth and mobility, and its specific forms. They involve different attempts to rearticulate the relations between the global and the local forms of capitalism. Harvey identifies the central paradox of contemporary capitalism in just these terms: "The less important the spatial barriers, the greater the sensitivity of capital to the variations of place within space, and the greater the incentive for places to be differentiated in ways attractive to capital."[79] If it is true that capital always moves to where it is made to feel at home, then the situation of global capitalism requires the proliferation of places where and ways in which capital can be made to "feel at home."

Thus, while we are witnessing the creation of a truly global system of capitalism, it is also true that locales, nations and regions continue to play an important role and exert powerful influences. Despite their declining power, the Western industrialized nations are playing a crucial role in putting these new forms of global accumulation into place. Yet, as Meaghan Morris has said, neither the West nor any Western industrial nation can see itself as the sole sovereign subject of, as coextensive with, capitalism.[80] In fact, it is quite possible that we can no longer think of a subject of capitalism!

Rather, we must look to the struggles between the global and national trajectories and axiomatics of capitalism. The key to understanding the role of capitalism as agency within contemporary hegemonic struggles in the U.S. lies in America's place in global capitalism and its crisis. Mike Davis, for example, describes "American hegemony" as "a historically specific form of adequation between the capitalist state systems and the world economy."[81] He goes on to argue that

> the relative shrinkage of the domestically generated U.S. share of world industrial production, or the emergence of a secular trade deficit, is not logically incompatible with the maintenance of American dominance over the general conditions for the reproduction of world capitalism.[82]

Davis would no doubt interpret America's domestic political struggles in relation to this attempt to reestablish America's international

economic hegemony. If the United States has in fact lost its hege-
monic role, it may all be a futile defensive effort to hold back
the tide of globalization and to reassert the strength of its national
economy.

But I am led to another conclusion because I believe that it is not
capitalism per se (as some specifiably heterogeneous set of interests)
which is the site of real agency in American politics but the contem-
porary crises of and struggles within capitalism. What is the relation
between this agency, the redeployment of the postmodern frontier
and the construction of everyday life as a disciplined mobilization?
Its effect is to put the U.S. "on hold," an important strategic move
given that it has played, and continues to play, a crucial role in the
contemporary economic and political structure of the world. After
all, the U.S. is still a very powerful force—even a key one—which,
for the sake of its own interests, could easily define powerful blocks
to the new flows of capital, unless capital can continue circulating
within the nation even while its mobilities relocate the nation within
a changing international economy, an economy which will resonate
throughout political and cultural life. It is not a question of the
similarities or homologies between economics, politics and culture,
but of the ways in which political and cultural struggles are them-
selves strategically deployed in the service of resolving the crisis of
capitalism, allowing capitalism to work its way through the crisis,
and enabling "the new to be born."

The agency of capitalism, immanent within culture, produces a
language of "decoded flows . . . as opposed to a signifier that strangles
and overcodes the flows."[83] Its signs do not mean anything; instead
they function as a part of the territorialization and disciplinization
of capital's flows. Culture itself is articulated to capitalism's decon-
struction of all fixities (places) and to its elimination of public spaces.
It produces an endless flow of differences which make no difference
but deny any stable moment of identity and commonality. The
disciplined mobilization is an articulation of this principle of deterri-
torialization as territorialization; it marks in cultural space the inter-
section (transversal) of the different temporal and spatial logics of
global capitalism and American politics. Its effect is, quite literally,

a pregnant pause; it creates a temporal and spatial demilitarized zone in which the political, social and cultural energy of the U.S. is contained, enabling capitalism to confront its own crisis. In this space, capitalism can attempt to reshape itself and to relocate the national ego/interests of America within the axiomatics of the new global circulations of people and capital. Neither capitalism, nor America nor the world will be the same. It is not clear that we should welcome this new economic-cultural formation with open arms, but it is also not clear that we have any way of escaping the facticity of capitalism in the world and the culture of disciplined mobilization in the U.S.

15

"YOU CAN'T ALWAYS GET WHAT YOU WANT": THE STRUGGLE OVER THE LEFT

In the effort to give culture its due, contemporary cultural theory too often goes overboard, erasing the relations between culture and specific economic and political realities. Formulating a viable strategy of opposition demands, among other things, analyses of how the various agents of capitalism have been able to appropriate and deploy the logics and sites, the spaces and places, of postmodern culture and everyday life. While Fred Jameson reads the Bonaventura Hotel in Los Angeles as a text, looking for signs of postmodernity within its borders,[1] Mike Davis points to the "savagery of its insertion into the surrounding city."[2] Culturally, the building is a billboard of the "superexploitation of the urban proletariat."[3] It is, as well, a spatial marker, part of a larger project to "polarize [the city] into radically antagonistic spaces,"[4] excluding Chicano, Black and poor populations from participation in certain urban spaces, activities and pleasures. Critics have become so concerned with the struggles within culture (Volosinov talked about "the class struggle enacted within the sign"[5]), ignoring the forces that are articulated into and articulate culture. The struggle over the sign becomes an end in itself, producing and reproducing nothing but the relations of cultural difference and power. But the sign—i.e., culture—can be deployed in other ways. Perhaps we are entering a new middle ages, for example, in which the rich increasingly use culture to fortify their spaces and places, to literally and figuratively protect themselves from incursion, not only by the poor but also by the working and middle classes.

Political struggles and events are too quickly incorporated into the tapestry of cultural logics: "The collapse of the old political certitudes in Eastern Europe and the awakening of new political alternatives to market capitalism are precisely of a piece with the erasure of the old artistic 'avant-garde' and the ceaseless searching for the 'new.' "[6] How they are "of a piece" is presumably immediately obvious. This peculiar critical practice subsumes all of history, including real political and economic changes, under the sign of culture. This makes it almost impossible to differentiate between and evaluate different struggles. For example, Hebdige sees both the Miners' Strike (1984) and the "Acid-House Panic" as struggles over "the right to community and free association, the right of people to congregate en masse and to act in concert to achieve a common purpose." The fact that "the first struggle was fought as a matter of life and death" while the second "is about communion and crowds, pleasure and the body" should not "be allowed to obscure the fact that both are struggles and both are simultaneously political and cultural."[7] Both involve questions about the configuration of everyday life. The fact that the former obviously connects to questions of economic existence and governmental power is apparently secondary to its everyday articulation.

The fact that all cultural practices are related to questions of economics does not presuppose that they are all equal or related in the same ways. Certainly, cultural production (both "high" and popular) is increasingly absorbed into economic markets—not merely as commodities (for that happened long ago) but as a speculative market for finance capital. Advertising and public relations campaigns are quick to appropriate cultural strategies and references. Cultural production is increasingly sensitive to, even determined by, the exigencies of market demands and marketing possibilities. But such developments do not justify the claim that the line between culture and economics is collapsing, or that the relations are always the same. It does suggest that economic agents are very aware that cultural relations are an important source of both capital and power, and that, in the face of the contemporary situation, new techniques of regulating culture and policing everyday life may be necessary.

The effectiveness of such techniques depends precisely, not on their remaining hidden from view, but on the ways their very visibility enables their externality to remain hidden.

It is not surprising that capitalism is so hospitable to the postmodern sensibility and so capable of articulating it to its own projects. After all, capitalism itself is fundamentally based on a kind of economic cynicism: it assumes that the source and essence of wealth lie in the exploitation of labor.[8] In fact, as Deleuze and Guattari argue, "there is no longer any need of belief and the capitalist is merely striking a pose when he [or she] bemoans the fact that nowadays no one believes in anything anymore. Language no longer signifies something that must be believed."[9] What is more postmodern than striking a pose in the face of cultural meaninglessness! The "family," emptied of its representational value, can be relocated in the lives of individuals, communities and the nation; it is taken up, invested in and placed into the spaces between everyday life and the social formation. Whatever the intentions of the new conservative's defense of the family (and there are probably many), contemporary capitalism is articulating the family and the home to mobilize the productivity of capital itself and to discipline the population and its culture.

It is a question of the strategic deployment of the postmodern sensibility into everyday life, of the articulation of the very structures of everyday empowerment into larger structures of political disempowerment. By erasing anything but local antagonisms, people are disempowered by their search for empowerment, demobilized by their very mobility. Intellectuals have allowed theory to direct their work even when it contradicts the real demands of historical domination and oppression, as in the following double transformation of "power":

> Not the overt power of armies and governments, but the more subtle powers encoded in the social order of modernism which has positioned the experiences of being female, male, black and white, an artist, reader, writer, from First or Third World, as having an immovable and constitutive character.
>
> Against these orders and powers, postmodernism has proposed a more multiplex, shifting, heterogeneous set of cultural relations that have persistently evaded stable and particular readings and

meanings, have evaded the snares of grand systematic narratives, have challenged the hegemony of totalising doctrine and histori-cally-rooted theory.[10]

In their desire to renounce vanguardism, hierarchy and authori-tarianism, too many intellectuals have also renounced the value of intellectual and political authority. This renunciation of authority is predicated on a theoretical crisis of representation in which the authority of any knowledge is suspect, since all knowledge is histori-cally determined and implicated in hierarchical relations of power. The political reflection of this suspicion is that structures and hierar-chy are equated with domination. Intellectuals cannot claim to speak the "truth" of the world, and they cannot speak for or in the name of other people. There are only two strategies available to the critic. First, the ability to describe the reality of people's experience or position in the world can be given over entirely to the people who are the subjects of the analysis. They are "allowed" to speak for themselves within the intellectual's discourse. The critic merely inscribes the other's own sense of their place within and relationship to specific experiences and practices.[11] Second, the critic analyzes his or her own position self-reflexivly, and its consequences for his or her study (i.e., my history and position have determined the inevitable failure of my authority) but without privileging that posi-tion.[12] In either case, there is little room for the critic's own authority.

While such a moment of intellectual suspicion is necessary, it goes too far when it assumes that all knowledge claims are equally unjustified and unjustifiable, leaving the critic to celebrate difference and a radical and pluralist relativism. The fact of contextual determi-nation does not by itself mean that all knowledge claims are false, nor does it mean that all such claims are equally invalid or useless responses to a particular context. It need not entail relativism. The fact that specific discourses are articulated into relations of power does not mean that these relations are necessary or guaranteed, nor that all knowledges are equally bad—and to be opposed—for even if they are implicated with particular structures of power, there is no reason to assume that all structures of power are equally bad. Such an assumption would entail the futility of political struggle and the

end of history. This is the conundrum of the intellectual Left, for you can't have knowledge without standards and authority. Similarly, although all structures of commonality, normality and the sacred may be suspect, social existence itself is impossible without at least the imagination of such possibilities.

This "intellectual's crisis" of representation becomes particularly dangerous when it is projected on everyday life and political struggle, when it is mistakenly identified with a very different crisis of authority. In the post–Vietnam, post–Watergate, post–Three Mile Island, post–Challenger, post–Jimmy Bakker world, many if not all of the traditional sources of moral, political and even intellectual authority (including those empowered by the postwar consensus) have collapsed or at least lost a good deal of their aura. There is a deep seated public anxiety that America's power (moral, political, economic, etc.) is on the wane and that none of the traditional authorities is capable of protecting Americans from the many forces—natural and social—that threaten them. Here we must assent to part of the new conservative argument: Structures of ironic cynicism have become increasingly powerful and do represent a real cultural and political problem.

Both "crises" involve a struggle to redefine cultural authority. For the former it is a struggle to reestablish the political possibility of theory. For the latter it involves the need to construct politically effective authorities, and to relocate the right of intellectuals to claim such authority without reproducing authoritarian relations. The intellectuals' crisis is a reflexive and rather self-indulgent struggle against a pessimism which they have largely created for themselves. The conflation of the two glosses over the increasing presence (even as popular figures) of new conservative intellectuals, and the threatening implications of the power of a popular new conservatism. The new conservative alliance has quite intentionally addressed the crisis of authority, often blaming it on the Left's intellectual crisis of representation (e.g., the attacks on "political correctness"), as the occasion for their own efforts to set new authorities in place: new positions, new criteria and new statements. Left intellectuals have constructed their own irrelevance, not through their "elitist" lan-

guage, but through their refusal to find appropriate forms and sites of authority. Authority is not necessarily authoritarian; it need not claim the privilege of an autonomous, sovereign and unified speaking subject. In the face of real historical relations of domination and subordination, political intervention seems to demand, as part of the political responsibility of those empowered to speak, that they speak to—and sometimes for—others. And sometimes that speech must address questions about the relative importance of different struggles and the relative value, even the enabling possibilities of, different structures.

DIFFERENCE AND THE POLITICS OF IDENTITY

The Left has instead opted for a politics of identity, continuing a strategy which organized many of the important social struggles (including feminism and antiracism) of the past decades. This has been augmented by an important and sophisticated body of theoretical work on the social construction of identity within difference.[13] A politics of identity is predicated on the assumption that different social positions (e.g., nation, class, gender, sexual, race) define radically distinct political and cultural constituencies. Every social position has its own experience of the world, and anyone occupying that position shares—at some level—that "authentic" experience which in turn defines a common political and cultural agenda.

A politics of identity reifies and sometimes even fetishizes the differences between fractions of the population, undermining any possibility that such fragmentation can be appropriated as a historical resource. Every group is different and that difference must be respected and accommodated before all else. Not only must politics be organized according to the specific nature of the group and only for that group, but it must be constantly reiterated across groups and time, ad infinitum. Generalization can only be possible because the activities of different groups are determined by common social differences (e.g., one can study and write about "women" or "people of color"). While recent theories of difference locate and complicate

such identities, even challenging the essential nature of the relation between identity and experience, they do not substantially challenge the practice of a politics of identity.[14]

Recently, some critics, especially feminists, have offered a sustained critique of

> a troubling, volatile politics in which each group justifies itself, its sense of worth and its pursuit of power, through difference alone. . . . Groups are forced to assert their entitlement and vie for power based on the single quality that makes them different from one another.[15]

They have challenged "a politics steeped in identity and personal experience"[16] which assumes a hierarchy rather than a structured interconnectedness of oppression. In such a politics, moral and political legitimacy, even superiority, is determined by the singular difference (or, in more recent work, by the set of differences) which determines the position of subordination.

Identity politics is an extension of feminists' argument that the personal (i.e., experience, determined by social difference) is political. But it ignores the fact that "the political cannot be reduced to the personal."[17] It assumes that politics is determined by identity and consequently, ignores the most obvious lesson of contemporary political history: the politics of any social position is not guaranteed in advance, even if it appears to be stitched tightly in place. There is no necessary reason why anyone inhabiting a particular experiential field or located in a particular social position has to adhere to particular political agendas and interests. The illusion can be maintained only by assuming that people who do not have the "right" politics must be suffering from false consciousness and they have yet to authentically experience their own lives. It is too easy to assume that abortion is "a woman's issue" and, further, that a woman who is against abortion is acting against her own experience and interests. More importantly, this often leads people to miss broader political possibilities (e.g., that *Rust v. Sullivan* limits free speech in any federally funded institution and overrides professional codes of responsibility and significantly strengthens both state courts and the Executive Branch). As June Jordan puts it,

> People have to begin to understand that just because somebody is
> a woman or somebody is black does not mean that he or she and
> I should have the same politics. We should try to measure each
> on the basis of what we do for each other rather than on the basis
> of who we are.[18]

Political struggle is too easily replaced by the ongoing analysis of
one's own oppression and experience or, only slightly better, by a
politics in which the only site of struggle is the local constitution of
one's experience within a structure of difference. While the personal
is most certainly political, it is often impossible to reach it other than
through indirection, through struggles over and within the public
sphere. As a political practice, identity politics has (unintentionally)
played into efforts by the Right to marginalize many important
struggles over both civil liberties and civil rights as "special interests."

A politics of identity can easily lead one to assume that every
activity of a subordinated social fraction is an authentic expression
of its position and, as such, must be celebrated as some form of
resistance (e.g., Black anti-Semitism or the Islamic treatment of
women), creating complex and often impossible contradictions. And
since subordination is only defined by its opposition to an imaginary
abstract other always located in a dominant position (Black against
white, street culture against "legitimate culture," female against
male, workers against capitalists), there is little room for any distinc-
tions. All struggles are apparently equal since every struggle has an
equally credible case for those implicated within the space of its
specific identifications. The claim of every subordinated social
group, and just about every social group is subordinated in some
dimension, must be granted equal validity since there is no way to
measure oppression from outside of the experience or position of the
specific imagined community. There can be no measure of political
immediacy, importance and value, no way of evaluating the reasons,
forms, legitimacy or at least pragmatic necessity of particular mo-
ments of subordination. All subordination is evil; all subordinated
groups are good! Of course, in practice, particular forms of subordi-
nation are privileged, and politics can degenerate into comparative
measurements of suffering.

And while the Left cautiously walks around certain groups and identities (this is partly responsible for the fact that it has avoided important public debates around such issues as "affirmative action" and "quotas"), it often tramples across other subordinate groups, especially those with ambiguous social and political histories (e.g., religious minorities such as Jews and Arab Christians). Other questions—e.g., geographical or regional identity—are given short shrift, although they may actually play an important role in political agendas (e.g., in the U.S., regional identity sometimes displaces ethnic identity in all but local politics). But perhaps the most serious practical problem with a politics of identity is that it cannot control the list of identities. It constantly faces the possibility of an endless proliferation of subordinations which cannot be controlled by appealing either to some simple privileged mantra (race, class and gender)[19] or to some singular dominant other against which every subordination can be measured (e.g., white middle-class male).[20] This courting of difference contrasts markedly with the Right's constant labors to repress differences.

The politics of identity has had a particularly negative effect on the Left, albeit unintentionally: it has produced a "politics of guilt"[21] or a "diagnostics of discourse"[22] in which anyone's social position already determines their authority to address specific social problems. Disagreements can always be traced back to the social differences between the speakers (and the social "illnesses" and distortions which these differences produce) rather than projected forward into an analysis of the historical adequacy and political efficacy of the alternatives.[23] Every individual and struggle is judged by a standard of linguistic self-righteousness and moral purity. Being morally and politically correct is defined by the constant need to demonstrate the proper deference to the subordinate terms within the systems of differences. Everyone is held accountable to an ever-expanding and unpredictable series of potential exclusions and subordinations. This demand for political purity reduces the context of struggle to the sum of particular identifications and identities. It is a strategy designed to alienate no one but, in the end, it merely constructs situations in which different fragments are constantly warring with each other.

Such passionate diagnoses of other people's inevitable failure, coupled with the seemingly endless fragmentation of the Left into different subordinate identities and groups, is at least partly responsible for its current powerlessness. The old cliché that the Left constantly devours its own is no longer a joke. Donna Minkowitz's report on the 1991 National Lesbian Conference provides a sad but telling indictment of any attempt to organize a Left politics around identity (for it is only the most recent example). Despite the empowerment derived from "the profusion of lesbian personae," the conference demonstrated that the different lesbian groups "do not trust each other." The attempt to create a national organization

> fell by the wayside as the main business emerged: an inquisition into the political sins of conferencegoers, . . . Activism took a back seat: How could people be motivated toward political action when their value to the movement was constantly being questioned?[24]

In admittedly naive terms, a politics of guilt undermines the possibility of free and open discussion about the necessity to put aside differences in the name of common political goals, or at least common opposition to the changing balance of forces in the contemporary world. Rather than assuming a minimum of "good will," absences and disagreements become signs of inevitable moral and political failure. Supportive and even polite debate has all but disappeared and guilt and intimidation, whether intended or not, have become common experiences within the Left!

This is partly the result of the fact that a politics of identity lets intellectuals too easily off the hook. It correctly rejects the old liberal model which gave select groups the unchallenged power to speak and act for others (assuming that subordinate groups are passive victims who need things done for them). But it often goes too far, undermining any recognition of the ways in which different groups of people are implicated together in relations of power and mutual responsibility. At best, such a politics seeks to identify positions from which the oppressed might be empowered to speak. However, as Spivak has argued, it is not sufficient to identify the differential access

which people have to various speaking positions. It is also necessary to identify the conditions which have made it impossible for certain people to take up such positions, and to speak particular sorts of discourses.[25] Acknowledging the material reality of oppression should lead intellectuals to rethink the need for, and effectiveness of, practices of representation. Given that some groups are effectively silenced, part of the political responsibility of those empowered to speak may be that they speak for—represent—others.

New Times and Postmodern Identity Politics

There is another—postmodern—version of the politics of identity, a part of what, in Britain, is referred to as "New Times." Here the analysis begins with "the proliferation of the sites of antagonism and resistance, and the appearance of new subjects, new social movements, new collective identities—an enlarged sphere for the operation of politics, and new constituencies of change."[26] In this version, any identity is itself divided, and the subject is seen as internally fractured. More accurately, the global binary structures of differences—class, gender, race—which organized the population into simple aggregates in simple relations of power have broken down. Individuals are always simultaneously located in a number of fluid, temporary and competing positions. If it is no longer possible to speak of a singular group identity or an authentic grounding experience, politics has to confront the increasing power of such multiple identities in the contemporary world:

> Most of us do not have one fixed political identity. We are not in any simple sense "black" or "gay" or "upwardly mobile." Rather, we carry a bewildering range of different and often conflicting subjectivities around with us in our heads at the same time. And there is a continual smudging of personas and lifestyles, depending on where we are operating (at work, on the street) and what cultures we move along. It is the speed, the fluidity with which these identities merge and overlap which makes any notion of fixed political subjects seem anachronistic.[27]

These new identities have created new, fluid communities; whether they are real or imagined is irrelevant, for they are often highly

charged for the individuals who live within them. Moreover these new structures of identity are inseparable from the forms of power which increasingly infiltrate the structures of everyday life: the family, health, food, sexuality, body, etc. It is these new forms of identification and community on the one hand, and of power and antagonism on the other, which have produced the various new social movements and struggles of the past few decades (e.g., ecology, animal rights, feminism). To respond, the Left needs to further develop these new models of political activity.

While Jameson pessimistically sees postmodernity—the "cultural logic of capitalism"—as destroying the possibility of constructing any map of the social domain,[28] New Times argues that by expanding the definitions of subjectivity and political struggle, we can begin to reconstruct a map of a radically reconceptualized social: "We lack . . . any overall map of how these power relations connect and of their resistances. Perhaps there isn't, in that sense, one 'power game' at all, more a network of strategies and powers and their articulations—and thus a politics which is always positional."[29] Hebdige goes even further: "New political agendas and priorities are being forged on the ruins of the old and there seems little likelihood that a new set of universal values or objectives will emerge to bind us all together 'beyond the fragments' into one progressive bloc."[30] Such a permanent "politics of position . . . means accepting looser definitions of commitment. A revised perspective may lead us to question distinctions between 'serious' and 'superficial' struggles. . . ."[31]

But what such a view actually does is to relieve the Left of the burden of answering many of the most difficult questions. It is quite true that contemporary individuals seem to have fragmented and fluid identities, but is it a qualitative change in the nature of individuality?[32] What has changed are the sources (and perhaps the degree) of these mobile identities, which are more likely to originate from the media and the economic practices of consumption, and the place of this fragmentation in cultural theory, if not also in everyday life. New Times does not seek out (or construct) the mechanisms by which such fragmentation is or can be articulated into effectively unified structures of subjectivity. It ignores the contribution and

empowering possibilities of such "essential moments of identity," for, as Spivak has argued, "the ones talking about the critique of the subject are the ones who have had the luxury of a subject."[33]

New Times, as a postmodern identity politics, attempts, correctly I think, to address real people on the terrain where they live: the real fears, needs, desires, aspirations, hopes, struggles and problems which constitute the limits within which people can imagine their own political positions. But it confuses the site of address with the project of politics; the latter involves moving people from where— or, in this case, what—they are, sometimes gradually, sometimes by leaps, to a different position.

According to New Times, there are "some uncanny resemblances between lifestyle market segmentation and the individualities thrown up by the new political movements of the 80s."[34] Consumption and media have moved out of the realm of mere comfort and competition (keeping up with the Joneses) and into the arena of the impossible construction of one's own difference. Consumption has become the place where people can construct their difference (from others and from their different selves). It may be the only place where such signs are available and such commitments possible. One consumes as a way of designing one's "self" for the moment and in the particular context. The current marketing strategy of "hyping the appeal of the unique you" has to be located then, not only in the context of "the proliferation of individualities, of the number of 'yous' on offer" but also as a response to the contemporary "social agenda"—the changing shape of working-class culture, the impact of feminism, ethnic spending power, the 'new man' . . ."[35]

Apart from the rather abstract and depersonalized image of consumption operating here—which assumes that people have the money and that their consumer activity is not a form of domestic labor—there is a surprising gap in the argument. If the new individualities and communities are the product of changing economic relations, if capitalism itself is largely responsible for the proliferation of differences, then it seems rather odd to assume that they precede those economic relations or that they are a response to some other development. In other words, the position of New Times begins with

historical changes which have been produced by the very structures of power it wishes to attack. But instead of just beginning there, it builds a politics on the assumption that these changes form not merely the condition of possibility of any new politics but the only and the best form of politics available. It conflates that which people are with that which they must struggle to become, and with the form of the struggle itself. Any contemporary politics will have to deal with the power of consumption in the world, with the fact of mobile and fragmented subjects, and with the relations between them. But it cannot assume that political struggle is defined by and limited to the definitions of reality and change embodied in the relations between consumption, culture and identity. After all, the instability of such fragmented identities (and their extension into various forms of politics) may be a source of vulnerability and even weakness deployed by and into the service of capitalism itself.

The Politics of Alliance: Transcending Difference

Ultimately, the major task facing any politics of identity is to overcome its isolationist, fragmenting tendencies. Whether a movement is defined by some purportedly singular identity (women, lesbians, Blacks) or by a project of bringing together different identities, it has to construct alliances which can transcend the specific links between identity and interests of its various groups. Certainly this is true of the Left itself. Of course, there is no singular Left, but that is just the point, for increasingly, the leading edge of both the political and the intellectual Left start with the necessity of fragmentation. So the Left is faced with the impossible task of reconstructing its unity. Alliances construct a "unity in difference."[36] They are different from coalitions in which every group remains totally independent, maintains its own interests and is promised a piece of the pie (often the strategy of political parties).

There are a number of different strategies of alliance. First, in structures of solidarity, the interests of each group remain intact and defined as they were independently of the alliance. But the interests of a specific group are given priority (both theoretically and tempo-

rally), with the promise that at some unspecified future time, the dominant group will support the struggles of the other groups. Solidarity solicits the nominal support of different groups for each other's causes while foregrounding a particular structure of subordination and oppression. While the struggles of all subordinate groups are recognized and validated, one group's oppression is seen as more fundamental, sometimes even to the point of assuming that if it were overcome, other groups' oppression would quickly follow suit. This is, of course, the view of the traditional masculinist Marxist Left, which not only demands allegiance to the liberation of the working class, but also assumes that all forms of subordination can be explained in economic terms, as if overthrowing capitalism would simultaneously undo all of the forms of oppression and subordination characterizing contemporary capitalist societies.[37]

While the different groups in solidarity remain independent (and sometimes, even able to determine their own strategies), their equality is in name only. If the alliance is too rigid and hierarchical, the very real claims of many groups will constantly be deferred and the alliance will function in authoritarian ways. Eventually, such an alliance comes to be seen as what it is, for all practical purposes: a single-issue (single-constituency) group, and struggles will ensue over its relation to other issues. Inevitably, any issue, when it is publically addressed within a structure of solidarity, is likely to be presented in terms which are designed to avoid alienating anyone (e.g., the various charity mega-events such as Farm Aid, which are often unable to raise concrete political issues of legislation and banking practices).

The second model of alliance is a structure of equivalence. Here each group maintains its own identity and interests, but these interests are subsumed as expressions of a broader principle which articulates the different groups into a common unified structure of interest. Laclau and Mouffe, for example, have advocated such a strategy to combat the increasing power of new conservative (hegemonic) alliances in the various Western industrialized nations.[38] They argue that the various new social movements (including ecology, feminism, gay and lesbian struggles, struggles against racism and imperi-

alism by peoples of color) can be articulated together around a common commitment to the extension of the principle of democracy.

However, there are serious problems with this strategy as well. In the first place, it is doubtful that any single principle could be guaranteed to unite all of the "desirable" groups (e.g., what could incorporate ecology, antiracism and anticapitalism) and exclude all of the "undesirable" groups (e.g., a commitment to democracy might also empower anti–gun control groups). Any principle is likely to be the occasion for further struggles over both its meaning and its application, and the problems are only worsened if such alliances are extended, as they must eventually be, beyond local and national boundaries. In fact, the very notion of equivalence operates with a rational model of politics as a dialogic process through which a single common identity expands the space of its operation across the field of social differences.[39] Any such principle (e.g., democracy) is likely to be predicated on an assumed lack (e.g., of democratic rights) rather than on the conditions of oppression and exploitation which actually might enable organized opposition.

More immediately, it is difficult to see how any such principle could ameliorate the contradictions that exist between competing claims and struggles. Civil liberties (protection from the state), for example, often conflict with the demand for various rights (granted by the state). The demand for economic growth in impoverished regions and nations often rubs against the most extreme ecological concerns, just as ecological concerns often contradict the economic interests of working families. Current protests against ROTC on college campuses (because of their homophobic policies) ignore those protesting the inability of people of color to attend universities (where in fact ROTC is one of the few mechanisms of financial support). Ecologists demand regulation of the present in the name of the future, while feminists oppose such arguments in the context of fetal rights. Some gay rights activists advocate "outing," forcing prominent gay people out of the closet, despite the fact that this clearly violates their civil liberties, but do so in the name of the protection of the lives of those who are dying or will die as a result

of society's homophobia and its consequent reluctance to confront the AIDS crisis head-on. Struggles to legalize drugs compete with the antidrug concerns of many within urban ghettos.

There is the danger of spreading scarce resources (time and money) too thinly. Competing simultaneous demands will still require adjudication because such unifying principles draw particular groups into broader struggles, opening up unresolvable debates over commitments and strategies (e.g., a typical debate threatens to split Act-Up over whether it should confine itself to struggles to obtain drugs for PWAs [persons with AIDS] or expand its concerns to the variety of AIDS-related issues, or even to the struggle for gay and lesbian rights). Alliances of equivalences attempt to construct a common struggle by defining a singular principle of opposition to the dominant structures of power. This principle creates an identity that transcends the specific agendas of the different groups while leaving each group's identity intact. But the fact that there is no simple and homogeneous structure of dominance means that the oppositional bases on which such a common principle and identity are constructed is already too fragmented to sustain the necessary coherence.

The final strategy of alliance, an articulated alliance, is the most ambitious because it attempts to construct a new common identity which both transcends and transforms the identities of the various groups. In its most hierarchical forms, such an alliance can easily devolve into structures of solidarity. In its more positive forms, such an alliance seeks to incorporate and even nurture differences. Jesse Jackson's Rainbow Coalition is perhaps the most visible attempt to transcend the limits of coalition politics by forging a new common identity across social and cultural differences. And recent efforts among Black intellectuals (and peoples of color) to construct a "diaspora politics" based on an assumed but irretrievably lost origin offer a new subjectivity located, not in the lack of particular power (although that is certainly a consequence of history) but in the suppressed and exploited existence of a positive identity.[40] Such an articulated alliance attempts to use the contemporary fragmentation of identity to its advantage. Since it cannot be ignored, the struggle is to make it into a resource by which a new empowered position

can be created which is defined, not merely by its exploitation but by its historical existence and unity. Such articulated alliances are extraordinarily fragile, however, as different groups struggle over the ways in which the new identity is articulated to the specific interests brought with their continuing attachment to older identities (e.g., the struggle over rap between poor and middle-class Blacks). Its fragility is even more deepseated. It is not merely a matter of the tendency of such "groups-in-fusion" to collapse back into seriality, but of the conflicts inherent in any attempt to ground power in identity.[41] Deleuze and Guattari locate the failure of such revolutionary struggles in the fact that "groups and individuals contain microfascisms just waiting to crystallize."[42]

In the final analysis, all of these strategies rest upon two assumptions: first, a contemporary politics must not only respond to but must build itself upon the proliferation of social differences, the discourse of otherness, which contemporary culture puts into place. Second, political struggle is always predicated on the relationship between identity, experience and interests; either interests are inherent in the experiences of specific identities, or the links between them have to be made as the first step of any struggle. The politics of identity continues the rationalist assumptions that defined both the old and the new Left: people act based on a calculation of their interests, which are rooted in their experiences, which are determined by their identity, which is an expression or representation of their place within a system of social differences.

The politics of identity and alliance is a cultural politics of representation built upon the collapse of the difference between the portrait and the proxy, between the self and the "we," between culture and power, between difference and unity, between identity and society. Power is located in the space between the construction of an identity which can represent the individual and the construction of a social subject which can represent the subject of resistance. The various strategies of alliance are all attempts to construct a "we" which can represent and speak for and across different identities and groups, a collective identity which transcends differences. "We" speaks as a unity from the position which the other has already

constructed for it (i.e., the essentialist view). "We" speaks from an imaginary place (the site of alliance) located in the midst of the differences (i.e., the postmodern view). The project inherent in the very notion of a politics of identity—the attempt to forge unity on top of difference—must always reinstate relations of power within the struggle itself, thus splitting it back into its fragments.

TOWARD AN AFFECTIVE OPPOSITION

By focusing on the construction of social individuality, identity politics actually loses any common sense of power and oppression. It mistakes empowerment and resistance for opposition. It begins with the correct observation that people often find pleasures in unexpected places and activities, that they often use activities in unexpected ways in order to struggle to change the conditions of their everyday life. But ways of life are not inherently politicized; they do not necessarily map onto way of struggling unless they are defined by and directed against some dominant "other," which may or may not actually be the agent responsible for maintaining their subordinate position. The resistance of a politics of identity requires establishing a social conflict rather than a political antagonism, a relation between individuals or groups with specific positions in everyday life. Such a politics confuses identity for the relation between subjects and agencies. And antagonism disappears into the practice of articulation.

I do not mean to deny the intellectual importance of notions of identity and difference, nor do I want to assert that they have become politically irrelevant. The question, however, is whether a politics of identity can provide a sufficient ground to organize both opposition and alternatives to the contemporary conservative hegemony. The Left cannot ignore the issues of the differential structures of power that are inscribed upon the population, but it must refuse to begin by assuming that power can always be adequately understood or contested by simply acknowledging the suffering of the subordinate. It has to address the increasing segmentation of the various subordinante groups. Groups which have been traditionally produced

through and within a binary mechanism are increasingly deployed in complex and context-specific ways. The contemporary organization of power may construct and enable particular structures of binary racism in one place, while fragmenting the binarism in another. It may refuse racism at particular sites, and at others, demand it. And it may articulate specific fractions of apparently subordinated groups into real positions of power, or into positions in which their "real" interests lead them into conservative positions within which they seem to embrace their subordination. Thus, it cannot be a simple question of Blacks or women or differentially abled organizing against the new conservatism (since they are clearly not all in opposition), but rather of constructing a movement which can strategically and effectively mobilize people against it. It requires, in Deleuze and Guattari's terms, a politics of the minor.[43]

Oppositional struggle depends upon an analysis and identification of the agents and agencies, the historical forces (economic, cultural and political) which construct the configuration of everyday life, specific positions within it, and the relations between these and the larger social formation. The politics of identity is always a politics of resistance, operating at the local level, within the configurations of everyday life, since it refuses to transcend the specific identities and oppressions which are being contested. It allows only the extremes of political involvement: one can only act very locally or at very great distances.

The Left, because it must allow any morally correct protest (and who is to decide except the victims), cannot strategically define its priorities. Too often, it trivializes itself in public struggles which focus on the most minor signs of subordinate identities, especially given the real problems facing not only minorities but also the world.

To develop a new conception of politics and alliance, we must move beyond both essentialism and the assumption that identity is *the* major site of political struggle.[44] We have to define politics and the appropriate sites and forms of struggle by something other than the feelings of the oppressed. Racism, for example, whether aimed at Blacks, Latinos, Jews, Arabs, Asians, or any other group, is not merely a matter of the experience of the subordinate although that

experience—the pain and anger—is very real. But it can only become a resource if it is articulated into a viable political strategy. We need to confront all forms of racism, including the racisms of subordinate groups, in our society. And we need to confront as well the ways racism is deployed in specific hegemonic struggles.

This requires a politics of practice (e.g., a politics of antiracism) built on agency rather than identity. It requires a public sphere (which is not necessarily democratic) and a morality (on the basis of which we might struggle to judge and democratize it). Such a politics of practice need not necessarily involve the creation of critical communities but it does require the production of spaces of articulation and places of investment.

By making social identity the cornerstone of its political analysis, identity politics has effectively erased affective subjectivity and has no theory of political commitment. In fact, the motivation to struggle can only be derived out of self-interest or charity (the latter is both patronizing and imperialistic). To the extent that such identities are mobile and fractured, the political commitment will itself be temporary and fluid: "Politics here becomes something to be plugged into and pulled out of,"[45] much like a stereo or a designer life-style. This is the dilemma presented by such events as BandAid and by such struggles as that over abortion rights. The very fragmentation of identity becomes a source of disempowerment as struggles multiply and proliferate. According to identity politics, only direct experience can legitimate commitment and any other involvement is suspect. Without a theory of commitment which is somewhat independent of identity, it is impossible to understand the possibilities of active political opposition which transcends any specific identity or local struggle.

This suggests another way of viewing political struggle, one which locates the will to oppose the trajectories of history in the articulation of common affective structures and antagonisms. It does not involve the representation of ideological subjects but the mobilization of affective subjects. It does not have to construct a "we" which purports to represent anyone. Rather, it strategically and provisionally deploys "we" as a floating sign of a common authority and commitment to

speak and to act. Authority, like representation, refers to a certain kind of proxy, but it is a proxy which empowers a position from which peoples' lives can be measured and from which the agents and agencies responsible for maintaining those lives can be challenged. Authority is the mechanism by which control over the places and spaces of everyday life is assigned. The struggle for authority is not merely the struggle to control one's own life but to structure the commitments which fashion everyday life and its relations to the social formation.

The question of commitment returns us to the plane of affective subjectivity and offers an alternative to notions of identity built around people's investment and mattering maps. Hall in fact offers a similar revision in the concept of ethnicity:

> By "ethnicity" we mean the astonishing return to the political agenda of all those points of attachment which give the individual some sense of "place" and position in the world, whether these be in relation to particular communities, localities, territories, languages, religions or cultures.[46]

If ethnicity is defined by commitments, then it becomes possible to organize movements which, at least temporarily, transcend social differences and notions of positive ideological identities in favor of common commitments:

> Political identity often requires the need to make conscious commitments. Thus it may be necessary to momentarily abandon the multiplicity of cultural identities for more simple ones around which political lines have been drawn. You need all the folks together, under one hat, carrying one banner, saying we are this, for the purpose of this fight, we are all the same, just black and just here.[47]

This suggests a different vision of alliance as well although commitments are not always a matter of "free" or conscious choice. Affective maps are themselves historically structured. Political struggles are not necessarily identified with or anchored in particular social identities (although they may be). Rather, struggles are located in terms of the organization of power in the social formation. And while the interests of different groups or the integrity of different struggles can remain in

tact (depending on analyses of their possible articulations), particular struggles or networks of struggles are granted a temporary, strategic priority at specific times and places. Such priorities will depend upon a variety of calculations and analyses (e.g., their immediacy, their consequences, their chances for victory). Rather than arguing about the relative suffering of different groups, such a revised structure of solidarity is committed to a strategic opposition to the existing structures of power based on common affective principles and antagonisms. The problem with this model is that it still sees commitments as tactical rather than strategic, as temporary rather than spatially distributed.

I believe that the success of the new conservative alliance depends precisely on the attempt to construct such sites of authority and commitment for its positions and actions. It creates a cultural hegemony through the articulation of positions from which only the Right is empowered to speak. Insofar as the Left continues to locate people in a context of difference and to valorize the local, it cannot even enter into the struggle. The Right does not have to offer a singular national identity, although at any moment, and in different discourses, such identities are offered as tactical constructions of authority. In fact, rarely does the politics of the Right in the U.S. depend upon offering new subject positions (or even old ones for that matter). The Right's politics is a politics of issues rather than identities, of commitments rather than differences. It focuses on the places in which people are invested and organizes them around sites of power and struggle, often strategically chosen for their already constituted moral authority. (For example, it is hard, albeit not impossible, to be against life or for satanism.)

This strategy, however unconscious and incompletely realized, establishes the Right's claim to political and moral authority as already given in the position from which its spokespersons act and speak. Authority is not constructed from the identity of the actor but from the already invested worthiness of the site. It is an affective and emotional politics in which appeals to identity are at best tactical. After all, if you assume (as the Right often does) that people are intrinsically greedy and selfish, their identities and intentions be-

come irrelevant. If, on the other hand, you assume that people are good and even perfectible, then questions of identity and intentions seem to be quite important. Nor does the Right need to construct unitary identities; its alliances are always and only strategic, defined by people's differential investment in different sites. In this way, the Right has successfully controlled the agenda of political struggle. Not only is the Left forced to respond to those sites which the Right has already selected and charged, but it must address the questions that the Right has posed around these sites (e.g., the collapse of family values, the danger of drugs) and often, in the language (e.g., values, citizenship) that the Right has used.

The Right's politics attempt to redefine the spaces and places of social existence, differentiating them according to their degree of authority, recruiting people to them. Such articulations do not demand that everyone invest in all of these places, nor that people invested in one actively support (or even think about) other places. At the same time, the Right does actively seek to articulate issues into larger structures, even hierarchically organized structures, of commitment: abortion is linked to pornography, which is linked to art, which is linked to taxes. People are positioned within an ever-expanding circular path of affective investment which does not allow for temporary investments. Thus, a movement and an organization become sites of investment in their own right. The Right uses single-issue groups tactically to affectively and institutionally organize specific struggles. But it always places them into the broader context of a range of overlapping antagonisms and an efficiently organized movement, against the backdrop of state and electoral politics. Recruiting people to single-issue groups, it is able to articulate their passion into this broader field by actively working to repress the differences and antagonisms between them. The Right does not recognize the existence of an investment unless it is actively enacted whenever necessary. At the same time, the investment that is demanded is left open, to be defined by each individual's sense of the authority of the struggle: from writing letters to boycotts to civil disobedience to violence. It is the mobilization of commitment that constructs a "we," not as a representable identity or community but

as a collective body, acting with its own authority. For example, it is not surprising that the Right feels "empowered to stop art."[48] Specific agents (like the American Family Association, the Eagle Forum, etc.) strategically locate an active site of struggle and then mobilize people to act out their commitment to the authority of the struggle itself. Authority is not located in the leaders nor in the community, but in the place that has been constructed, through cultural and often intellectual labor, as authoritative.

Often unable to mobilize any comparable demonstration of investment, the Left appears as merely an extremist, antidemocratic "special interest" (e.g., of artists and academics) with no respect for any authority. Nowhere is this demonstrated more clearly than the current epidemic of "political correctness" which is articulated to contemporary fears about education (curriculum), racism and declining labor and university markets (affirmative action), and the meaning of America.[49] The intellectual Left has for the most part seen fit to respond only in the terms of their own crisis, as if it were a question of the accuracy of the Right's representation of its ideas and the Left's power within the academy.[50] If nothing else, this leaves the "liberal" middle ground to the Right as well. Occasionally, someone will point out that the practice of "policing" ideas has a long and continuous history within the Right. But this is not a debate about representing reality or people; it is a strategy within a politics of authority. The Left needs to admit its own complicity in the problem: not only is there a good deal of "political correctness" in the political and the academic Left, but some people have taken extreme, sometimes absurd positions which should be criticized (but not silenced!). Additionally, there are significant problems facing universities (e.g., funding, professionalization, the relation of teaching and research) and public schools (ethnic and cultural diversity, the failure to teach minimal skills, soaring dropout rates) that have to be confronted; and solutions will have to be forged from whatever resources can be found. The Left has to recognize the truth in the Right's accusations: e.g., affirmative action in universities has not solved the problem and has created new ones. But it has to go on to defend the principles behind such practices and actually place the

failure where it belongs (e.g., lack of funds but also lack of faculty involvement and investment in new and appropriate programs which would do the necessary work to enable these students to flourish in the academy). Most importantly, the Left needs to consider why this strategy has been deployed by the Right at this moment, and why it has been so successful, taken up within popular discourses and sentiments. After all, universities are not particularly powerful sites of opposition, so why should the Right bother? Perhaps it is because the Right knows something about the importance of cultural and intellectual production. Perhaps it is because the Right sees it as a powerful way of articulating a number of different affective sites together. Perhaps it is because the Right wants to de-legitimize attacks on its own racism and sexism. Perhaps it is because the university presents one of the last stable sites of authority, a site of stable authority, in the contemporary world. Perhaps it is part of a larger strategy which is not immediately articulated to educational struggles but involves instead a strategic attack on the politicization of culture (in art and intellectual production) in order to redeploy the politics of culture into a depoliticizing formation.

Unless such questions are raised, the battle is lost before it is even entered. While the Left develops strategies which answer to the intellectual's crisis of representation, the Right has responded to the historical crisis of authority. The Left has to move beyond a position which challenges all authority by equating it with authoritarianism. It has to reassert the moral and political authority of specific ideas and visions which can provide the grounds of struggle. Of course, such "assertions" are neither simple nor obvious; they require a great deal of intellectual, political and cultural (and even sometimes economic) labor if they are to reconstruct the sites and vectors of moral and political commitment. And they require a willingness to confront the institutional conditions of possibility for the deployment of authority. The Left needs to reconsider the conditions of possibility of its own discourses and authority as it speaks to an as yet unimagined constituency, albeit one that is often already located within the Left's still unarticulated authority.

POLITICS AS THE ART OF THE POSSIBLE

Too often, the Left conflates morality, ideology and politics, and attempts to derive its "morality" from its political agenda. By morality I mean the system of values and normative commitments on the basis of which one is able to condemn or embrace specific practices, structures and relations and imagine the possibility of better ones. The Right recognizes that it cannot articulate or recruit people into political positions unless it can speak to and rearticulate their sense of morality. Morality cannot be derived from a theory of human nature, nor can it be supplied, after the fact, to a political program. Morality and the possibility of imagining a "better" world (which need not be utopian) has to be articulated out of the concrete relations and feelings of daily life. Without such connections, it will always be difficult, if not impossible, to find the affective lines along which people can be drawn into real political struggles.

But while it is necessary to connect politics to people's moral commitments, it is a serious mistake to confuse political struggle with a demand for moral purity. If politics is the art of the possible and if the Left want to be politically effective, then it must question the basis for its own strategies and decisions. In the first place, it has to articulate its own politics to people's moral and emotional life rather than attacking them. Consider three examples. Recently, friends were accosted when they attempted to bring their families to see the whales in the newly constructed environmental tanks at the Chicago Aquarium. Animal-rights activists succeeded in making them feel guilty, but not in stopping them, nor in winning them over to a different political position. A more effective strategy might be talking to people after they had seen the whales, articulating the powerful emotions produced by such an experience to raise questions about the role of the government in the extermination of the world's whale population. But moral purity appears to outweigh any pragmatic sense of politics.

Nowhere has the failure of the Left been more evident than in the Iraq war, where notions of moral correctness seemed to override

385

any commitment to political intervention. Once again the Left was too worried about motives—whether Bush's or those of the protesters, forgetting that intentions and motives don't make history. The antiwar protest latched on to a simplistic analysis (a war for oil) which left it unable to speak to the majority of the population or even sustain the commitment of its adherents (e.g., by February, attendance at antiwar demonstrations in Los Angeles has fallen to about one-eighth their original number[51]). But this simple agenda was even incapable of creating a single organization or movement: the antiwar movement was born fragmented.

For the sake of its sense of self-righteousness, it morally condemned any feelings of ambivalence:

> These days the only thing more distressing than the mindless euphoria of warmongers and their legions of flag-waving true believers is hearing the "second thoughts" from some members of the Vietnam generation.
> These "second thoughts"—if that is not too strong a term for what in some cases are self-serving excuses to sit this war out—manifest themselves in myth.[52]

Presumably this description of "frumppies (formerly radical upwardly mobile professionals)" included one of the editors of the same journal who, just eight pages later, writes: "In the Persian Gulf, the U.S. is not intervening in a civil war or propping up a European colonial regime but is attempting to prevent the brutal conquest of a small nation by an expansionist power."[53] The antiwar movement demanded ideological purity, even if that meant overlooking the complexities of the event (Iraq did violate the U.N. charter), and the ambivalences that characterized the feelings of many on the Left (e.g., around Israel's possible involvement and the anti-Semitism of segments of the antiwar movement). As a friend put it during the war, many people opposed to the war were more upset by the sight of a bird covered in oil than by the sight, available months before the war, of the Iraqi slaughter of Kurds. But the most regrettable consequence of the moral position of the antiwar movement was that it rendered it strategically ineffective. For the fact of the matter is that there was significant uncertainty about the war, even in the

prowar majority (precisely those second thoughts which said, "I support the war but . . . "). Often support of the war was organized, by the government and the media, around support for the nation (as a defender of moral principles and the underprivileged) and the troops, and had to fight the growing isolationism of the population. These were powerful affective sites and they could have been articulated against the war, although it would have taken strategic planning, work and some compromise.

The third example concerns the romantic populism that often emerges from the moralism of the Left, which lets people off the more difficult challenge of working through the contradictions involved. Nowhere is this more evident than in the celebration which greeted the various anticommunist, antistatist revolutions in the Eastern European nations as popular democratic struggles. There has been far too little popular discussion of the differences among these struggles, or of the fact that often these uprisings depended upon the survival of spaces of traditional civil societies and forms of communication, cooperation and identification within each society. In many cases, these residual spaces, while absolutely necessary, are not entirely progressive and their liberation brought various ethnic and religious hatreds, as well as nationalistic and even fascistic tendencies. Moreover, these uprisings were often not as spontaneous as they appeared in the media, involving internal struggles within the state. On the other hand, the rather anarchic way in which many of these uprising were staged has produced immense problems of governance. In many instances, it has simply opened the floodgate of capitalization, not only giving the native spaces of civil society over to the commodified relations of capitalism, but also condemning many of these nations to the status of third world enclaves within Europe (e.g., the rapidly rising cost of living and unemployment rates in eastern Germany). Finally, the likely integration of some of these nations into a European economic community and the possibility of an impending collapse of the Soviet Union (with declining hostilities between the Eastern and Western blocs) will more than likely worsen the political and economic relations between the "northern" and "southern" hemispheres. It is the realities of such

contradictions that the Left needs to consider, rather than celebrating popular uprisings for their own sake or, for that matter, for the sake of their ability to liberate the Left itself from the stigma of authoritarian communism.

The demand for moral and ideological purity often results in the rejection of any hierarchy or organization. The question—can the master's tools be used to tear down the master's house?—ignores both the contingency of the relation between such tools and the master's power and, even more importantly, the fact that there may be no other tools available. Institutionalization is seen as a repressive impurity within the body politic rather than as a strategic and tactical, even empowering, necessity. It sometimes seems as if every progressive organization is condemned to recapitulate the same arguments and crisis, often leading to their collapse.[54] For example, Minkowitz has described a crisis in Act Up over the need for efficiency and organization, professionalization and even hierarchy,[55] as if these inherently contradicted its commitment to democracy. This is particularly unfortunate since Act Up, whatever its limitations, has proven itself an effective and imaginative political strategist. The problems are obviously magnified with success, as membership, finances and activities grow.

This refusal of efficient operation and the moment of organization is intimately connected with the Left's appropriation and privileging of the local (as the site of democracy and resistance). This is yet another reason why structures of alliance are inadequate, since they often assume that an effective movement can be organized and sustained without such structuring. The Left needs to recognize the necessity of institutionalization[56] and of systems of hierarchy, without falling back into its own authoritarianism. It needs to find reasonably democratic structures of institutionalization, even if they are impure and compromised.

If the Left can give up its demand for purity, it may be able to make the compromises which may be necessary for effective political opposition in the contemporary world. It will act strategically and tactically. For example, it could use contemporary advertising to its own advantage (e.g., when Reagan came out in support of gun

control, or in the "Big Green" campaign in California, where effective advertising could have prepared people for the corporate-sponsored media barage opposing the initiative). Politics is always a strategic matter: one must decide where and how to struggle. It has to be decided when identities, or ideologies or state politics are appropriate and important sites of struggle. And this will sometimes involve the need to compare, evaluate and perhaps even prioritize the demands and claims of particular struggles, based not solely on moral commitments or theoretical reductions (as in alliances of solidarity) but on the exigencies and possibilities of the context. Questions need to be raised about the effective mobilization and deployment of resources, about when different fractions have to come together under a common identity, and when one group should act on behalf of another group's interest, rather than its own immediate interest. Such decisions will have to be based on political calculations of importance and possibility, but also on calculations about how best to mobilize people into the particular struggle and into a broader movement. Sometimes that will mean having to bear defeats in one place, in order to win a victory somewhere else. But at least there will be victories which can be slowly brought together to build a new optimism. But this will require, above all, the proliferation of forums of debate in which any statement can be made and taken seriously, without the threat that "improper" statements condemn the speaker to being dismissed as a moral failure and political outcast. People have to be able to say that a particular battle is not worth it—perhaps because the odds of winning are too small, perhaps because it is likely to alienate too many other fractions, etc.

If it is capitalism that is at stake, our moral opposition to it has to be tempered by the realities of the world and the possibilities of political change. Taking a simple negative relation to it, as if the moral condemnation of the evil of capitalism were sufficient (granting that it does establish grotesque systems of inequality and oppression), is not likely to establish a viable political agenda. First, it is not at all clear what it would mean to overthrow capitalism in the current situation. Unfortunately, despite our desires, "the masses" are not waiting to be led into revolution, and it is not simply a case

of their failure to recognize their own best interests, as if we did. Are we to decide—rather undemocratically, I might add—to overthrow capitalism in spite of their legitimate desires? Second, as much as capitalism is the cause of many of the major threats facing the world, at the moment it may also be one of the few forces of stability, unity and even, within limits, a certain "civility" in the world. The world system is, unfortunately, simply too precarious and the alternative options not all that promising. Finally, the appeal of an as yet unarticulated and even unimagined future, while perhaps powerful as a moral imperative, is simply too weak in the current context to effectively organize people, and too vague to provide any direction. Instead, the Left must think of ways to rearticulate capitalism without either giving up the critique or naively assuming that it can create a capitalism "with a human heart." Leaving such images to Hollywood, the Left can organize to change specific axiomatics of capitalism in particular local, regional, national and global contexts. For example, there is good evidence that the ways in which contemporary American corporations have chosen to deal with labor are not necessarily the most effective in terms of capital productivity itself. This does not entail simply championing unions as they have existed, but restructuring unions to meet the new demands of a changing labor force, and to work within the new systems of global capitalism. We can recognize and argue that the rich are no longer primarily entrepreneurs being rewarded for taking risks, but managers (CEOs) and financial manipulators, even criminals of various sorts. The expansion of capital as a social utility has given way to its immediate private appropriation, with little reinvestment into capitalism's future. It therefore seems reasonable to limit the ability to privately appropriate wealth. In this context, we might argue for guaranteed minimum and maximum incomes, linking such arguments to notions of the value of human life. We might propose to limit investors' abilities to reap short-term profits by any number of means, including linking executives' salaries to capital gains and investments rather than profits.

But this would mean that the Left could not remain outside the systems of governance. It has sometimes to work with, against and within bureaucratic systems of governance.[57] Consider the case of

Amnesty International, an immensely effective organization when its major strategy was (similar to that of the Right) exerting pressure directly on the bureaucracies of specific governments. In recent years (marked by the recent rock tour), it has apparently redirected its energy and resources, seeking new members (who may not be committed to actually doing anything; membership becomes little more than a statement of ideological support for a position that few are likely to oppose) and public visibility.[58] In stark contrast, the most effective struggle on the Left in recent times has been the dramatic (and, one hopes, continuing) dismantling of apartheid in South Africa. It was accomplished by mobilizing popular pressure on the institutions and bureaucracies of economic and governmental institutions, and it depended upon a highly sophisticated organizational structure. The Left too often thinks that it can end racism and sexism and classism by changing people's attitudes and everyday practices (e.g., the 1990 Black boycott of Korean stores in New York). Unfortunately, while such struggles may be extremely visible, they are often less effective than attempts to move the institutions (e.g., banks, taxing structures, distributors) which have put the economic relations of Black and immigrant populations in place and which condition people's everyday practices.

The Left needs institutions which can operate within the systems of governance, understanding that such institutions are the mediating structures by which power is actively realized. It is often by directing opposition against specific institutions that power can be challenged. The Left has assumed for some time now that, since it has so little access to the apparatuses of agency, its only alternative is to seek a public voice in the media through tactical protests. The Left does in fact need more visibility, but it also needs greater access to the entire range of apparatuses of decision making and power. Otherwise, the Left has nothing but its own self-righteousness. It is not individuals who have produced starvation and the other social disgraces of our world, although it is individuals who must take responsibility for eliminating them. But to do so, they must act within organizations, and within the systems of organizations which in fact have the capacity (as well as the moral responsibility) to fight them.

Without such organizations, the only models of political commitment are self-interest and charity. Charity suggests that we act on behalf of others who cannot act on their own behalf. But we are all precariously caught in the circuits of global capitalism, and everyone's position is increasingly precarious and uncertain. It will not take much to change the position of any individual in the United States, as the experience of many of the homeless, the elderly and the "fallen" middle class demonstrates. Nor are there any guarantees about the future of any single nation. We can imagine ourselves involved in a politics where acting for another is always acting for oneself as well, a politics in which everyone struggles with the resources they have to make their lives (and the world) better, since the two are so intimately tied together! For example, we need to think of affirmation action as in everyone's best interests, because of the possibilities it opens. We need to think with what Axelos has described as a "planetary thought" which "would be a coherent thought—but not a rationalizing and 'rationalist' inflection; it would be a fragmentary thought of the open totality—for what we can grasp are fragments unveiled on the horizon of the totality.[59]

Such a politics will not begin by distinguishing between the local and the global (and certainly not by valorizing one over the other) for the ways in which the former are incorporated into the latter preclude the luxury of such choices. Resistance is always a local struggle, even when (as in parts of the ecology movement) it is imagined to connect into its global structures of articulation: Think globally, act locally. Opposition is predicated precisely on locating the points of articulation between them, the points at which the global becomes local, and the local opens up onto the global. Since the meaning of these terms has to be understood in the context of any particular struggle, one is always acting both globally and locally: Think globally, act appropriately! Fight locally because that is the scene of action, but aim for the global because that is the scene of agency. "Local struggles directly target national and international axioms, at the precise point of their insertion into the field of immanence."[60]

This requires the imagination and construction of forms of unity,

commonality and social agency which do not deny differences. Without such commonality, politics is too easily reduced to a question of individual rights (i.e., in the terms of classical utility theory); difference ends up "trumping" politics, bringing it to an end.[61] The struggle against the disciplined mobilization of everyday life can only be built on affective commonalities, a shared "responsible yearning: a yearning out towards something more and something better than this and this place now."[62] The Left, after all, is defined by its common commitment to principles of justice, equality and democracy (although these might conflict) in economic, political and cultural life. It is based on the hope, perhaps even the illusion, that such things are possible. The construction of an affective commonality attempts to mobilize people in a common struggle, despite the fact that they have no common identity or character, recognizing that they are the only force capable of providing a new historical and oppositional agency. It strives to organize minorities into a new majority.

This requires finding ways of getting people to care again: to care about the potential ecological, political and economic disasters facing the world; to care about the structures of inequality which maintain some people in luxury and condemn others to poverty, starvation and death; to care about the attacks on people's freedom and equality, especially within a nation which claims to cherish these values; and to care about the feeling that any viable relationship between affect, desire and ideology in our lives has collapsed (even if we admit that the existence of such a relationship was only imagined). This does not require a spiritual transcendence or selflessness. "Others need the immortality of the soul, need gods and angels. We need to feel ourselves possessed by the demons that make us leave ourselves a little in order to try to love, to understand and to act on human history."[63] It does require strategic campaigns, aimed at creating something beyond a local commitment. It requires using the cultural logics and media that already connect to people's lives to articulate interconnected antagonisms to the present and a common commitment to the future. (Is this what we want to leave our children? Is this how we want to be remembered? Could this happen to us?) If

people want to feel good, then such desires can be inflected into a progressive agenda.

Perhaps the Left needs to be less suspicious of the media's power to construct charismatic leaders who can call forth and mobilize those affectively charged places that will pull people out of their everyday lives and propel them back into the social and political realm where the real struggles of power are taking place. I do not mean to suggest that a single passionate leader, or any number for that matter, will suffice. If people are to change history, it is their passions that must be awakened, for the crisis of the Left is not ideological. It is a matter of people's affective involvement, of the intensity people are willing to invest in their political beliefs and struggles, and of the vectors which increasingly discipline and regulate their everyday lives. These affective relations are not determined solely by their location within a system of discursive differences or by their position within society. They are actively made and remade, and they now have to be unmade if the Left is to successfully struggle to make the history that it desires. Those of us "on the left" have to find tactical ways of resisting and even breaking out of the disciplined mobiliziation of everyday life, to reenter the strategic politics of the social formation: "Hitler got the fascists sexually aroused. Flags, nations, armies, banks get a lot of people aroused. A revolutionary machine is nothing if it does not acquire at least as much force as those coercive machines have for producing breaks [places] and mobilizing flows [affect]."[64] I have tried to describe some of the ways this has been produced, but I have no answers for its demolition.

It will require locating sites of affective investment. Without the luxury of an innocent beginning, such a project has to acknowledge the already existing sites of people's investments, the structures of their mattering maps. It can struggle to reshape and rearticulate them, but it has to think twice before rejecting them entirely. For example, too often, attacks on "America"—on the nation and nationalism—ignore the simple fact that many people cannot imagine living elsewhere, and certainly not anywhere better. It is particularly ironic if one considers that popular culture often represents the nation in terms quite compatible with the ideological commitments

of the Left (e.g., Walt Disney's *Johnny Tremain*). But it will also require constructing vectors which are able to link these sites into a movement, perhaps even into a range of organizations.

In fact, it is often the case that such sites and vectors are mapped in popular culture in such a way that politics is not immediately at stake. If one of the challenges facing the Left is to construct new sources of hope and affective commonality, perhaps it should return to the possibilities of the rock formation and of postmodern culture. There it will face a paradox: how can a popular culture which is increasingly committed to the impossibility of commitments become the source of new oppositional commitments? How can a popular culture which is increasingly fragmented enable new structures of commonality? How can a popular culture which is increasingly contaminated by its own cynicism offer new maps of hope and possibility? It is finally the power of the rock formation to answer these impossible questions that has made it such a strategic site of struggle in the contemporary world. Its different strategies can be placed in the service of the new conservatism, providing at least a part of the context and resources for its hegemonic project. Yet the complexity of the Right's attacks on rock make two things clear: first, that each of them is potentially a point sign from which lines of flight can be reconstructed, lines which might breach the wall which they themselves have helped build around everyday life. Second, that the power of such popular practices depends on the mobility of the investments which they call forth. Every fan is something of a fanatic whose investments cannot easily be disciplined; it is not coincidental that the attacks on rock are often directed at just those forms where fans become fanatics. If it is still within the power of the rock formation to construct mattering maps, to redefine the configuration of places and spaces of everyday life, then this territorializing power must be policed (by the Right) and recharged and rearticulated by the Left.

After all, "hope cannot be said to exist, nor can it be said not to exist. It is just like roads across the earth. For actually, the earth had not roads to begin with, but when many people pass one way, a road is made."[65] It is precisely the ability of the rock formation to make

roads over which millions have passed and will pass, its power to locate people in an affective structure of hope, that makes it dangerous for the Right and an important resource for the Left. But as both fans and critics, we must find ways of challenging the complacency of the rock formation, of pushing it beyond everyday life and reinvigorating its possibilities.

Above all, rethinking the possibility of a Left politics will require a new model of intellectual and political authority which does not begin by confidently judging every investment, every practice, every articulation and every individual. It will have to measure both intellectual and political progress by movement within the fragile and contradictory realities of people's lives, desires, fears and commitments, and not by some idealized utopia nor by its own theoretical criteria. It will offer a moral and progressive politics which refuses to "police" everyday life and to define a structure of "proper" and appropriate behaviors and attitudes. An impure politics—certainly, without the myth of a perfect reflexivity which can guarantee its authority (for authority is not an intellectual prize). A contaminated politics, never innocent, rooted in the organization of distance and densities through which all of us move together and apart, sometimes hesitatingly, at other times recklessly. A politics that attempts to move people, perhaps just a little at first, in a different direction. But a politics nonetheless, one which speaks with a certain authority, as limited and frail as the lives of those who speak it. It will have to be a politics articulated by and for people who are inevitably implicated in the contemporary crisis of authority and whose lives have been shaped by it. A politics for and by people who live in the contemporary world of popular tastes, and who are caught in the disciplined mobilization of everyday life. A politics for people who are never innocent and whose hopes are always partly defined by the very powers and inequalities they oppose. A modest politics that struggles to effect real change, that enters into the often boring challenges of strategy and compromise. An impure politics fighting for high stakes.

GLOSSARY TO PART I

Affect: the energy invested in particular sites: a description of how and how much we care about them. Affect is often described as will, mood, passion, attention, etc.

Affective alliance: a particular segment or articulation of a cultural formation; a configuration of texts, practices and people. For example: a rock alliance will include a variety of musics, images of style, forms of behavior and talk, styles of dance, drugs, fans, etc.

Agency: the actual forces producing the larger structures of articulation; the long-term forces which struggle to determine the direction and shape of history. For example: nationalism, capitalism.

Agent: the actors, institutions and groups which act to change or direct history consistent with the interests of particular agencies, although this may not be intentional. For example: various regulatory agencies, the media, the New Right.

Apparatus: alliances which actively function to produce structures of power. Sometimes described as machines of power.

Articulation: the practice of linking together elements which have no necessary relation to each other; the theoretical and historical practice by which the particular structure of relationships which defines any society is made. For example: while there is no obvious reason why a particular hair color is tied to a particular level of intelligence, the notion of the "dumb blonde" was a particular powerful articulation for many decades.

Conjuncture: the specific context of an analysis. Conjunctural analysis emphasizes the contextuality of any description. For example: this study is about contemporary U.S. society which is, on the one hand, a specific context and, on the other hand, a rather abstract notion (since it ignores many important differences of region, class, etc., within U.S. society).

Difference (differentiating machine): a particular structure of power organized by the construction of a system of binary difference (man/woman,

397

Black/white, old/young). People's identities are shaped through processes of identification with one or the other term. One term is almost always privileged as the "normal" and dominant.

Disciplined mobilization: a situation in which a particular structure of territorialization is established in which every moment of stability is dissolved, leaving only paths of constant mobility. For example: consider the shuttling of people through Disneyland, or the sense of difficulty navigating through certain "postmodern" buildings.

Discourse: the material existence of cultural and linguistic practices; used to stress the fact that such practices have a wide range of effects beyond producing meaning.

Effect (effectivity): every practice transforms the world in some way. But there are many different dimensions which can be changed: physical, economic, cognitive, semantic, affective, desire, etc. Effectivity describes the particular domains and range of the effects of any practice.

Formation: a configuration of practices that form a particular structure of unity which transcends any single group's relation to the practices. The configuration allows certain practices to exist and to have power within its boundaries. For example: the broad notion of a rock culture.

Ideology: the maps of meaning which are taken to represent reality; the systems of interpretation which determine how we experience the world. People live as much within their ideological maps as within the "real" world.

Lines of flight: vectors of effectivity which disrupt and escape any particular structure of power.

Mattering map: a socially determined structure of affect which defines the things that do and can matter to those living within the map.

Meaning: used narrowly here to define the semantic content or message of any text or cultural practice.

Popular culture: cultural practices and formations whose primary effects are affective.

Sensibility (empowerment): a logic of articulation which governs a specific formation or alliance. It defines what sorts of effects the formation produces and what sorts of activities and attitudes people within the alliance can undertake. For example: the general sensibility of "high culture" is cognitive, resulting in the fact that we always attempt to find its "significance," while the general sensibility of popular culture is more affective and emotional.

Subject: the identities of individuals defined by the positions they are allowed to occupy within the various cultural maps of a society. Ideological subjects are positions from which individuals may experience a meaningful world; affective subjects are positions from which individuals can organize their investments in the world.

Territorialization (structured mobility, territorializing machine): the or-

ganization of daily life into places and spaces, moments of stability (identity, activities) and mobility (lines connecting the various places). When the territorialization of daily life becomes something that is struggled over for the sake of establishing hegemony in the society, it is a structured mobility.

NOTES

INTRODUCTION: THEORY, POLITICS AND PASSION

1. See L. Grossberg, "I'd Rather Feel Bad Than Not Feel Anything at All [Rock and Roll: Pleasure and Power]," *Enclitic*, 1984, vol. 8, pp. 94–111. Also S. Hall, "Notes on Deconstructing 'the Popular,' " in R. Samuel (ed.), *People's History and Socialist Theory*, London, Routledge and Kegan Paul, pp. 227–40; A. McRobbie, *Feminism and Youth Culture*, London, Macmillan, 1991; J. Fiske, *Understanding Popular Culture*, Boston, Unwin Hyman, 1989.

2. See T. Modleski (ed.), *Studies in Entertainment: Critical Approaches to Mass Culture*, Bloomington, Indiana University Press, 1986; and M. Budd et al., "The Affirmative Character of U.S. Cultural Studies," *Critical Studies in Mass Communication*, 1990, vol. 7, pp. 169–84.

3. I use "American" with apologies, since there is no other adjective for the United States. For an analysis of the devastating consequences of this transformation, see P. Mattera, *Prosperity Lost*, Reading, Addison-Wesley, 1990. For an earlier effort to describe this transformation, see L. Grossberg, *It's a Sin: Essays on Postmodernism, Politics and Culture*, Sydney, Power Publications, 1988.

4. See L. Grossberg, "Teaching the Popular," in C. Nelson (ed.), *Theory in the Classroom*, Urbana, University of Illinois Press, 1986, pp. 177–200.

5. L. Grossberg, "Rock Resistance and the Resistance to Rock," in T. Bennett (ed.), *Rock Music: Politics and Policy*, Brisbane, Institute for Cultural Policy Studies, 1989, pp. 29–42.

6. "Daily life" refers to the socially organized material pattern and events of people's existence. I use it, rather than "experience," to avoid assuming the centrality of the experiencing subject.

7. A. Bloom, *The Closing of the American Mind*, New York, Simon and Schuster, 1987, pp. 74–75.

8. G. Greenwald, *Rock a Bye Bye Baby* (audio tape), The Eagle's Nest, n.d.

9. See E. F. Brown and W. R. Hendee, "Adolescents and Their Music," *Journal of the American Medical Association*, 1989, vol. 262, pp. 1659–63.

10. All quotes taken from T. Gore, letter, Parents' Music Resource Center, n.d.

11. *Rock and Roll Confidential*, July 1990, no. 80, p. 1.

12. *Rock and Roll Confidential*, June 1991, no. 89, p. 1, points out that only 14 months after the deal was struck, 13 states introduced mandatory labeling bills in 1991, in clear violation of the agreement.

13. *You've Got a Right to Rock: Don't Let Them Take It Away*, by the editors of *Rock and Roll Confidential* (3d ed., 1991) is available from Box 341305, Los Angeles, CA 90034.

14. T. Carson, "What We Do Is Secret: Your Guide to the Post-Whatever, *Village Voice Rock and Roll Quarterly*, Fall 1988, p. 24.

15. See L. Martin and K. Segrave, *Anti-Rock: The Opposition to Rock 'n' Roll*, Hamden, CT, Anchon, 1988.

16. I use "new conservatism" to describe a popular political sensibility in daily life; it refers to the growing saliency and popularity of certain conservative positions among broad segments of the population. Such conservative positions include the growing acceptance of economic and political inequalities and of structures of local discrimination against various (but not all) subordinated groups, the attempt to impose minority-held moralities on society, the reduction of equality to the possibilities of economic competition, the rejection of freedoms in the name of social values, and the marginalization of radical oppositional groups and alternatives. The "new conservative alliance" refers to an amorphous and largely unorganized collection of the various political and economic agents, organizations and movements that actively (although not always publicly) support the new conservatism, work for its victory and attempt to ensure that its success will be translated into governmental policy. While the new conservative alliance includes many fractions of the Republican party, neofascist paramilitary organizations and many procapitalist groups, the New Right refers to a narrower and more explicit alliance between particular groups that had been largely marginalized even within the Republican party before Reagan's presidency. Their political platform is often but not always based on a series of moral appeals to particular "American" values.

17. From one angle, the attacks on rock can be seen as just another token of the cultural panic and paranoia which has greeted, not merely postwar popular culture, but popular cultures throughout the centuries. By emphasizing the fact that popular culture is simultaneously attacked and desired, some critics are able to treat it as an enduring domain of existence outside of, or opposed to, dominant structures of power. See P. Stallybrass and A. White, *The Politics and Poetics of Transgression*, London, Methuen, 1986.

18. R. Goldstein, "Swept Away: In the Wake of Bush," *Village Voice*, January 10, 1990, p. 23.

19. The quote is from Marx but has recently been popularized in M.

Berman, *All That Is Solid Melts into Air: The Experience of Modernity*, New York, Simon and Schuster, 1982.

20. A. Gramsci, *Selections from the Prison Notebooks*, trans. Q. Hoare and G. Nowell Smith, New York, International Publishers, 1971, p. 331.

21. "Physicians Losing Interest in Abortion, Report Claims," *Daily Illini*, Champaign-Urbana, May 1, 1991, p. 4.

22. Alan Wolfe, "Politics By Other Means," *The New Republic*, November 11, 1991, pp. 39 and 40.

23. My own view of cultural studies depends heavily on the ideas of Stuart Hall. For discussions of cultural studies, see: S. Hall, "Cultural Studies and the Centre: Some Problematics and Problems," in S. Hall et al. (eds.), *Culture, Media, Language*, London, Hutchinson, 1980, pp. 15–47; S. Hall, "Cultural Studies and Its Legacies" in L. Grossberg et al. (eds.), *Cultural Studies*, New York, Routledge, 1991, pp. 277–286; S. Hall, "The Emergence of Cultural Studies and the Crisis of the Humanities," *October*, 1990, no. 53, pp. 11–23; R. Johnson, "What Is Cultural Studies Anyway?," *Social Text*, 1986/87, pp. 38–80; L. Grossberg, "The Formation(s) of Cultural Studies," *Strategies*, 1989, no. 2, pp. 114–49; L. Grossberg, "The Circulation of Cultural Studies," *Critical Studies in Mass Communication*, 1989, vol. 6, pp. 413–21; Patrick Brantlinger, *Crusoe's Footprints: Cultural Studies in Britain and America*, New York, Routledge, 1990; Cary Nelson et al., Introduction to L. Grossberg et al. (eds.), *Cultural Studies*; and G. Turner, *British Cultural Studies: An Introduction*, Boston, Unwin Hyman, 1990.

24. There are particular reasons why cultural studies found a home in communications (and secondarily in education) in the U.S. First, it depended on a particular reading of cultural studies as a literary-based alternative to the existing work on mass communications. Second, there was an indigenous tradition in the work of the Chicago School of Social Thought and John Dewey in particular. Third, normative concerns with culture, the assumption that culture mattered in the life of society, had been largely marginalized in literary studies (by new criticism) and in anthropology and sociology (under pressure to be scientific). The field of communication was partly born out of and into the midst of the mass culture debates (a continuation of the mass society debates which had earlier given rise to other disciplines of the human sciences) and hence could not escape the question of culture's normative weight. Finally, these debates were caught between the pessimism of the Frankfurt School and the optimism of American liberals. Communication could not escape the tension or its own ambivalence. Interestingly, the recent incorporation of cultural studies into literary studies has often meant a turn to theory, to theories which do not sanction interpretation (e.g., Foucault) or to non-literary and popular cultural texts. Rarely has it opened up discussions about the difficulties of doing cultural studies of "canonical literature," where the relation between the context and the critic's reading becomes difficult to identify.

25. The situation varies in each country. Australia, for example, has a

longer history both of a "native" cultural studies tradition and of a serious engagement with British cultural studies.

26. Many of those now describing their work as cultural studies were attacking cultural studies only a few years ago although they have not changed their project in the interim. Many of those who now appropriate the term want to read only very selectively in the tradition. While I do not believe that one has to read everything, it is helpful to read enough to orient oneself. Ironically, many of these critics would be quite upset if someone were to read their own theoretical sources (e.g., Lacan) as superficially as they read in cultural studies. And even more ironically, they are often the very critics who refuse to allow that people may read popular culture in a similar way.

27. Histories of British cultural studies often paper over significant differences, e.g., within the "subcultural" studies: cf. S. Hall and T. Jefferson (eds.), *Resistance through Rituals: Youth Subcultures in Post-war Britain*, London, Hutchinson, 1976, and D. Hebdige, *Subculture: The Meaning of Style*, London, Methuen, 1979. They also overlook counterexamples to the master narrative that has already been constructed; e.g., the first collective project undertaken at the Centre for Contemporary Cultural Studies at the end of the 1960s was a study of women's magazines, and in particular a short story called "Cure for Marriage." The Centre also embraced a variety of forms of collective and individual work (often determined partly by people's part-time work and commuting schedules) and of political interventions (e.g., involvement in policy debates, monitoring media, etc.).

28. After all, everyone has a different political and intellectual biography. My own intellectual development led me from science into philosophy and history (Hayden White, Loren Baritz) to British cultural studies at a reasonably early moment in its development (Richard Hoggart and Stuart Hall) to American cultural studies (James Carey) to phenomenology and hermeneutics (Paul Ricoeur) to Gramsci and Foucault (basically skipping the so-called Althusserian moment).

29. For example, in England, there was *Working Papers in Cultural Studies, Screen Education, I & C* and *Feminist Review*; in Australia, *Art and Text* and the Local Consumption Press, as well as the *Australian Journal of Cultural Studies*. The apparent unity of cultural studies has to be imagined, constructed and imposed and therefore also deconstructed and opposed. We need to examine how the appearance of orthodoxy or homogeneity is deployed in ways that position cultural studies both intellectually and politically.

30. G. Spivak, "The Making of Americans, the Teaching of English, and the Future of Culture Studies," *New Literary History*, 1990, vol. 21, pp. 781–98.

31. C. West, cited in J. Pfister, "The Americanization of Cultural Studies," *The Yale Journal of Criticism*," 1991, vol. 4, p. 204. The question of ethics here suggests that cultural studies might fruitfully turn to the work of Spinoza and Schopenhauer.

32. A. Gramsci, cited in S. Hall, "Cultural Studies and its Theoretical Legacies," in L. Grossberg et al. (eds.), *Cultural Studies*.

33. As we shall see later, this is because it is articulated to the popular.

34. Increasingly, what is passing for cultural studies in the U.S. is simply too easy. The two most common examples are literary deconstructionism and various studies of popular culture which forget what is at stake. In fact, British cultural studies was formed by a series of engagements and rearticulations of works from other national formations (largely French). Such serious engagement and rearticulation is unfortunately not evidenced in much of the American appropriations of cultural studies.

35. P. Patton, "Notes for a Glossary," *I & C*, 1981, no. 8, p. 47.

36. This is not to say that intellectual activity, even politically motivated and directed work, is a form of, or substitutable for, political activity. In certain instances, intellectuals may be involved qua intellectuals in a political movement. Still, it may be the case that intellectual work is vital to political change. See the debate over the role of cultural criticism in the battle against AIDS: D. Harris, "AIDS and Theory," *Lingua Franca*, June 1991, pp. 16–19. Also E. Michaels, *Unbecoming: An AIDS Diary*, Rose Bay (Australia), Empress, 1990.

37. For example, the enormous guilt that has been constructed around the reality of the death of people with AIDS: see J. Z. Grover, "AIDS, Keywords, and Cultural Work," in L. Grossberg et al. (eds.), *Cultural Studies*.

38. Hall, "Cultural Studies and Its Legacies."

39. Too often interdisciplinarity is taken to mean: (1) you do basically what you were doing but with a few theoretical references from another discipline; or (2) you do basically what you were doing but add some allusions to the context taken from another discipline. Cultural studies' interdisciplinarity is an aggressive counterdisciplinary logic.

40. R. Williams, *The Long Revolution*, London, Chatto and Windus, 1961, and *The Country and the City*, London, Oxford University Press, 1973.

41. J. W. Carey, *Communication as Culture*, Boston, Unwin Hyman, 1989.

42. See, e.g., the work in *Public Culture* and *Diaspora*. For an elaboration of this argument, see Cary Nelson et al., Introduction to L. Grossberg et al. (eds.), *Cultural Studies*.

43. Williams, *Culture and Society 1780/1950*, New York, Columbia University Press, 1958, p. 295.

44. See R. Hoggart, *The Uses of Literacy*, New York, Oxford University Press, 1970 (orig. 1957).

45. In its own way, the "post–colonialist" critique of History replaces one totality (Europe as the scene of History) with another (the postcolonial scene). Postcolonialism can be nothing more than a convenient term to mark the variety of ways in which nations have incorporated and dominated other populations and cultures. (See K. Tololyan, "The Nation-State and

its Others," *Diaspora*, 1991, vol. 1, pp. 3–7.) We have to recognize the history and diversity of such relations: colonial populations which the colonizers define as "Others even as it constitutes them, for purposes of administration and the expansion of markets, into programmed near-images of the very sovereign self" such as India (G. Spivak, cited in R. Young, *White Mythologies: Writing History and the West*, London, Routledge, 1990, p. 17); settler colonies such as the United States, Canada and Australia; genocide and Apartheid (through spatial compression—reservations—and imprisonment: e.g., native populations in most settler colonies); homeless populations dispersed as ethnic, religious or racial enclaves within national formations (e.g., Kurds, Palestinians); and the variety of "voluntary" and forced diasporas (e.g., expatriates, slave trade, guest workers, forced exiles, and emigrant communities).

46. R. Williams, *Culture and Society 1780/1950*. (Stuart Hall, personal communication).

47. See G. Viswanathan, "Raymond Williams and British Colonialism," *The Yale Journal of Criticism*, 1991, vol. 4, pp. 47–66.

48. Dipesh Chakrabarty, personal communication.

49. For example, we might consider the relation between the concept of culture and racism/slavery in various post–Civil War Southern writing. Also, we need to explore the erased history of writings on culture that have come out of the Afro–American diaspora. See, e.g., J. B. Childs, *Leadership, Conflict, and Cooperation in Afro-American Social Thought*, Philadelphia, Temple University Press, 1989. My thanks to Herman Gray for raising this question. We also need to avoid the arrogance of assuming that "culture" is a category invented by Europe.

50. See I. Hunter, *Culture and Government: The Emergence of Literary Education*, London, Macmillan, 1988; and C. Steedman, *Childhood, Culture and Class in Britain: Margaret McMillan, 1860–1931*, New Brunswick, Rutgers University Press, 1990.

51. This work is already ongoing in a variety of discourses in and around cultural studies. I do not mean to suggest that these issues are only relevant to the project of articulating cultural studies into America.

52. R. Young, *White Mythologies*, p. 14.

53. Ibid., p. 3.

54. Ibid., p. 13.

55. R. Barthes, *The Empire of Signs*, New York, Hill and Wang, 1982.

56. J. Baudrillard, *America*, London, Verso, 1988.

57. R. Young, *White Mythologies*, p. 15.

58. This sense of spatial identity began with some of the first colonizers, the Puritans, who saw their new home as an-other space, the new Eden. The constitutional debates recorded in *The Federalist Papers* focus on the attempt to define the new nation in terms of distances traveled. And John Dewey, that most American of American philosophers, defined community in terms of proximity—face to face relations—rather than traditional and knowable communities. For an interesting discussion of space and time,

see D. N. Parkes and N. Thrift, "Timing Space and Spacing Time," *Environment and Planning*, 1975, vol. 7, pp. 651–70.

59. Tony Bennett, "Culture: Theory and Policy," *Culture and Policy*, vol. 1, 1989, pp. 5–8. Such a spatial logic of power should not be seen as the binary opposite of temporal logics but as the result of a rhizomatic critique of "modern" thought in which one subtracts temporality as a transcendental term.

60. C. Gordon, "The Subtracting Machine," *I & C*, 1981, no. 8, p. 36.

CHAPTER ONE: ARTICULATION AND CULTURE

1. Compare S. Hall, "Encoding/Decoding," in S. Hall et al. (eds.). *Culture, Media, Language*, London, Hutchinson, 1980, pp. 128–38, and D. Morley, *The Nationwide Audience: Structure and Decoding*, London, British Film Institute, 1980.

2. See, for example, P. Smith, *Discerning the Subject*, Minneapolis, University of Minnesota Press, 1988.

3. See S. Hall, "Religious Ideologies and Social Movements in Jamaica," in R. Bocock and K. Thompson (eds.), *Religion and Ideology*, Manchester, Manchester University Press, 1985, pp. 269–96.

4. See L. Grossberg, "Ideology of Communication: Post-structuralism and the Limits of Communication," *Man and World*, 1982, vol. 15, pp. 83–101.

5. E.g., John Fiske, *Reading the Popular*, Boston, Unwin Hyman, 1989.

6. S. Hall, "Signification, Ideology and Representation: Althusser and the Post-Structuralist Debates," *Critical Studies in Mass Communication*, 1985, vol. 2, pp. 91–114; and "The Problem of Ideology: Marxism without Guarantees," in B. Matthews (ed.), *Marx: A Hundred Years On*, London, Lawrence and Wishart, 1983, pp. 57–86, For another view of ideology, see W. F. Haug, *Commodity Aesthetics, Ideology and Culture*, New York, International General, 1987.

7. See D. Adlam et al., "Psychology, Ideology and the Human Subject," *Ideology and Consciousness*, 1977, no. 1, pp. 5–56; and "Debate" with Stuart Hall and the Editorial Collective, *Ideology and Consciousness*, 1978, no. 3, pp. 113–27. Also C. Geertz, *The Interpretation of Cultures*, New York, Basic Books, 1973.

8. M. Foucault, *The Birth of the Clinic: An Archaeology of Medical Perception*, trans. A. M. Sheridan Smith, New York, Pantheon, 1973, p. xvi.

9. See E. Laclau and C. Mouffe, *Hegemony and Socialist Strategy: Towards a Radical Democratic Politics*, London, Verso, 1985; and E. Rooney, "Discipline and Vanish: Feminism, the Resistance to Theory, and the Politics of Cultural Studies, *Differences*, 1990, vol. 2, pp. 14–27.

10. S. Hall, "New Ethnicities," *Black Film, British Cinema*, ICA Documents 7, London, ICA, 1988, p. 27.

11. G. Lukacs, *History and Class Consciousness*, trans. R. Livingstone, Cambridge, MIT Press, 1971, p. 111.

12. F. Guattari, "A Liberation of Desire," in G. Stambolian and E. Marks (eds.), *Homosexualities and French Literature*, Ithaca, Cornell University Press, 1979, p. 65.

13. M. Foucault, "Politics and the Study of Discourse," *Ideology and Consciousness*, 1978, no. 4, p. 15.

14. M. Foucault, *The Archaeology of Knowledge*, trans. A. M. Sheridan Smith, New York, Pantheon, 1972, p. 27.

15. Ibid.

16. M. Foucault, "Truth and Power," in M. Morris and P. Patton (eds.), *Michel Foucault: Power, Truth, Strategy*, Sydney, Feral Publications, 1979, p. 33.

17. G. Deleuze and F. Guattari, *Anti-Oedipus: Capitalism and Schizophrenia*, trans. R. Hurley, M. Seem and H. R. Lane, New York, Viking Press, 1977, pp. 111–12.

18. See M. Foucault, *The Archaeology of Knowledge*.

19. G. Deleuze and F. Guattari, *A Thousand Plateaus: Capitalism and Schizophrenia*, trans. B. Massumi, Minneapolis, University of Minnesota Press, 1987, p. 380.

20. See P. Bourdieu, *Distinction: A Social Critique of the Judgment of Taste*, trans. R. Nice, Cambridge, Harvard University Press, 1984.

21. Even as early a work in the history of British cultural studies as S. Hall and T. Jefferson, (eds.), *Resistance through Rituals: Youth Subcultures in Post-war Britain*, London, Hutchinson, 1976, recognizes the diverse possibilities of cultural effects.

22. It is important to realize that anti-essentialism is not the same as social constructionism. Although any anti-essentialist position is likely to embrace social constructionism, not all social constructionist positions are anti-essentialist (e.g., various phenomenological or pragmatist versions).

23. M. Foucault, *The Archaeology of Knowledge*, p. 17.

24. Ibid., p. 80.

25. See E. Laclau, *Politics and Ideology in Marxist Theory*, London, Verso, 1977; and S. Hall, "On Postmodernism and Articulation: An Interview," *Journal of Communication Inquiry*, 1986, vol. 10, pp. 45–60.

26. M. Foucault, "Interview with Lucette Finas," in M. Morris and P. Patton (eds.), *Michel Foucault: Power, Truth, Strategy*, Sydney, Feral Publications, pp. 74–75.

27. G. Deleuze and F. Guattari, "Rhizome," *Ideology and Consciousness*, 1981, no. 8, pp. 49–71.

28. See S. Hall, "Marx's Notes on Method: A 'Reading' of the '1857 Introduction,' " *Working Papers in Cultural Studies*, 1974, no. 6, pp. 132–71.

29. See K. Marx, *Grundrisse*, trans. M. Nicolaus, New York, Vintage, 1973.

30. S. Hall, "Psychoanalysis and Cultural Studies," forthcoming.

31. R. Williams, *The Long Revolution*, New York, Columbia University Press, 1961.

32. M. Foucault, "Questions of Method: An Interview," *Ideology and Consciousness*, 1981, no. 8, p. 11.

33. D. Hebdige, "Towards a Cartography of Taste 1935–1962," *Block*, 1981, no. 4, pp. 39–56; and "Digging for Britain: An Excavation in 7 Parts," in *The British Edge*, Boston, Institute of Contemporary Arts, 1987, pp. 35–69.

CHAPTER TWO: MAPPING POPULAR CULTURE

1. M. Foucault, *The Archaeology of Knowledge*, trans. A. M. Sheridan Smith, New York, Pantheon, 1972, p. 74.

2. P. Bourdieu, *Distinction: A Social Critique of the Judgment of Taste*, trans. R. Nice, Cambridge, Harvard University Press, 1984. Raymond Williams describes the structure of feeling as follows:

> This was the area of interaction between the official consciousness of an epoch—codified in its doctrines and legislations—and the whole process of actually living its consequences . . . it was a structure . . . yet it was one of feeling much more than of thought—a pattern of impulses, restraints, tones . . .
>
> The peculiar location of a structure of feeling is the endless comparison that must occur in the process of consciousness between the articulated and the lived. . . . For all that is not fully articulated, all that comes through as disturbance, tension, blockage, emotional trouble, seems to me precisely a major source of major changes in the relation between the signifier and the signified.

Raymond Williams, *Politics and Letters: Interviews with New Left Review*, London, New Left Books, 1979, pp. 159 and 168.

3. Bourdieu, *Distinction*.

4. My thanks to Larry Bennett for his help.

5. See, e.g., M. Shiach, *Discourse on Popular Culture*, Stanford, Stanford University Press, 1989.

6. P. Stallybrass and A. White, *The Politics and Poetics of Transgression*, London, Methuen, 1986.

7. Tony Bennett, "Popular Culture: A 'Teaching Object,' " *Screen Education*, 1980, no. 34, pp. 18–29; and "Marxist Cultural Politics: In Search of 'the Popular,' " *Australian Journal of Cultural Studies*, 1983, vol. 1, pp. 2–28. See also Iain Chambers, "Rethinking 'Popular Culture,' " *Screen Education*, 1980, no. 36, pp. 113–17.

8. S. Hall, "Notes on Deconstructing 'the Popular,' " in R. Samuel (ed.), *People's History and Socialist Theory*, London, Routledge and Kegan Paul, 1981, pp. 227–40.

9. Ibid., p. 239.

10. Judith Williamson, "The Problems of Being Popular," *New Socialist*, September 1986, p. 14. See also Meaghan Morris, "Banality in Cultural Studies," in P. Mellencamp (ed.), *Logics of Television*, Bloomington, Indiana University Press, 1990, pp. 14–43.

11. S. Hall, "Editorial," *New Left Review*, 1960. no. 1, p. 1.

12. See L. Grossberg, "Postmodernity and Affect: All Dressed up with No Place to Go," *Communications*, 1988, vol. 10, pp. 271–93.

13. B. Massumi, Notes on the Translation and Acknowledgments, in G. Deleuze and F. Guattari, *A Thousand Plateaus: Capitalism and Schizophrenia*, Minneapolis, University of Minnesota Press, 1987, p. xvi.

14. Libido is sexualized psychic energy. See Gilles Deleuze, *Nietzsche and Philosophy*, trans. H. Tomlinson, New York, Columbia University Press, 1983; J. Laplanche and J.-B. Pontalis, *The Language of Psychoanalysis*, trans. D. Nicholson-Smith, New York, Norton, 1973.

15. See, e.g., M. Heidegger, *Being and Time*, trans. J. Macquarrie and E. Robinson, New York, Harper and Row, 1962.

16. In classic philosphical terms, "will" refers to the difference between my raising my hand and my hand rising. It is the difference between activity and passivity, the amount of energy invested in any specific site.

17. R. Goldstein, *The Mind-Body Problem*, New York, Laurel, 1983, p. 272.

18. J.-F. Lyotard, *Heidegger and "the Jews,"* trans. A. Michel and M. Roberts, Minneapolis, University of Minnesota Press, 1990, p. 26.

19. James Klein, a student at Kent State University, in "Letter to the Next Generation," broadcast on *P.O.V.*, PBS, 1990.

CHAPTER THREE: POWER AND DAILY LIFE

1. See S. Hall, "The Toad in the Garden: Thatcherism among the Theorists," in C. Nelson and L. Grossberg (eds.), *Marxism and the interpretation of Culture*, Urbana, University of Illinois Press, 1988, pp. 35–57.

2. See R. Williams, "Base and Superstructure in Marxist Theory," in *Problems in Materialism and Culture*, London, Verso, 1980, pp. 31–49.

3. This is a model of mainstream/avant-garde which has animated a great deal of contemporary film theory, including most of the work that came to be associated with the journal *Screen*. See C. Penley (ed.), *Feminism and Film Theory*, New York, Routledge, 1988.

4. E.g., T. Modleski, *The Women Who Knew Too Much*, New York, Methuen, 1988.

5. This has been an important and influential model in cultural studies. See D. Hebdige, *Subculture: The Meaning of Style*, London, Methuen, 1979, and Janice Radway, *Reading the Romance*, Chapel Hill, University of North Carolina Press, 1984.

6. Although most writers would use "everyday life" in this context, I will

reserve this term for a more specific historical articulation of daily life. See chapter 7.

7. For example, see Iain Chambers, *Popular Culture: The Metropolitan Experience*, London, Methuen, 1986.

8. For example, see John Fiske, *Reading the Popular*, Boston, Unwin Hyman, 1989. Actually, it is not clear that this is Fiske's position as much as it is the reading that has been constructed of him, but one that he seems to accept at times.

9. John Clarke, personal communication. Similarly, Raymond Williams defended his notion of culture as a whole way of life (answering E. P. Thompson's concept of a whole way of struggle) by maintaining the distinction between class conflict and class struggle: "If you define the whole historical process as struggle, then you have to elude or foreshorten all the periods in which conflict is mediated in other forms, in which there are provisional resolutions or temporary compositions of it." Raymond Williams, *Politics and Letters: Interviews with New Left Review*, London, New Left Books, 1979, p. 135.

10. See, e.g., Lynn Segal, *Is the Future Female?*, London, Virago, 1987; and Paul Gilroy, *There Ain't No Black in the Union Jack: The Cultural Politics of Race and Nation*, London, Hutchinson, 1987.

11. See J. Rutherford (ed.), *Identity: Community, Culture, Difference*, London, Lawrence and Wishart, 1990; Carolyn Steedman, *Landscape for a Good Woman: A Story of Two Lives*, London, Virago, 1986.

12. See L. Grossberg, "Experience, Signification and Reality: The Boundaries of Cultural Semiotics," *Semiotica*, 1982, vol. 41, pp. 73–106. See also the discussion of the politics of identity, chapter 16.

13. M. Foucault, "The Confession of the Flesh," in *Power/Knowledge: Selected Interviews and Other Writings, 1972–1977*, C. Gordon (ed.), New York, Pantheon, 1980, pp. 194–228.

14. G. Deleuze and F. Guattari, *A Thousand Plateaus*, trans. B. Massumi, Minneapolis, University of Minnesota Press, 1987.

15. Foucault, "Confession,", p. 194.

16. M. Foucault, "Questions of Method: An Interview," *Ideology and Consciousness*, 1981, no. 8, pp. 4–5. The relation between apparatuses and regimes is ambiguous since each can be constructed from multiples of the other.

17. See M. Foucault, "The Discourse on Language," in *The Archaeology of Knowledge*, New York, Pantheon, 1972, pp. 215–39.

18. M. Foucault, *The History of Sexuality, volume I: An Introduction*, trans. R. Hurley, New York, Pantheon, 1978.

19. M. Foucault, "Truth and Power," in M. Morris and P. Patton, *Michel Foucault: Power, Truth, Strategy*, Sydney, Feral Publications, 1979, p. 47.

20. M. Foucault, "Confession." p. 195.

21. M. Foucault, "Method," p. 6.

22. Ibid.

23. G. Deleuze and F. Guattari, *Plateau*, p. 210.

24. See G. Deleuze, *Foucault*, trans. S. Hand, Minneapolis, University of Minnesota Press, 1988. Note that my use of "spaces" and "places" does not correspond to that of M. de Certeau, *The Practice of Everyday Life*, trans. S. F. Rendall, Berkeley, University of California Press, 1984.

25. Meaghan Morris, "At Henry Parkes Motel," *Cultural Studies*, 1988, vol. 2, p. 42.

26. Fishman, quoted in A. Snitow, "Suburban on the Rocks: Waking up from the American Dream, *Village Voice Literary Supplement*, March 1988, p. 22.

27. Morris, "Motel," 37.

CHAPTER FOUR: ARTICULATION AND AGENCY

1. Stuart Hall, "On Postmodernism and Articulation: An Interview," *Journal of Communication Inquiry*, 1986, vol. 10, pp. 56–59.

2. A. Gramsci, *Selections from the Prison Notebooks*, trans. Q. Hoare and G. Nowell Smith, New York, International Publishers, 1971, p. 324.

3. I am grateful to Meaghan Morris for this observation.

4. See L. Althusser, "Marxism and Humanism," in *For Marx*, trans. B. Brewster, New York, Vintage, 1970, pp. 219–47. See also the critique of empiricism in L. Althusser and E. Balibar, *Reading Capital*, trans. B. Brewster, London, New Left Books, 1970. Notice that discussions of the death or decentering of the subject may refer to: (1) any essential or centered human nature; (2) a particular liberal conception of human nature; or (3) a particular subject-position identified with the speaker/author.

5. E. Benveniste, *Problems of General Linguistics*, trans. M. E. Meek, Coral Gables, University of Miami Press, 1971, p. 224.

6. See K. Silverman, *The Subject of Semiotics*, New York, Oxford University Press, 1983.

7. M. de Certeau, *The Practice of Everyday Life*, trans. S. F. Rendall, Berkeley, University of California Press, 1984. For a more detailed critique, see M. Morris, "The Banality of Cultural Studies," in P. Mellencamp (ed.), *Logics of Television*, Bloomington, Indiana University Press, 1990, pp. 14–43.

8. G. Spivak, "Can the Subaltern Speak?" in C. Nelson and L. Grossberg (eds.), *Marxism and the Interpretation of Culture*, Urbana, University of Illinois Press, 1988, pp. 271–313.

9. H. Lefebvre, *Everyday Life in the Modern World*, trans. S. Rabinovitch, New Brunswick, Transaction, 1984, p. 92.

10. I have not tried to give a complete description of contemporary theories of the subject. For a more adequate account, see E. Cadava, P. Connor, J.-L. Nancy (eds.), *Who Comes after the Subject?*, New York, Routledge, 1991.

11. For example, see C. Mouffe, "Hegemony and New Political Sub-

jects," in C. Nelson and L. Grossberg, *Marxism and the Interpretation of Culture*, pp. 89–101.

12. See J. Kristeva, *Desire in Language: A Semiotic Approach to Literature and Art*, trans. T. Gora, A. Jardine and L. S. Roudiez, New York, Columbia University Press, 1980; L. Irigiray, *This Sex Which is Not One*, trans. C. Porter, Ithaca, Cornell University Press, 1985; M. Foucault, "Powers and Strategies," in *Power/Knowledge: Selected Interviews and Other Writings, 1972–77*, C. Gordon (ed.), New York, Pantheon, 1980, pp. 134–45.

13. See G. Deleuze and F. Guattari, *Anti-Oedipus: Capitalism and Schizophrenia*, trans. R. Hurley, M. Seem and H. R. Lane, New York, Viking, 1977.

14. See R. Coward, "Class, 'Culture' and the Social Formation," *Screen*, 1977, vol. 18, pp. 75–105; and I. Chambers, et al., "Marxism and Culture," *Screen*, 1978, vol. 19, pp. 109–19.

15. See Stuart Hall, "Grasmci's Relevance for the Study of Race and Ethnicity," *Journal of Communication Inquiry*, 1986, vol. 10, pp. 5–27.

CHAPTER FIVE: ROCK CULTURES AND FORMATIONS

1. S. Frith, "BritBeat," *Village Voice* (personal communication).

2. This is, of course, most of rock journalism. For an example of this work at its best, see S. McClary, *Feminine Endings: Music, Gender, and Sexuality*, Minneapolis, University of Minnesota Press, 1991; and Simon Reynolds, *Blissed Out: The Raptures of Rock*, London, Serpent's Tail, 1990.

3. Many commentators on American rock miss the importance of regional identity in defining affective alliances. In fact, questions of race, class and gender are often directly inflected according to regions (south, northeast, etc.) and to the type of living space (e.g., urban, suburban, rural, etc.).

4. There is at least one other set of conditions worth mentioning here: the economics and technology of the recording industry. See Andrew Goodwin, "Sample and Hold: Pop Music in the Digital Age of Reproduction," *Critical Quarterly*, 1988, vol. 30, pp. 34–49; Simon Frith, "Video Pop: Picking up the Pieces," in S. Frith (ed.), *Facing the Music*, New York, Pantheon, 1988, pp. 88–130; Will Straw, "Systems of Articulation, Logics of Change: Communities and Scenes in Popular Music," *Cultural Studies*, 1991, vol. 5, pp. 368–88; and Mark Fenster, "The Institutional and Economic Terrain for Alternative Musics," unpublished manuscript, 1991.

CHAPTER SIX: ROCK AND EVERYDAY LIFE

1. *Time*, May 30, 1955, cited in D. Pichaske, *A Generation in Motion: Popular Music and Culture in the Sixties*, New York, Schirmer Books, 1979, p. 4.

2. See J. Clarke, *New Times and Old Enemies*, London, Routledge, 1991.

3. E.g., R. Williams, *The Long Revolution*, London, Chatto and Windus, 1961.

4. A. Ross, *No Respect: Intellectuals and Popular Culture*, New York, Routledge, 1989, ch. 2.

5. T. Hine, *Populuxe*, New York, Knopf, 1986.

6. Cited in D. Pichaske, *Generation*, p. 27.

7. H. Lefebvre, *Everyday Life in the Modern World*, trans. S. Rabinovitch, New Brunswick, Transaction, 1984, p. 38.

8. Ibid., p. 33.

9. Ibid., p. 11.

10. Jacques Attali, *Noise: The Political Economy of Music*, trans. B. Massumi, Minneapolis, University of Minnesota Press, 1985, p. 11.

11. H. Lefebvre, *Everyday Life*, p. 19.

12. S. Frith, "Golden Lite," *Village Voice*, April 24, 1990, p. 91.

13. J. Attali, *Noise*, p. 3.

14. F. Guattari, *Molecular Revolution: Psychiatry and Politics*, trans. R. Sheed, New York, Penguin, 1984, p. 107.

15. G. Tate, "Black Medallions, Soul Gold," *Village Voice*, September 4, 1990, p. 69.

16. A. H. Rosenfeld, "Music, the Beautiful Disturber," *Psychology Today*, December 1985, p. 48. The fact that live rock occasions are so highly charged partly explains why it is so difficult to carry out ethnographic research. That affective power creates such a powerful identification and involvement that anyone with the distance necessary to undertake research is immediately suspect.

17. G. Deleuze and F. Guattari, *A Thousand Plateaus: Capitalism and Schizophrenia*, trans. B. Massumi, Minneapolis, University of Minnesota Press, 1987, p. 311. I particularly want to thank Meaghan Morris for suggesting this creation refrain as an explanatory image.

18. B. Coleman, "TV's Bum Rap," *Village Voice*, November 11, 1990, p. 57.

19. "Vital Statistics: Pessimism," *Newsweek*, December 24, 1990, p. 6.

20. See L. Grossberg, "Music Television: Swinging on the (Postmodern) Star," in I. Angus and S. Jhally (eds.), *Cultural Politics in Contemporary America*, New York, Routledge, 1989, 254–68.

21. J. D. Stern, "Behind Vanna's Seduction of America," *TV Guide*, March 4, 1989, p. 5.

22. W. Greider, "Rolling Stone Survey: Portrait of a Generation," *Rolling Stone*, April 7, 1988, p. 36.

23. R. A. Koch, "Activism vs Apathy," *U: The National College Newspaper*, March 1991, pp. 6–7.

24. B. E. Ellis, "The Twentysomethings: Adrift in a Pop Landscape," *New York Times*, December 2, 1990, p. H1.

25. Koch, "Activity."

26. B. Ehrenreich, *Fear of Falling: The Inner Life of the Middle Class*, New York, Pantheon, 1989, p. 70.

27. J. Mulvagh, "The Manic Pursuit of Novelty," *The Irish Times Weekend*, December 30, 1989, p. 1.

28. J. Rosen, "The Sleep of Reason," *New Statesman and Society*, September 1988, p. 24.

29. S. O'Shea, "Just Say Yes," *Elle*, December 1990, p. 144.

30. R. Goldstein, "We So Horny," *Village Voice*, October 16, 1990, p. 35.

31. Quoted in M. Segell, "Music," *Cosmopolitan*, November 1988, p. 54.

CHAPTER SEVEN: ROCK AND YOUTH

1. See L. Y. Jones, *Great Expectations: America and the Baby Boom Generation*, New York, Coward, McCann and Geoghegan, 1980.

2. *Time*, 1948, cited in ibid., p. 36.

3. Ibid., p. 37.

4. Ibid.

5. R. Hofstadter, cited in ibid., p. 47.

6. John Updike, cited in ibid., p. 47.

7. It is important to remember that America found itself in this position without having ever chosen to seek it.

8. E. H. Erikson, *Identity: Youth and Crisis*, New York, Norton, 1968.

9. W. Baker, "The Global Teenager," *Whole Earth Review*, 1989, no. 65, p. 13.

10. Ibid.

11. *The Complete Works of William Shakespeare*, W. G. Clarke and W. A. Wright (eds.), Garden City, Doubleday, n.d., vol. 2, p. 791.

12. Adrian Martin, personal communication.

13. See, e.g., V. Walkerdine, *Schoolgirl Fictions*, London, Verso, 1990.

14. D. Hebdige, "Posing . . . Threats, Striking . . . Poses: Youth, Surveillance and Display," *Substance*, 1983, no. 37/38, pp. 68–88.

15. T. Benn, "Sexual Spaces/Public Places," and R. Brooks, "Between the Street and the Screen," *Z/G*, n.d., n.p.

16. *The Chicago Tribune Sunday Magazine*, October 23, 1988.

17. D. Marsh, "The Who: Middle-Aged Wasteland," *Village Voice*, July 11, 1989, pp. 78–79.

18. Charles Krauthammer, "Time Is Right for Censoring Rock Music," *Chicago Sun Times*, September 23, 1985, p. 23.

19. B. E. Ellis, "The Twentysomethings: Adrift in a Pop Landscape," *New York Times*, December 2, 1990, p. H1.

20. This appears to be the argument of J. Myerwitz, *No Sense of Place:*

The Impact of Electronic Media on Social Behavior, New York, Oxford University Pres, 1985.

21. D. Polonoff, "Backyard Mobility," *Village Voice*, 1986.

22. D. Leavitt, "The New Lost Generation," *Esquire*, May 1985, p. 94.

23. B. E. Ellis, "Twentysomethings," p. 37.

24. National Commission on the Role of the School and the Community in Improving Adolescent Health, *Code Blue: United for Healthier Youth*, n.d., n.p.

25. "Blackboard Jungle, 1940–1982," *Harper's*, March 1985, p. 25.

26. K. Zinsmeister, "Growing up Scared," *Atlantic Monthly*, June 1990, p. 66.

27. See D. Nathan, "The Ritual Sex Abuse Hoax," *Village Voice*, June 12, 1990, p. 36.

28. T. Carson, "Head 'Em Up, Move 'Em Out," *Village Voice*, November 6, 1984, p. 73.

29. *Newsweek* (special edition), *The New Teens*, Summer/Fall, 1990.

30. K. Zinsmeister, "Growing Up Scared," p. 53.

31. Ibid., p. 52.

32. Ibid., p. 53.

33. T. Gore, *Raising PG Kids in an X-Rated Society*, Nashville, Abingdon Press, 1987, p. 13.

34. Ibid., p. 12.

35. Ibid., p. 41.

36. Ibid.

37. Ibid., p. 46.

38. A. Bloom, *The Closing of the American Mind*, New York, Simon and Schuster, 1987.

39. Ibid., p. 49.

40. Ibid.

41. Ibid., p. 51.

42. Ibid., p. 50.

43. Ibid., p. 51.

44. Ibid., p. 55.

45. Ibid., p. 53.

46. Ibid.

47. Ibid., p. 55.

48. Ibid., p. 56.

49. Ibid., p. 33.

50. Ibid., p. 29.

51. Ibid., p. 27.

52. Ibid., p. 25.

53. Ibid., p. 59.

54. Ibid., p. 73.

55. Ibid., p. 77.

56. Ibid., p. 79.

57. Ibid., pp. 80–81.

58. Reported in "Rockbeat," *Village Voice*, July 24, 1990, p. 87.
59. C. Steedman, *Landscape for a Good Woman: A Story of Two Lives*, London, Virago, 1986, p. 122.
60. L. Bangs, from G. Marcus, personal communication.
61. T. B. Brazelton, "Why Is America Failing Its Children?" *New York Times Magazine*, September 9, 1990, p. 41.

CHAPTER EIGHT: ROCK AND AUTHENTICITY

1. K. Marx, cited in M. Berman, *All That Is Solid Melts into Air*, New York, Simon and Schuster, 1982.
2. P. Schjeldahl, "Appraising Passions," *Village Voice*, January 7–13, 1981, p. 67.
3. J. Carroll, *The Basketball Diaries*, New York, Bantam, 1980, p. 108.
4. See, e.g., S. Chapple and R. Garofalo, *Rock 'n' Roll Is Here to Pay: The History and Politics of the Music Industry*, Chicago, Nelson Hall, 1977.
5. By describing it as a sensibility, I want to claim that the "postmodern" is a real feature of contemporary life, without assuming that it is in any sense an "accurate" representation of either reality or experience. By describing it as a structure of feeling, I want to emphasize the gap between the lived and its possible articulation. What makes postmodernity unique is that it is the gap itself which is represented as unrepresentable. In this sense, postmodernity may be seen as modernism lived, where modernism is the bourgeois indictment of the bourgeois structures of the modern. This indictment has now become part of the popular and of commonsense, even though we continue to live in the modern. Thus, high modernism is turned on its head and deprived of any status as an avant garde.
6. W. Allen, "Program Notes," Krannert Center for the Performing Arts, Urbana, Ill., 1990.
7. Berke Breathed, *Bloom County* cartoon.
8. M. Coleman, "New Order's Leap of Faith," *Village Voice*, January 11, 1983, p. 61.
9. B. A. Mason, *In Country*, New York, Harper and Row, 1985, p. 226.
10. D. DeLillo, *White Noise*, New York, Penguin, 1985, p. 139.
11. B. Latour, personal communication from Paula Treichler.
12. D. Leavitt, "The New Lost Generation," *Esquire*, May 1985, pp. 93–94.
13. Ibid., p. 94.
14. Ibid.
15. R. Goldstein, "Home Cooking," *Village Voice*, July 26, 1988, p. 35.
16. G. Felton, "Students of 'The Pitch'," *Newsweek*, September 26, 1988, p. 11.
17. P. Aufderheide, "Sid and Nancy: Just Say No," *In These Times*, November 19–25, 1986, p. 14.

18. T. Ward, "Sex and Drugs and Ronald Reagan," *Village Voice*, January 29, 1985, p. 15.

19. Tufts University student newspaper.

20. D. Sheff, "Rolling Stone Survey: Portrait of a Generation," *Rolling Stone*, May 5, 1988, p. 50.

21. Ibid., pp. 47–49.

22. P. Moffitt, "R U Hip, Sixties People," *Esquire*, April 1981, p. 6.

23. R. Lacayo, "Madonna," *People Extra: The 80's*, Fall 1989, p. 50.

24. N. Tennant/C. Lowe, "It's a Sin," ASCAP Cage Music/10 Music/Virgin Music Inc., 1987.

25. N. Tennant/C. Lowe, "Rent," ASCAP Cage Music/10 Music/Virgin Music, Inc., 1987.

26. P. Oakley/I. Burden, "Love Action (I Believe in Love)," Sound Diagrams/Virgin Music Ltd. Dinsong Ltd., 1981.

27. M. Coleman, "New Order's," p. 61.

28. P. Rudnick and K. Andersen, "The Irony Epidemic: The Dark Side of Fiestaware and the Flintstones," (*Spy*), rpt. *Utne Reader*, May/June 1989, no. 33, p. 35.

29. F. Rose, "Welcome to the Modern World," *Esquire*, April, 1981, p. 32.

30. R. Goldstein, "Home Cooking."

31. R. Lacayo, "Madonna."

32. T. Ward, "Sex and Drugs," 48.

33. J. G. Ballard, *The Atrocity Exhibit*, London, Triad/Panther, 1985, p. 63.

34. R. Lacayo, "A Kindler Gentler Nation," *People Extra: The 80's*, Fall 1989, p. 105.

35. G. O'Brien, "What Is Hip?" *Interview*, July 1987, vol. 271, pp. 42–43.

36. O. Sacks, *The Man Who Mistook His Wife for a Hat and Other Clinical Tales*, New York, Harper and Row, 1987, pp. 108–15.

37. Ibid., p. 116–17.

38. Ibid., p. 119.

39. Ibid.

40. F. Jameson, *Postmodernism, or The Cultural Logic of Late Capitalism*, Durham, Duke University Press, 1991. See also C. Newman, "What's Left out of Literature," *New York Times Book Review*, July 12, 1987, p. 1ff.

41. Cited in S. Zizek, "The Subject Supposed to . . . (Know, Believe, Enjoy, Desire)," paper delivered at the Wars of Persuasion Conference: Gramsci, Intellectuals and Mass Culture, University of Massachusetts at Amherst, April 24, 1987.

42. M. Ventura, *Shadow Dancing in the USA*, Los Angeles, Jeremy Tarcher, 1985, p. 24.

43. Kirsten Lentz, personal communication.

44. See, e.g., R. Christgau, "Madonnathinking, Madonnabout, Madonnamusic," *Village Voice*, May 28, 1991, pp. 31–33; and Andrew Good-

win, "Popular Music and Postmodern Theory," *Cultural Studies*, 1991, vol. 5, pp. 174–90.

45. B. E. Ellis;, "The Twentysomethings: Adrift in a Pop Landscape," *New York Times*, December 2, 1990, p. H37.

46. Jon Crane, "Terror and Everyday Life," *Communication*, 1988, vol. 10, pp. 372–74.

47. S. Frith, "Art of Poise," *Village Voice*, April 9, 1991, p. 74.

48. S. Reynolds, "Dazed and Confused," *Village Voice*, January 1, 1991, p. 70.

49. S. Frith, "The Club Class," *Village Voice*, November 21, 1989, p. 77.

50. Ibid.

51. Ibid.

52. P. Schjeldahl, "Irony and Agony," *In These Times*, August 20–September 2, 1986, p. 16.

53. Arion Berger, "No Great Shakes," *Village Voice Pazz and Jop Supplement*, February 27, 1990, p. 9.

54. "This is the postrock generation gap. The young listen to more and more, and it means less and less. The old listen to less and less, but it means more and more. The young are materialists; music is as good as its functions. The old are idealists, in search (like the band in *The Commitments*) of epiphany." Simon Frith, "He's The One," *Village Voice*, October 29, 1991, p. 88.

CHAPTER NINE: NATION, HEGEMONY AND CULTURE

1. This chapter draws heavily on the work of Stuart Hall and John Clarke, as well as personal conversations with both of them. See S. Hall, *The Hard Road to Renewal: Thatcherism and the Crisis of the Left*, London, Verso, 1988; S. Hall and M. Jacques (eds.), *The Politics of Thatcherism*, London, Lawrence and Wishart, 1983; S. Hall et al., *Policing the Crisis: Mugging, the State, and Law and Order*, London, Macmillan, 1978; J. Clarke, *New Times and Old Enemies*, London, Routledge, 1991.

2. R. Williams, *Marxism and Literature*, Oxford, Oxford University Press, 1977, pp. 108–14; T. Gitlin, *The Whole World Is Watching: Mass Media in the Making and Unmaking of the New Left*, Berkeley, University of California Press, 1980.

3. S. Hall, "The Toad in the Garden: Thatcherism Among the Theorist," in C. Nelson and L. Grossberg (eds.), *Marxism and the Interpretation of Culture*, Urbana, University of Illinois Press, 1988, pp. 33–57.

4. Ibid.

5. A. Gramsci, *Selections from the Prison Notebooks*, trans. Q. Hoare and G. Nowell Smith, New York, International Publishers, 1971, p. 12.

6. E. Laclau and C. Mouffe, *Hegemony and Socialist Strategy: Towards*

a Radical Democratic Politics, London, Verso, 1985; and E. Laclau, "Metaphor and Social Antagonisms," in C. Nelson and L. Grossberg, *Marxism*, pp. 249–58. Hall, Laclau and Mouffe all interpret hegemony as a struggle between the people and the power bloc, rather than taking the more traditional view which locates hegemony in the relation between the state and civil society.

7. E. Laclau and C. Mouffe, *Hegemony*; C. Mouffe, "Hegemony and New Political Subjects: Toward a New Concept of Democracy," in C. Nelson and L. Grossberg, *Marxism*, pp. 89–101.

8. S. Hall, personal conversation.

9. J. Solomos, B. Findlay, S. Jones and P. Gilroy, "The Organic Crisis Of British Capitalism And Race: The Experience of the Seventies," in Centre for Contemporary Cultural Studies, *The Empire Strikes Back: Race and Racism in 70s Britain*, London, Hutchinson, 1982, pp. 11 and 21. See also Women's Studies Group of the Centre for Contemporary Cultural Studies, *Women Take Issue: Aspects of Women's Subordination*, London, Hutchinson, 1978. Both of these are exemplary in their recognition of the complex relations of politics, economics, culture and identity, although the latter does fall back at times into a fetishism of the local overdetermination of identity. For a discussion of the cynicism in the new conservative's deployment of racism as an electoral issue in the U.S., see D. Ireland, "Press Clips," *Village Voice*, November 26, 1991, p. 10.

10. S. Hall, *The Hard Road to Renewal*.

11. S. Hall, "Authoritarian Populism," *New Left Review*, 1985, no. 151, p. 118.

12. See R. Pollin and A. Cockburn, "The World, the Free Market and the Left," *The Nation*, February 25, 1991, pp. 224–36; and C. J. Lang, "The Hole in America's Stocking," *Village Voice*, December 25, 1990, p. 38ff.

13. R. L. Berke, rpt. *Champaign Urbana News Gazette*, May 6, 1990, p. B1. See also C. Page, "Bush Has Drifted from Mainstream," *Chicago Tribune*, November 5, 1990, section 5, p. 13; J. B. Judis, "Slurs Fly in Right's Uncivil War," *In These Times*, October 18–24, 1989, p. 3; and J. B. Judis, "The War at Home," *In These Times*, March 14–20, 1990, p. 12ff.

14. See T. Ferguson, "F. D. R., Anyone?" *The Nation*, May 22, 1989, p. 689.

15. Thus, Gramsci noted that Italy's national popular was largely composed of cultural texts imported from other European cultures. See A. Gramsci, *Selected Writings, 1916–1935*, ed. D. Forgacs, New York, Schocken, 1988, pp. 363–78.

16. Patrick Buchanan, "In the War for America's Culture, the 'Right' Side Is Losing," *Richmond News Leader*, June 24, 1989. Note also that the new conservative alliance is actively concerned with more local—i.e., state, county and city—state apparatuses as well.

CHAPTER TEN: HEGEMONY AND THE POSTMODERN FRONTIER

1. Andrew Ross, *No Respect: Intellectuals and Popular Culture*, New York, Routledge, 1989, chapter 2.

2. J. Crane, "Terror and Everyday Life," *Communication*, 1988, vol. 10, p. 320.

3. A. Bloom, *The Closing of the American Mind*, New York, Simon and Schuster, 1987, p. 147.

4. James Stone, quoted in Geoffrey Stokes, "Pressclips," *Village Voice*, October 17, 1989, p. 8.

5. S. Blumenthal, "Marketing and the President," *New York Times Magazine*, September 13, 1981.

6. R. Stone, "Keeping the Future at Bay: Of Republicans and Their America," *Harper's*, November 1988, p. 61.

7. "Reagan . . . manages to make you feel good about your country, and about the times in which you are living. All those corny feelings that hid inside of you for so long are waved right out in public by Reagan for everyone to see—and even while you're listing all the reasons that you shouldn't fall for it, you're glad that you're falling. If you're a sucker for that act, that's okay." B. Greene, "It's Confession Time," *Chicago Tribune*, December 11, 1985, Sec. 5, p. 1.

8. W. Schneider, "The In-Box President," *Atlantic Monthly*, January 1990, pp. 34–43.

9. B. Minzensheimer, "Abortion Most Cited Issue," *USA Today*, November 8, 1988, p. 31.

10. "Which Issues Are Very Important to Women," *Time*, December 4, 1989, p. 82.

11. D. Sheff, "Rolling Stone Survey: Portrait of a Generation," *Rolling Stone*, May 5, 1988, p. 46.

12. W. Greider, "Money Matters," *Rolling Stone*, April 7, 1988, p. 47.

13. D. Sheff, "Survey," p. 51.

14. A. Gordon-Reed, "New York Stock Boys Shelved Ethics," *In These Times*, January 10, 1990, p. 18.

15. *Harper's*, November, 1988.

16. W. Greider, "Turned out, Turned off," *Rolling Stone*, April 7, 1988, p. 53.

17. "What We Watch," *TV Guide*, December 24–30, 1988, p. 7.

18. M. Oreskes, "America's Politics Loses Way As Its Vision Changes World," *New York Times*, March 18, 1990, p. A16.

19. Ibid.

20. Ibid.

21. See E. Clift, "Racing to Control the Buzzwords," *Newsweek*, December 24, 1990, p. 21.

22. R. Stone, "Keeping the Future at Bay," p. 61.

23. Quoted in L. Savan, "Gettin' Tipsy," *Village Voice*, August 29, 1989, p. 56.

24. T. Carlson, "The Show That Wouldn't Die . . . ," *TV Guide*, January 13, 1990, p. 6.

25. Quoted in L. Savan, "The Trad Trade," *Village Voice*, March 7, 1989, p. 49.

26. Ibid.

27. Ibid.

28. J. Levy, "Joy and Pain," *Village Voice*, February 28, 1989, p. 66.

CHAPTER ELEVEN: IDEOLOGY AND AFFECTIVE EPIDEMICS

1. Hugo Burnham, "When the Music's Over," *Details*, July 1991, pp. 35–36.

2. Unlike moral panics, such affective epidemics need have no anchor in reality; they can be entirely symbolic.

3. See, e.g., Fred Jameson, "The Cultural Logic of Late Capitalism," in *Postmodernism, or The Cultural Logic of Late Capitalism*, Durham, Duke University Press, 1991, pp. 1–54.

4. Reported in D. Lazere, "Drug Peace (with Honor), *Village Voice*, November 27, 1990, p. 12.

5. S. Reynolds, "Ladybirds and Start-Rite Kids," *Melody Maker*, September 26, 1986, pp. 44–45.

6. A. Silverblatt, "Families and Fries That Bind," *In These Times*, January 10–16, 1990, p. 21.

7. E. Willis, "Coming down Again: Excess in the Age of Abstinence," *Village Voice*, January 24, 1989, p. 22.

8. B. Ehrenreich, *Fear of Falling: The Inner Life of the Middle Class*, New York, Pantheon, 1989, p. 181.

9. R. Lacayo, "A Kinder Gentler Nation," *People Extra: The 80's*, Fall 1989, p. 104.

10. Ibid., p. 107.

11. C. Rickey, "Twilight of the Idols," *Fame*, December 1988, p. 42.

12. J. Hoberman, "What's Stranger Than Paradise," and K. Dieckman, "Stupid People Tricks," *Village Voice Film Special*, June 30, 1987, pp. 3–8 and 11–5, respectively.

CHAPTER TWELVE: THE MOBILIZATION OF EVERYDAY LIFE

1. See, e.g., S. Blumenthal, *The Rise of the Counter-Establishment: From Conservative Ideology to Political Power*, New York, Harper and Row, 1988.

2. E. P. Valk, "From the Publisher," *People Extra: The 80's*, Fall 1989, p. 5.

3. H. Lefebvre, *Everyday Life in the Modern World*, trans. S. Rabinovitch, New Brunswick, Transaction, 1984, pp. 61 and 64. I am particularly grateful to Meaghan Morris, whose work already suggested the possibility of linking Lefebvre and Deleuze and Guattari.

4. Ibid., p. 72.

5. This is a good example of the way industry is consciously dissolving the line between economics and culture.

6. This is not to say that post-punk music fails to achieve any politics, or that punk defined a political high point in the cyclical history of rock. Rather, punk was a particular project to articulate a specific politics which in fact missed many of the possibilities of a politics of affect, bliss and the postmodern sensibility. See L. Grossberg, "Another Boring Day in Paradise: Rock and Roll and the Empowerment of Everyday Life," *Popular Music*, 1984, vol. 4, pp. 225–58.

7. A disciplined mobilization cannot be understood within the traditional problematic of the individual (solipsism) and the social (tradition). Moreover, within such formations, affective alliances, unlike communities, need have no immediate consequences on people's way of life.

8. C. Sarler, "Fashion Falls Victim to Its Own Whims . . . ," *The Sunday Times*, January 15, 1989, n.p.

9. I want to acknowledge the contribution of Harris Breslow to this argument.

10. F. Mort and N. Green, "You've Never Had It So Good—Again!" *Marxism Today*, May 1988, p. 33.

11. E.g., J. Baudrillard, *In the Shadow of the Silent Majorities*, New York, Semiotexte, 1983.

12. Quoted in M. Feinberg, "Nancy Cole: Savvy Organizer," *In These Times*, May 16–22, 1990, pp. 4–5.

13. R. A. Koch, "Activism vs. Apathy," *U: The National College Newspaper*, March 1991, pp. 6–7.

14. R. Brunt, "The Politics of Identity," in S. Hall and M. Jacques (eds.), *New Times: The Changing Face of Politics in the 1990s*, London, Lawrence and Wishart, 1989, p. 152.

15. H. Lefebvre, *Everyday Life*, p. 197.

16. E. P. Valk, "From the Publisher."

CHAPTER THIRTEEN: LIFE DURING WARTIME

1. "Budget Analysts Cite Surge in Income Gap during '80s," *Daily Illini*, Champaign, Illinois, 1990.

2. George Winslow, "A System Out Of Control, Not Just One Bank," *In These Times*, October 23–29, 1991, p. 10.

3. C. Lasch, "The Disappearance of Left and Right," *Rochester Review*, Summer 1991, p. 3.

4. This work started immediately after Goldwater's defeat.

5. According to Clarkson, the Coalition on Revival, a "secretive interdenominational theopolitical movement . . . now has a pilot project to take over local government in California's Orange and Santa Clara counties—phase one of a 60 city, five year plan." Clarkson, "Don Wildmon: He's No Jim Bakker," *In These Times*. Sometimes, paranoids do have enemies!

6. For an example of an analysis based on the multiple relations of culture and economics, see Women's Studies Group of the Centre for Contemporary Cultural Studies, *Women Take Issue: Aspects of Women's Subordination*, London, Hutchinson, 1978.

7. B. Ehrenreich, *Fear of Falling: The Inner Life of the Middle Class*, New York, Pantheon, 1989, p. 8.

8. I am indebted to Meaghan Morris for this argument.

CHAPTER FOURTEEN: THE STRUGGLE OVER CAPITALISM

1. L. Althusser and E. Balibar, *Reading Capital*, trans. B. Brewster, London, New Left Books, 1970.

2. D. Moberg, "The Fate of Nations in New World Market," *In These Times*, April 3–9, 1991, p. 20. This chapter owes an enormous debt to Meaghan Morris, James W. Carey, Fred Gottheil and Harris Breslow. See also A. G. Ingham, "From Public Issue to Personal Trouble: Well-Being and the Fiscal Crisis of the State," *Sociology of Sport Journal*, 1985, vol. 2, pp. 43–55.

3. E.g., G. Andrews (ed.), *Citizenship*, London, Lawrence and Wishart, 1991.

4. D. Moberg, "Fate," p. 20.

5. Ted O'Leary, personal communication.

6. A. L. Cot, "Neoconservative Economics, Utopia and Crisis," *Zone*, n.d., no. 1/2, pp. 292–311.

7. M. Davis, "The Political Economy of Late-Imperial America," *New Left Review*, 1984, no. 113, p. 12.

8. G. de Jonquières, "The West's Moving Target," *Financial Times Industrial Review*, January 8, 1990, p. 2.

9. C. Leadbeater, "A Corporate Global Trend," ibid., p. 1.

10. C. Mann, "The Man with All the Answers [Lester Thurow]," *The Atlantic Monthly*, January 1990, p. 47.

11. C. R. Morris, "The Coming Global Boom," *The Atlantic Monthly*, October 1989, pp. 51–58.

12. D. Harvey, *The Condition of Postmodernity*, London, Blackwell, 1989, p. 189.

13. A. Gramsci, "Americanism and Fordism," in *Selections from the*

Prison Notebooks, trans. Q. Hoare and G. Nowell Smith, New York, International Publishers, 1971, pp. 277–320.

14. A. Lipietz, "Towards Global Fordism?" *New Left Review*, 1982, no. 132, p. 34.

15. M. Davis, "Reaganomics' Magical Mystery Tour," *New Left Review*, 1985, no. 149, pp. 7–25.

16. M. Davis, "The Political Economy of Late-Imperial America," p. 18.

17. Ibid., p. 16.

18. A. Lipietz, "Towards Global Fordism," pp. 35–36.

19. A. Lipietz, "The Debt Problem, European Integration and the New Phase of World Crisis," *New Left Review*, 1989, no. 178, pp. 37–50.

20. M. Davis, "The Political Economy of Late-Imperial America," p. 15.

21. D. Harvey, *Condition*, p. 170.

22. Ibid., p. 195.

23. Martin Wolf, "Globe Can Struggle Through," *Financial Times Industrial Review*, January 8, 1990, p. 2.

24. M. Davis, "Reaganomics' Magical Mystery Tour," p. 10.

25. D. Harvey, *Condition*, p. 194.

26. James W. Carey, personal communication.

27. G. de Jonquieres, "West's Moving Target."

28. M. Davis, "Reaganomics' Magical Mystery Tour," p. 8.

29. This term is used by the "regulation school" in France to describe a new regime of accumulation and its associated mode of social and political regulation. See, e.g., Michel Aglietta, "World Capitalism in the Eighties," *New Left Review*, 1982, no. 186, pp. 5–41; and D. Harvey, op. cit.

30. See S. Hall and M. Jacques (eds.), *New Times: The Changing Face of Politics in the 1990s*, London, Lawrence and Wishart, 1989.

31. D. Harvey, *Condition*, p. 124.

32. Guy de Jonquieres, "West's Moving Target."

33. R. Murray, "Benetton Britain," in S. Hall and M. Jacques (eds.), *New Times*, p. 57.

34. R. Murray, "Fordism and Post-Fordism," in S. Hall and M. Jacques (eds.), *New Times*, p. 49.

35. A. Lipietz, "The Debt Problem, European Integration and the New Phase of World Crisis," p. 40.

36. See S. Hall and M. Jacques (eds.), *New Times*.

37. S. Hall, "The Meaning of New Times," in S. Hall and M. Jacques (eds.), *New Times*, p. 118.

38. Paul Hirst, "After Henry," in S. Hall and M. Jacques (eds.), *New Times*, pp. 321–29; John Clarke, *New Times and Old Enemies*, London, Routledge, 1991.

39. Hall, "Meaning," p. 119.

40. A. Gramsci, "Americanism," p. 302.

41. D. Harvey, *Condition*, pp. 125–6.

42. P. Hirst, "After Henry."

43. J. Clarke, *New Times and Old Enemies.*

44. S. Hall, "Meaning," p. 125.

45. Ibid.

46. A. Gramsci, "Americanism," p. 285.

47. Ibid., p. 291.

48. Ibid., p. 293.

49. Ibid., p. 302.

50. G. Deleuze and F. Guattari, *Anti-Oedipus: Capitalism and Schizophrenia*, trans. R. Hurley, M. Seem and H. R. Lane, New York, Viking, 1977, p. 224.

51. Ibid., p. 227.

52. Ibid., p. 249.

53. Ibid.

54. Ibid., p. 230.

55. Ibid., p. 239.

56. Ibid., p. 237.

57. Ibid.

58. Ibid., p. 197.

59. G. Deleuze and F. Guattari, *A Thousand Plateaus: Capitalism and Schizophrenia*, trans. B. Massumi, Minneapolis, University of Minnesota Press, 1987, p. 453.

60. I have taken this argument from conversations with Meaghan Morris.

61. G. Deleuze and F. Guattari, *Anti-Oedipus*, pp. 230–31.

62. Ibid., p. 259.

63. Ibid., p. 238.

64. G. Deleuze and F. Guattari, *A Thousand Plateaus*, p. 454. John Clarke (personal conversation) correctly points out that if these barriers are exclusively immanent, this position could easily drift into a variant of the "logic of capital" argument.

65. G. Deleuze and F. Guattari, *Anti-Oedipus*, p. 224.

66. Ibid., p. 257.

67. Ibid., p. 233.

68. G. Deleuze and F. Guattari, *A Thousand Plateaus*, p. 458.

69. G. Deleuze and F. Guattari, *Anti-Oedipus*, p. 236.

70. Ibid., p. 252.

71. G. Deleuze and F. Guattari, *A Thousand Plateaus*, p. 457.

72. G. Deleuze and F. Guattari, *Anti-Oedipus*, p. 251. It is worth noting here that Deleuze and Guattari, like Foucault, are problematizing the taken for granted centrality of questions of the subject in cultural theory, and of the concept of appropriation in cultural studies.

73. G. Deleuze and F. Guattari, *A Thousand Plateaus*, p. 454.

74. Ibid., p. 458.

75. Ibid., p. 210.

76. Ibid., p. 469.

77. This transition presumably constitutes a potentially major change, not only in capitalism, but in its relations to states, subjects, etc. It is not the working out of internal contradictions, nor a consciously directed development. It is the site of a major struggle around which cultural practices and logics are deployed.

78. S. L. Malcolmson, "Rough Trade: Democracy Goes with the Cash Flow," *Village Voice Literary Supplement*, 1990, p. 37.

79. D. Harvey, *Condition*, p. 296.

80. Meaghan Morris, personal communication.

81. M. Davis, "The Political Economy of Late-Imperial America," p. 7.

82. Ibid.

83. G. Deleuze and F. Guattari, *Anti-Oedipus*, p. 240.

CHAPTER FIFTEEN: THE STRUGGLE OVER THE LEFT

1. Fred Jameson, *Postmodernism, or The Cultural Logic of Late Capitalism*, Durham, Duke University Press, 1991, pp. 39–44.

2. Mike Davis, "Urban Renaissance and the Spirit of Postmodernism," *New Left Review*, 1985, no. 143, p. 112.

3. Ibid., p. 110.

4. Ibid., p. 113.

5. V. N. Volosinov, *Marxism and the Philosophy of Language*, trans. L. Matejka and I. R. Titunik, New York, Seminar Press, 1973.

6. B. Taylor, "Critical Condition," *Marxism Today*, June 1990, p. 49.

7. D. Hebdige, "Fax to the Future," *Marxism Today*, January 1990, p. 21. The acid-house panic was a moral panic in the late 1980s in response to a musical style and a practice of unlicensed late night warehouse parties for youth.

8. G. Deleuze and F. Guattari, *Anti-Oedipus: Capitalism and Schizophrenia*, trans. R. Hurley, M. Seem and H. R. Lane, New York, Viking, 1977, p. 259.

9. Ibid., p. 250.

10. B. Taylor, "Critical Condition," p. 49.

11. See, e.g., J. Clifford and G. E. Marcus (eds.), *Writing Culture: The Poetics and Politics of Ethnography*, Berkeley, University of California Press, 1986. Also, L. Grossberg, "Wandering Audiences, Nomadic Critics," *Cultural Studies*, 1988, vol. 2, pp. 377–91; L. Grossberg, "The Contexts of Audience and the Politics of Difference," *Australian Journal of Communication*, 1989, vol. 6, pp. 13–36.

12. See, e.g., P. Smith, *Discerning the Subject*, Minneapolis, University of Minnesota Press, 1988.

13. See J. Rutherford (ed.), *Identity: Community, Culture, Difference*, London, Lawrence and Wishart, 1990; R. Ferguson, et al. (eds.), *Out There: Marginalization and Contemporary Culture*, Cambridge, MIT

Press, 1990; and L. Appignanesi (ed.), *Identity: The Real Me*, London: ICA, 1987.

14. See my discussion in chapter 5.

15. S. Steele, "The Recoloring of Campus Life," *Harper's*, February 1989, pp. 49 and 52.

16. M. L. Adams, "There's No Place Like Home: On the Place of Identity in Feminist Politics," *Feminist Review*, 1989, no. 31, p. 24.

17. P. Parmar, "Other Kinds of Dreams," *Feminist Review*, 1989, no. 31, p. 59.

18. Cited in ibid., p. 63.

19. Kobena Mercer, " '1968': Periodizing Postmodern Politics and Identity," in L. Grossberg et al. (eds.), *Cultural Studies*, New York, Routledge, 1991.

20. A great deal of contemporary intellectual energy is devoted to rediscovering basically the same genealogy of the tropes of subordination, whether in the literary models of difference (e.g., in the work of Spivak, Bhabha, etc.) or in the Foucauldian models of normalization and exclusion (Said), or in the psychoanalytic models (often derived from Fanon). In each case, the positivity of the other gives way to othering as the construction of difference. Furthermore, to the extent that this work reduces the emotional/affective dimensions of such relations to psychoanalytic desire in every instance, not only is desire always directing the subordination/exclusion of the other, it is always the same desire. (I am grateful to Dick Hebdige for his willingness to talk about these issues.)

21. Parmar, "Other Kinds."

22. A. Gouldner, *The Future of Intellectuals and The Rise of the New Class*, London, Macmillan, 1979.

23. Everyone has his or her own stories to tell. One of my own rather mild examples will suffice here. Recently, when I challenged a woman researching "myths" of rape because of the analytic and political consequences of her rather naive understanding of "myth," I was told that I obviously did not care about the women who were being raped.

24. D. Minkowitz, "The Well of Correctness," *Village Voice*, May 21, 1991, p. 39.

25. G. Spivak, "Can the Subaltern Speak?" in C. Nelson and L. Grossberg (eds.), *Marxism and the Interpretation of Culture*, Urbana, University of Illinois Press, 1988, pp. 271–313.

26. S. Hall and M. Jacques, Introduction to *New Times: The Changing Face of Politics in the 1990s*, London, Lawrence and Wishart, 1989, p. 17.

27. F. Mort and N. Green, "You've Never Had it So Good—Again!," *Marxism Today*, May 1988, pp. 32–33.

28. F. Jameson, "Cognitive Mapping," in C. Nelson and L. Grossberg (eds.), *Marxism*, pp. 347–57.

29. S. Hall, "The Meaning of New Times," in S. Hall and M. Jacques (eds.), *New Times*, p. 130.

30. D. Hebdige, "After the Masses," pp. 92–93.

31. D. Hebdige, "Fax to the Future," p. 20.

32. See K. Marx, *The Eighteenth Brumaire of Louis Bonaparte*, in *Surveys from Exile*, New York, Vintage, 1974, pp. 143–249.

33. G. Spivak, "Subaltern," p. 272.

34. F. Mort and N. Green, "You've Never," p. 32.

35. Ibid.

36. S. Hall, "Signification, Representation, Ideology: Althusser and the Post-Structuralist Debates," *Critical Studies in Mass Communication*, 1985, vol. 2, pp. 91–114.

37. D. Lazere, "The Cult of Multiculturalism," *Village Voice*, May 7, 1991, pp. 29–31, offers a similar critique of the Left. Unfortunately, his solution is to return to some kind of masculinist Marxism in which the class struggle provides the foundation and unity of contemporary politics.

38. E. Laclau and C. Mouffe, *Hegemony and Socialist Strategy: Towards a Radical Democratic Politics*, London, Verso, 1985.

39. Harris Breslow, personal communication.

40. See C. West, "The New Cultural Politics of Difference," *October*, 1990, no. 53, pp. 93–109; *Third Scenario: Theory and Politics of Location* (special issue), *Framework*, 1989, no. 36; E. Carter (ed.), *Black Film, British Cinema*, London, ICA, 1988; and N. Goldman and S. Hall (eds.), *Pictures of Everyday Life*, London, Comedia, 1987.

41. J. P. Sartre, *Critique of Dialectical Reason*, trans. A. Sheridan-Smith, London, New Left Books, 1976.

42. G. Deleuze and F. Guattari, *A Thousand Plateaus*, trans. B. Massumi, Minneapolis, University of Minnesota Press, 1987, p. 9.

43. Ibid., chap. 10.

44. See W. Brown, "Feminist Hesitations, Postmodern Exposures," *Differences*, 3, 1991, pp. 63–84.

45. D. Hebdige, "Fax to the Future, p. 23.

46. S. Hall, "The Meaning of New Times," p. 133.

47. Cited in A. C. Chabram and R. L. Fregoso, "Chicana/o Cultural Representations: Reframing Alternative Critical Discourses," *Cultural Studies*, 1990, vol. 4, p. 210.

48. C. Carr, "War on Art: The Sexual Politics of Censorship," *Village Voice*, June 5, 1990, p. 27.

49. The literature is already too large to list. Some of the more popular articles are: W. A. Henry III, "Upside-down in the Groves of Academe," *Time*, April 1, 1991, pp. 66–69; J. Taylor, "Thought Police on Campus," *Reader's Digest*, May 1991, pp. 99–104; J. Adler, "Taking Offense," *Newsweek*, December 24, 1990, pp. 48–55; P. Gray, "Whose America?" *Time*, July 8, 1991, pp. 12–21; D. D'Souza, "Illiberal Education," *The Atlantic Monthly*, March 1991, pp. 51–79; D. Ravitch, "Diversity and Democracy," *American Educator*, Spring 1990, pp. 16–20ff. In addition, essays, articles, editorials and comments have appeared in *New Criterion*, *New Art Examiner*, *New Republic*, *New York Review of Books*, *Salmagundi*, *Tikkun*, *Village Voice*, *In These Times*.

50. For two typical "Left" responses which manage to avoid most of the issues and absolve themselves of all blame, see R. Goldstein, "The Politics of Political Correctness," and M. Berube, "Public Image Limited: Political Correctness and the Media's Big Lie," *Village Voice*, June 18, 1991, pp. 39–41 and 31–37, respectively. For an interesting comparison, see James W. Carey, "The Academy and Its Discontents," *Journalism History*, forthcoming; and Henry Giroux and David Trent, "Cultural Workers, Pedagogy and the Politics of Difference: Beyond Cultural Conservatism," *Cultural Studies*, forthcoming.

51. "Attendance Lowers at L.A. Anti-War Rallies," *Daily Illini*, February 19, 1991, p. 3.

52. J. Bleifuss, "The First Stone," *In These Times*, February 6–12, 1991, p. 4.

53. J. Judis, "Take Two on the War," ibid., p. 12.

54. C. Landry et al., *What a Way to Run a Railroad: An Analysis of Radical Failure*, London, Comedia, 1985.

55. D. Minkowitz, "Act Up at a Crossroads," *Village Voice*, June 5, 1990, p. 19.

56. A. Gramsci, *Selected Writings, 1916–1935*, ed. D. Forgacs, New York, Schocken, 1988, pp. 219–21 and 238–43.

57. I have taken the phrase from Tony Bennett, whose recent work uses Foucault to turn cultural studies to questions of governmentality and policy. See, e.g., the journal *Culture and Policy*.

58. Andre Frankovits, personal communication.

59. K. Axelos (*Arguments* 2, p. 222), cited in C. Stivale, "From Heterodoxy to 'Counter-Discourse': The *Arguments* Group," *Rethinking Marxism*, 1990, vol. 3, p. 117.

60. G. Deleuze and F. Guattari, *Plateaus*, p. 464.

61. James W. Carey, personal communication.

62. D. Hebdige, "Some Sons and Their Fathers," *Ten-8*, 1985, no. 17, p. 38.

63. E. Morin (*Arguments* 2, pp. 155–56), cited in C. Stivale, "From Heterodoxy," p. 116.

64. G. Deleuze and F. Guattari, *Anti-Oedipus*, p. 293.

65. Lu Xun (1921), quoted in M. Gottschalk, "China's Old and Dirty Hands," *In These Times*, June 20–July 3, 1990, p. 26.

Index

431

*Author's note: I want to thank Keehyeung Lee for compiling this index.